Portraiture

CRITICAL INTRODUCTIONS TO ART

This major new series aims to provide critically-informed textbooks which utilise the latest research and a wide range of approaches, to survey and analyse subjects studied widely on art history courses.

Using a thematic structure to cover individual artists, specific periods and genres, authors will highlight issues of contemporary concern such as gender, race, art practice and institutions to expand debates around mainstream subject areas for students. Each of these well-illustrated books will include a full bibliography and a detailed index.

PORTRAITURE

Facing the subject

edited and introduced by JOANNA WOODALL

Manchester University Press

MANCHESTER AND NEW YORK

distributed exclusively in the USA by St. Martin's Press

Published by Manchester University Press
Oxford Road, Manchester m13 9nr, UK
and Room 400, 175 Fifth Avenue, New York ny 10010, USA

Distributed exclusively in the USA
by St. Martin's Press, Inc.,
175 Fifth Avenue, New York, ny 10010, USA

British Library Cataloguing-in-Publication Data
A catalogue record for this book is available from the British Library

Library of Congress Cataloging-in-Publication Data
Woodall, Joanna.
 Portraiture : facing the subject / edited and introduced by Joanna Woodall.
 p. cm. — (Critical introductions to art)
 isbn 0-7190-4612-2. — isbn 0-7190-4614-9 (pbk.)
 1. Portraits. 2 Identity (Psychology) in art. I. Title. II. Series.
 n7575.w66 1997
 704.9'42—dc20 96-16844

isbn 0 7190 4612 2 *hardback*
isbn 0 7190 4614 9 *paperback*

First published in 1997

01 00 99 98 10 9 8 7 6 5 4 3 2

Typeset in Scala
by Koinonia, Manchester
Printed in Great Britain
by Redwood Books, Trowbridge

Contents

List of illustrations

List of contributors

ERNST VAN ALPHEN teaches comparative literature at the University of Leiden and is a member of the Amsterdam School for Cultural Analysis. Recent publications on visual art are *Francis Bacon and the Loss of Self* (1992), 'Facing defacement: "models" and Marlene Dumas' intervention in Western art', in Marlene Dumas, *Models* (1995), and the forthcoming *Caught in History: Holocaust Effects in Contemporary Art and Theory*.

PAUL BARLOW is Lecturer in the History of Art at the University of Northumbria. He has published on aspects of Victorian portraiture and the work of Thomas Carlyle and on the relationship between the legacy of Hogarth and nineteenth-century British painting.

JOHN GAGE is Reader in the History of Western Art at Cambridge University and a Fellow of the British Academy. He read Modern History at Oxford University and History of Art at the Courtauld Institute, where he was awarded a Doctorate in 1968. His most recent book, *Colour and Culture: Practice and Meaning from Antiquity to Abstraction*, won the Mitchell Prize for Art History in 1994.

LUDMILLA JORDANOVA is Professor of Visual Arts at the University of East Anglia. She has taught at the Universities of Cambridge, Oxford, Essex, York and California, San Diego. Her publications include *Languages of Nature* (1986, editor and contributor), *Sexual Visions* (1989), and *The Enlightenment and its Shadows* (1990, editor and contributor).

DAVID LOMAS teaches art history at the University of Manchester. His doctoral dissertation (1996) at the Courtauld Institute of Art explores aspects of psychoanalysis and subjectivity in Surrealism. Graduating in medicine before undertaking studies in art history, he has also published on medical imagery in the art of Frida Kahlo and on *Les Demoiselles d'Avignon* and physical anthropology.

KATHLEEN NICHOLSON is Professor of Art History at the University of Oregon. She is a specialist in early modern European art, with emphasis on classical traditions in both portraiture and landscape painting. She is the author of *Turner's Classical Landscapes* (1990). The essay in this collection is part of a study in progress on the phenomenon of allegorical portraits of women in eighteenth-century France.

CHRISTOPHER PINNEY is Lecturer in South Asian Anthropology at the School of Oriental and African Studies, University of London. His Ph.D. research was concerned with industrial workers' temporal conceptions in Madhya Pradesh. Later research has focused on nineteenth-century archival photography and contemporary studio

photography in central India. He is currently completing a book-length study of popular Hinduism and the printed image.

MARCIA POINTON is Pilkington Professor of Art History at the University of Manchester. She has written extensively on British and French art in the eighteenth and nineteenth centuries, on portraiture and patronage, and issues of gender in visual culture. Her recent published works include *Naked Authority: The Body in Western Painting 1830-1908* (1990), *The Body Imaged: The Human Form and Visual Culture since the Renaissance* (1993, edited with Kathleen Adler) and *Hanging the Head: Portraiture and Social Formation in Eighteenth-Century England* (1993). Her forthcoming book, *Strategies for Showing: Women, Possession and Representation in English Visual Culture 1650–1800*, will be published by Oxford University Press in 1997. She is currently engaged in research for a study of the display culture of jewels and jewellery in early modern Europe.

ANGELA ROSENTHAL is Andrew W. Mellon Assistant Professor of Art History at Northwestern University, USA. She is author of *Angelika Kaufmann: Bildnismalerei im 18. Jahrhundert* (1996) and her articles on contemporary art and on eighteenth- and nineteenth-century visual culture have appeared in *Art History* and *Kritische Berichte,* as well as other journals and anthologies. She is co-editor of the German feminist journal *Frauen Kunst Wissenschaft.*

PATRICIA SIMONS is Associate Professor in History of Art and Women's Studies at the University of Michigan, Ann Arbor, having held previous positions in Australia. Her research concentrates on the gendered construction of authority and identity in Renaissance Italy, especially in relation to patronage and to portraiture.

MARILYN STRATHERN is Professor of Social Anthropology at Cambridge University and has published on many aspects of culture and society in Papua New Guinea over the last thirty years. She is best known for her theoretical work on gender and sociality, in which the aesthetics of form plays an important part.

SARAH WILSON worked at the Centre Georges Pompidou, Paris, and the Barbican Art Gallery, London, before taking up a lectureship at the Courtauld Institute of Art in 1982. She specialises in European art after 1945, and has contributed to many exhibition catalogues of Paris-based artists such as Dufy, Léger, Picabia, in particular for the Pompidou retrospectives such as 'Paris–Paris, 1937–1957', Max Ernst, Kurt Schwitters, 'Féminin–Masculin', etc. *When Modernism Failed: Art and Politics of the Left in France, 1935–1955* is forthcoming from Yale University Press.

JOANNA WOODALL was curator at Christ Church Picture Gallery in Oxford before her appointment as a lecturer in early modern Netherlandish art at the Courtauld Institute of Art, University of London. Her most recent publication concerns love as a creative theme in seventeenth-century Dutch painting. She is currently writing a book on sixteenth-century portraiture focused on the work of Anthonis Mor.

Preface

Portraiture occupies a central position in the history of western art. It has been the most popular genre of painting and lies at the heart of the naturalist project. It has been crucial to the formation and articulation of 'individualism'. Yet its status as a work of art remains uncertain and there is a dearth of critical history of the subject.

This book aims to introduce major issues in portraiture from the Renaissance onwards and to provide a series of studies illustrating critical perspectives from which they can be approached. In particular, it seeks to take account of recent shifts in the understanding of the human subject and representation. While intended to be accessible to undergraduates, it is envisaged that the contributions, by leading scholars in their fields, will also interest specialists. Arranged under analytical subheadings and broadly chronological, the selection of essays is designed to fulfil the pronounced need for texts with which to teach courses on portraiture.

The immediate origin of the volume lies in a conference on Portraiture and the Problematics of Representation, held at the Whitworth Art Gallery, Manchester, in September 1993. I should like to thank everyone who contributed to this event, especially Linda Aleci, Malcolm Baker, Jane Beckett, Jean Borgatti, Malcolm Bowie, Andreas Broekmann, Suzanne Butters, Diana Donald, Joseph Koerner and Shearer West. The expertise and generosity of the conference's co-organiser, Marcia Pointon, have been indispensable to the evolution of the book.

I have enormously enjoyed working collaboratively with the twelve other authors of this volume, and have learned a great deal from them. Equally, I am indebted to the editorial staff of Manchester University Press, who have consistently supported a complex publishing enterprise. My thanks, in particular, are due to Rebecca Crum, Gemma Marren, Jane Raistrick and Katherine Reeve.

More generally, I can only gesture towards the innumerable conversations and relationships which have shaped my thinking about identity and visual representation. I am especially grateful, in different ways, to Caroline Arscott, Rose-Marie San Juan, Gail Simon, Dian Kriz, Susan Siegfried, David Solkin, Mariët Westermann and Rele Adetiba.

On the king's portrait

Kneller, with silence and surprise
We see *Britannia's* Monarch rise,
A Godlike Form, by Thee display'd
In all the Force of Light and Shade;
And, Aw'd by thy Delusive hand
As in the Presence Chamber stand.
The Magick of thy Art calls forth,
His Secret Soul and hidden Worth,
His Probity and Mildness shows,
His Care of Friends and scorn of Foes.
In ev'ry Stroke, in ev'ry Line,
Does some exalted Virtue shine;
And *Albion's* Happiness we trace,
Thro' all the Features of his Face ...

Joseph Addison (1672–1719)

Introduction: facing the subject

JOANNA WOODALL

The first image was a portrait. In classical mythology, a lovely youth named Narcissus lay beside a pool gazing in adoration at his own reflection. Ignoring the loving attention of the nymph Echo, he wasted away, died and was metamorphosed into a flower bearing his name. Another myth tells of the Maid of Corinth who, wishing to capture her lover before their separation, drew around the shadow cast by his head on the wall of a cave. In the Bible, St Veronica compassionately pressed a cloth against Christ's face as he stumbled to Calvary, and found His true image miraculously imprinted into the material. Christian legend relates that St Luke became a painter because, having experienced a vision of the Virgin Mary, he was inspired to produce a faithful portrait of her.

A story of portraiture

THE HISTORICAL CONTINGENCY OF LIKENESS

These stories indicate the centrality of naturalistic portraiture, and in particular the portrayed face, to western art. By 'naturalistic portraiture', I mean a physiognomic likeness which is seen to refer to the identity of the living or once-living person depicted. The genre existed in antiquity and the early Christian world, in the form of statues, busts and herms, coins, sarcophagi, wall-paintings. In the medieval period, however, physiognomic likeness was not the primary way of representing a person's identity. The position and status of a nobleman, for instance, was conventionally symbolised by his coat of arms. Nevertheless, examples of naturalistic portraiture do survive and images of Christ and the saints were considered to be true likenesses. During the fourteenth century, physiognomic likeness was increasingly employed to represent 'donors' and sovereigns.

The 'rebirth' of portraiture is considered a definitive feature of the Renaissance and marks the beginning of the period covered by this book. More precisely, the early fifteenth century saw the adoption of intensely illusionistic, closely observed facial likeness, including idiosyncrasies and imperfections, to represent elite figures, including artists themselves. The work of Jan van Eyck, executed in a sophisticated oil technique, was extremely influential. His clientele was wide:

clerics, sovereigns and great nobles, statesmen, native citizens and foreign merchants, his wife and probably himself. By the turn of the sixteenth century, the 'realistic' portrait was widespread. However, other artists, particularly in Italy, reconciled attention to the physiognomic peculiarities of the subject with more generalising visual devices, such as the profile view (especially for women), or the analysis of face and body in smooth, consistently lit geometrical shapes. Such techniques were traditionally understood to attribute universal and ideal qualities to figures.

EMULATION OF EXEMPLARS

With a few exceptions, the majority of individualised portraits in oil produced during the fifteenth century were bust or half-length, or full-length figures in reduced scale (see, for example, Figure 3). During the first third of the sixteenth century, the life-sized, whole-length figure was accepted as a paradigm for images of secular rulers. Technically, this change was connected with the wider use of canvas supports in place of panel, which facilitated the transport of large-scale portraits between distant courts. Iconographically, the full-length, standing figure *without* physiognomic likeness had previously been associated with genealogical series and universal exemplars: figures whose transcendent qualities or achievements merited emulation. From the mid-fifteenth century, the union of this traditional, 'idealising' format with 'realistic' likeness personalised the articulation of socio-spiritual authority.

Collections of exemplary portraits, including 'beauties', were increasingly amassed by intellectuals and rulers, following the lead set by the humanist Paolo Giovio at Como. Such collections of 'famous men' were often included in the universal exemplary collections known as Kunst- and Wunderkammers, constituting personal identity as a product of divinely produced nature and human self-fashioning. The genealogical collections of naturalistic portraits which also became widely established amongst the titled and aspirant nobility were based on ancestry rather than achievement. In both types of collection, however, the identity of the owner was produced through identification with authoritative predecessors.

The association of the full-length format with images of sovereigns was also part of a wider process of emulation. During the sixteenth century, a visual repertoire was established which was emulated in naturalistic portrayal for the following three centuries and beyond. During this period, the courtly console tables, wooden chairs, curtains, columns, helmets and handkerchiefs repeated in countless later works were introduced into the portrait repertoire. Subordinate figures such as dogs, dwarfs, servants, jesters and black attendants were strategically placed to render the sitter's elevated status and natural authority clearly apparent.

Furthermore, recognised positions, such as the high-ranking cleric, the military leader, the prince, the scholar and the beautiful woman, became associated with distinctive portrait formats, attributes and even pictorial languages. To take one example, the cleric was conventionally identifiable not only by his gorgeously rendered attire and ring of office but by the employment of a three-quarter-length, usually three-quarter-view of the sitter enthroned in an upright, rectilinear chair. One might think, for example, of van Dyck's portrait of Cardinal Bentivoglio (1623),[1] or Velazquez's image of Pope Leo X (1650).[2]

This method of characterisation by imitation of a recognisable iconographic type still takes place in conservative portraiture. It involves visual reference to

precedents, often including an authoritative prototype. For example, a generic resemblance can be traced between the van Dyck or the Velazquez and Raphael's famous image of the maecenas Pope Julius II (1511-12).[3] Such pictorial 'founding fathers' of a 'visual genealogy' seem to have been authorised by the renown of their painter as well as their sitter. Titian and Raphael were important in this respect, as was van Dyck. Minor variations and major deviations from the informal and flexible iconographic lineages could be exploited to characterise particular people in relation to the conventional expectations of their role. Portrait imagery was also responsive to the social and political circumstances of the sitter. For example, a portrait might refer to the sitter's marriage, or a commander's victory in a battle.

PORTRAITURE AND ARISTOCRATIC IDEOLOGY

Portraiture thus became central to noble culture during the sixteenth century, although many citizens were also depicted, often in marital pendants. Specialist portraitists began to be employed at courts and reference was made to the antique exemplar of the Emperor Alexander's intimate relationship with his portraitist Apelles. These elite specialists included a few women, such as Sophonisba Anguissola at Philip II's court in Spain. The metaphor of the body politic meant that portraiture played a vital ideological role. By silently assimilating the real to the ideal, naturalistic portraiture enabled a particular human being to personify the majesty of the kingdom or the courage of a military leader.

Portraiture also articulated the patriarchal principle of genealogy upon which aristocratic ideology was built. The authorising relationship between the living model and its imaged likeness was analogous to that between father and son, and processes of emulation presumed identity to be produced through resemblance to a potent prototype. The subject was situated within chains or hierarchies of resemblance leading to the origin of Nature herself: God. Indeed, this mechanism for establishing a form of personal immortality fits into a larger ideological regime in that it can be compared with the identification between the Son and the Father in the Catholic understanding of the Mass. The assimilation of image to prototype, sign to referent, was the source of salvation.

Furthermore, an understanding of portraits as direct substitutes for their sitters meant that the circulation of portraits could mirror and expand the system of personal patronage whereby power, privilege and wealth were distributed. Their uses included arranging dynastic marital alliances, disseminating the image of sovereign power, commemorating and characterising different events and stages of a reign, eliciting the love and reverence due to one's lord, ancestor or relative. Because of these crucial functions, portraiture had to be theorised as unmediated realism. Yet although explicit invention or idealisation was problematic, the *raison d'être* of these images was actually to represent sitters as worthy of love, honour, respect and authority. It was not just that the real was confused with the ideal, but that divine virtue was the ultimate, permanent reality.

COURT AND CITIZEN PORTRAITURE

If the sixteenth century saw the consolidation of visual motifs and signifying principles fundamental to the genre, the seventeenth century can be associated with an expansion in portrait types and numbers. This was in part a consequence of Protestant objections to religious imagery, which encouraged people to turn to other genres, including portraiture. At the same time, Protestantism articulated a

3

profound change in the relationship between image and prototype which affected the conception of portraiture.[4]

The expansion of portraiture was, however, also connected with the aspirations of monarchy and the assertion of noble values. Some courts were identifiable with distinctive, quite consistent portait modes, associated with prestigious and well-paid portrait painters: the restrained virtuosity of Velazquez's images of the Spanish Habsburgs, for example, or the shimmering coloured drapery, dynamic 'grace' and frequently outdoor settings of the van Dyckian manner in England. On the other hand, portraiture at the increasingly influential French court was comparatively diverse, drawing on a number of traditions. The obverse to honorific portraiture was caricature, which was accorded a degree of aesthetic validity in the wake of Leonardo, and began to gain a wider distribution through political prints.

The enrichment and enhanced confidence of elites outside the hereditary noble order was associated with the continued increase in portraiture of these clienteles. This was especially marked in the Dutch Republic. A wide range of portraits was produced, from individuals to married couples, family groups and civic bodies. Some of these images emulated previous or current court models, while others emphasised qualities and activities which justified the distinct position of non-hereditary elites. Some of Frans Hals's images of Haarlem citizens, for example, depicted responsive communicativeness, rather than the personal autonomy conventionally attributed to the hereditary, landed nobility (see Figure 54). More generally, there was a tendency to emphasise the head and the hands of the non-aristocratic body, rather than the trunk and genital area which conventionally characterised nobility of blood. Thus sites associated with the origin and execution of thought, spirit, personality were stressed at the expense of bodily regions associated with physical prowess and the generation of a lineage. Reduced-scale portraiture, appropriate to more modest interiors, became more popular and the distinction between such portraiture and genre painting became less clear.

The eighteenth century was in some respects the apogee of portraiture in England and France. A huge number and variety of images were produced, ranging from refined domestic 'conversation pieces' to images of professionals alluding to progressive intellectual endeavour (see Figures 29–33), or overwhelmingly large and splendid evocations of monarchs and great lords. Visual reference to classical prototypes, such as the Apollo Belvedere, became popular as part of a more general appeal to antique authority. Grand portraits with an implied heroic, historical narrative were paralleled by naturalised fictions in pastoral or mythological mode (see Figures 10–15). These became, respectively, increasingly gendered masculine and feminine. Beside a strong adherence to the restrained and convincing depiction of sitters in their social personae, masquerade gained unprecedented importance. This involved not only the adoption of roles by conventional sitters especially for portrayal, but also an interest in the depiction of actors (see Figures 53, 55 and 56).

The vast print culture enabled honorific images to be widely disseminated. Chronicles of events were structured through portrait prints, most famously in the massive work of James Granger.[5] The exemplary and genealogical principles of traditional portrait collections were here combined with textual authority to support a powerful history of 'great men'. On the other hand, the economy of portrait prints also encompassed a vigorous, scatological and topical genre of personal caricature.

In addition to its established aristocratic functions, portraiture became crucial to the cultivation of civility in commercial society. This was achieved by pictured affection and communication, or by the similar formats and group display of portraits depicting figures united and defined by their civility, such as members of the Kit-Kat club in London.[6] Furthermore, portraiture was increasingly recognised as cultural practice as well as effigy. Sitting to a fashionable portraitist entered into literary discourse as a self-conscious, socially prestigious interaction and the exhibition of portraits invited public discussion. Academies and salons facilitated debate on issues such as the nature and limits of likeness.

In contrast to this vigorous portrait culture, the status of the genre within art theory was low. Portraiture occupied an anomalous and therefore debased position within an academic hierarchy based on the degree of invention demonstrated in a work of art. This was because its ideological conviction depended upon an elision of image and 'reality' which denied any fabrication on the part of the artist. Portraits could either be theorised as exact, literal re-creations of someone's external appearance, or as truthful accounts of the artist's special insight into the sitter's inner or ideal self. Both could be assimilated to the concept of realism.

THE AUTHORITY OF LIKENESS

Issues of realism and truth were central to nineteenth-century portraiture. In portraits of men, overt role-playing was abandoned in favour of attempts to reconcile a convincing characterisation of the sitter's socio-political position with depiction of the essential inner quality which was considered to justify his privileged place. The honorific elite eligible for portrayal was expanded to incorporate new heroes such as scientists and explorers. Old iconographies of scholars and soldiers were respectively adapted to suit these different kinds of intellectual and conqueror. By means of the exemplar, change and 'progress' were thus assimilated to the authority of precedent.

From the mid-nineteenth century, this broadened conception of the portrayed exemplar came to serve contemporary political ideology through the establishment of national portrait galleries. Here the communal body of the polity was historically constituted through images of the agents deemed responsible for the formation and advance of a rich, distinctive national identity. A narrative of change which looked forward and upward to ultimate fulfilment existed alongside received belief in a natural, permanent order looking backward and upward to God. Although the constituency of exemplars was wider, the right to representation remained exclusive in that responsibility for change was attributed to the inspired ideas of exceptional individuals, rather than to structural shifts involving everyone.

Except for ceremonial and unorthodox figures, an authoritative palette of black, white and neutral shades dominated masculine imagery. The shimmering colour which had previously become associated with aristocratic portrayal was now largely restricted to images of women. This gendered difference seems somewhat more exaggerated in portraiture than in surviving dress, or in genre or contemporary history painting. It can be associated with the authority of *disegno* over *colore* in academic art theory, which was in turn based upon a distinction between the certain, immutable qualites attributed to the mind and the deceptive, transient, changeable body. Black and white was a 'modern' aesthetic in the sense that it could be related to an urban, working environment and sober, disciplined lifestyle. At the same time, reference back to the widespread employment of black and white

in seventeenth-century Dutch burgher portraiture accorded this virile bourgeois identity a putative heritage of community and spiritual uprightness. The price of black and white authority was a certain visual uniformity, which both set off and offset the nineteenth-century conception of identity as unique, personal individuality, articulated in the face.

The mode of depiction was also a significant factor in nineteenth-century portraiture. For example, a transparent visual rhetoric was broadly seen to privilege truth to the appearance of the subject over the painter's mediation. It likewise linked portrayal with genre painting: the depiction of unnamed, 'ordinary' people enacting stories authorised by general cultural norms rather than a particular text. In Ingres's *Madame Moitessier* of 1856,[7] the combination of transparent treatment with simplification of form and an abstract, decorative linearity created a feminine persona which seemed both vividly present and a universal ideal. At the same time, it was unmistakably 'an Ingres'. By comparison, 'virtuoso' brushstroke could be seen directly to embody the insight of the artist, rendering articulation of the inner spirit of the sitter inseparable from the genius of the painter. In the work of the Impressionists, by contrast, visible and varied brushstroke became part of a visual mode which subverted the distinction between sight and insight, object and subject.

Throughout the nineteenth century, the authority of the depicted likeness as a representation of the sitter's identity was often guaranteed by recourse to the science of physiognomy. Physiognomic treatises provided systems whereby a person's character could be deduced from his (and less commonly her) external appearance. Such systems had existed since antiquity, but in the late eighteenth century they acquired a more empirical basis and renewed popularity, thanks largely to the work of J. C. Lavater (1775-8).[8]

Physiognomic explanation claimed scientific objectivity, but was in fact justified by the ancient, naturalised hierarchy which subjected individuals to the supposed divine–bestial balance within humanity as a whole. Facial features and aspects were compared to anthropomorphised animals, such as the courageous lion, crafty fox or stupid cow. They were also positioned within modes of visual characterisation descending from the angelic to the monstrous. At the summit were tall (or long), smooth, symmetrical, contained geometric entities; at the base lay squatness, unevenness, openness, roughness, irregularity. These visual languages respectively connoted the ideal and the grotesque; the recognised and the caricatured; the honoured or the denigrated.[9] Physiognomic principles were invoked not only in portraits of 'great men', but in images of pathological and insane individuals by, for example, Goya and Géricault.[10]

The need for a transparent, scientific likeness also seemed to be met by photography, which was considered to guarantee an inherent, objective visual relationship between the image and the living model. As a technology, photography was the culmination of prolonged experimentation with mechanical devices. As a visual mode, it emerged from the use of visual and verbal 'reportage' to characterise more ordinary people. It soon admitted an unprecedentedly wide clientele to portraiture, enabling people who could not previously afford, or were not considered worthy of, painted immortality to have their features recorded for posterity.[11] Photographic portraits were, for example, soon commonly circulated as calling cards and collected into albums by the middle-class intelligentsia.

At the same time, the objectivity attributed to photography quickly led to its

use in the identification or investigation of criminal, insane, diseased, orphaned and otherwise 'deviant' individuals. This was because the camera objectified the sitter and the photographic technique tended to record imperfections and physical idiosyncrasies which were, according to the idealist precepts underlying honorific portraiture, indicative of the accidental and animal elements of humanity. The particularities of personal appearance had, for instance, been regarded as 'defects' by Sir Joshua Reynolds.[12] By exposing the conceptual hierarchy within which portraiture signified, the advent of photography implicitly challenged and problematised portraiture's claim to absolute truth.

QUESTIONING THE PRINCIPLES OF PORTRAYAL

Physiognomic interpretation was predicated upon a 'symptomatic' relationship between external appearance and an invisible, internal self which was the ultimate subject of interest. The work of Courbet, Manet and the Impressionists interrogates this presumed identification between individualised physiognomy and a distinctive, interiorised identity. The disturbing power of images such as Manet's *Bar at the Folies Bergères* (1881–2),[13] for example, derived in good part from its dialectic with received notions of portrayal.

Portraits depicting the friends and family of the artist had existed since at least the fifteenth century, but in the late nineteenth century 'avant-garde' portraiture was markedly confined to uncommissioned images of these categories of sitter. This enhanced the authority of the artist by making worthiness to be portrayed dependent upon one's relationship to him or her. It implied a lived intimacy between painter and sitter, imaginatively reproduced in the viewer's relationship to the painting. The distinction between portrait sitter and artist's model became less clear, challenging the normal politics of the portrait transaction. In van Gogh's portraiture, for instance, the images referred primarily to the identity of the artist, as opposed to that of the sitter. All this, together with unconventional, informal compositions, leisured outdoor or domestic settings, and the assertive, opaque materiality of the paint, implied a self distinct from the abstract, interior identity which justified orthodox public recognition.

THE DEATH OF THE PORTRAIT?

In the twentieth century, the status of naturalistic portraiture as a progressive form of elite art has been seriously undermined. Commissioned portraiture, long discussed as a source of artistic subservience, has become widely regarded as necessarily detrimental to creativity. More fundamentally, the early twentieth-century rejection of figurative imagery challenged the belief that visual resemblance to a living or once-living model is necessary or appropriate to the representation of identity (whether such identity is attributed to the sitter or the artist).

Yet naturalistic portraiture has never entirely disappeared from the 'progressive' arena. Images recognisable as their own faces remained significant in the work of many artists, such as Joan Miró (Figures 58, 59, 65) or Elizabeth Frink. Lucien Freud's paintings can be considered in terms of a preoccupation with the relationships between paint as a material substance, figurative images of particular individuals, and personal identity. In Marc Quinn's *Self* (1991),[14] a mould taken from the artist's head was filled with his own blood and frozen. The resulting effigy questions the idea of the portrait as a lifelike representation of essential identity: the quintessence of the sitter in flesh and blood.

Cindy Sherman's popular and influential photographs of herself in the guise of 'old master' paintings subversively exploit conventional techniques of portrayal. Physiognomic likeness to an unchanging self is effaced, despite the use of photography. The self-dramatising, parodic identification with a wide variety of different pictorial models unravels characterisation through resemblance to a patriarchal prototype. Yet Sherman's images can, paradoxically, be situated firmly within the tradition of naturalistic portraiture, in that a supposedly realist technique vividly represents the dynamic, unstable and relativised identity claimed for the female artist-sitter.

Besides elite work like this, everyone is seemingly surrounded by naturalistic portraits. It is not just that there is still a flourishing market for honorific portrayal, ranging from board-room paintings to drawings by street artists. Portrait-like physiognomies also embellish our stamps, coins and banknotes. Images of the writer frequently accompany books and articles, to authorise and amplify the text. Pictures of celebrities are widely employed to endorse products by imbuing them with the star's qualities – a contemporary twist on the old idea of the exemplar. Caricature continues to flourish. Above all, the cheapness and ubiquity of photographs corresponds to a seemingly insatiable desire to fix and preserve the appearance of those we know, love and admire. The same medium is universally employed for purposes of identification and arrest: on passports and identity cards, bus and library passes, some credit cards.

Portraiture as representation

PORTRAYAL AS PARADIGM

The desire which lies at the heart of naturalistic portraiture is to overcome separation: to render a subject distant in time, space, spirit, eternally present. It is assumed that a 'good' likeness will perpetually unite the identities to which it refers. This imperative has been appreciated since antiquity. For Aristotle, portraiture epitomised representation in its literal and definitive sense of making present again: re-presentation. According to him, our pleasure in seeing a portrait consists primarily in recognition, which is the process of identifying a likeness with what it is perceived to be like, of substituting something present for something absent. For him, a proper illusion of the bodily self necessarily entailed a sense of the presence of the person depicted.[15]

Leon Battista Alberti, in his groundbreaking and influential treatise *On Painting and Sculpture* of 1435 (first printed 1540), agreed with Aristotle:

Painting contains a divine force which not only makes the absent present, as friendship is said to do, but moreover makes the dead seem almost alive. Even after many centuries they are recognised with great pleasure and great admiration for the painter. Plutarch says that Cassander, one of the captains of Alexander, trembled all through his body when he saw a portrait of his King ... Thus the face of a man who is already dead certainly lives a long life through painting.[16]

This account makes portraiture a paradigm for naturalistic painting's divine capacity to overcome the separations of absence and death. Portrayal is attributed an inherent quality or force, linking the image of Alexander with his actual presence. The portraitist's admired role is to mobilise that power; that of the viewer

is to appreciate it. Alberti thus locates portraiture at the centre of Renaissance painting's marvellous, newly realised capacity to produce vivid illusions of a world focused on humanity. He implicitly assumes that illusionistic portraiture involves the sitter's identity. Indeed, for Alberti, identity is inseparable from the sense of presence achieved through mimesis. Speaking semiotically, the signifier (the painted portrait) is conflated with both the referent (the living presence of Alexander) and the signified (Alexander's identity as a monarch).

PORTRAYAL AS PROBLEMATIC

Naturalistic portraiture no longer consistently achieves these effects for us. It does not always work as re-presentation. For example, although the quest for a 'good' photograph of someone – an image that satisfies us that the depicted person is present to us – is known to all who have eagerly sifted through a newly developed film, the ineffable sense of disappointment which generally follows such a search is perhaps equally familiar. We are even less willing to attribute 'presence' to the many photographs made for purposes of identification, as if this function somehow precludes the perception of identity. In *Camera Lucida*, Roland Barthes related that he could find no photograph which captured the image of his dead mother until he saw 'her' in a picture taken when she was a child, before his relationship with her began, and when she did not much resemble the person he had known.[17] While the status of photography as the fetishised trace of someone's existence persists here, the quality of 'likeness' has become elusive, and personal to the viewer rather than the sitter.

Today, the fixed, immovable features of a portrayed face can seem like a mask, frustrating the desire for union with the imaged self. In looking at a conventional portrait, we no longer have implicit faith in a moment of phantasised unmasking, of release, the carnival's conclusion when one can 'call things by their real names'. This phrase seeks the union of language (representation) with the things to which it refers. It comes from a striking passage in Hermann Broch's *Esch the Anarchist* (Vienna, 1928–31) which makes clear the frustration aroused by the sense that it is structurally impossible to remove portraiture's mimetic mask and make her communicate.[18]

Concepts of identity

DEFINING DUALISM

I suggested at the beginning of this introduction that a portrait is a likeness which is seen to refer to the identity of the person depicted. If this is the case, then the history of portraiture will be closely connected with changes in beliefs about the nature of personal identity, and in ideas about what aspects of identity are appropriate or susceptible to portrayal. The sense of frustration expressed by Esch the anarchist results in part from a 'dualist' conception of identity. In such a view, there is a division between the person as a living body and their real or true self. An insistence upon this opposition means that a vivid physiognomic likeness cannot represent the identity of the sitter in the satisfying way claimed by Aristotle and Alberti. Bodily resemblance comes to seem a barrier to union with the sitter, rather than the means whereby it can be achieved.

When did this sense of separation occur? The notion of the body quickened by an individuating life-force dates from the dawn of civilisation. However, this did

not necessarily mean that the two were seen as distinct, even in the realm of meaning ultimately addressed by portraiture: the attainment of some form of immortality through the denial of absence and death. In traditional Catholic belief, immortality was guaranteed by individual virtue, but this was not an entirely abstract, spiritual concept. Resurrection on the Last Day involved the body as well as the soul. Furthermore, the nobility's claim to the virtue which justified honour and fame in this world and immortality in the next was founded upon a mysterious, quasi-mystical but at the same time bodily quality called 'blood'. From a 'noble' point of view, the object (the body) is an incarnation of the subject (the virtue of the person depicted). Like Jesus Christ, whose great virtue enabled Him to defy death, the persona whose virtue rendered him or her worthy of immortalisation in paint was *both* matter and spirit.

We now conceive portraiture primarily as a representation of 'personality', rather than virtue, and an interest in what would now be described as psychology can be discerned in Renaissance portraiture. Cranach the Elder's *c.* 1503 images of the humanist Johannes Cuspinian and his wife Anna Putsch, for example,[19] contain symbolism relating to the theory of the four humours and astrology. It is notable, however, that such systems explain psychology in physiological terms. Different humours were considered to be the result of the amount of black bile in the system and the impact of astrology on personality was physically grounded in the moment of birth. Furthermore, the psychology of gender was explained in terms of the proportion of the four elements in the body. Men were spiritual, passionate, intellectual and active because they were made up primarily of air and fire. Women, on the other hand, were liable to animality, material concerns and lethargy because they were constituted mostly of earth and water.

A sense of the *difference* between an inner, abstract subjectivity and an objectivised, material body has been discerned in portrait practice from the seventeenth century. Rembrandt's work, for example, is celebrated for its visualisation of the sitter's interiority. Historically, this separation between the body and identity corresponds with the consolidation of the Protestant Reformation, which asserted a space between sign and prototype. It also has to do with the increasing importance of non-noble elites, which located virtue not in 'blood' but in abstract qualities such as talent, genius and acumen. The definitive formulation of dualism in its oppositional sense is credited to the French philosopher René Descartes (1596-1650), for whom personal identity was located in a concept of the mind or thinking self. As pure, divine intellect, the mind was quite separate from the machine-like, material body. Others would define identity in terms of the soul, virtue, genius, character, personality, subjectivity. The crucial point about dualism was the stress on the distinction between identity and the material body.

DUALISM AND LIKENESS

If identity and body are opposed, there is a problem about how the portrayed body can re-present someone's identity, however this may be defined. Likeness in the sense of a perceived visual resemblance between the image and the embodied model is now separable from likeness in the sense of a perceived link between the image and the sitter's 'inner' identity.[20] An increasingly dualist perspective on portraiture is the main reason why likeness became such a contentious issue from the late eighteenth century.

Physiognomy, which relied upon symptomatic or indexical (pointing to)

relationships between 'external' likeness and 'internal' identity, provided a supposedly scientific way of closing the gap which had opened up between them. In photography, on the other hand, the idea was scientifically to close the gap between 'external' likeness and the depicted person her- or himself. This resolved the dualist problem to the extent that the portrayed body no longer *represented* the sitter, it *was* the (trace of the) sitter, so that difficult questions of the relationship between personal identity and the body simply did not arise. The iconic (imaging of) identification between photograph and living reality was supposedly guaranteed by the passage of light waves from the sitter's body to the photographic emulsion.

Despite the difficulties which it posed, dualism preserved the notion of a self capable of existence after physical death, which is crucial to the efficacy of portraiture as re-presentation. Some kind of eternal or persistent dimension to identity is necessary if the viewer is to be satisfied that the absent person depicted is present, at least in a 'good' or 'authentic' likeness. In dualism, it is as if the immortal subject retreated from the body into an abstract realm, in order to preserve its integrity in the face of the need for an increasingly scientific, materialist understanding of the body. Yet the portrayed body remained an adequate symbol for an identity conceived in this coherent, self-contained way, because notions of identity proposed within a dualist paradigm until the mid-nineteenth century were, like the imaged body, characteristically consistent, unified and autonomous.

DUALISM AND PORTRAYED FEMININE IDENTITY
The dualist subject was implicitly masculine. For example, during the eighteenth century, treatises on human character articulated a conception of femininity which was, although absolute, the very opposite of the developing dualist ideal. It was the *lack* or *absence* of the personal uniqueness, constancy and interiority which constituted true virtue. Feminine virtue was ultimately a contradiction in terms, a fragile alliance always liable to fall apart and release its erotic, self-engulfing opposite. In the production and discussion of feminine portraiture, these negative and negating conceptions of feminine identity were often linked with oppositions associated with academic art theory. *Colore* was liable to be considered more appropriate than *disegno*, idealisation preferred to objectivity, flattery to resemblance, myth to reality, frivolousness to exemplarity. Questions of likeness and authenticity, which became so crucial to portraiture's continued capacity to re-present an immutable, immortal self, lost their urgency and significance when applied to figures whose femininity denied them the true, fully realised humanity claimed by the dualist subject.

THE DUALIST SUBJECT DENIED
From the mid-nineteenth century, however, the reality and integrity of this dualist subjectivity was challenged. This meant that the 'objectively' portrayed body became a less appropriate means of visualising the self. The historical analysis of society developed by Karl Marx (1818–1883), for example, assumes personal identity to be neither autonomous nor true to the way things actually are. The 'Marxist' self does not exist immutably, outside history, but is related to the changing socio-economic arrangements in which it lives (feudalism, capitalism or revolution, for instance). The concept of ideology, which has been described as 'the imaginary relationship of individuals to their real conditions of existence',[21] posits a 'false consciousness' or set of delusions whereby people make sense of, and reconcile themselves to, their material situation.

Psychoanalysis, the influential psychological theory and treatment developed by Sigmund Freud (1856–1939), also involves complex, divided models of identity. For example, the Freudian concept of the 'unconscious' locates the driving force of identity in repressed sexual instincts and experiences, leaving the cognisant mind no longer 'master in its own house'. Freud's critical disciple Jacques Lacan (1901–1981) reconciled this sexualised self with Marx's socially produced identity by emphasising the role of language in the constitution of identity. For Lacan, the young child's entrance into speech produces subjectivity by structuring his or her libidinous energy like a language. Selfhood, far from being autonomous, unique and permanent, thus depends upon engagement in a shared system of signs.

Lacan also understands desire, as articulated in the gaze, to play a constitutive role in the formation of sexual and social identity. Looking in a mirror, the child, before it is able to speak, is supposed both to mistake the image for itself and to take the image for a unified, autonomous self, after which it strives.[22] The reflected image is thus identified with an idea(l) of the self whose integrity and consistency are at odds with the incoherent, disjointed experience of embodied selfhood. It is notable that naturalistic portraits have, historically, routinely been compared with images seen in a mirror and Lacan's account of the 'mirror stage' begs comparison with the 'aristocratic' understanding of portraiture as both truthful re-presentation and virtuous exemplar. Significantly, however, Lacan regards this picture of the self as an immature, alienated distortion.

The breakdown of the hegemony of received, 'essentialist' views about the human subject has been articulated in many other ways. For example, the philosophical innovations pioneered by Edmund Husserl (1859–1938) under the heading of phenomenology questioned the basic Cartesian distinction between intellectual subject and material object in the constitution of knowledge about the world. The theory of evolution proposed by Charles Darwin (1809–1882) rent religious and scientific truth asunder and began a process whereby physical individuality has been reduced to a set of impersonal, genetic blueprints. In the overtly political field, movements to liberate oppressed groups – women, blacks, homosexuals – have understood the claim to an inviolable, unchanging and purposive self as a justification for the exercise of power. They emphasise relativised, protean and playful experiences of selfhood, deploying them to undermine the belief that essentialist identity has a natural, objective existence.

RETHINKING THE BODY

Such challenges to the idea of the subject as an abstract, autonomous entity have necessarily involved recognition of the body as a site of rich and complex meanings, not just a material fact. Human embodiment has been recognised as a fundamental and inescapable factor in the formation of beliefs about the world (knowledge) and interaction with it (behaviour). Recent critical analysis rejects Descartes's conception of the mind as the thing we have in common with God, and the body as the thing we have in common with animals. This implicitly assumes the natural hierarchy descending from the divine to the bestial – a hierarchy which can be ascended through identification with and emulation of recognised superiors. The body is now being defined in ways which subvert the consequent oppositions between intellect and matter, the ideal and the materially real, virtue and vice.

Instead of being the source of a confusion between apparent (sense-based) and real (mathematical) properties, the body becomes 'that area where life and

thought intersect'.[23] This lived process involves differing and changing senses of being in the world. It also implicitly questions belief in an existence separate from the living body; an identity which continues beyond death. These positions clearly undermine appreciation of naturalistic portraiture as a form of immortality in the traditional sense. However, they also make it possible to analyse historically the ways in which portrayed bodies articulated ideas and beliefs. In contemporary culture, the artist's own body is widely used to guarantee 'presence' in representation. The French artist Orlan, for example, repeatedly performs plastic surgery to shape her body in ways which conform to her lived sense of her own (ideal) identity. She thus becomes a living, honorific portrait, using flesh and blood rather than canvas and paint to create a likeness.

THE RETURN OF THE REPRESSED

The French philosopher Jacques Derrida (1930–) has deconstructed the idea of identity as a separate, bounded entity. He sees the notion of the subject as a unique, autonomous essence as *dependent on*, rather than *opposed to*, the objectification and subordination of everything perceived to lie outside that self. This excluded realm includes the body, 'nature' and marginalised social groups such as criminals, blacks and Jews. Such repression, however, always involves a haunting trace of the suppressed other. In a Derridian view, identity is defined not as a fixed entity but an ongoing process, enacted through language, between subjects. Activities such as creating, perceiving, describing, remembering and borrowing become part of this 'text', replacing a notion of re-presentation as a unifying, revelatory encounter between subject and object. In the field of portraiture, the interplay between viewer, artist and sitter,[24] or within the psyche of the artist-sitter,[25] or amongst written texts in which portraiture exists as literature,[26] can all now participate in an identity inseparable from representation.

A critique of dualist accounts of portraiture

SUBJECT AND OBJECT

Oppositions between subject and object, subjectivity and objectivity, are fundamental to the interpretation of portraiture within a dualist paradigm. Knowledge of what someone is like 'internally' (the sitter as subject) is supposed to be guaranteed by a faithful likeness of that person's external appearance (the sitter as object). The interdependence of these two kinds of knowledge is evident in Ludwig Burkhardt's famous description of the onset of the Renaissance, when naturalistic portraiture re-appeared:

In the Middle Ages both sides of human consciousness – that which was turned within as well as that which was turned without – lay dreaming or half awake beneath a common veil. The veil was woven of faith, illusion and childish prepossession, through which the world and history were seen clad in strange hues. Man was conscious of himself only as a member of a race, people, party, family or corporation – only through some general category. In Italy this veil first melted into air; an *objective* treatment of the state and of all things in the world became possible. The *subjective* side at the same time asserted itself with corresponding emphasis; man became a spiritual individual, and recognised himself as such ... [A]t the close of the thirteenth century Italy began to swarm with individuality; the ban laid upon human personality was dissolved; and a thousand figures meet us each in his own special shape and dress.[27]

In this account, published in 1860, the existence of a self-conscious, spiritual self is yoked to the possibility of exact observation: 'an objective treatment of ... all things in the world'.[28] The existence of the human subject is dependent upon the ability to produce a separate, distinctive object. Spirit and body are divided from one another, yet potentially re-united by a notion of objective truth. While the object in itself is worthless and dispensable as mere physical matter, objectivity is a means whereby the subject can be recognised as spirit – something infinitely and eternally valuable. In a Derridian sense, the privileged term (the subject) is thus constituted by what it suppresses (the object).

The dualist separation of subject and object has some pernicious consequences. In the archive of facial resemblance, it naturalises an absolute distinction between subjects worthy of celebration and commemoration and those objectified in 'mug-shot' images produced to facilitate social control or arrest. What is actually an ideologically loaded opposition between ideal virtue and deviant imperfection is represented as a neutral account of the way things inherently are. As Allan Sekula has argued in relation to nineteenth-century photographic practice, an awareness of the continuity between the respectful and the repressive archive of types of personae subjected to visual record is essential to a critical understanding of the portrayed self: 'every proper portrait has its lurking, objectifying inverse in the files of the police'.[29]

The denial of a fully realised subjectivity to the objectified other, while simultaneously asserting the possibility of objective representation, can result in physical oppression. Actual violence against women, homosexuals, blacks, Jews, the 'disabled' depends upon the exclusion of these groups from the honoured realm of the subject, together with the elision of image and reality upon which portraiture depends. If this identification of the signifier with the signified is taken seriously, its terms can be inverted and living, breathing people situated in the repressive visual archive. They thus become caricatures, base types, mere mug-shots with no reference to the divine subject. As such they are *both* dispensable objects *and* symptomatic of the threatening other which, within a dualist paradigm, needs to be obliterated in order to purify and perpetuate the self. The Jewish holocaust and 'ethnic cleansing' become in this perversion a kind of appalling, displaced iconoclasm, perceived by its perpetrators in similar terms to setting light to a photograph of a hated enemy, or tearing up the image of a lover who needs to be forgotten.

LOCATING DUALISM HISTORICALLY

Burkhardt's analysis presumes a fully fledged dualism to be a definitive feature of the Renaissance. Yet it has been argued above[30] that in the fifteenth century the body was not clearly distinguished from the self in portraiture and related fields of knowledge and belief. Furthermore, in Alberti's 1435 discussion of portrayal,[31] the vivid illusion of Alexander's physical presence was equated with recognition of his identity as a sovereign. For Alberti, portrayed bodily resemblance was thus not only inseparable from the self, but the self was conceived in terms of the role or position in society which Burkhardt ascribed to a primitive, medieval identity.

One reason for Burkhardt's assimilation of Renaissance identity to nineteenth-century values was the dualist conception of the inner self as a transcendent and absolute fact, an objective reality which denied or trivialised any other version of personal identity. If the true self was immutable, permanent and independent of

historical change, it was unthinkable that it could have been genuinely different in the Renaissance. Any other conception of identity had to be explained as an inability to see the truth through Burkhardt's veil of 'faith, illusion and childish prepossession'.

BOURGEOIS INDIVIDUALITY VERSUS NOBLE STATUS?

A second reason for Burkhardt's anachronistic interpretation of Renaissance identity was the strong link between the dualist subject and a heroic story of the rise of the bourgeoisie, starting in the Renaissance. The irreducible subjectivity produced by a fully fledged dualist view was aptly named the in-dividual. When Burkhardt was writing in the mid-nineteenth century, both this notion of the self and realism in its various forms were identified with the non-hereditary urban elites whose position had been greatly enhanced by industrialisation and the symbolic defeat of the titled aristocracy in the French Revolution. By tracing such individuality back to the supposed rebirth of classical and naturalistic culture, liberal accounts such as Burkhardt's authorised bourgeois identity as a fundamental truth of western civilisation and the foundation of liberty, equality and fraternity.

The visual individualisation associated with Renaissance portraiture continues to be associated with bourgeois individuality. For example, Norbert Schneider's sophisticated 1994 account of early modern portraiture claims that the idea of human dignity asserted by Renaissance philosophy legitimated 'the self-regard of a bourgeoisie whose confidence was already enhanced by technical and economic progress, as well as ... geographical expansion and social mobility'. This intellectually sanctioned bourgeois identity was in turn articulated by 'images of individuality' which focused on the inner self, as opposed to the rank and power characteristic of aristocratic identity.[32]

In this account, individuality ultimately remains a natural, objective attribute of the bourgeoisie, rather than a historically conditioned ideological stance. The bourgeois self is inherently autonomous, interior, self-conscious, active and unique, whereas aristocratic identity is socially and politically determined. The (masculine) bourgeois thus claims 'true' subjectivity, while the aristocrat is deluded, feminised, objectified.

It is, however, arguable that in the history of portrayal individuality actually has a considerable amount in common with nobility, in that both have long been reliant upon notions of exemplary virtue. From their beginning in the later fifteenth century, collections of exemplary portraits included both members of the hereditary nobility and the non-noble elites which ultimately became identified as bourgeois. As exemplars, they all signified admired qualities or achievements which rendered them worthy of immortalisation in paint and inclusion within an honorific archive. Possession of an honourable and enduring identity (enacted virtue) was thus common to both groups. Within an exemplary framework, portrayed noble and 'bourgeois' identity were therefore not opposed but complimentary constituents of the honoured stratum of society, distinguished from the rest by its claim to re-presentation and thus, implicitly, immortality.

The humanist elites (including artists) which emerged in Italian cities from the fourteenth century, and were regarded by Burkhardt as the origin and sign of individuality, could thus equally be regarded as an alternative kind of nobility. They certainly made strenuous claims to noble status, asserting that their virtues of personal genius, talent and originality were derived directly from God, rather than

bestowed by God's lieutenant, the monarch. Viewed in this way, individuality becomes just another category of virtue-inspired social behaviour, even if it is a category which consists of only one person.

Noble and non-noble virtue differed not in *kind* but in *content*. It is this difference which explains the correspondence between the 'rise of the bourgeoisie' and the dualist distinction between identity and the body. The hereditary nobility's reliance upon blood and family genealogy rendered noble identity inseparable from the body. By contrast, that of humanist and commercial elites was necessarily detached from the body in order to justify a position of honour not dependent upon biological inheritance. Family genealogies were replaced by 'inspirational' lineages consisting of influential figures. It was important, furthermore, that non-noble groups should deny any dependence upon the physical, manual work which was the hallmark of their subordinate position within established aristocratic ideology. It is notable, however, that these 'bourgeois' responses signified within received noble parameters: identification with authoritative precedent and the naturalised, divine–bestial hierarchy.

THEORY AND PRACTICE

Another reason why portraiture from the Renaissance onward has been explained in terms of dualist individuality has been art historians' heavy reliance upon the theory of art to authorise interpretation. This in itself involves a dualist privileging of the intellect ('theory') over the body ('practice'). Distinctions between mental and mechanical work, head and hand, idea and execution, and thus, potentially, mind and body were established very early in Italian theories of art in order to justify the artist's claim to nobility. By the mid-sixteenth century, the work of art was theorised as creative imitation in which the essential or ideal character of things is rendered visible by the genius of the artist. This sort of intellectual, noble imitation (Italian: *imitare*) was distinguished from mechanical imitation (Italian: *ritrarre*), which was defined as the unmediated copying of external appearances.

Initially, these two types of imitation were not seen as mutually exclusive. A good portrait could thus be both exact resemblance and an ideal likeness, man in the likeness of Man, as Aristotle had put it.[33] Such a conception allowed the portrayed body to function both as absence made present and as an exemplar of virtue. Increasingly, however, works of art were theorised as ideal imitation as opposed to mindless, mechanical reproductions. While this successfully promoted the position of artists as intellectual, innovative figures rather than mere craftsmen, it did not account for the complex relationship between bodily and personal presence assumed in portraits. Furthermore, the ideological requirement that a portrait should be taken as a true representation of the sitter meant that, in the discourse of art, portraiture could only be explained as the exact, literal re-creation of someone's appearance (*ritrarre*), or as the accurate record of the artist's special insight (a particular form of *imitare*). Both positions implied a dualist conception of the self, a separation between body and mind, the materially real and the abstract ideal.

In other, more 'practical' fields of discussion, however, portraiture was conceived in quite a different way. In their recent surveys of early modern portraiture, both Lorne Campbell and Norbert Schneider point out that the reference of the terms 'to portray' and 'portrait' was not limited to the human subject until the mid-seventeenth century. They report that Villard de Honnecourt's thirteenth-century

Livre de Portraiture included representations of animals, and that fifteenth-century usage of the terms included city views, religious subjects such as saints, and even heraldic devices.[34] A portrait (Italian: *ritratto*) originally meant a visual reproduction which conveyed the specificity of the item under scrutiny. Use of the term for an image of a lizard, or of the piazza and church of San Marco in Venice, suggests that, while certainly concerned to individualise, a 'portrait' was not concerned with the 'individuality' of the subject in a fully fledged, Burkhardtian sense.

Seen in crudely oppositional terms, employment of the visual rhetoric called portrayal seems initially to have prioritised visual *identification*, over insight into an interior, essential, personal *identity*. From this perspective, Renaissance portraiture might seem to have more in common with the modern passport photograph than with the 'artistic portrait',[35] which seems to convey some insight into the sitter's subjectivity. The concept of the portraitist as camera has, indeed, resulted in a number of attempts to explain the intense illusionism of early Renaissance portraiture by analogy with the requirements of identification by a legal witness. The most famous of these is Erwin Panofsky's interpretation, published in 1934, of Jan van Eyck's *Arnolfini Marriage* as legal evidence of a marriage, and in 1994 Norbert Schneider intimated that the entire re-adoption of visual resemblance for the representation of personal identity was connected with the adoption of Roman Law by the social elite, which rendered identification or recognition 'existentially significant in everyday life'.[36]

This view of things is in fact the other side of the dualist coin. If Renaissance portraiture did not refer poetically to an inner subjectivity, it must be an objective record of an externalised, visual reality. Yet if we re-read Alberti's 1435 account,[37] it is evident that portraiture is seen as paradigmatic not only of the mimetic power of painting, but also of the painter's art. Recognition of a visual resemblance is *inseparable* from a sense of its subject's living presence as a social being and explicitly connected with admiration for the portraitist who created it. Furthermore, in mentioning the pleasure which results from such recognition, and drawing an analogy between mimetic re-presentation and the bond between friends, Alberti distinguishes the interests of the viewer from those of the artist and the sitter. Mimetic painting, epitomised by portraiture, thus involves a relationship between three distinguishable personae or voices.

The friendship alluded to by Alberti was a humanist ideal: an ongoing, lived, multiple and normatively homosocial connectivity articulated primarily through the circulation of verbal and written texts. This 'friendship' model of interpretation can be distinguished from the later, dualist notion of a single, disembodied eye, simultaneously the mind's eye and the camera eye, in a one-off, penetrating and appropriating encounter with a feminised image whose reference oscillates, uneasily, between extreme subjectivity and a dehumanised object. Indeed, it bears more resemblance to Derrida's understanding of identity as an intersubjective process enacted through the word than to Burkhardt's dualist subjectivity, exposed and encountered through visual objectivity.

If dualism does not provide an adequate account of individualising likeness at the outset of the Renaissance, why was naturalistic portrayal re-adopted? It was no doubt connected with the development of the technical capacity to fulfil the desire for vivid, illusionistic representation. However, this still begs the question why that desire had previously been suppressed. It may have been because of a fear that a 'graven image' risked a damningly pretentious identification with the divine,

following the great Byzantine controversy about mimesis of the eighth and ninth centuries. The initial confinement of portraiture to truncated or reduced-scale figures seems to bear witness to such a concern. Similarly, the attention paid to physiognomic specificity may have acknowledged human imperfection and fallibility, since it functioned within an established, idealising hierarchy which equated symmetry and smoothness with the divine. The avoidance of the idealising, full-length format suggests that at first no claim was being made to belong to the pantheon of immortal virtue.

Devout imitation was, however, a means of ascending the hierarchy from the bestial to the divine, so that a portrait could be rationalised as an act of faith. The inscription 'Léal Souvenir' (Loyal Remembrance) on van Eyck's portrait of 'Timoteos' (1432)[38] thus both verified the all-too-human likeness and signified the sincere, perpetual commemoration by artist and viewer which was considered to help elevate the faithful believer towards heavenly immortality.

This book

This book establishes frameworks for interpretation which are not dominated by dualist assumptions, although they necessarily enter into dialogue with them. It is like a conventional portrait gallery in that it consists of a series of exemplary, empirical case studies, arranged broadly chronologically, beginning with Renaissance Italy. However, these case studies demonstrate a variety of methodologies and perspectives, rather than advocating a universal, virtuous truth. They are also arranged under thematic headings which expand or interrogate dualist concerns. Although they are paired together, the contributions are not intended to signify through opposition. Rather, they interpret the title themes under which they are placed in ways which speak to, inform and enrich each other. Similarly, the themes themselves are not meant to be independent and autonomous. 'The social self', for instance, could encompass almost every contribution to the volume, in the sense that the portrayed self is understood to be formulated through relationships between subjectivities which are themselves socially produced.

The two essays by Patricia Simons and Kathleen Nicholson address the theme of the sexual self. They focus attention upon the sexualised and gendered character of identity, radical redefinitions of the self associated particularly with psychoanalytic, feminist and gay hermeneutics. Simons's contribution tackles Burkhardt on his adopted home ground, the Italian Renaissance. It shifts individuality from here to a western modernism, which universalises masculine agency as the norm. Renaissance masculinity is described not as timeless and essential, but as formed and performed through various fields of representation, including portraiture. These discourses reveal, in addition, the unselfconscious, erotic play of desire, which cannot be contained within fixed, identificatory categories such as 'masculine' or 'feminine', 'homosexual' or 'heterosexual'.

Nicholson's essay uses representation of the vestal virgin in eighteenth-century French allegorical portraiture to explore constructions of feminine identity in response to developing discourses of individuality. Nicholson argues that the persistence and ingenuity of vestal virgin images bespeaks, not women's vain complicity in their own marginalisation, but rather a witty attempt to reconfigure selfhood as an inventive and performative process. That this is a current, feminist

understanding of the self, associated with the theory of masquerade, is acknowledged by the essay's concluding analogy between women's self-representation as vestal virgins in eighteenth-century France and Cindy Sherman's self-portrait photographs. Nicholson's acknowledgement of the connection between historical analysis and our own beliefs about, and discourses of, personal identity challenges objectivity as an ideal of history and, by implication, portraiture.[39]

The essays by Joanna Woodall and Ludmilla Jordanova which are placed under the heading of 'The social self' concern, respectively, the portrayal of leading citizens in seventeenth-century Holland and of medical men in England at the turn of the nineteenth century. They specifically address the role of portraiture in the creation and maintenance of social hierarchies and in the formation, naturalisation and empowerment of social categories of identity, including that of individuality itself. However, they question the definition of portraiture as a discourse of forward-looking, bourgeois individualism as opposed to the primitive, conservative self attributed to aristocracies. This potent analytical configuration can be implicit not only in liberal accounts such as Burkhardt's, but also in Marxist-inspired critical accounts, in which portrayed individuality is recognised as a social construction and a way of justifying and naturalising social, gender and racial oppression.

Both Woodall's and Jordanova's essays are concerned with the portrayed representation of a category of subjects whose social identity can be seen as insecure. Whereas in early-seventeenth-century Holland such identity is considered primarily in terms of status within the social order, in late-eighteenth-century England it is defined through occupation. During the first half of the seventeenth century, the factional, Protestant, mercantile elite of Amsterdam sought recognition and respect from both the hereditary nobility whose political power it had in good part displaced, and the remaining city population, over whom it was busily establishing a new oligarchy. In late-eighteenth-century England, the diverse group of practitioners who constituted the medical profession sought a collective identity which allayed the vague threat to the established order implicit in the transgressive and 'modern' character of medical knowledge and practice. In their common enthusiasm for portraiture, both groups resorted to an established genre to make conventional claims to recognition, respectability, reliability and trustworthiness. In short, they used portraiture to lay claim to a position alongside, and yet distinguishable from, accepted categories of the great and the good.

John Gage's and Christopher Pinney's contributions consider the relationship between likeness and identity, an intensely problematic issue in dualist interpretation. Both are concerned with photographic imagery, which assures objective likeness according to the criteria of dualist science. John Gage's essay starts from the contrary assumption that concepts of portrait likeness are complex and historically conditioned. He points out that in the early practice of photographic portraiture in England, an idealising aesthetic at first dominated photography's immediately appreciated capacity to produce an 'exact' resemblance of a person or object, replete with surface detail and directly accessible to the spectator. Photography was thus initially responsive to the neoclassical opposition between exemplary likeness and caricature.

Gage notes the early adoption of photographic practices which fully exploit the intrusively close observation of surface effects made possible by the camera for portraits of writers and artists. Such a transgression of honorific portrayal may be

related to the unorthodox social identity and especially penetrating, realist insight claimed for the mid-nineteenth-century author. Gage's essay also explores the impact of the objectifying resemblance which came to be associated with photography upon the relationship between likeness and the 'portrait effect' in twentieth-century realist and hyper-realist visual imagery. The debasing and dehumanising connotations of submission to close, intense, prolonged and relentless 'mechanical' scrutiny are seen to problematise the assumption that symptomatic likeness is an inevitable, independent product of exact visual resemblance.

Christopher Pinney's essay on recent photographic portraiture in central India also questions the definition of the photographic image as an objective, iconic likeness which is symptomatic of a unique, distinctive 'individual'. Indian conceptions of personal identity, and its relationship to physical appearance, are distinguished from received western wisdom. Furthermore, photography as a medium is shown to be conceptualised in a way very dissimilar to the emphasis upon scientific objectivity and documentary truth so central to western cultures. Rather than the quintessential realist technique, portrait photography seems to be regarded in Nagda as an accessible, inexpensive way of making dreams come true. By adducing a concept of 'inter-ocularity',[40] Pinney suggests that the referential paradigm of such photography is the fantastic, explicitly theatrical arena of Bombay cinema, rather than an actual, unmediated visual encounter with the subject.

The essays by Angela Rosenthal and David Lomas address the theme of the portrait transaction. This way of conceptualising portraiture, which defines identity as an interactive process rather than a revelatory, unifying encounter between opposed figures, is foreign to dualist interpretation. Angela Rosenthal's contribution concerns the social transaction implied by eighteenth-century male subjects sitting to female portraitists in England. This is used as a means of exploring some of the psychic and visual consequences of reversing the gender positions implicit in the opposition between the insightful, penetrating gaze of the artist and a passive, unselfconscious and unimaginative 'sitter'.

Rosenthal shows that this artistic paradigm corresponded to a more general 'gaze polity' in which women were not supposed to direct the prolonged, searching look at men required in the production of a portrait by a female artist. Yet these codes of practice were subverted by a theoretical opposition between genres in which history painting, as the rational and creative pursuit of ideals, was associated with the true, virile artist, while portraiture, as mere reproductive copying, was seen as suitable for women. Elizabeth Vigée Lebrun's 'Records on Portraiture' and Angelica Kauffman's 1764 portrait of the actor David Garrick (Figure 53) are interpreted as material traces of this complex, paradoxical situation.

David Lomas, whose work is informed by psychoanalytic and particularly Lacanian concepts, discusses three portraits of Joan Miró, of 1937–8, 1938 and 1942. Whereas in Angela Rosenthal's essay the transaction between self and other takes place between historical, embodied figures of the artist and the sitter within the cultural space of the portrait-painter's studio, in David Lomas's contribution the transaction takes place within the psychical space of a single persona. He regards otherness as inscribed *within* the subject, so that the self is divided; it is not an in-dividual. The body is also explicitly breached. It no longer serves as the oscillating yet absolute boundary between self and other, subject and object, 'the real me' and 'that world out there', characteristic of a dualist understanding of portrayal. As Lomas states, Surrealism proposed that psychical otherness, in the

form of irreducibly heterogeneous voices from the unconscious, is implicated in the constitution of the self, fracturing the illusory unity, familiarity and permanence of the mirror-image.

Belief in identity as an immutable, recognisable and eternal truth unique to the named body has been crucial to portraiture's claim to immortalise. The contributions by Marcia Pointon and Sarah Wilson which are paired under the heading 'identity and truth' reconsider the relationship between these terms in the light of recent critical thought. Pointon deals primarily with Picasso's Cubist portrait of the art-dealer and writer Daniel-Henry Kahnweiler, an image which has been discussed primarily as a work of art: 'a Picasso' rather than 'Kahnweiler'. Pointon notes that in modernism portraiture still stands as the yardstick for communication and truth and at the juncture between the related discourses of the sitter and the artist which constitute the reflected, reflective subject. She demonstrates, however, that the sitter is not the passive object of the artist's active subjectivity. The portrait involves a perpetual oscillation between artist and sitter, observer and observed. This ultimately fuses into a composite representation of identity, which refers to the biographies, rather than the bodies, of Picasso and Kahnweiler.

Both Pointon and Wilson are concerned with the ways in which artistic borrowings function in the production of identity. They thus provide alternatives to the authoritative, patriarchal genealogies of natural ancestry and intellectual influence through which the subject and knowledge have previously been created. By breaching the clear distinction between artist (author), viewer (reader) and sitter (textual subject), identity as the origin, enactment and end of desire is no longer confined to the divine, virile patriarch Jupiter. Indeed, Wilson invokes Prometheus, the clever, sexually ambiguous Greek mortal who deceived and stole from Jupiter, in her reconfiguration of identity.[41]

In Wilson's Derridian account, identity is enacted through the interpenetration of authored texts (intertextuality). Setting aside the usual opposition between word and image, she considers a group of published writings by the deconstructivist philosopher Jacques Derrida[42] and the writer Jean Genet. Genet made artistic virtue out of his lived experience of abandonment, imprisonment and homosexuality, turning the conventional hierarchy on its head. At the end of the 1950s, he constituted himself through texts exploring his identification with Rembrandt's late, alienated self-portraits and his experience of sitting to Giacometti for his own portrait. In the early 1970s, Derrida in turn published two texts called *Glas*, which means the tolling bell, death knell (of all certanties). 'Genet' was here buried and reborn, purloined and commemorated, through the fragmentation, appropriation and redeployment of his previous pieces.

Challenges to accepted notions of truth and identity encourage interrogation of the authority of portraiture. Contributions by Paul Barlow and Ernst van Alphen address this theme from different historical perspectives. Barlow's essay concerns the foundation of the National Portrait Gallery in London in 1856. It demonstrates how the concept of 'authenticity' was developed in order to preserve the authority of the portrayed image as truth and exemplar within the novel conditions of industrial society. An 'authentic' portrait was defined as a painting produced within the lifetime of the subject, preferably with the sitter present before the artist. The portraitist had to be capable of faithfully representing his confrontation with the sitter, so that it could be re-experienced by the viewer. While this idea originated from a perceived need for historical accuracy, it developed into an account of

portrait painting in which the pictorial characteristics of the image were identified with the personality of the sitter. Authentic portraits came to be understood to offer a direct confrontation with individual identity, revealed truth about the sitter's personality. Barlow regards this position as motivated as much by yearning for the imagined faith and intimacy of pre-industrial society as by competitive, forward-looking, bourgeois individualism.

Van Alphen's essay focuses on recent artistic responses to the breakdown of essentialist views of personal identity. He points out that the authority of naturalistic portraiture has also been profoundly challenged by the rejection of figurative imagery, because the consolidation of an authorising presence (referring to both sitter and artist) had become inseparable from such realism. Van Alphen emphasises the role of figures speaking from positions of perceived otherness – feminine, homosexual and racial – in producing visualisations of personal identity which provide creative, liberating alternative visions of the self. He also discusses the ways in which the pernicious consequences of dualism have been mourned in the artistic practice of these 'marginalised' figures. For example, he adopts the term 'holocaust effect' to explain the subversion of iconic likeness by the Jewish artist Christian Boltanski, and suggests that, in the work of Francis Bacon, Christ's Crucifixion has become a despised metaphor for mimetic portrayal: 'nailing down' the subject.

Conclusion

This sacrificial metaphor could be extended to include 'capturing' a likeness and 'taking' a photograph. Indeed, the idea of self-sacrifice as the price of personal representation is common to a number of the essays. Both Wilson and Lomas allude to the arrest of the subject-in-process entailed by representation. Sacrifice is also central to the Promethean myth of identity, which is invoked by Lomas as well as Wilson. Prometheus was condemned by Jupiter, from whom he had stolen the fire of inspiration, to be bound to a rock, where the sharp-eyed eagle was to feed upon his liver. Because this fleshy organ continually renews itself, Prometheus was sacrificed to a living death: captured, consumed, tortured, incapable of either freeing or annihilating himself. In Lomas's discussion of Joan Miró's *Self-Portrait I*, fire is stolen from Blake and van Gogh and becomes, through a text by Bataille, an image of self-sacrifice in which death and orgasm are inseparable. Constant surrender to that loss of self, partial or total, which is communication is needed for the brilliance of life to transverse and transfigure dull existence.[43]

In Hermann Broch's story of Esch the anarchist, which is discussed by Marcia Pointon, Esch threatens, in his desperation, to burn a portrait photograph of his recalcitrant lover's previous husband and, if she will not comply, to set fire to everything, to reduce everything meaningful to ashes. This threat to burn, although expressed in terms of hostility to an externalised, bestial opponent, is claimed by Esch to be an apocalyptic act of semiotic purification and revelation. The Apocalypse, in which Christ's second coming is unveiled, encompasses both the flames of eternal hell and the life-giving, brilliant sun.

These themes can be seen as secular restatements of Christian faith in sacrifice as a means of gaining personal, embodied immortality (not just in paint, but in 'reality'). This view evolved from very ancient, widespread and persistent beliefs in

sacrifice as a claim to divine favour. One paradigmatic example is the Judaic story of the patriarch Abraham, who was prepared to pin down and sacrifice his son Isaac (his progeny, his earthly immortality, his living portrait, his re-presentation) to prove his faith in God.[44] In medieval and early modern Europe this story was recognised as a prototype of the Crucifixion, in which God's son, Jesus Christ, was taken, captured, nailed up and sacrificed to attain personal salvation for every believer.

Abraham's sacrifice was to be executed by severing the head from the body. This can be seen as a symbolic castration, like the male circumcision which commemorates the Jewish covenant with God, gaining His special favour. Sarah Wilson calls attention to the conventions of bodily severance in mimetic portraiture in her reference to photographs of faces representing the decapitated, guillotined heads of the previous inhabitants of Jean Genet's cell. One might thus begin to discern, in the mute, immobile, disembodied heads of western portraiture, traces of violent sacrifice in the cause of an enduring identity.

An awareness of this other way of looking at things perhaps allows us, at last, to attempt sensitively to translate the terms in which the selves of different societies are articulated visually. At the beginning of the book's final essay on prefigured features, the anthropologist Marilyn Strathern describes the Asmat of Irian Jaya's previous convention of bestowing upon their children the name belonging to a person whose head they had severed. This naming might be considered a form of 'pointing to' or indexical portrayal, in that ethnographers suggest that the named child was assumed to partake in the life-force of the decapitated victim. The severed head, stripped to the bone, or remodelled beyond recognition, sometimes honoured with valuable decoration, was not itself a portrait, but rather a material guarantee of the desired elision between the signifier (the child's body) and the signified (the spirit or life-force of an embodied name). Strathern proceeds to show that the men of Papua New Guinea articulate their identity visually through communal dance, a living display of personal energy and endurance. 'Decorative' self-enhancement represents the dancer as a specific nexus of social relations comparable to a scientific view of the self as a genetic locus produced by sexual relations.

Yet the majority of the contributions to this volume are historical studies concerned with western culture. It is thus implied that, set into conversation with others, a self-centred historical discourse can still make a valuable contribution. To remember and mourn our own past provides access to voices, to images, which can be recognised as both like and different from our present views and concerns, providing a sense of the nature and possibility of change. History, like the image in the mirror, or a mimetic portrait, can certainly be an oppressive, if consoling fiction of 'permanence, identity and substantiality'.[45] But while taking care of the deluded, dazzled toddler and engaging fully in the struggle against patriarchal authority, we may also seek to take responsibility for historical discourse as a subject-in-process, in which every face is recognisable as both different and similar. Inscribed across each and all are traces of both presence and absence, self and other, life and death.

Notes

1 Florence, Pitti Palace.

2 Rome, Galleria Doria-Pamphili.

3 London, National Gallery.

4 See further below, p. 10.

5 M. Pointon, *Hanging the Head. Portraiture and Social Formation in Eighteenth-Century England* (London and New Haven, Yale University Press, 1993), ch. 2.

6 D. Solkin, *Painting for Money. The Visual Arts and the Public Sphere in Eighteenth-Century England* (London and New Haven, Yale University Press, 1993), ch. 1.

7 London, National Gallery.

8 Cf. Gage, p. 121.

9 Cf. J. Koerner, 'Rembrandt and the epiphany of the face', *Res: Anthropology and Aesthetics*, 12 (1986), pp. 5–32.

10 On physiognomy and dualism, see further, pp. 10–11.

11 On photography and dualism, see further, p. 11

12 Cf. Barlow, p. 224.

13 London, Courtauld Institute Galleries.

14 London, Saatchi Gallery.

15 Aristotle, *Poetics*, iv 3; iv 8; xv 8. Portraiture was the paradigm of representation in Aristotle's discussion of poetry and drama, literary genres which in turn informed thinking about pictures. The *Poetics* became the most powerful text of literary theory in early modern Europe after its rediscovery in the Renaissance. J. Peacock, 'The politics of portraiture', in K. Sharpe and P. Lake (eds), *Culture and Politics in Early Stuart England* (London, Macmillan, 1994), pp. 199–208, p. 207.

16 L. B. Alberti, *On Painting and Sculpture*, ed. and trans. C. Grayson (London, Phaidon, 1972), p. 63.

17 R. Barthes, *Camera Lucida: Reflections on Photography*, trans. R. Howard (London, Flamingo, 1984), pp. 63–72.

18 On Barthes, cf. p. 137. Broch discussed in Pointon, pp. 198-200, esp. p. 199.

19 Winterthur Sammlung Oskar Reinhart 'Am Römerholz'.

20 Cf. van Alphen, pp. 239, 240.

21 L. Althusser, 'Ideology and ideological state apparatuses (notes towards an investigation)', in *Lenin and Philosophy and other Essays*, trans. B. Brewster (New York, Monthly Review Press, 1971), p. 162.

22 J. Lacan, 'The mirror stage as formative of the function of the "I"', *Ecrits: A Selection*, ed. and trans. A. Sheridan (London, Tavistock, 1977); E. Grosz, *Jacques Lacan: A Feminist Introduction* (New York, Routledge, 1991), pp. 31–48.

23 M. Feher (ed.), *Fragments for a History of the Human Body* (New York, Zone Books, 1989), pt. I, p. 11.

24 Cf. Rosenthal's essay.

25 Cf. Lomas's essay.

26 Cf. Wilson's essay.

27 J. Burkhardt, *The Civilisation of the Renaissance in Italy*, trans. S. Middlemore, intr. P. Burke, notes P. Murray (London, Penguin, 1990), p. 98.

28 *Ibid.*, p. 199.

29 A. Sekula, 'The body and the archive', *October*, 39 (Winter 1986), pp. 3–64.

30 See above, p. 10.

31 See above, p. 8.

32 Norbert Schneider, *The Art of the Portrait. Masterpieces of European Portrait-Painting 1420–1670* (Cologne, Benedikt Taschen, 1994), pp. 9–10.

33 J. Woodall, 'Honour and profit. Antonis Mor and the status of portraiture', *Leids Kunsthistorisch Jaarboek* (Nederlandse Portretten. Bijdragen over de Portretkunst in de Nederlanden uit de Zestiende, Zeventiende en Achtiende Eeuw), 8 (1989), pp. 69–89, p. 85.

34 L. Campbell, *Renaissance Portraits. European Portrait-Painting in the 14th, 15th and 16th Centuries* (London and New Haven, Yale University Press, 1990), p. 1; Schneider, *Art of the Portrait*, p. 10. Schneider states that André Felibien in books published in 1676 and

1707 was the first art theorist to suggest that the term portrait be reserved exclusively for likenesses of (certain) human beings.

35 Cf. van Alphen, p. 239.
36 E. Panofsky, 'Jan van Eyck's Arnolfini portrait', *Burlington Magazine*, 44 (1934), p. 117; Schneider, *Art of the Portrait*, p. 14.
37 See above, p. 8.
38 London, National Gallery.
39 Cf. Pinney, p. 143, quoting A. Coomaraswamy: 'portraiture in the accepted sense is history'.
40 Pinney, p. 137, citing A. Appadurai and C. Breckenridge, 'Museums are good to think: heritage on view in India', in I. Karp *et al.* (eds), *Museums and Communications: The Politics of Public Culture* (Washington, Smithsonian Institution Press, 1992).
41 J. Lemprière, *Lemprière's Classical Dictionary*, 1st edn 1788 (London, Bracken Books, 1994), p. 563.
42 See above, p. 13.
43 Lomas, p. 174.
44 Genesis 22: 1–19.
45 J. Lacan, *Ecrits*, p. 17, quoted by Lomas, p. 167.

PART I

The sexual self

I

Homosociality and erotics in Italian Renaissance portraiture

PATRICIA SIMONS

Conventional accounts of portraiture's history regard the genre as a Renaissance invention articulating the rise of the individual.[1] A particular kind of modernist, western, autonomous individualism is assumed, a sense of unique and publicly staged selfhood, so that masculine agency is universalised as the norm. These approaches also assume a universal heterosexuality for both sitters and viewers, thus repressing more complex subjectivities and illicit pleasures. But the social circumstances, sexual practices, written languages and visual discourses of male bonding suggest that charged, erotic elements often informed the formation and performance of Renaissance masculinity. Whether or not bodily contact occurred, or would satisfy criteria of a 'sexual' kind for twentieth-century observers, Renaissance men addressed each other in affective ways which were often so tinged with the arousal of desire that they were erotic. Male sexuality was performed across a wider spectrum of sensualities than modern standards usually allow, collapsing any clear boundaries between an essential 'gayness' and a straightforward 'heterosexuality'. A complex sense of sexuality and erotics can be gleaned through a reading of certain Italian Renaissance images of men. Rather than relying on a notion of identity as a fixed, self-contained essence, Renaissance portraits of men employ a framework of multiple selves which are contextual, not universal, and suggest sexualities which are multilayered, not self-evident.

Many Renaissance portraits of men present a seemingly straightforward, public notion of what being a man meant. Masculinity was enacted as a collectivity of men in the arenas of politics, commerce and leisure. In an overdetermined patriarchy, audiences were predominantly male and chiefly saw members of their own gender and class populating the spaces and images of the Renaissance city (Figure 1). The representation of groups of men especially stressed homosociality, that is, the bonding between men through social and emotive ties. Friendship and homosociality were primarily figured as idealised solidarities, insistently presenting a civic, familial and patriarchal peace which did not threaten the public order. Yet the psychic and social worlds could be ambivalent, fraught with a tension between the assertion of affective friendship and the awareness of its insincerities.[2] The Renaissance State increasingly sought to regulate the forms of homosociality. Hypermasculinity was accompanied by anxiety, and the exercise of

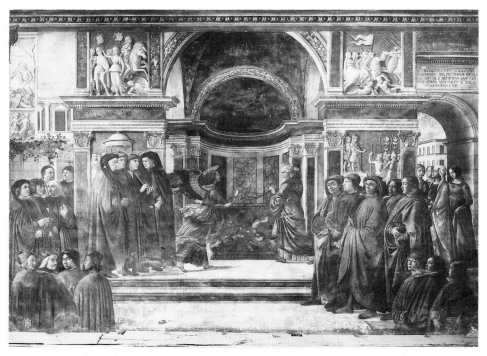

1 Domenico Ghirlandaio, *Annunciation to Zacharias*, 1490. Fresco, S. Maria Novella, Florence. Twenty-one male portraits of the patron's extended family and other Florentines, including humanists, crowd a space represented as both civic and sacred. An inscription proclaims that 'the most beautiful city' of Florence 'enjoyed wealth, health and peace'.

a seeming pansexuality by men was checked by tensions and compensations. Privileges came with obligations; from friendship, factionalism could blossom, trust could turn to betrayal, love to sin. Many Renaissance portraits display an idealised masculinity which nevertheless suggests, instead of inviolable fortitude or bland self-possession, such characteristics as overemphatic virility (Figure 8), ambiguous sexuality (Figure 3), melancholic sensitivity (Figure 4), wary vulnerability (Figure 5) or complicated power relations (Figure 9).

Ambiguous sexualities

For many Renaissance men, the boundaries of sexual activity were fluid to a degree that gender divisions were not, while the ostensibly allowable bonds of affection between men (between family members, especially fathers and sons, between patrons and clients, and amongst friends) could have sensual undercurrents. Sex with either men or women was practised concurrently by some men, while others had sex solely with men, but adolescent sodomy more often served as a transitional acculturation into adult male heterosexuality and sociability.[3] A man's youthful experience of sodomy became a memory generating repression, tolerance, nostalgia, or desire. Erotic arousal could be motivated by people of either sex, so the modern word 'homosexual' does not properly apply

because men often had variable objects of desire in the Renaissance.[4] The very search for certainties in gender roles and bodily behaviour betrayed the anxieties and opportunities of a less fixed notion of sexuality and social relations. Masculinity was intertextual, produced interdependently rather than individualistically. It was not only a function of heterosexuality (relational to women) but also depended upon homosociality (relational to men). To the extent that homosocial ties were desirable (in terms of power, prestige, influence, wealth, companionship and beauty), they could be eroticised or homoerotic.[5] Yet the divide between homosocial and homoerotic effects is difficult to define since Renaissance notions of masculinity and male sexuality were both fluid and overdetermined, emphatically drawn in terms of gender roles but more open in terms of desire. Homosociality and homoerotics were co-existing, mutually informing and yet not always overlapping.

Ambiguous sexualities in male portraiture

Ambiguities imbue the processes of viewing, posing for, and producing Renaissance portraits. The implications for the erotics of viewing are multiple: a young man, for instance, could be aroused by images of 'active', masculine figures like Hercules or portraits of soldiers, while for an older man, such bodies would present glorious physicality and affirm his own idealised masculinity without necessarily having any bearing on his heterosexuality. For young viewers, images of 'pretty boys' such as Parmigianino's *Amor*, Donatello's bronze *David* or any number of portraits could offer narcissistic pleasure while teaching lessons about ideal youth; the beauty could stimulate older viewers to feel nostalgia about their younger selves, to desire actual embodiments of that ideal, and/or to fantasise about whatever body next came by. As with the reception of portraits, so too in the performance of portrayed roles masculinity was not a static, immutable exercise of power. Men varied amongst themselves, desperately seeking advancement and status, and varied within themselves, fervently denying their dependence upon men whilst continually networking and loving their fellows. 'Renaissance Man' was not an indivisible, singular and coherent entity; men enacted roles ranging from hypermasculine rogue to celibate saint. Women were filtered through notions of beauty and propriety, and they could be disguised as pious imitators of saints or as attractive nymphs and goddesses like Flora. So too men were mediated by standards of masculinity and were often portrayed in the guise of another, presenting a different persona to audiences increasingly aware of public display and fractured social roles.

Unlike more straightforward portraits which give the appearance of naturalism, role playing portraits overtly manifest invention on the part of both sitter and artist, thus acknowledging and permitting the performance of fantasy by the viewer, too. For instance, around 1538–40 Cosimo I de' Medici was disguised as 'the great lover Orpheus' in Bronzino's painting seemingly directed at Cosimo's new bride Eleanora of Toledo (Figure 2).[6] An 'icy sensuality' and suggestive gestural references to the excitation of male and female genitals have been discerned in this allegorical nude portrayal of the young Medici ruler. During the Renaissance, Orpheus was cast not only in the roles of musical charmer, devoted lover, philosopher and peacemaker, but also as the mortal who discovered male–

male love.[7] Orphic homosexuality was praised by Poliziano and visually referred to by Mantegna's circle and by Dürer. Whether or not Bronzino and his audience consciously recalled this tradition, the portrait evokes a sensual response that does not fit simple stereotypes about either homo- or heterosexuality.

The eroticism in Bronzino's portrait presents neither an effete prettiness nor a stern, distant hero, but an appealing muscularity which is both smoothly moulded and carefully accentuated so that a tactile engagement is invoked. The painting entices viewers through such features as a supple pose (seen from the rear), elongated fingers stressing arousal, and a teasing play between mysterious depths and silken highlights. Shed of his defensive armour common in other portraits, and displaying the vigorous body of a young adult, Cosimo's persona is cast in the guise of a luscious, posed, and mythic figure. The duke Cosimo here charms not only one heterosexualised woman, his wife whose chief purposes were to signify the forging of an international alliance and bear children. He also seduces his courtiers and Florence itself, all to be stirred in admiration and swayed by the Medicean will. That the portrait eroticises a naked ruler's body and that Bronzino's poetry includes homoerotic references, whilst Cosimo's State heavily condemned sodomy, are signs of Renaissance contradictions about embodied masculinity and 'homosexuality' which, however, cannot in themselves 'explain' the portrait.[8] To prove or disprove that Cosimo or Bronzino were 'homosexuals' in the modern sense would not adequately locate the portrait in its cultural context, or encompass the range of visual, ideological and sensual affects it could instigate.

Nor do portraits of men who *do* have some documented connection with behaviour beyond normative heterosexuality offer direct clues to the sitters' sexuality. Borso d'Este, the popular, gregarious, vain and always bejewelled ruler of Ferrara from 1450 to 1471, was said by a contemporary to abstain from sex with *women*; the total absence of women and children from his life is indeed unusual for a prince of his times.[9] Yet neither celibacy nor homosexuality can be deduced from his portraits in the Palazzo Schifanoia cycle, where he appears in the aspect of a robust man of military skill who enjoys hunting and the company of male courtiers. Only if his delicate gestures in a particular manuscript are read through the lens of a much later Camp style, and with the assumption that both heterosexuality and masculinity only operate within a narrow register, can he be characterised as appearing in 'almost effeminate ease' and 'unusually effete'.[10] Rules of courtly demeanour allowed a refined elegance and homosocial bodily contact between men that was not automatically coded as abnormal or sinful. On the other hand, Aretino's biting criticism of courtiers early in the next century characterised their lot as akin to harlotry, where the sycophant had to 'play the nymph'.[11] Demeaning feminisation was further stressed when he said courtiers were forced 'to be active and passive', by which he meant play the roles of both the sodomiser and sodomised, using the respective terms for the polarities, 'agente' and 'paziente'. Aretino also attacked men like Michelangelo for their attraction to boys, yet he had such interests himself and temporarily fled Venice in 1538 after being accused of sodomy.[12] Admitting to having been 'born a sodomite', he proclaimed he had changed his ways and that a now-lost portrait of him by Titian displayed this rejection of the 'horrendous vice'.[13] His surviving portraits show a burly, serious presence and give no hint of his pansexual hedonism, although an alter-ego is indicated on the reverses of two medals which celebrate his satire and penile fixation to excess by composing a head made up of phalli.[14]

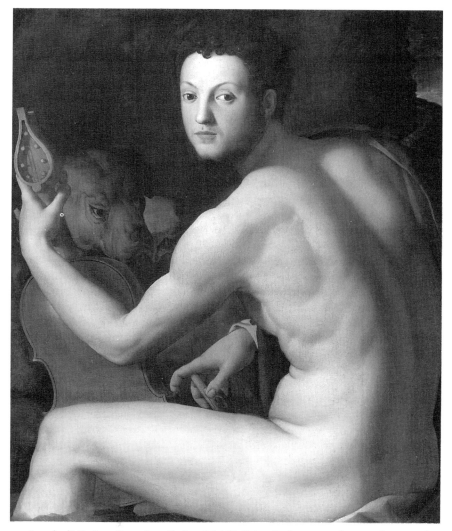

2 Agnolo di Cosimo Bronzino, *Cosimo I de' Medici as Orpheus*, c. 1538–40. Oil on panel, 94 x 76 cm. The court painter pays homage to his patron Cosimo (1519–1574) with a mythological, seductive portrait.

What distinguishes the social and visual displays of men like Borso and Aretino is an obsession with the camaraderie of men and the trappings of homosocial surroundings. Portraits of other men, which appear more androgynous to our eyes, are often anonymous. Even if we do have some access to biographical information, neither history nor the visual mask clarify the sitter's sexuality in a categorical way. A portrait identified as that of either a man *or* a woman and attributed to Boltraffio, a Milanese pupil of Leonardo da Vinci, is smoothed over and idealised to the point where neither the figure's gender nor the painting's status as a portrait would be immediately clear to modern viewers employing anachronistic standards for masculinity and for portraiture (Figure 3).[15] To a contemporary, however, the sitter's gender would have been evident: the gesture

and costume are masculine; the panoply of jewellery and finery indicates a delight with wealth and decoration and perhaps also the sitter's mercantile occupation with jewels; the long unbound tresses and adolescent androgyny are common in Leonardesque depictions of men. Further clues are provided by inscriptions which clearly mark the painting as a portrait: the initials CB divided by a pearl on the lapel, which probably notes the poet's name in Latin, and on the reverse, a *memento mori* skull which is accompanied by the statement 'I am the insignia of Girolamo Casio'. A friendship between sitter and painter resulted in other portraits of the poet and jewel merchant Casio, who praised the artist's naturalism but also his capacity for making 'each man more beautiful'.[16] We cannot be sure whether the process of beautification was impelled by explicit homoerotic desire, but it does display a level of extravagant refinement and a homosocial thrall with young men which were considered acceptably visualisable rather than shameful.

Neither inscriptions nor poetry are attached to Lorenzo Lotto's haunting image of a young pensive gentleman leaning over a table in his study (Figure 4).[17] There are countless objects scattered through the scene which may signify more than has yet been deciphered. A lute rests against the back wall; hunting horn, dead bird and cap with hatbadge hang from the shelf; keys lie on a storage chest; on the table rests an inkstand, green lizard, some letters and, closer to the man's book, an opened letter atop a pair of gloves and a gold chain, with pink rose petals and a ring nearby. The two letters neatly bound to one side contrast with what seems to be a newly received or re-read missive. The very plethora of possessions impels the viewer to spin a tale about the sitter. One hypothetical story would be that the open letter has reported a rejection since the chain and ring could be tokens returned by a lover. That beloved still seems to occupy the man's thoughts as he idly fingers the pages of a weighty tome. Whatever the implicit narrative, the portrait conjures for its commentators an air of lost love, subtle melancholy and introspection. The scattered petals seem to stand for the perishable fragility of youth and beauty, marking the man's passage from the pursuits of hunting and music to the more mature, bookish task before him, which nevertheless fails to captivate his full attention. A lizard alertly looking at the wistful man is the most disruptive, unexpected element and may indicate the cause of the sitter's mood. In Caravaggio's painting from the end of the century, a biting lizard shocks a youth with its message of rejection and disappointment.[18] In general, the lizard was a 'symbol of shyness or coolness in love, but also of constancy', meanings clustered around pondering and desire.[19] Since Lotto's reptile observes rather than bites, it indicates a less shocking but still wounding loss.

Nothing in the painting unequivocally suggests heterosexual relations and there are no indications that the absent one only could be female. The *possibility* that male viewers, including the artist, were being drawn into an erotic story should be recognised rather than repressed. The sitter, a barely adult man with down on his upper lip, does not show masculine stoicism in the face of loss. The very visualisation of a wounded, affected man was relatively uncommon in the Renaissance. A proposal that the sitter is Alessandro Cittolini, who with Lotto witnessed the will of the architect Serlio in April 1528 (the approximate date of the painting), suggests a friendship and possible empathy between the sitter and the artist, who never married.[20] The portrait refers ambiguously to a desire that reaches beyond a simplistic reduction to either homo- or heterosexuality. The possibility of homoerotic discourse in a given portrait is indefinable not only because it is

3 Boltraffio, *Portrait of a Youth
(G. Casio?)*, *c.* 1490s. Panel,
42.5 x 28.5 cm. Leonardo da Vinci's
Milanese pupil adapted his teacher's
interest in androgyny to produce a
portrait sometimes misidentified as
an image of a woman.

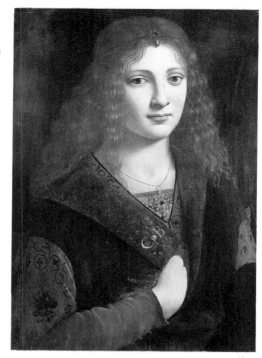

4 Lorenzo Lotto, *Portrait of a
Man in his Study*, *c.* 1527–8.
Oil on canvas, 98 x 111 cm.

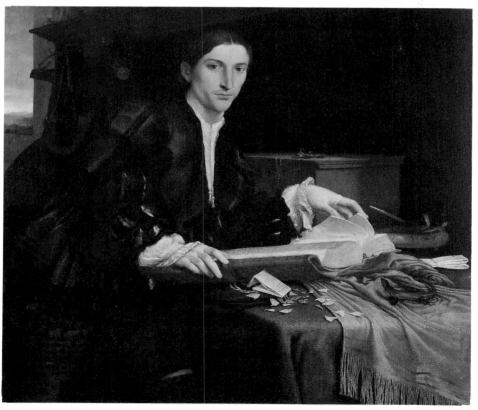

difficult to 'prove' by documentation, but also because masculine desire in the Renaissance evades modern categories. The 'sites of sexual possibilities, the syntax of desires not readily named' are elusively visible in portraiture.[21]

Beautiful men

Masculinity was portrayed across a range of mediations. It was shown as individualised and apparently recognisably distinct, but also allegorical or idealised in the cases of men like Cosimo I, Girolamo Casio or Andrea Doria (Figures 2, 3 and 8). The rhetoric of mythological poetics, masculine grandeur or youthful beauty addressed predominantly male viewers, bonding them in discourses of power, erudition and erotics. Elizabeth Cropper has pointed out that 'many portraits of unknown beautiful women are now characterised as representations of ideal beauty in which the question of identity is immaterial. No unidentified male portrait, on the other hand, is ever said to be a beautiful representation made for its own sake.'[22] Until recently, art historians have indeed avoided the issue of beauty in male portraits, thus repressing their sensual dimension. When now raised, beauty is often invoked as a reason to deny that a painting is a male portrait, so Cropper's point still holds. Images of beautiful men disturb some art historians, because they do not fit standard notions of masculine individuality, 'true' portraiture, decorous embodiment, or normalised heterosexuality.

One such example is Pontormo's *Halberdier* (Figure 5), often thought to be a portrait of Cosimo I de' Medici painted around 1537–8, but variations in dating and identification of the sitter occur.[23] Lorne Campbell's assessment of the painting is revealing. He lists a series of visual elements which make him extremely uncomfortable, as though none of these fits his unstated assumptions about what constitutes a 'true' or 'proper' portrait:

the features are not highly particularised but resemble closely those of idealised young men and angels in Pontormo's religious paintings. The youth, with his narrow, slanting shoulders, ridiculously small waist, relatively wide hips, jutting codpiece and rather phallic pike, is sexually ambiguous. His breeches, opening to reveal his shirt, seem insecurely suspended; his pouting, parted lips and expression of almost orgasmic vacancy are peculiar; and his hat badge shows Hercules and Antaeus – two naked men grappling in an embrace to the death. The picture is perhaps not a portrait, but rather an idealised image of a handsome guardsman.[24]

For Campbell, a supposed lack of particularisation is allied with a surfeit of sexual innuendoes, and those are all homoerotic. A body that appears malformed because it does not meet some standard of stocky masculinity becomes 'sexually ambiguous', though only after costume details are included alongside a description of body build. The codpiece and lance each stress a phallic presence, but against what is deemed an implicitly feminine body with a 'ridiculous' waist, this results only in abnormality.

Yet, the typical manner in which any artist approached the construction of a face does not exclude portraiture in a particular face, while many of the supposed eccentricities appear in other portraits. An assertive red codpiece, for example, occurs in Bronzino's *Guidobaldo della Rovere* of 1532, where it stresses the young man's defiance of his father and states virile independence.[25] Forster discerns in

the Pontormo the 'cocksure stance' of a young Medici who is a '*capo* and son of the famous *condottiere* Giovanni delle Bande Nere ... portrayed as an imposing figure of youthful and stylish vigor'.[26] What Campbell reads as 'orgasmic vacancy' in the expression, others have interpreted as 'ravaged ... self-questioning', apprehension or 'elusive reticence', often seeing an evasion or self-reflexivity which suggests complexity rather than sexual imbecility.[27] Whilst the painting could be a retrospective or aggrandising representation of the sitter's youthful watchfulness, there is no reason to doubt that it is a portrait. The costume and profession may be uncommon in portraiture, but the clothing and decoration are also too specific and detailed to suit a generic ideal. That a certain type of attractive, vulnerable yet

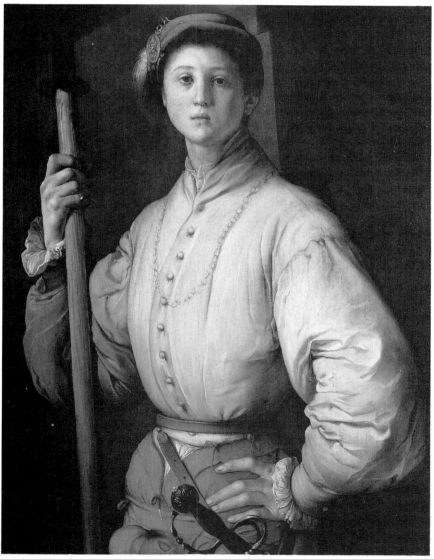

5 Pontormo, *Portrait of Halberdier (Cosimo I de' Medici?)*, late 1520s–1530s.
Panel transferred to canvas, 92 x 72 cm.

vigilant youth is the particular mask chosen for a portrait does not make it a typology *only* of that mask, with all reference to a particular practitioner evacuated. This is a Florentine as a young armed patriot, not a generalised ideal, nor even a classical disguise. A sensual beautification of male bodies does not delete them from the category of portraiture.

The very attractiveness of the idealised male body added to the sitter's charisma, status and honour, just as the visualisation of Christ's supreme beauty was necessary in order to induce reverence. So Alfonso Cambi and his portrayer Vasari saw nothing wrong in having him 'portrayed nude and at full length in the

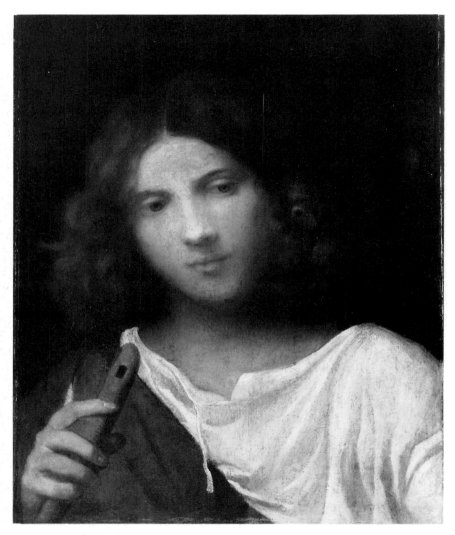

6 Titian (attributed), *A Boy with a Pipe (The Shepherd)*, c. 1512. Canvas, 61 x 46.5 cm.

person of the huntsman Endymion beloved by the Moon'.[28] Inspired by Vasari's earlier male and female mythological nudes, this 'very beautiful youth, well-lettered, accomplished, and most gentle and courteous' chose to commission the artist to show him as attractive like those glorified figures. Endymion was a telling selection: a youth of great beauty visited in his dreams by an adoring Luna or Diana, he sought immortality through eternal sleep. Cambi's (now lost) portrait as Endymion conferred immortality, since portraits were thought to preserve one forever. The man's abandonment, caught always in the innocent sleep of eternal youth, would have invited viewers to adore, like the Moon, a glorious instance of

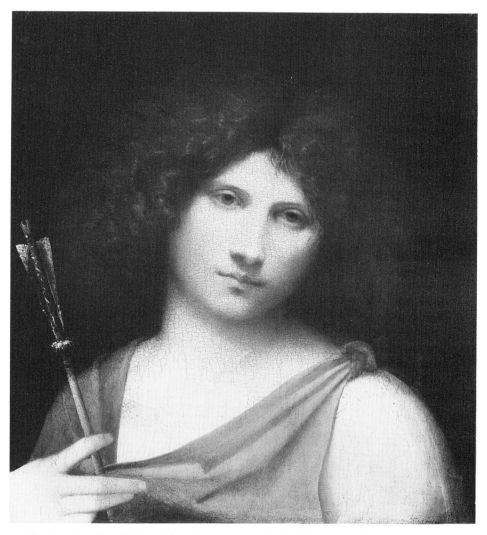

7 Giorgione (attributed), *Boy with an Arrow*, c. 1505. Panel, 48 x 42 cm. The rich merchant Giovanni Ram was particularly attracted to arcadian heads, owning three according to Michiel: 'the head of the young Apollo, playing the pipes' attributed to Catena, a 'head of the young shepherd holding a fruit in his hand' and 'the head of the boy holding an arrow' both by Giorgione.

bodily perfection as well as to admire the artist's divine skill. Cambi's own attraction to himself and its displacement through the vocabulary of classicism produced a portrait that would have appealed to other narcissistic oligarchic youths, thrilled by the authorisation of their self-loving fantasies.

Since viewers responded viscerally, emotionally and physically when encountering portraits, it is likely that Cambi's startling portrait would have appealed to a variety of male viewers, from similar youths beginning their own awakenings into adulthood, to older men nostalgic for their adolescence, each possibly desirous of male lovers. Male viewers could take on the guise of Luna worshipping the golden age of youth; they could delight in a passive body and be aroused by their own potency if they followed contemporary divisions of erotic power. The viewing dynamics were particularly complex for the sitter himself, who both identified with his portrait and contemplated himself as an object of desire. The very act of viewing risked putting Cambi in a subordinate position, since he became an object of the masculine gaze, whether operated by himself or his male friends and family. Yet when looking at his own portrait, he also gazed as an omnipotent man. Thus he oscillated between imagining the experiences of objectification and voyeurism, emasculation and empowerment, adolescent narcissism and adult egocentrism, eternal sleep and waking dreams, somatic pleasure and classical erudition, self-preoccupation and mythic distancing. The delicate curves and slumbering body of an adolescent male could be fantasised as signs of a 'passive' partner for a man while not ambiguous enough to allow Cambi's total feminisation. Women could adore a masculine body and remain complicit with social norms of hetero-sexualised femininity; men could exercise their masculinity without being restricted to a heterosexual–homosexual dichotomy.

The Cambi example indicates that mythological figures and unexpected formats were not alien to Renaissance portraiture. Fiction and disguise informed the visualisation of sitters' personae. For example, radiography shows that the Giorgionesque *Shepherd* at Hampton Court (Figure 6) began as a 'more conventional and more formal portrait' and was worked up to an 'eventually informal, or "fancy"' portrait where the youth is presented in 'the guise of a Virgilian shepherd'.[29] Another painting of a shepherd, by Francesco Torbido and dated to the mid-1520s, began as a portrait of the nobleman Francesco Badoer but when an unrelated man soon purchased the painting he 'had the Venetian dress changed into that of a shepherd or herdsman' without altering the face.[30] Ten paintings inventoried in Palma Vecchio's studio in 1529 were male heads of secular subjects, one of which was a 'head of a shepherd' whereas the other nine were 'portraits', listed by sitter's name or by type, and amongst the latter was one simply called a 'portrait of a youth' as though immature age alone was an identifying category.[31] While many fifteenth- and early-sixteenth-century male heads from Venice, attributed to Giovanni Bellini and others, are readily accepted as portraits, the situation is murkier for various heads of youths clustered around Leonardo's Milanese 'school' and the Venetian circle of Giorgione.[32] It is not so much that the faces appear even younger or more idyllically sweet than in traditional portraits, but that the figures are also presented against plain, usually dark, backgrounds and are masked in classical garb. Pastoral and sensual fantasies are thereby enabled, with taboos rooted in the everyday replaced by the ease to imagine arcadian dreams. There is no simple opposition between the particular and the ideal, for known portraiture in the case of men like Badoer and Campi was also transposed from the

quotidian to the nostalgic. Allegorical references made on the backs or covers of some portraits were incorporated, as it were, into the portrayal itself.

The Hampton Court *Shepherd* (Figure 6) has been seen as an instance of 'ideally pretty youths ... [that] would have appealed to the various tastes of many'.[33] A rejection of Giorgione's *Boy with an Arrow* (Figure 7) from the portrait category is made by Paul Holberton on similar grounds of an idealism which is assumed to be tainted by a particular kind of sensuality.[34] A 'meditative ... resigned, even melancholic air' results from an arrow which carries 'the prick both of love and death, the prick both of desire and pain'. To Holberton the painting has no meaning as a portrait, and the arrow's 'metaphorical value ... remains true *even if* one takes the boy *only* as a pretty boy painted for a homosexual: the arrow will refer to love'. Apparently, homosexuality is a matter that may demean the painting but not affect the arrow's meaning for any viewer. A similar demotion had been offered earlier by Charles Hope who labelled Titian's *La Bella* 'just a pretty girl' and placed it in the same group as other 'mildly erotic' 'anonymous pretty girls' like the *Flora* 'which were no more than elaborate pin-ups'.[35] In both cases, it is assumed that the paintings are only for male audiences, whether in the sixteenth or twentieth centuries; that those viewers can only exclusively appreciate *either* homo- or heterosexual images; and that the presence of erotic interest implicitly removes any such paintings from consideration as portraits.

Yet fantasy could be all the more charged by a referential element, by the suggestion of some actual presence pre-existing the representation.[36] The idyllic youths could be based on memories of actual boys, sons or lovers or younger selves, who are then presented by an idealising, nostalgic classicism. The Renaissance visual fascination with mythologised youth bespeaks a homosocial and homoerotic tension about intergenerational relations, with the art often didactically preaching heterosexuality at the same time as it tempts viewers with sights of male adolescent flesh. The prettification of youth was a standard feature of homoerotic paeans, and vernacular language abounded with references to a 'sweet boy', 'pretty boy' or 'beardless youth' as the 'passive' or sodomised object of an 'active' man's idolising desire.[37] Smooth faces were attractive signs of puberty before full manliness arrived. The sexually arousing stage of youth was not simply a matter of feminisation; equally stimulating was the ambiguity of adolescence, a less powerful stage before categorical adulthood, so that patriarchal domination between different sorts of masculinities was an erotic issue.

The very language used to refer to beautiful youths, whether by critics or by proponents of male–male love, conflated individual males with mythological figures. An anonymous Florentine denunciation made in 1495 commented that a weaver 'sees no other god but' his lad.[38] San Bernardino's homophobic attacks against sodomy in the 1420s bemoaned the heretical adoration yet resorted to similar verbal imagery: 'the *fanciulli* are the idols of old men, who consider them gods'.[39] Delighted by an assistant's 'lovely face', 'incredible beauty and the great love he showed me', the sculptor Cellini was 'not at all surprised at those silly stories the Greeks wrote about their gods'.[40] Around 1557, Cellini wrote a sonnet which admired the 'beautiful face' of a youth who 'modelled for me' for *Apollo and Hyacinth*, *Narcissus* and *Perseus*, such 'silly' classical fables as form the generic language for these earlier beautified, divine youths.[41]

Some of the popular painted heads in mythological or idyllic guise are perhaps not 'portraits', but they could be regarded as metaphorical or apotheosised

portrayals, objects close to what Cropper reminds us cannot be found in traditional art historical accounts, 'a beautiful representation [of a man] made for its own sake'. Paintings of a soldier in half-length, or of a youth holding pipes, a flute, a piece of fruit or an arrow, perhaps in the guise of a shepherd or prepubescent Apollo, were called 'heads' rather than 'portraits' or 'portrayals' by Marcantonio Michiel when he itemised certain Venetian collections in the 1520s and 1530s.[42] Rather than eroticism defining the issue of which male heads are or are not portraits, the language of the period is a better guide. And that language is ambivalent, usually describing these figures as 'heads' but sometimes noting them as 'portraits', as though an unusual experiment by artists like Giorgione could not be pinned down by contemporaries.

To some art historians, the *Boy with an Arrow* (Figure 7) is either a meaningless 'pretty boy' or a classical figure; the *Halberdier* (Figure 5) is either not a portrait at all or a portrait whose features below the waist are ignored; Cosimo I's portrait (Figure 2) is understood only as a nuptial, heterosexual lover in a 'private' intimacy which excludes any 'public' discourse of erotics. But Renaissance standards of ideal masculinity and male beauty did not always match twentieth-century expectations. Cellini praised a soldier, for instance, as 'the most courteous warrior I ever came across, with the exquisite manners of a young girl, and yet, when necessary, showing himself incredibly bold and ruthless'.[43] It is not simply that some texts constructed heterosexuality whilst others opened the subliminal possibilities for homosexuality – these terms are later inventions – but rather that male sexuality in the Renaissance was unstable, ambiguous. If we consider a spectrum of what portrayal meant in the Renaissance, we can better allow the richness of portraiture to breath through the strictures of anachronistic definitions of portrayal, masculinity and sexuality.

Patronage, friendship and the artist

Networks of patronage and friendship provided the mechanisms whereby privileges were obtained, reciprocal obligations cemented, political and economic interests advanced, and bonds of intimacy formed. Modes of address, however conventional, applied affective terms of love and bondage. Men wrote to other men as slaves, creatures, brothers and devotees, asking 'for love of me ... serve me as I have served' or invoking 'that fine and perfect love which should exist between father and son, and which I am certain you have for me'.[44] The overlapping of love and virility with homosocial ties between men is revealed in Antonio Pérez's entreaty to his patron that 'clients love masculine men as wives their husbands'.[45] Just as a binary standard of 'active' and 'passive' was used to distinguish sodomitic partners, here a client describing power relations constructs such bonds as erotic whilst resorting to a heterosexual model. The 'perfect friendship' of marriage was treated by Francesco Barbaro in a treatise he delivered to the newly married Lorenzo de' Medici around 1415 'in honour of our close friendship' and 'love', offering it as a 'wife's necklace'; thus even gift-giving and writing about a wife's duties were means of emotive exchange between men.[46] An actual marriage provided the means for verbal, metaphorical bonding of a homosocial kind.

So too the exchange of portraits between men could connect them in networks of friendship and patronage. Vasari, for example, painted Luigi Guicciardini's

portrait because he 'was very much my friend' and because 'out of love for me' he had used his influence to assist Vasari's acquisition of land.[47] Andrea Doria was portrayed in 1526 by Sebastiano del Piombo as a landed official of the seas, clothed and powerful, in an image executed at the suggestion of Pope Clement VII as a 'sign of the love' he bore this influential admiral.[48] Around 1533 another portrait was produced and here Bronzino adopted a reference made in a fountain statue to

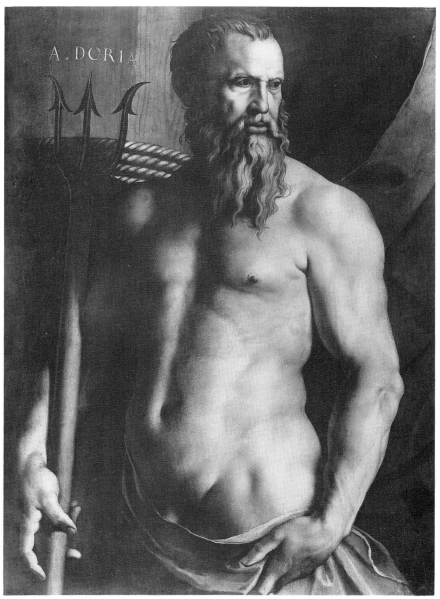

8 Agnolo di Cosimo Bronzino, *Andrea Doria as Neptune, c.* 1533. Oil on panel, 115 x 53 cm. Akin to other projects associated with Doria (1466–1560), this portrait makes the admiral appear as classically inspired and sensually virile.

Doria's divine apotheosis, to show also a semi-nude Doria appearing as Neptune, potent ruler of the oceans (Figure 8).[49] This latter portrait of an attractively virile man in classical guise was given by Bronzino to his friend Paolo Giovio, who was forming an important collection of portraits of notables. A conqueror of the forces of Nature and connected to the mythological realms of power, Doria is portrayed by means of a seemingly naturalised classicism. The remarkable mythologising conceit and revelatory confidence are usually interpreted as only erudite rather than as being also sensually embodied and seductive. The production and exchange of portraits was a process that bonded as well as manipulated the members of the patriarchy. Oligarchs flattered and watched. Sitters marshalled a vocabulary of power and idealised masculinity to further their claims to authority. Artists referred to each other's work, thus competing with and acknowledging their peers as well as furthering their own networks of influence.

A portraitist appropriated feminine Beauty to proclaim his skills and status as much as to render a specific woman visible. In the case of male portraiture, artistic skill was a factor in the theatre of conflicting claims among men for recognition and visibility. A homosocial dialogue among artist, sitter and viewer could position the male artist as a seducer; his products conducted a sensual courtship with his predominantly male audience. Leonardo claimed that the painter's 'very effigy of the beloved' can 'inflame men with love' so that 'the lover often kisses and speaks to the picture'.[50] He told of a man who fell in love with a painting of a saintly woman and requested the removal of pious attributes so that the image could be kissed without shame (*sospetto*).[51] Ultimately, scruples overruled the man's desire (*libidine*), so he removed the painting from his house. This client may also have been dissatisfied by the absence of the artist, the true seducer, when a displaced homoerotic desire was still not fulfilled. In the practice and fantasies of other Renaissance viewers, portraits were indeed sometimes the focus of animated speech and kissing.[52] More generally, all art was acknowledged as akin to seduction. Cennino Cennini promised any good artist that 'you will make everyone fall in love with your productions'.[53] In instances like Lotto's portrait (Figure 4), it is possible the sitter also might seduce the artist. According to Vasari, Filippo Lippi compensated himself by portraying women he could not sexually possess.[54] Michelangelo, who despised the notion of mere resemblance in favour of creative idealisation, nevertheless relented in the case of Tommaso de' Cavalieri and drew the 'infinite beauty' of a man he loved.[55] Portraiture could enact as well as displace or sublimate the very desire it visualised.

Same-sex behaviour between Renaissance artists, apprentices and models is not surprising since Cennini, at the beginning of the fifteenth century, and Paolo Pino, in the middle of the sixteenth century, both advised that artists avoid the company of women. In Cennini's words, women 'can make your hand so unsteady that it will waver more ... than leaves do in the wind'.[56] A didactic model could be sexualised in the Renaissance, as sodomy became infamously associated with humanists, tutors and schools.[57] The educational metaphor extended to other fields such as the visual arts or public office. A Venetian herald's adolescent trainee characterised his sodomitical relationship as 'friendship' because the older man was 'teaching him like a master'.[58] When an age differential did not pertain, Renaissance texts readily recognised intimacy between two youths, 'the closest of friends' who 'shared the same bed, happy one with another' or who resolved 'to be buried in the same grave so that in death, as in life, they should not be divided'.[59]

Such patterns of idyllic intimacy were visible not only in literature but also in portraits of young friends.[60] Nor was such intimacy restricted to adolescence, for the humanists Giovanni Pico della Mirandola and Girolamo Benivieni were indeed buried together 'to prevent separate places from disjoining after death the bones of those whose souls were joined by Love while living'.[61] In their circle around Ficino, such men wrote an elaborate Neoplatonic justification of same-sex friendship and appreciation of physical beauty as leading the soul by spiritual love to the divine. Michelangelo similarly subscribed to a tortured intellectual defence of the purity of his love, relying also on a Petrarchan model of a remote, idealised object of desire. To search now only for bodily sex as a determining sign of whether or not masculine erotics existed is to apply anachronistic standards.

Masculine passion resulted in an early example of the friendship portrait, one painted by Mantegna around 1458 before the Hungarian humanist and poet Janus Pannonius returned to his homeland.[62] The poet was portrayed with Galeotto Marzio da Narni, his 'intimate friend and room-companion' from their days of tutelage in Ferrara. Mantegna painted these two friends whilst they were re-united in Padua, as a keepsake of a special relationship soon to be disrupted by international distance. The painting is lost, but the portrait's appearance is perhaps reflected in a Venetian painting of two noblemen attributed to Cariani, where the number of copies suggests that it was a renowned composition.[63] The bodies are close to each other, indeed overlapping, and intimate also with the viewer, who seems to stand close and is recognised by the gaze of one of the men. Pannonius's surviving Latin elegy speaks of Mantegna's 'gift' of the two men breathing together in the one frame, representing 'a knot of unbroken friendship'. Like Pico and Benivieni, the two are linked past death: 'Thou makest our faces to live for centuries, though the earth cover the bodies of us both. Thou makest the one able to lie in the other's bosom, whenever a wide world shall separate us.' No matter what the sexual relationship between these two men, a movingly erotic bond linked them, one joined by the artist Mantegna, whose gifting extended the range of homosocial affection and who in turn was tied to the sitters by a poem of lavish praise.

Raphael included himself *inside* the frame when he presented his self-portrait with an unknown companion (Figure 9).[64] Now physical closeness is further declared, with one of the artist's hands laid on the other man's shoulder and Raphael's other hand hidden between the men. The foreground figure is larger in size but placed below the master, towards whom he turns as though seeking assurance from the very man who has indeed painted his portrait. His portrayer seems, however, to refuse further affirmation. The sitter cannot divert the painter's eyes from an audience in whom Raphael appears more interested. Portraiture's claim that the sitter is 'really present' through artistic representation is here exploited by Raphael. Portraiture's necessary confusion between the sign and the referent, the art and the sitter(s), produces a meaningful, complex treatment of presence and artifice. The audience is firstly Raphael himself, whose face indicates a near-frontal gaze into a mirror in order to produce the resulting self-portrait. As though trying to distract Raphael from a self-regarding narcissism, the companion is close to his own representor, yet so far. In one sense, he has totally captivated Raphael's attention, for otherwise the portrait would not exist; on the other hand, Raphael frames the men as though his own patronage is a desired yet difficult thing to obtain. A dialogue about an artist's power and about the limits of art's artifice seems at work here, played out through the anxious possibilities of intimacy between men.

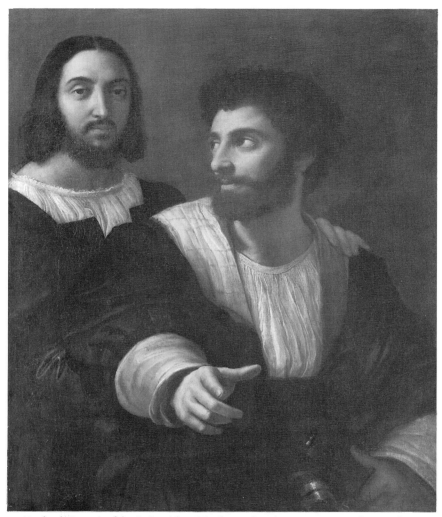

9 Raphael, *Portrait of the Artist with a Friend*, c. 1518. Oil on canvas, 99 x 83 cm. The physical intimacy between two men in this portrait puzzled many and led to the title 'Raphael and his Fencing Master'.

The projecting gesture from the subordinate figure stresses the portrait's rhetorical consciousness of a wider audience. Beholders are, like the unknown companion, riveted upon Raphael's persona but somewhat distanced too, so that a final closure or explanation of the portrait seems elusive. Frustration about the anonymity of the second sitter has been voiced in current scholarship, but knowledge of his identity would not reduce the double portrait to simple clarity.[65] Some contemporaries who saw the portrait probably did not know the man's name and status, either. The painting presents an intricate play between attention and reserve, subordination and superior distance, anxiety and comfort, intimacy and withdrawal, absorbed narcissism and detached exclusion. Viewers are presented with a complex negotiation, here heightened by portraiture's special tension between idealisation and individualisation. The painting offers a play between

men in a complicated relationship inside the frame, and between artist, sitter and viewer outside the frame. To reduce the portrayed relationship to a 'homosexual' one in the modern sense would be anachronistic, missing the physical closeness combined with superiority that the upper classes could practice, as did the Duke of Milan 'with his hands on the shoulders of his two valets as nicely posed as is possible and appropriate to his Lordship'.[66] To reduce the relationship exclusively to one between male 'heterosexuals' would ignore the ambiguous, emotive links between the two. Such categorical sorting would overlook much about the painting's seduction of its predominantly male audience, including the artist and the sitter.

Women without male company were hardly ever shown together in a single frame simply as friends rather than as sisters or conspiratorial seducers. Renaissance friendship portraiture functioned primarily as a visual record of male homosocial bonds, representing physical closeness between men, including the viewer and artist each imaginatively placed near the sitter(s). The portraits provide a material means of exchange and gifting, a keepsake not only of visages but also of affectionate yet complex links amongst men. Friendship as a potentially deceitful or sodomitical relationship was usually recognised in visual terms more by its obsessive denial or subconscious presence than by its overt acknowledgement. Visual signs of tensions and differentials between men partly result from a requirement to produce an interesting picture that is not locked into boring symmetry. But variations in the art also follow certain patterns which are socially informed and hence visually communicative to their contemporary viewers.

Conclusion

Ubiquitous homosociality imbued portraiture and the relationships among sitter(s), viewers, artists and patrons, sometimes at a more conscious or evident level than at other times. Homosocial structures like friendship, patronage, education and mentorship were usually acceptable, but on occasion dangerous. Renaissance art could display and produce male–male relations as decorous, humorous, sinful, incidental, arousing. Sometimes to disavow obsessively or condemn didactically, at other times to amuse, tempt, or declare desire, art was a discourse producing a certain level of homoerotic visibility. Portraiture, as the representation of various identities, was imbricated with social ambiguity and personal multivalencies about a whole range of relational issues including erotics. It may now be hard for us to see because our history is different and we are looking too much for strict categorisation according to our own norms. If we think again about where and how we look, we may observe in Renaissance portraiture masculinities that are neither coherent nor universal and Renaissance erotics that are neither 'deviant' nor solely heterosexual. Perhaps, in a sense, we should look less hard, less directly, and instead, with a historically aware gaze, imitate the slightly averted eyes or return the sidelong glance cast at us by some portraits.[67]

Notes

For attentive comments I am grateful to my friends Cristelle Baskins, Julia Perlman, Thomas Willette and Joanna Woodall.

1　J. Pope-Hennessy, *The Portrait in the Renaissance* (Princeton, Princeton University Press, 1966); L. Campbell, *Renaissance Portraits* (New Haven, Yale University Press, 1990); cf. S. Greenblatt, *Renaissance Self-Fashioning* (Chicago, University of Chicago Press, 1980); and P. Simons, 'Portraiture, portrayal, and idealization: ambiguous individualism in representations of Renaissance women', in A. Brown (ed.), *Language and Images of Renaissance Italy* (Oxford, Oxford University Press, 1995), pp. 263–311.

2　R. Weissman, 'The importance of being ambiguous: social relations, individualism, and identity in Renaissance Florence', in S. Zimmerman and R. Weissman (eds), *Urban Life in the Renaissance* (Newark, University of Delaware Press, 1989), pp. 269–80; G. F. Lytle, 'Friendship and patronage in Renaissance Europe', in F. W. Kent and P. Simons (eds), *Patronage, Art, and Society in Renaissance Italy* (Oxford, Clarendon, 1987), pp. 56ff.

3　The term 'sodomy' applied to bestiality, anal intercourse with women, intercrural and oral as well as anal sex between men, and occasionally sex between women. Most sodomy was conducted between what was described as a 'passive' youth and an older 'active' man. See R. Canosa, *Storia di una grande paura* (Milan, Feltrinelli, 1991); P. Labalme, 'Sodomy and Venetian justice in the Renaissance', *Legal History Review*, 52 (1984), pp. 217–54; M. J. Rocke, 'Male homosexuality and its regulation in late medieval Florence', Ph.D., State University of New York at Binghamton, 1990; G. Ruggiero, *The Boundaries of Eros* (Oxford, Oxford University Press, 1985); G. Scarabello, 'Devianza sessuale ed interventi di giustizia a Venezia nella prima metà del xvi secolo', in *Tiziano e Venezia* (Verona, Neri Pozza, 1980), pp. 75–84. On women, see P. Simons, 'Lesbian (in)visibility in Italian Renaissance culture: Diana and other cases of *donna con donna*', *Journal of Homosexuality*, 27 (1994), pp. 81–122.

4　In the 1420s Beccadelli's poem *L'ermafrodito* celebrated pansexual masculinity, with such claims as 'If my prick frequently yearns for a gaping cunt, occasionally my cock also lusts after a supple backside': M. de Cossart, *Antonio Beccadelli and the Hermaphrodite* (Liverpool, Janus Press, 1984), p. 55. Current debates tend to rely on dichotomies whereby sexuality is posited as either a socially constructed phenomenon or a psychobiological, essentialist one. Moreover, a Foucauldian binary divides the modern identity of the 'homosexual' species from pre-modern acts: M. Foucault, *The History of Sexuality*, trans. R. Hurley (Harmondsworth, Penguin, 1981), I, p. 43. Both categorical approaches are problematic for the Renaissance. 'Homosexual' is an inadequate term, but 'sodomite' is also insufficient if it denotes only physical, sporadic behaviour, as sodomites were sometimes 'inveterate', 'habitual' or committed practitioners: Rocke, 'Male homosexuality', pp. 181, 415, 402ff; M. Rocke, 'Sodomites in fifteenth-century Tuscany: the views of Bernardino of Siena', *Journal of Homosexuality*, 16 (1988), pp. 7–31; for group convictions and a sub-culture, see Ruggiero, *Boundaries of Eros*, pp. 121, 124, 127f, 135ff.

5　V. Traub, *Desire and Anxiety. Circulations of Sexuality in Shakespearean Drama* (New York, Routledge, 1992), p. 22: 'homoerotic' refers 'to erotic bonds animated by specifically erotic desire, though that desire may not be fully conscious to or accepted by the desiring subject'. For 'homosexual activity' as 'an integral part of male culture that in various ways implicated such basic social relations and networks as kinship, age-cohort solidarities, neighbourhood, work, patronage, and friendship', see Rocke, 'Male homosexuality', pp. 17, 347ff.

6　R. Simon, 'Bronzino's *Cosimo I de' Medici as Orpheus*', *Bulletin. Philadelphia Museum of Art*, 81 (1985), pp. 16–27, quoted from p. 20, then pp. 22–3. For personae, see Simons, 'Portraiture, portrayal, and idealization'.

7　Ovid, *Metamorphoses*, 10: 83–5; A. Poliziano, *Poesie italiane*, ed. S. Orlando (Milan, Rizzoli, 1976), pp. 125–6; J. Saslow, *Ganymede in the Renaissance* (New Haven, Yale University Press, 1986), pp. 31–3, 121–3, 210 n. 36; Rocke, 'Male homosexuality', pp. 460–1; A. Sternweiler, *Die Lust der Götter: Homosexualität in der italienischen Kunst* (Berlin, Verlag Rosa Winkel, 1993), pp. 133–7.

8 A. Bronzino, *Rime in burla*, ed. F. P. Nardelli (Rome, Istituto della Enciclopedia Italiana, 1988); Rocke, 'Male homosexuality', pp. 543ff.

9 W. Gundersheimer, 'Clarity and ambiguity in Renaissance gesture: the case of Borso d'Este', *Journal of Medieval and Renaissance Studies*, 23 (1993), pp. 1–17.

10 Gundersheimer, 'Clarity and ambiguity', pp. 11, 12. The article concludes by 'abandoning, as an anachronistic reading, [his] hypothesis of Borso's overt homosexuality', finally arguing the portrait 'can perhaps best be read as desexualized rather than effeminate, and self-contained rather than provocative' (p. 17). Note the heterosexist assumption that any element of femininity makes a figure sexual but that its absence renders a body sexless.

11 P. Labalme, 'Personality and politics in Venice: Pietro Aretino', in D. Rosand (ed.), *Titian. His World and His Legacy* (New York, Columbia University Press, 1982), p. 121.

12 Labalme, 'Personality and politics', pp. 124–5; Saslow, *Ganymede*, pp. 48–9, 70–3, 82–4.

13 P. Aretino, *Lettere sull'arte*, ed. F. Pertile and E. Camesasca (Milan, Milione, 1957–60), III, p. 212; Saslow, *Ganymede*, p. 72; Labalme, 'Personality and politics', p. 130 n. 50.

14 H. Wethey, *The Paintings of Titian, II, The Portraits* (London, Phaidon, 1971), pp. 26–7, 75–7, 118, 152–3; M. Hirst, *Sebastiano del Piombo* (Oxford, Clarendon, 1981), pl. 119; R. Waddington, 'A satirist's *impresa*: the medals of Pietro Aretino', *Renaissance Quarterly*, 42 (1989), pp. 655–81.

15 C. Pedretti, *Documenti e memorie riguardanti Leonardo da Vinci a Bologna e in Emilia* (Bologna, Fiammenghi, 1953), pp. 9–62, pl. II, for the reverse inscribed 'INSIGNE SUM IERONYMI CASII'; E. Rama, 'Un tentativo di rilettura della ritrattistica di Boltraffio fra Quattrocento e Cinquecento', *Arte Lombarda*, 64 (1983), pp. 79–92; D. A. Brown, 'Leonardo and the idealized portrait in Milan', *Arte Lombarda*, 67 (1983), pp. 108–11; V. Markova, 'Il "San Sebastiano" di Giovanni Antonio Boltraffio e alcuni disegni dell'area leonardesca', in M. T. Fiorio and P. Marani (eds), *I leonardeschi a Milano: fortuna e collezionismo* (Milan, Electa, 1991), pp. 100–7.

16 Pedretti, *Documenti*, pp. 22, 40–1: 'Beltraffio che col stile e col penello / Di Natura feceva ogni uom più bello'.

17 G. Nepi Scirè, in *Venezia restaurata 1966–1986* (Milan, Electa, 1986), p. 122; D. W. Galis, 'Lorenzo Lotto: a study of his career and character', Ph.D., Bryn Mawr, 1977, pp. 233–4; A. Gentili, '*Virtus* e *voluptas* nell'opera di Lorenzo Lotto', in P. Zampetti and V. Sgarbi (eds), *Lorenzo Lotto* (Treviso, n.d.), pp. 420–1.

18 D. Posner, 'Caravaggio's homo-erotic early works', *Art Quarterly*, 34 (1971), p. 305; D. Posner, 'Lizards and lizard lore, with special reference to Caravaggio's leapin' lizard', in M. Barasch and L. Freeman Sandler (eds), *Art the Ape of Nature. Studies in Honour of H. W. Janson* (New York, Abrams, 1981), pp. 387–91; H. Hibbard, *Caravaggio* (London, Thames and Hudson, 1983), pp. 44, 284.

19 E. Wind, *Pagan Mysteries in the Renaissance* (Harmondsworth, Penguin, 1967), p. 149 n. 31; H. Friedmann, *A Bestiary for Saint Jerome* (Washington, Smithsonian Institution Press, 1980), pp. 268–9; G. de Tervarent, *Attributs et symboles dans l'art profane, 1450–1600* (Geneva, Droz, 1958), cols 234–5.

20 The identification was suggested by L. Puppi, 'Riflessioni su temi e problemi della ritrattistica del Lotto', in Zampetti and Sgarbi (eds), *Lorenzo Lotto*, p. 398.

21 J. Goldberg, *Sodometries. Renaissance Texts, Modern Sexualities* (Stanford, Stanford University Press, 1992), p. 22.

22 E. Cropper, 'The beauty of woman: problems in the rhetoric of Renaissance portraiture', in M. Ferguson, M. Quilligan and N. Vickers (eds), *Rewriting the Renaissance. The Discourses of Sexual Difference in Early Modern Europe* (Chicago, University of Chicago Press, 1986), p. 178.

23 The identification follows an inventory of 1612: H. Keutner, 'Zu einigen Bildnissen des frühen Florentiner Manierismus', *Mitteilungen des Kunsthistorischen Institutes in Florenz*, 8 (1959), pp. 139–54; K. W. Forster, 'Metaphors of rule. Political ideology and history in the portraits of Cosimo I de' Medici', *Mitteilungen des Kunsthistorischen Institutes in Florenz*, 15 (1971), pp. 72–4, 82, 88; R. B. Simon, 'Bronzino's portraits of Cosimo I de' Medici', Ph.D., Columbia University, 1982, pp. 170–87, 338–41. For the identification as the teenager Francesco Guardi in soldier's garb, painted at the time of the siege of Florence, see G. Vasari, *Le vite de' più eccellenti pittori, scultori ed architettori*, ed. G. Milanesi

(Florence, Sansoni, 1906), VI, p. 275; L. Berti, 'L'*Alabardiere* del Pontormo', *Critica d'arte*, 55: 1 (1990), pp. 39–49. Another identification is suggested in J. Cox-Rearick, *The Drawings of Pontormo* (New York, Hacker, 1981), pp. 269–71, 276–7, 357/6.

24 Campbell, *Renaissance Portraits*, p. 9.

25 K. Eisenbichler, 'Bronzino's portrait of Guidobaldo II della Rovere', *Renaissance and Reformation*, 12: 1 (1988), pp. 21–33; P. Simons, 'Alert and erect: masculinity in some Italian Renaissance portraits of fathers and sons', in R. Trexler (ed.), *Gender Rhetorics* (Binghamton, Medieval and Renaissance Texts and Studies, 1994), pp. 163–86.

26 Forster, 'Metaphors of rule', pp. 72–4.

27 Pope-Hennessy, *Portrait*, p. 110; L. Berti, *L'opera completa del Pontormo* (Milan, Rizzoli, 1973), p. 104; C. McCorquodale, *Bronzino* (London, Jupiter, 1981), p. 23.

28 Vasari–Milanesi, VII, p. 690; G. Vasari, *Lives of the Most Eminent Painters, Sculptors and Architects*, trans. G. Du C. de Vere (New York, Abrams, 1979), III, p. 2249, for this and the subsequent quotation.

29 J. Shearman, *The Early Italian Pictures in the Collection of Her Majesty the Queen* (Cambridge, Cambridge University Press, 1983), fig. 19, pp. 253–6; *Le Siècle de Titien* (Paris, Réunion des Musées Nationaux, 1993), p. 739.

30 Vasari–Milanesi, III, p. 654, V, p. 294; Vasari–de Vere, pp. 757, 1182; Aretino, *Lettere sull'arte*, II, p. 136, pl. 21; M. Repetto Contaldo, 'Francesco Torbido detto "il Moro"', *Saggi e Memorie di Storia dell'Arte*, 14 (1984), p. 56, fig. 7.

31 P. Rylands, *Palma Vecchio* (Cambridge, Cambridge University Press, 1992), p. 350.

32 Brown, 'Leonardo and the idealized portrait'; P. Zampetti, *L'opera completa di Giorgione* (Milan, Rizzoli, 1968), nos. 14, 15, 38–41, 66; *Le Siècle de Titien*, nos. 19, 29–32.

33 Campbell, *Renaissance Portraits*, p. 9.

34 P. Holberton, 'Of antique and other figures: metaphor in early Renaissance art', *Word and Image*, 1 (1985), p. 54 (my emphasis added in a later quotation). Shearman, *Early Italian Pictures*, p. 255 says the Vienna painting 'may also be a portrait' like the *Shepherd*.

35 C. Hope, *Titian* (New York, Harper and Row, 1980), pp. 62, 81–2.

36 Simons, 'Portraiture, portrayal, and idealization'. G. Della Casa, *Galateo*, trans. K. Eisenbichler and K. Bartlett (Toronto, Centre for Reformation and Renaissance Studies, 1986), p. 38 noted that 'one listens with more pleasure and one imagines the event more clearly if it involves people we know' and then 'we can visualize it'.

37 De Cossart, *Antonio Beccadelli*, pp. 52, 53; Poliziano in Saslow, *Ganymede*, pp. 30, 210 n. 36; Rocke, 'Male homosexuality', pp. 231, 237–44, 406; R. and M. Wittkower, *Born under Saturn* (New York, Norton, 1969), pp. 169, 173; P. Burke, *The Historical Anthropology of Early Modern Italy* (Cambridge, Cambridge University Press, 1987), pp. 154–5; *The Letters of Marsilio Ficino* (London, Shepheard-Walwyn, 1978), II, pp. 73–4, 101; Rocke, 'Male homosexuality', p. 219.

38 Rocke, 'Male homosexuality', p. 406.

39 Rocke, 'Sodomites', p. 12; 'the beauty of youths' attracted 'both mental and physical' vision (p. 15).

40 B. Cellini, *Autobiography*, trans. G. Bull (Harmondsworth, Penguin, 1956), p. 45.

41 J. Pope-Hennessy, *Cellini* (New York, Abbeville, 1985), p. 231.

42 T. Pignatti, *Giorgione* (London, Phaidon, 1971), pp. 111, 131, 166.

43 Cellini, *Autobiography*, p. 360.

44 D. Kent, *The Rise of the Medici. Faction in Florence 1426–1434* (Oxford, Oxford University Press, 1978), pp. 83–104, esp. 87, 102.

45 A. Bray, 'Homosexuality and the signs of male friendship in Elizabethan England', *History Workshop*, 29 (1990), p. 18 n. 17. Pérez, who was charged with sodomy by the Inquisition and who appears in various documents related to homoeroticism (Bray, pp. 4–12), collected art when he was state secretary in Madrid. One such acquisition was Parmigianino's luscious *Amor* now in Vienna: S. J. Freedberg, *Parmigianino. His Works in Painting* (Cambridge, Mass., Harvard University Press, 1950), p. 184. I thank Alan Bray for mentioning Pérez's collecting activities to me.

46 F. Barbaro, 'On wifely duties', in B. Kohl and R. Witt (eds), *The Earthly Republic. Italian Humanists on Government and Society* (Manchester, Manchester University Press, 1978), pp. 196, 191, 189, 228.

47 Vasari–Milanesi, VII, p. 688; Vasari–de Vere, p. 2248.

48 Hirst, *Sebastiano del Piombo*, pp. 104–6; Pope-Hennessy, *Portrait*, p. 240.

49 Vasari-Milanesi, VI, pp. 154, 157, VII, p. 595; Pope-Hennessy, *Portrait*, p. 244; E. Baccheschi, *L'opera completa del Bronzino* (Milan, Rizzoli, 1973), no. 76; McCorquodale, *Bronzino*, pp. 61, 64.

50 L. da Vinci, *Treatise on Painting*, trans. A. P. McMahon, (Princeton, Princeton University Press, 1956), I, pp. 21–2.

51 Leonardo, *Treatise*, p. 22, with the Italian in J. P. Riehter (ed.), *The Literary Works of Leonardo da Vinci*, 3rd edn (London, Phaidon, 1970), I, p. 64.

52 Campbell, *Renaissance Portraits*, pp. 107, 183, 196, 205–6, 220–5; J. Shearman, *Only Connect … Art and the Spectator in the Italian Renaissance* (Princeton, Princeton University Press, 1992), pp. 135–6.

53 C. Cennini, *The Craftsman's Handbook*, trans. D. Thompson, Jr. (New Haven, Yale University Press, 1933), p. 75.

54 Vasari–Milanesi, III, p. 616.

55 Vasari–Milanesi, VII, pp. 271–2.

56 Cennini, *The Craftsman's Handbook*, p. 16; P. Pino, 'Dialogo di pittura', in P. Barocchi (ed.), *Trattati d'arte del Cinquecento* (Bari, Laterza, 1960), I, p. 137.

57 Labalme, 'Sodomy', p. 227; Ruggiero, *Boundaries of Eros*, pp. 113, 138, 195; G. Dall'Orto, '"Socratic love" as a disguise for same-sex love in the Italian Renaissance', *Journal of Homosexuality*, 16 (1988), pp. 33–65; Rocke, 'Male homosexuality', pp. 234, 328–30, 370–4; L. Barkan, *Transuming Passion. Ganymede and the Erotics of Humanism* (Stanford, Stanford University Press, 1991), pp. 48ff; Canosa, *Storia di una grande paura*, pp. 78–87, 114–15, 134.

58 Ruggiero, *Boundaries of Eros*, p. 116. Portraits of men with their pages or servants deserve attention as instances of erotic, sometimes racialised, relations.

59 G. Bumgardner, *Novelle cinque. Tales from the Veneto* (Barre, Mass., Imprint Society, 1974), p. 111; *Tales of Firenzuola* (New York, Italica, 1987), p. 61.

60 For example, the double portrait attributed to Giorgione, in the Palazzo Venezia, Rome: A. Ballarin, 'Giorgione e la Compagnia degli Amici: il "Doppio ritratto" Ludovisi', in *Storia dell'arte italiana*, pt. 2, I (Turin, Einaudi, 1983), pp. 481–541. For friendship portraits see H. Keller, 'Entstehung und Blütezeit des Freundschaftsbildes', in D. Fraser, H. Hibbard and M. Lewine (eds), *Essays in the History of Art Presented to Rudolf Wittkower* (London, Phaidon, 1967), pp. 161–73.

61 The tomb's inscription, from Dall'Orto, 'Socratic love', p. 43.

62 R. Lightbown, *Mantegna* (Oxford, Phaidon, 1986), pp. 459–60, from which the following quotations are drawn. See also Shearman, *Only Connect*, p. 134.

63 G. Mariacher, 'Giovanni Busi detto Cariani', in *I Pittori Bergamaschi dal XIII al XIX secolo. Il Cinquecento* (Bergamo, Poligrafiche Bolis, 1980), I, p. 298 fig. 6, p. 292 no. 51; R. Pallucchini and F. Rossi, *Giovanni Cariani* (Bergamo, Credito Bergamasco, 1983), pp. 26, 135–6, 278–9, 298; *Le Siècle de Titien*, pp. 272–3.

64 L. Dussler, *Raphael. A Critical Catalogue* (London, Phaidon, 1971), pp. 46–7; *Raphael dans les collections françaises* (Paris, Réunion des musées nationaux, 1983), pp. 101–4; R. Jones and N. Penny, *Raphael* (New Haven, Yale University Press, 1983), p. 171; Shearman, *Only Connect*, p. 140.

65 Jones and Penny, *Raphael*, p. 171, and Shearman, *Only Connect*, p. 140. C. Gould, 'Raphael's *Double portrait* in the Louvre: an identification for the second figure', *Artibus et Historiae*, 10 (1984), pp. 57–60 suggests Aretino, and the intended primary viewer as Agostino Chigi, Raphael's powerful patron whom Aretino sought to impress. Aretino first resided with Chigi when he arrived in Rome around 1517, and a contemporary referred to the 'innaturali rapporti fra ospite e ospitato' (p. 59, citing Aretino, *Lettere sull'Arte*, III, p. 134).

66 The programme for a fresco cycle, quoted by Holberton, 'Antique and other figures', p. 50.

67 For the sidelong glance, see Hirst, *Sebastiano del Piombo*, p. 94 n. 18, and *Petrarch's Lyric Poems*, trans. R. Durling (Cambridge, Mass., Harvard University Press, 1976), no. 159.

2

The ideology of feminine 'virtue': the vestal virgin in French eighteenth-century allegorical portraiture

KATHLEEN NICHOLSON

Eighteenth-century French allegorical portraits of women are paradoxical hybrids: as images of specific individuals they presume to document a sitter's physical appearance as well as confirm her social status; as projections of mythic or exotic identity they idealise both in terms of likeness and an operative construction of womanhood (Figure 10). To eighteenth-century critics (and perhaps modern viewers as well), the patent artificiality of these portraits seemed at odds with the Enlightenment's emphasis on naturalness and its valuation of the self. Portraiture in fact played a significant role in picturing or defining this new attention to individuality in France. During the eighteenth century the genre's mainline development was marked by an increasingly acute depiction of physiognomy, gesture, and ambiance that calls attention to one's uniqueness and personal identity. Seen in the context of this tendency toward naturalism, allegorical portraits appeared anachronistic to critics and writers on art.

Pastel portraits by Maurice Quentin de la Tour (1704–1788) epitomised the idea of a 'speaking likeness' through their detailed observation of nuances of expression and the particularities of physical features and bearing. In La Tour's portrait of the Abbé Huber (1742; Figure 11) we apprehend the sitter not as the diplomat and man of affairs that he was in public life, but privately, as an avid reader (of a volume legibly labelled on its spine, 'Montaigne'). His quality of mind is suggested by his wry smile, his concentration, and even his physical engagement with the book.[1] By comparison the women in the allegorical portraits illustrated here seem devoid of personality or distinguishing traits, and the mythological or exotic settings appear as frivolous backdrops that contribute to an overall decorative sense. With no small amount of exasperation, the critic and Enlightenment *philosophe* Denis Diderot complained that the artist most readily identified with allegorical portraiture, Jean-Marc Nattier (1685–1766), 'always painted women as Hebe, as Diana, as Venus etc. All his portraits look alike; one thinks one is always seeing the same face.'[2]

One explanation for Diderot's appraisal might lie in the fact that allegorical portraits tended to be of a size and elaboration that suggested they were merely complements to glittering Rococo interiors. Indeed some were conceived as part of a decorative programme, often functioning as overdoors, in which position they

would not likely have been contemplated for the psychological nuances that increasingly came to be considered the mark of fine portraiture.[3] Diderot had remarked in his 1766 *Essay on Painting* about the torment the human face must be for artists like La Tour, 'the face of man being a canvas that is in constant agitation, movement, which expands, contracts, colours, dims according to the infinite multitude of alternatives of this light and movemented breath one calls the soul'.[4] The mask-like faces in allegorical portraits did not or could not register such subtle fluctuations of inner life. But the fundamental problem for Diderot's

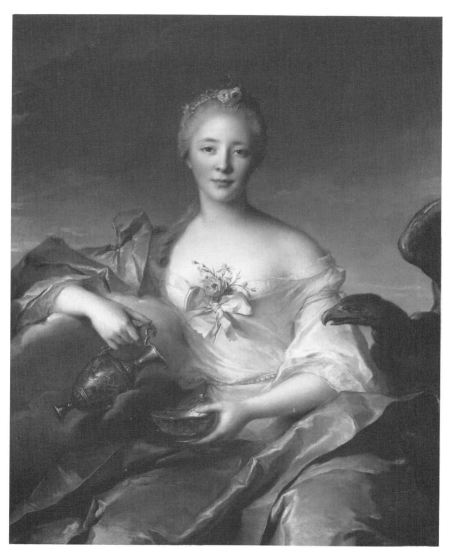

10 Jean-Marc Nattier, *Mme de Caumartin as Hebe*, 1753. Oil on canvas, 102.5 x 81.5 cm. An inscription on the back of the canvas identified the sitter (née Mouffle) as the wife since 1749 of François de Caumartin, who served as the chief administrative officer of the Paris guilds from 1778 to 1784. Hebe, daughter of Zeus, cupbearer to the gods, and goddess of youthful beauty, was a flattering mythological persona selected by a number of Nattier's aristocratic women patrons for their portraits.

contemporaries lay less in the decorative embellishments of the imagery or in the perceived deficiencies of a given artist's treatment, than with the *women* who sat for the portraits – which is to say with women in general.

From the very beginning of the eighteenth century, artists, critics, theorists, and viewers saw women's portraiture of whatever sort, allegorical or not, through the lens of an artistic theory rooted in the prevailing, largely negative, cultural formulation of the character of womanhood. Roger de Piles, the highly influential theoretician and proponent of the liberating effect of colour and sensation (*Rubénisme*), as the modern corrective to the prevailing academic classicism (*Poussinisme*), articulated the case in his *Principles of Painting* first delivered between 1700 and 1708 as a set of lectures to the French Royal Academy of Art. He posited that while everyone should agree that the objective of portraiture is faithful resemblance, women (and cavaliers!) held a contrary point of view: 'I have seen women who told me clearly that they had no use for painters who produce too exacting resemblances; they would like better to be portrayed with less resemblance and more beauty.'[5] He then stated more categorically that he doubted one could create speaking likenesses of women without displeasing them. In France, he declared, women must be heeded but 'the bagatelles which are to their taste destroy painting of the grand manner. [Women] would be capable of perverting Titian and van Dyck, if these artists were still alive and were forced to paint portraits for them.'[6]

While de Piles did not elaborate on the deficiencies of women in comparison to men, he made it clear that the difference resided in the contrast between women's attention to surface and men's inner substance, a recurring theme in subsequent treatises on both art and human character. In a clever gesture he brought portraiture to life by having an array of sitters identify themselves in descending social order, beginning with the king. The males proclaimed themselves to be the embodiment of their respective virtues, announcing 'I am this valorous captain who carries terrible might everywhere, or else who by my fine conduct has demonstrated so much glorious success', or 'I am this man of letters completely absorbed in the sciences', or 'I am this wise and steadfast man who has been raised above mere desire and ambition by a love of philosophy'. The women who follow instead speak of aspects or appearances that solicit opinions of them. No qualities seem to reside within them, as they explain that 'I am this wise princess whose grandeur *inspires* respect and confidence', or 'I am this proud woman whose noble manners *bring esteem*'.[7]

Even at the technical level de Piles provided an insight into the idealisation process that robbed female sitters of their identity. He argued that capturing character is the essence of accurate resemblance, and that character is revealed through colouring: getting just the right flesh tones that differ from person to person. For de Piles such colouring was the visual point of access to the whole panoply of traits that make up a personality.[8] Since the convention for women was a mask-like white make-up that covered the skin, with rouge or beauty spots added for emphasis, any insight into character through nuances of individualised skin tones clearly would have been blunted at the outset.[9] Some observers intimated that, in any case, nothing of much interest lay beneath the physical shell or behind the public mask. Writer and playwright Pierre Marivaux (1688–1763) used the literary device of a foreigner's perceptions of Parisian life to comment upon women's vanity and shallowness with regard to their appearance. He had his narrator call too early one morning at the home of a particularly beautiful woman who was

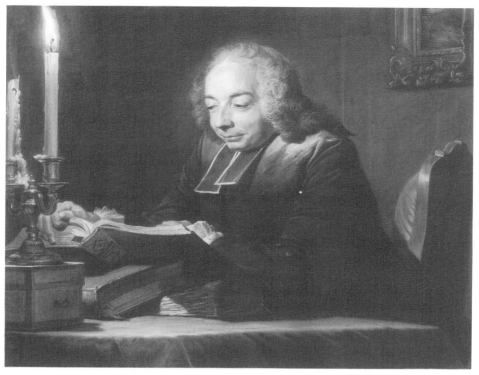

11 Maurice Quentin de la Tour, *Abbé Jean-Jacques Huber, Reading*, 1742. Pastel on paper,
102 x 81 cm. Huber was a Catholic theologian from Geneva who moved to Paris and
prospered as an agent in business and foreign affairs. The sitter was a personal friend and
benefactor of the artist, which accounts for the candidness and intimacy of the portrait.

deeply embarrassed and ashamed because she had not yet applied her make-up
and was in an extreme state of undress ('dans un négligé des plus négligés,
tranchons le mot, dans un négligé malpropre' – wordplay that emphasises the thin
line between unkemptness and indecency or vulgarity).[10] He described the woman
as seeming to have neither her wits about her nor her own tone of voice. 'No,' he
averred, 'she wasn't entirely there', and then generalised by concluding that when
one surprises a beautiful woman 'who has not yet arranged her physical assets,
who has not made her preparations for pleasing ... you cannot really say that it is
truly her'.[11] The narrator then imagines that by her comportment, 'she is telling
you: This isn't me, this is an ugly semblance of me, but you don't see me yet. Wait,
I am barely sketched out; two hours of toilette will finish me, after which you will
judge me.'[12]

By mid-century the commentary on women as well as on their taste in por-
traiture had taken on a still more pointedly negative tone. The misogynist
argument was put forward in no uncertain terms in an array of publications. For
example, one typical writer, Le Père Achille de Barantanne, in his 1754 *Discourse on
Women* proclaimed that 'this is what a woman is: an error of nature, a body of lies,
a real monkey ... A chaste woman is an obstacle, an immodest woman a source of
scandal, an ugly one a source of chagrin, a beautiful one a source of fire ... every-
thing is extreme in woman; anger makes her a lion, hunger a wolf, avarice a harpy,

55

refinement a fox, wariness a cerberus, malice a Proserpine, denizen of hell and wife of the devil.'[13]

Perhaps the most virulent attack within the arts came from La Font de St Yenne, one of the new critical voices bent on reforming art by arguing for a return to serious, virile, didactic history painting. In his essay, *Reflections on the Causes of the Present State of Painting in France*, published in 1747, and one of the preludes to neoclassicism, he castigated women sitters, whose foolish vanity led painters to produce indulgent, overpriced allegorical portraiture. He complained that a would-be history painter would 'indeed suffer for a certain time in seeing himself forced to flatter a pouting face often badly formed and beyond its prime, almost always without character'.[14] With a mocking tone he wondered:

what spectacle can be compared, for a real or presumed beauty, to that of seeing herself eternally with the attractions and the cup of Hebe the goddess of youth? of seeing showcased, everyday, under the guise of Flora, the burgeoning charms of spring, of which she is the image? or adorned with the attributes of the goddess of the forest [Diana], a quiver on the back, the hair gracefully disordered, an arrow in the hand, how could one not believe oneself the rival of the charming god who wounds all hearts?[15]

The critic imagined that such a woman 'persuaded herself easily that our sex, always indulgent, forced to see in her two different characterisations, would prefer that of the infantile goddess to that of the divine dowager, or at least that we would give her credit for her efforts and the time that she wasted every day trying to resemble that youthful goddess'.[16] 'Vanity,' he had earlier noted, 'whose hold on us is even more powerful than that of fashion, has had the skill to present to the eyes, and especially to those of the ladies, mirrors of themselves all the more enchanting in that they are less true.'[17] In La Font's underlying campaign against the bankruptcy of the *ancien régime* and the degeneracy of Louis XV's court, recast as a diatribe against the shallowness of women, the sitters and their portraits in effect became pawns – and the particular character or logic of allegorising obscured.

The efflorescence of allegorical portraiture in the first half of the century suggests that it met a need well beyond that of women's vanity.[18] Allegorical portraits of women were painted and exhibited in impressive numbers between 1700 and 1750 – just when they would seem least necessary, given the increasing attention to the fabric of contemporary existence. Tellingly, during this same period allegorical portraiture ceased to function as a viable convention for the representation of men, the few male allegorical portraits that were commissioned retaining only the most traditional allusions to gallant shepherds or Apollo or Hercules.[19] By contrast, women's portraits adopted new themes in addition to the sixteenth–seventeenth century royal repertory of Dianas, Floras, and Venuses. Sitters were portrayed as gardeners (an updating and demythifying of Flora, or Spring?);[20] as the presiding goddesses of newly built mineral waterworks;[21] as sultanas, Muses and an array of mythological or ancient personae from Hebe, the goddess of youth, to vestal virgins.

Rather than simply acting as a form of flattery, or a record of aristocratic fancy-dress pastimes, these portraits speak to the eighteenth century's fascination with charade, and its penchant for visual and verbal symbolism in the form of *énigmes* (literary riddles), or the *histoires secrètes*, with their promise of a behind-the-scenes view of court politics, or the *romans à clef*, which invited the public to identify the real people behind fictional characters. If viewers enjoyed solving the political symbolism encoded even in the fountain designs at Versailles, then it seems

reasonable to assume they would at least have acknowledged a play of meanings in allegorical portraits, particularly as the genre modernised itself. Precisely because allegorical portraiture became the province of women, and emphatically so, one should suspect that it served a purpose well beyond Philip Conisbee's general observation of portraiture as 'an ideological statement, promoting an image of high society to itself and to those outside its narrow confines', wherein allegorical portraiture in some simple way 'elevated' its subjects 'to a plane of mythic nobility'.[22]

During the Regency and under Louis XV, allegorical references in portraiture may indeed have functioned as ideological statements, but about deep-seated cultural values, and in particular those concerning gender. Through the agency of allegorical portraiture, a symbolic system evolved that plotted the complexity or difficulty of forging female identity in response to the negative assumptions governing women's behaviour and dictating their function in society. The very idealising that denies physiognomic individuality may even have underscored the issues common to all women that were addressed, however covertly, in the paintings. Through choice of subject and their nuancing, the allegories articulate the struggle between the values or expectations held by society and the women's own aspirations. In effect, allegorical portraiture opened a space in which women might question the notion of the limitations of which they were accused. That is, the sitter could reconfigure selfhood or identity as a process of continual invention, open to amendment.

The evidence of commissions suggests that the women sitters were at some level complicit in the process. Women in positions of power like Madame de Pompadour (and subsequently Madame du Barry) participated in generating a body of appropriate subjects for themselves, whether novel or commandeered from earlier periods and substantially transformed. For example Madame de Pompadour (1721–1764) commissioned and/or sat for portraits of herself as Diana, as an Arcadian shepherdess, as a gardener, as a sultana, as a vestal virgin, as the embodiment of friendship, and as a person of multiple accomplishments, the signs of which were placed on display in her study.[23] Just how perturbing the ploy could be of using portraiture to contest a too-limiting notion of identity is apparent from an attack levelled at La Tour for his 1755 large-scale pastel of Madame de Pompadour seated at a book and globe-laden table holding a musical score, now in the Louvre. Echoing de Piles, the critic chided that 'One might say that M. de la Tour was proposing to paint the portrait of a *philosophe*. Doesn't he know that the distraction and array of details and attributes must be avoided when one wants to represent a beautiful woman?'[24]

The wilfulness of women in taking control of their own images might also be seen in the defiance against her husband exercised in 1730 by the wife of an Aix-en-Provence notable, Madame de Gueidan. As letters between her husband and the artist Nicolas Largillière substantiate, contrary to her husband's expressed wishes and without his knowledge, she journeyed to Paris to have herself painted in the allegorical guise of Flora, which resulted in a more costly work than the non-allegorical portrait her husband had authorised.[25] Not surprisingly, allegorical portraits of women begin to diminish in numbers and cogency, or fall into decorative repetition, at the same time that philosopher Jean-Jacques Rousseau proposed a new and more restricted model of femininity as ideal wife and devoted, nursing mother through his immensely popular and widely read works *Julie, or The New*

Heloise (1761) and *Emile* (1762).[26] Not all women embraced the role: woman of letters and hostess of a famed salon, Madame du Deffand, scoffed to Voltaire that she had an antipathy for Roussseau because 'he would return everything to chaos. I have never seen anything more contrary to good sense than his *Emile*, nothing more contrary to good morality than his *Julie*.'[27] However, the evidence of letters from a broader cross-section of women written to Rousseau about his books suggests he had struck a resonant chord. Artists sensitive to the social landscape registered the change through the introduction of subject matter that exalted motherhood or the family.[28] The increasingly pervasive emphasis on the life and emotions of the contemporary woman in novels (including Richardson's *Clarissa* and *Pamela*)[29] as well as in philosophic debate would have made classical or exotic references in portraiture seem to be an empty gesture, as well as obsolete.[30]

But during the first half of the century allegorisation surely provided a positive means of exploring the polymorphous nature of identity; indeed, its very repertory epitomised possibility. Allegorical portraiture (as opposed to the ephemeral changes of persona permitted by the masked ball or theatrical productions) constituted a transformation with considerably more resonance and import than that achieved each morning in the boudoir through an elaborate toilette. As a demonstration of the ways in which allegorical reference could impart the otherwise elusive power to reconfigure or fashion oneself, portraits of women as vestal virgins (Figures 14 and 15) provide an excellent test case. The doubly charged theme of the impassioned virgin suggests the complexity, ingenuity, and even wit of the allegorising process. Through its various manifestations the vestal theme also makes clear the extent to which the essential transformative gesture lay not in the addition of superficial, external embellishments, but in the implicit acknowledgement of the sitter's internal make-up (taste, judgement, imagination) as well as intellectual capacity for engagement with history, literature, or mythology.[31] Asking himself why images of vestals always please, Diderot answered 'it's because they presuppose youth, charm, modesty, innocence, and dignity; it is because these qualities, rendered according to the models of antiquity, are joined by ancillary ideas of the temple, the altar, meditation, withdrawal, and the sacred ... it is because a vestal is a being at once historical, poetical, and moral'.[32]

The subject of the vestal virgin had appeared only rarely in French portraiture prior to the eighteenth century, and without the heroic overtones and didacticism of an exemplary, identifiable ancient vestal such as Tuccia, the lesson of whose steadfast virginity was so effectively appropriated in sixteenth-century England for state portraits of Elizabeth I.[33] Rather, in France, in the age of libertinage and royal mistresses, the topic of vestal virgins would seem to have been loaded and ironising – its erotic undertones heightened precisely through the notion of virginity to be despoiled. At the same time at least some of the vestals' more ennobling or serious aspects for women could be drawn upon. If unstable meanings surface in the portraits it is because the contradictions are within the cultural matrix; we should regard the portraits not as images whose meaning is fixed, but as blotters, picking up as well as refuting the traces of cultural assumptions through the dialogue fostered by the allegorical references.

The eighteenth century's historical understanding and interpretation of the ancient cult of Roman vestals was a mixture of archaeology and fantasising that at one and the same time evoked women's virtue and its erotic opposite. The literature on vestals was fairly consistent in its emphases. An early text entitled *Secret*

History of Vestals published in 1700 had been part of Madame de Pompadour's library.[34] It set the tone for subsequent publications in first outlining the history and practices of the cult based on classical sources, if with a healthy dose of opinion, and then, after fifty pages, switching to a lurid love story, based on ancient accounts, entitled 'Cornelia Maxima, or the Galant Vestals', whose main character is a young woman initiated into the cult of vestals against her will, and, presumably, contrary to her feminine nature.[35] It was followed in 1725 by the *History of Vestals*, whose author, the abbé Nadal, accused the earlier book of not treating the subject seriously enough but whose own curiosity led him to dwell on the punishments inflicted on vestals for misdeeds.[36] Vestals also earned a fairly lengthy entry in the *Encyclopédie* by Le Chevalier de Jaucourt, the account basically reproducing that of the abbé Nadal.

One learns from these sources that participation in the cult involved a period of thirty years, beginning in childhood, at age six or seven, and divided into three periods: ten years spent on indoctrination into the cult, ten years spent practising it, and then ten years instructing novices to become keepers of virtue. Besides tending the sacred flame dedicated to Vesta, the cult members performed good deeds: bringing errants back to the path of virtue, re-establishing peace within a family or reconciling enemies, looking after the poor. With an archaeological correctness worthy of a neoclassicist, Jean Raoux in 1727 imagined the realm of the vestals with notable vividness (Figure 12).[37]

He limited the number of vestals to six, the correct number of practitioners according to the texts. Raoux animated his scene with the task most readily associated with the cult, the maintenance of the perpetual fire, an act of devotion to a multivalent symbol. At a literal level it represented the vestals' ardent purity – a curiously asexual passion – while on a political level, the flame was construed as a symbol of the Roman Empire itself. The motif of tending the flame afforded the artist the opportunity to depict a society of exotic but purposeful women cloistered by their vows. He also painted a fascinating companion piece, imagining a modern counterpart, a sorority of contemporary virgins who would seem to be models of learning and refinement as they study, make garlands, and attend to table settings (Figure 13).[38]

His pairing of images and their overall tone suggests a relatively straight reading of the vestal, one which perhaps even intimates the commendable behaviour of the cult's practitioners, ancient and modern. In their decorum and dignity such images align with the spirit of publications ranging from Bernard Mandeville's 1709 moralising defence of women, *The Virgin Unmask'd*, to Madame de Lambert's 1727 *New Thoughts on Women* and her *A Mother's Advice to Her Daughter* (1728), which valorise virtue and chasteness ('*pudeur*') as key facets of feminine dignity.[39] As she cautioned, 'The reign of virtue is for life ... Keep in mind that you will only be beautiful for a brief period of time, and not [beautiful] for one much longer; that when women lose their allure, they maintain themselves only by fundamentals and estimable qualities. They must not hope to ally a voluptuous youth with an honourable old age. Once chastity is sacrificed, it will not come back any more than will the years of beauty.'[40] Raoux's portrayal of modern virgins with their books and decorous socialising would even seem to anticipate Madame de Lambert's repeated call for the intellectual liberation of women, and a rejection of the dissipation and frivolity of her day.[41] In his vestal portraits – for example, the stately, large-scale commemorative image of the recently deceased Marie

Perdrigeon standing beside a circular altar (1734)[42] or *Mademoiselle de Pressoy* (1724) – he definitely came down on the side of propriety. The latter painting of a sweet young girl garlanded with flowers carries an original inscription on the reverse indicating that the young girl was eight years of age – and thus genuinely innocent.[43]

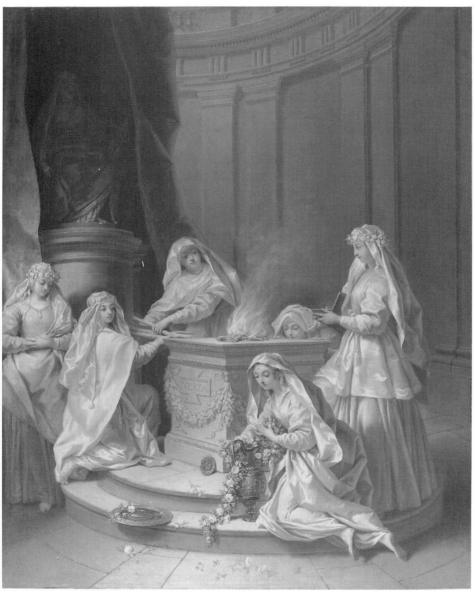

12 Jean Raoux, *Ancient Virgins*, 1727. Oil on canvas, 92 x 72.5 cm. The theme of the vestal virgin, whether in a genre setting like this one, or in allegorical portraits, formed an inventive part of Raoux's repertory of small-scale images of decorous young women. He reused or recombined figures from this work for other versions of young vestals.

The inherent propriety of the vestal theme was undercut in a variety of ways in both verbal commentary and painting. One common ploy compared modern decadence to ancient valour, but with the emphasis placed on transgression. A misogynist essay published *c.* 1736 and entitled *The Viciousness of Girls* lectured that:

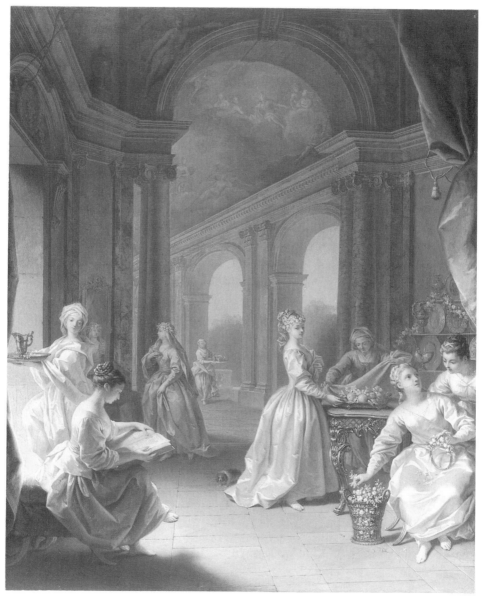

13 Jean Raoux, *Modern Virgins*, 1728. Oil on canvas, 92 x 72.5 cm. In this inventive pendant to *Ancient Virgins*, Raoux envisioned a modern-day women's academy or salon of the sort called for by proponents of women's education like Madame de Lambert (1647–1733).

The praises of virginity have been recounted throughout the centuries, where this virtue always shined liked a precious pearl that gives lustre and value to the chaste and virgin person; thus the Romans accorded great honour to the Virgin Vestals, consecrated to the Vestal goddess with a vow of virginity, to be more able to maintain and consecrate the sacred fire, and if anyone would commit shameless debauchery, she would be condemned to finish her life within four walls.

But for the hundred girls who keep their virginity like a precious treasure, there are a thousand today who only look for occasions to lose it: the causes of this unhappiness are amoung others too much freedom, idleness, seeking after pleasure, bad company, evil and lascivious talk, shamelessness, effrontery, too much leisure and the disdain of rebuke.[44]

The essay then details each of the above listed vices, to which gourmandise, perfidy and treason are added, the author reverting to ancient examples whenever possible for validation of the long-standing nature of the crimes.

Such thinking could invest vestal images and texts with a measure of prurience or satire. Nattier's late portrait of an unidentified young woman as a vestal reads as if ancient and modern had been melded (Figure 14). The sitter displays a seductiveness through the self-aware, self-promoting gestures; the décolletage of her gown; the lavish flow of drapery that emphasises her lower half; and the incidental quality of the two vestals near the altar behind her. The theatricality of the presentation mocks vestal propriety, not least because this vestal attends only to herself.[45] Diderot immediately savoured the effect in his 1759 Salon commentary:

Here is a vestal by Nattier and you are going to imagine youthfulness, innocence, candour; dishevelled hair and a drapery with deep, loose folds, brought up on the head and concealing a part of the forehead; a bit of paleness; for paleness well suits piety (and tenderness). Nothing of that, but in its place an elegant hairdo, an extravagant get-up, all the coyness of a woman of the world at her toilette, and with eyes full of voluptuousness, to say the least.[46]

The false virgin, that most titillating contradiction in terms, was, of course, a favourite motif even before the eighteenth century. Early novels like *The False Vestal or the Ungrateful Nun*, which was published in 1707, exploit the theme with a Boccaccian zeal, creating a dizzying spiral of infidelities.[47] The main character, the false vestal of the title, deals with two lovers and potentially embarrassing pregnancies. Set in contemporary times, the association with vestals is primarily through the joke of the title. For its more sustained humour, the author detailed the scandalous behaviour of modern-day life in the convents – hence the second part of the title. As a source for eroticism in the eighteenth century, vestals, women in convents, and harem women are all cousins, fostering in effect sexual fantasy intensified by the idea of seclusion – with its promise of ready availability – and of a purity ripe for defiling.[48]

So much the better when it is the women themselves who, having denied nature and their biological imperatives through vows of chastity, then yield to seducing passions and are punished for it. In both the *Encyclopédie* entry on vestals and J. G. Dubois-Fontanelle's *Essay on the Sacred Fire and Vestals*[49] the historical account picks up once the discussion shifts to a consideration of the vestals' virginity – and the manner in which transgressors were punished for the lack thereof. Le Chevalier de Jaucourt pointedly noted in his *Encyclopédie* account that the ancient vestals, contrary to popular opinion, lived luxuriously as well as sybaritically; they

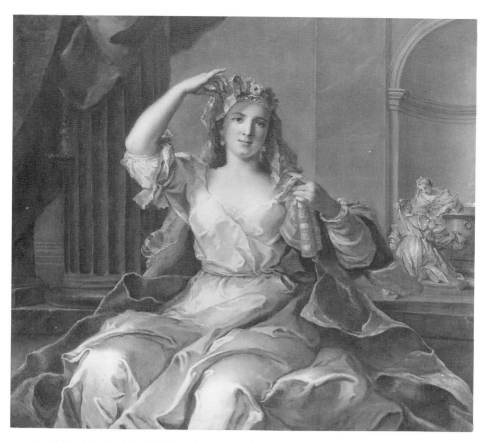

14 Jean-Marc Nattier, *Portrait of a Lady as a Vestal*, 1759. Oil on canvas, 114.3 x 135.9 cm. When exhibited at the 1759 Salon, this painting was entitled simply *A Vestal*. The sitter remains unknown. From the 1740s Nattier employed the vestal theme for a number of patrons, including the daughters of the King.

were not, in fact, sequestered, but circulated in the larger world, and hence were open to temptation by upper-class men. The various accounts showed unseemly zest in their discussions of the stonings, the cases of women buried alive, and even the very number of executions for incestuous behaviour (seventeen, according to Dubois-Fontanelle, citing the abbé Nadal); these 'facts' were then substantiated by the authors providing a list of the most famous of the condemned vestals.[50]

The mixed signals in the various treatments of the vestal theme correspond in a particularly vivid way to the contrasting definitions of women – and the corollary demands society placed upon them – as they were articulated in eighteenth-century France. Depending on which side of the nature versus culture debate one endorsed, social critics assigned women to one of two mutually exclusive constituent roles: as repositories of virtue and, in the most optimistic construction, capable of functioning within the social realm on a par with men, particularly if given the benefit of education; or as deceitful sexual entities who, as a legacy of Eve, were enslaved by biological imperatives and therefore were incapable of reason.[51] The vestal could be either or both depending on whether she remained virtuous or

15 Attributed to François-Hubert Drouais, *Madame de Pompadour as a Vestal Virgin* (Jean-Antoinette Poisson, 1721–1762), 1760. Oil on canvas. Madame de Pompadour had played the role of a vestal in theatrical productions performed for the amusement of Louis XV. Shown in her maturity in this portrait, she alludes to her intellectuality, and to the impressive library she had assembled, through the tome on the history of vestals that she holds.

succumbed to her sexual drive. The play between the valorising of the vestals' public role and the interrogation of their moral stamina in eighteenth-century texts suggests an implicit parallel drawn with contemporary women of high visibility and social responsibility, namely, the *salonnières*. These educated, intelligent women who facilitated gatherings of men from a cross-section of French society for the purpose of interaction and discussion of current ideas, opened themselves

to the whole gamut of gender-related misinterpretation by boldly moving into the realm of male culture.[52] Precisely because they transgressed in crafting public identities through their assimilation and manipulation of social intercourse and the 'masculine monopoly on linguistic meaning and usage', the unnatural women of the salons opened themselves to the familiar charge of being superficial temptresses, even by each other![53]

One final portrait may serve to underscore the way the particular character of the vestal would seem to have dialogued with the codes governing women's behaviour and the attendant debates over women's innate capacities, the usefulness of education, and their function in society. *Madame de Pompadour as a Vestal Virgin* (1760; Figure 15), attributed to François-Hubert Drouais, while more decorous than the late Nattier vestal portrait, strikes a note of parody in the seemingly odd fit of the king's former mistress in the guise of a vestal.[54] But there is another equally unsympathetic set of ideas about women and an imposed virtuousness that inform the portrait. The vestal cult differed from its eighteenth-century Christian counterparts, the historical accounts inform us, in that its members were free to leave and marry once their thirty years of service concluded. However, as Dubois-Fontanelle

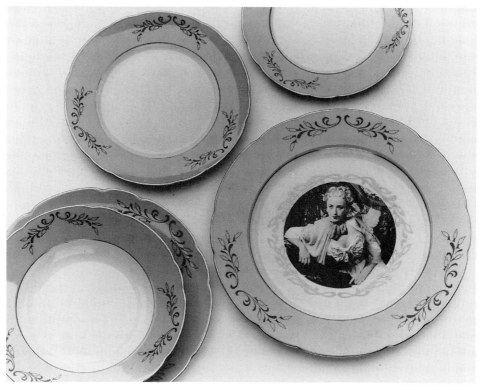

16 Cindy Sherman, *Artes Magnus Dinner Service*, 1990. Limoges porcelain. Photographer Cindy Sherman travelled to France to study the porcelain commissioned by Madame de Pompadour from the Royal Porcelain Factory at Sèvres. The dinnerware is modelled after an original design from 1756, onto which Sherman has transferred an image of herself in the guise of Madame de Pompadour by a complex photo-silkscreening process, thereby updating or bringing full-circle the idea of an allegorical portrait.

advises in his essay, that course of action was not always easy because of the senior vestals' age: at thirty-seven or thirty-eight years 'a girl, however much a vestal she is' had often lost her freshness – 'the first flower of youth lasts no more'.[55] And those who did marry were quickly sorry they had because, he imagined, their long period of continence weighed upon them. Being overly impatient to be free of their vows, the ex-vestals became sexual predators. The final insult is perhaps the most telling: these women, who effectively had had 'careers' of their own, were dismissed as the kind of *'vielles filles'* (old maids) who are always disdained by their young husbands.[56]

Casting the ageing Madame de Pompadour as a vestal clutching her *Book of Vestals* might appear as a highly loaded, sarcastic or ironic commentary, playing the imposed virtuousness of her current life as displaced mistress against the memory of her earlier, less-than-private role at court. Her costume, with its accent of pearl jewellery and the pert bow on her sleeve, in this context would seem to revisit the notion of the false vestal – with the added joke of women's ageing thrown in for good measure. Diderot, writing about a vestal portrait Greuze had exhibited of his wife in 1761, was annoyed precisely by the subject appearing too old, and perhaps too repentant: 'That one, a vestal! My dear Greuze, you joke with us; with her hands crossed on her chest, the long face, this agedness, these big eyes sadly turned toward the sky ... this is a mother of sorrows, but of petty character and somewhat scowling.'[57] His remark was tame in comparison to the invective in La Font de St Yenne's comments on portraiture cited earlier. Recall that the critic had levelled his attack at the ageing woman who would dare to have herself allegorised in portraiture:

Little did she doubt that the youth of Hebe could avenge her of the insults of Time, the least gallant and most impolite of the gods ... After all, is there a more pardonable error in the more beautiful sex? If the hell of beautiful ladies is old age, in the words of one of the greatest wits of the court of Louis XIV [La Rochefoucauld], why wouldn't the arts, and especially painting, strive to hide for them the decline of a state which was their entire happiness and distance or even conceal entirely, if the thing is possible, the vision of their greatest torture?[58]

I prefer to place Madame de Pompadour's vestal portrait in a more charitable light. She herself must have been at ease with her signs of ageing, her station, and accomplishment to have been pictured in her later years contentedly at work on her embroidery in the magisterial late portrait (1764) by François-Hubert Drouais in the National Gallery in London. Her vestal image, taken as part of a *series* of portraits that explore the very malleability of identity possible in the Age of Enlightenment – in real terms for men, but perhaps only in this fictive state for women – helps to thwart any single, easy definition of her according to an authorised category of womanhood. By assuming such allegorical roles she and the other sitters allowed for a subjectivity that confounds, that is polysemous, that offers a measure, however small, of the indeterminacy or unpredictability out of which one constructs one's own individuality.

Perhaps it is not too much of a historical leap to see allegorical portraiture in the eighteenth century as the grandmother of a contemporary, postmodern photographic practice, illustrated here in the 'radical update' (to quote *Mirabella* magazine) of Madame de Pompadour's dinnerware pattern, decorated with portraits of photographer Cindy Sherman in the guise of Madame de Pompadour (Figure 16).

Sherman has repeatedly photographed herself as a protean female character, thrust into a full range of female roles dictated by society, and in so doing has called those roles into question. Seen from a woman's point of view, and particularly from that of a woman like Madame de Pompadour, whose own panoply of roles, both allegorical and real, had brought her to power, but who undoubtedly suffered from the derogative assumptions about women nearing or over forty, the vestal as an allegorical persona may have offered a poignant, or perhaps even sardonic, way to reclaim a position within a culture of virtuous women.[59]

Allegorical references in French eighteenth-century portraiture in general provided a healthy infusion of 'culture', meant broadly and literally, into the lives of the women so depicted. However uncontrollable in their meaning(s), or subject to satirical abuse, these references removed the sitter from the confines of her prescribed gender role into a more intellectualised realm where she became someone who could bear deciphering, who had a dimension beyond the limiting fact of physical beauty.

Notes

All translations are my own.

1 Huber, a close friend of the artist, was an agent for the minister of foreign affairs, noted for having secured an important purchase of tobacco in Maryland in 1737. On Huber and the circumstances of the portrait see Christiane Debrie, *Maurice-Quentin de la Tour* (Saint-Quentin, Editions de l'Albaron-Société Présence du livre, 1991), pp. 123, 126–7. Note that Huber is shown so engrossed in his reading that he is unaware of the diminished light from the extinguished candle. His fingers marking a subsequent section of the book, as well as the slips of paper, suggest prior readings or favourite passages.

2 Jean Seznec and Jean Adhémar, *Diderot, Salons*, 4 vols, 2nd edn (Oxford, Clarendon Press, 1975), I, p. 206. Diderot was commenting on the 1763 Salon, the last one at which Nattier exhibited. The critic dismissed the painter as being old and blathering, explaining in an equally disparaging way that even in his good years he had been noted only as the painter of women. ('Le bonhomme Nattier est vieux et radote ... Nattier dans son bon temps était le peintre des femmes. Il les peignait toujours en Hébé, en Diane, en Vénus etc. Tous ces portraits se ressemblent, on croit toujours voir la même figure.')

3 For example the portrait of Madame de Pompadour as a sultana (now in the Hermitage), painted by Carle Vanloo as part of the decoration of her private residence, Bellevue, or Nattier's images of the daughters of Louis XV as allegorical representations of the four elements for Versailles. On the Bellevue commission see Perrin Stein, 'Madame de Pompadour and the harem imagery at Bellevue', *Gazette des Beaux-Arts*, 124 (1994), pp. 30–42.

4 Diderot, *Essai sur la peinture*, in *Oeuvres esthétiques*, ed. P. Vernière (Paris, Editions Garnier, 1968), p. 680. ('Quel supplice n'est donc pas pour eux le visage de l'homme, cette toile qui s'agite, se meut, s'étend, se détend, se colore, se ternit selon la multitude infinie des alternatives de ce souffle léger et mobile qu'on appelle l'âme.')

5 *Cours de peinture par principes* (Paris, Editions Gallimard, 1989), p. 132.

6 *Ibid.*, pp. 145–6.

7 *Ibid.*, p. 137, my emphasis.

8 *Ibid.*, pp. 133–4.

9 See Elise Goodman-Soellner, 'Boucher's *Madame de Pompadour at her Toilette*', *Simiolus*, 17 (1987), pp. 41–58, for a discussion of the importance of the art of *maquillage* in the daily toilette of aristocratic women.

10 Pierre Marivaux, *Le Spectateur Français, 1721–24* (Paris, Editions Bossard, 1921), Seizième Feuille, p. 193: Marivaux claimed to be translating from a journal written in Spanish that he had found among some books he purchased.

11 *Ibid.*, p. 194. The full citation is given to convey its satiric tone: 'Elle succombait sous tant d'embarras. La pauvre femme nous parlait, mais quoique je ne l'eusse vue qu'une seule fois, il me semblait qu'elle n'avait ni son eprit, ni son ton de voix. Non, ce n'était point là elle ne tout; c'était, si vous voulez ses yeux, sa taille et son visage, mais des yeux qui n'osaient regarder, une taille qui n'osait se faire valoir, un visage qui n'osait se montrer. En effet, une belle femme qui n'a point encore disposé ses attraits, qui n'a rien de préparé pour plaire, quand on la surprend alors, on ne peut pas dire que ce soit véritablement elle.'

12 *Ibid.* The paragraph concludes 'Oh! the fear she has that you will pre-judge her unsettles her mind as well.' ('Du moins, par sa façon de faire, vous dit-elle: Ce n'est pas moi, cela me ressemble en laid, mais vous ne me voyez pas encore; attendez, je ne suis qu'ébauchée, deux heures de toilette m'achèveront, après quoi vous me jugerez. Oh! la crainte qu'elle a que vous ne la jugiez par avance déconcerte aussi son esprit.')

13 *Discours sur les femmes* (Avignon, 1754), cited in *Miroir des femmes*, ed. Arlette Farge (Paris, Editions Montalba, 1982), pp. 32–3. ('Voilà donc ce que c'est qu'une dame, c'est une erreur de la nature, un corps de mensonges, un vrai singe ... La femme chaste est un écueil, l'impudique une source de scandale, la laide est une cause de chagrins, la belle une source de l'embrasement ... tout est extrême en elle, la colère en fait une lionne, la faim une louve, l'avarice une harpie, la finesse un renard, la défiance un cerbère, la malice une Proserpine, gibier d'enfer et femme du diable.') Even one of the four articles on the topic of women ('Femmes') in the 'enlightened' *Encyclopédie*, by Desmahis, argues for women's falseness, incapacity for friendship, and basic coquetry; *Encyclopédie, ou Dictionnaire raisonné des sciences, des arts et des métiers par une société des gens des lettres* (Paris, 1761–5). Desmahis's entry is discussed by Sara Ellen Procious Maleug, 'Women and the *Encyclopédie*', in Samia I. Spencer (ed.), *French Women and the Age of Enlightenment* (Bloomington, Indiana University Press, 1984), p. 262. For more positive descriptions of women by other *philosophes* see Paul Hoffman, *La Femme dans la pensée des lumières* (Paris, Editions Ophrys, 1980), pp. 496–7.

14 *Réflexions sur quelques causes de l'état présent de la peinture en France* (The Hague, 1747), p. 22 ('Il souffrira à la vérité pendant quelque tems de se voir forcé de flater un visage minaudier souvent difforme ou suranné, presque toujours sans phisionomie'). Madelyn Gutwirth, in her study of representations of women in the era of the French Revolution, *The Twilight of the Goddesses* (New Brunswick, New Jersey, Rutgers University Press, 1992) demonstrates how this misogynist, anti-aristocratic attitude served to permanently gender Rococo art as feminine, and thus inconsequential and vacuous.

15 La Font de St Yenne, *Réflexions*, p. 24 ('Et en effet, quel spectacle est comparable, pour une beauté réelle ou imaginaire, à celui de se voir éternellement avec les graces & la coupe de Hebe la Déesse de la jeunesse? d'étaler tous les jours sous l'habit de Flore les charmes naissans du Printems dont elle est l'image? ou bien parée des attributs de la Déesse des forêts, un carquois sur le dos, les cheveux agités avec grace, un trait à la main, comment ne se pas croire la rivale de ce Dieu charmant qui blesse tous les coeurs?').

16 *Ibid.*, p. 25 ('Elle s'est aisément persuadée que notre Sexe, toujours complaisant, forcé de voir chez elle deux phisionomies, préféreroit celle de la Déesse enfantie, à la Divinité douairiere, ou du moins qu'il lui tiendroit compte de ses efforts, & du tems qu'elle perd tous les jours à sâcher de lui ressembler').

17 *Ibid.*, p. 23–34 ('L'amour propre, dont l'empire est encore plus puissant que celui de la mode, a eu l'art de présenter aux yeux & sur tout à ceux des Dames, des miroirs d'elles-mêmes d'autant plus enchanteurs qu'ils sont moin vrais').

18 For a thought-provoking account of allegory and women see Martina Warner, *Monuments and Maidens: The Allegory of the Female Form* (New York, Atheneum, 1985). A historical study of allegory is provided in Stephen J. Greenblatt (ed.), *Allegory and Representation* (Baltimore and London, The Johns Hopkins University Press, 1981). See also Linda Nochlin, 'Courbet's real allegory: rereading the painter's studio', in Sarah Faunce and Linda Nochlin, *Courbet Reconsidered* (New Haven and London, Yale University Press, 1988), pp. 17–41. Craig Owen provided a thought-provoking theoretical discussion of allegory in contemporary art in a two-part essay entitled 'The allegorical impulse: toward a theory of postmodernism', in Scott Bryson *et al.*, *Beyond Recognition: Representation,*

Power, and Culture (Berkeley, Los Angeles and Oxford, University of California Press, 1992), pp. 52–87.

19 The most notable example is Rigaud's 1735 portrait of the Président Gaspard de Gueidan as an elegantly attired bagpipe-playing shepherd based on the character of Céladon from the novel *l'Astrée*, Musée Granet, Aix-en-Provence. It may have been occasioned by the earlier allegorical portrait of his wife, about which see below, p. 57. A pair of 1779 portraits by Heinius in the Musée des Beaux-Arts, Orléans, presents the more usual eighteenth-century solution: the husband, one Monsieur de Rivière, is shown in the contemporary clothing of a sportsman or hunter, holding his gun, while his wife is portrayed with the allegorising attributes of the goddess Diana.

20 For example, *Madame de Pompadour as a Gardener* ('La Belle Jardinière') by Carle Vanloo, *c.* 1760, Chateau de Versailles.

21 *Mademoiselle Clermont as the Goddess of the Waterworks* (*Mademoiselle Clermont en déesse des Eaux*), 1729, by Jean-Marc Nattier, Musée Condé, Chantilly.

22 *Painting in Eighteenth-Century France* (Oxford, Phaidon Press, 1981), pp. 113 and 122 respectively.

23 For a positive account of Madame de Pompadour as a patron of the arts, see *Madame de Pompadour et la floraison des arts* (Musée David M. Stewart, Montreal, 1988). A more negative, problematic account is provided by Donald Posner, 'Mme de Pompadour as a patron of the visual arts', *Art Bulletin*, 72 (1990), pp. 74–105.

24 Baron Louis-Guillaume Balillet de Saint-Julien, *Seconde Lettre à un partisan du bon goût sur l'exposition des peintures, gravures, et sculptures, faite par Messieurs de l'Académie Royale dans le grand sallon du Louvre, 12–28 aout, 1755*, p. 5. The presence of Enlightenment-oriented books entitled *l'Esprit des Lois*, *l'Histoire Naturelle*, as well as a plate from the *Encyclopédie* may have provoked the commentary.

25 The correspondence was first printed by M. Gilbert, 'Dix portraits et dix-neuf lettres de Rigaud et de Largillière', *Bulletin Archéologique* (1890), pp. 276–371. It is discussed by Nan Rosenberg in *Largillière and the Eighteenth-Century Portrait*, exhibition catalogue (Museum of Fine Arts, Montreal, 12 September – 15 November 1981).

26 Jean-Jacques Rousseau, *Julie, ou la Nouvelle Héloïse* (Amsterdam, 1761); *Emile, ou de l'Education* (Amsterdam, 1762).

27 Marie Anne du Deffand de la Lande, *Correspondance complète de la Marquise du Deffand*, ed. M. de Lescure, 2 vols (Paris, 1865; Geneva, Slatkine Reprints, 1971), I, p. 305; letter to Voltaire, 25 June 1764. ('Jean-Jacques m'est antipathique, il remettrait tout dans le chaos; je n'ai rien vu de plus contraire au bon sens que son *Émile*, rien de plus contraire aux bonnes moeurs que son *Héloïse*.')

28 For the reception of Rousseau's ideas and their female readership see Robert Darnton, *The Great Cat Massacre and Other Episodes in French Cultural History* (New York, Basic Books, 1984), pp. 215–56 and Claude Labrosse, *Lire au XVIIIe siècle: La Nouvelle Héloïse et ses lecteurs* (Lyon, Presses Universitaires de Lyon, Editions du CNRS, 1985). On the appearance of new subject matter in painting, see Carol Duncan, 'Happy mothers and other new ideas in French art', *Art Bulletin*, 55 (1973), pp. 570–83, reprinted in Norma Broude and Mary D. Garrard (eds), *Feminism and Art: Questioning the Litany* (New York, Harper and Row, 1982), pp. 201–20.

29 Samuel Richardson, *Clarissa, or the History of a Young Lady* (London, 1748); *Pamela, or Virtue Rewarded* (London, 1741).

30 In an anonymously written and published work entitled *Lettres d'une vestale et d'un jeune romain* (*Letters of a Vestal and a Young Roman*), 1797, the preface informs the reader that the text is a *roman à clef*, and that many will recognise the story as a real one about illicit love during the reign of Louis XV. However, the author apologises for the need to disguise the true identities in historical trappings, explaining that 'the fictions of Clarissa and especially Julie prescribe tight limits on the the truth even in this domain of the imagination'. He or she cautions by way of justification for the historicising that the truth runs the considerable danger of being boring (pp. 4–5).

31 Note the prominence of the historical text, *History of Vestals*, in the portrait of Madame de Pompadour, Figure 15. One of the most articulate proponents of women's social and intellectual liberation, Madame de Lambert, discussed the roles of taste, judgement and imagination in her 1728 *A Mother's Advice to Her Daughter* (*Avis d'une mère a sa fille*),

reprinted in Madame de Lambert, *Oeuvres* (Paris, Librarie H. Champion, 1990), pp. 95–134.

32 In the ellipsis, included here, Diderot waxed poetic about the vestals' attire: the unusual, picturesque, but also tasteful voluminous white gowns and veils, which, with their deep folds, conceal all but the hands and the face. This is the prologue to his critique of a painting of a vestal exhibited at the 1765 Salon by Carle Vanloo; *Salons*, II, p. 72. ('Mais pourquoi est-ce que ces figures de Vestales nous plaisent presque toujours? C'est qu'elles supposent de la jeunesse, des graces, de la modestie, de l'innocence et de la dignité; c'est qu'à ces qualités données d'après les modèles antiques, il se joint des idées accessoires de temple, d'autel, de recueillement, de retraite et de sacré; c'est que leur vêtement blanc, large, à grands plis, qui ne laisse appercevoir que les mains et la tête, est d'un goût excellent; c'est que cette draperie, ou ce voile qui retombe sur le visage et qui en dérobe une partie, est original et pittoresque; c'est qu'une vestale est un être en même-temps historique, poetique et moral.')

33 For a discussion of references to Tuccia and the thematic uses of chastity see Andrew Belsey and Catherine Belsey, 'Icons of divinity: portraits of Elizabeth I', in Lucy Gent and Nigel Llewellyn (eds), *Renaissance Bodies: The Human Figure in English Culture c. 1540–1660* (London, Reaktion Books, 1990), pp. 11–35. In 1763, at the height of the neoclassical vogue in France, Carle Vanloo exhibited at the Salon a now-lost painting in encaustic of *La Vestale Tuccia*, holding a sieve, which was in the collection of the Marquis de Marigny, Madame de Pompadour's brother.

34 *Histoire secrète des vestales* (Paris). Authorship has been attributed to the Chevalier de Mailly in the catalogue of the Bibliothèque Nationale.

35 The story becomes still more complicated and melodramatic when the mean-spirited Emperor also falls in love with Cornelia. Both she and her adoring beau die at the end and their deaths are avenged.

36 *Histoire des vestales avec un traité du luxe des dames romaines* (Paris, 1725).

37 Raoux (1677–1734) acquired initial training in his native Montpellier. He won the French Royal Academy's Rome prize in 1704, and spent three years in Italy. A professional contemporary of Watteau, he was received into the Academy as a history painter in 1717. His subject matter included allegorical portraits; fancy pieces, usually of young women reading or making music; and a number of vestal subjects, including allegorical portraits.

38 The one young virgin occupied with examining her own appearance in a mirror, just left of centre in the middle ground, nonetheless seems to be aiming for a more concealing arrangement of her veil.

39 Bernard Mandeville, *The Virgin Unmask'd* (London, 1709; Delmar, New York, Scholars' Facsimiles and Reprints, 1975); Madame de Lambert, *Réflexions nouvelles sur les femmes*, reprinted in *Oeuvres*, pp. 214–37.

40 Madame de Lambert, *Réflexions*, p. 216. ('La règne de la vertu est pour toute la vie ... Il faut penser qu'il y a peu de temps à être belle, et beaucoup à ne l'être plus; que quand les grâces abandonnent les femmes, elles ne se soutiennent que par les parties essentielles et par les qualités estimables. Il ne faut pas qu'elles espèrent allier une jeunesse voluptueuse et une vieillesse honorable. Quand une fois la pudeur est immolée, elle ne revient pas plus que les belles années.')

41 Madame de Lambert offered as an example the salons of the seventeenth century, where talking and thinking had been permitted, 'where the Muses kept company with the Graces', like Madame Henriette d'Angleterre's, held at Rambouillet, *ibid.*, p. 217 ('Il y avait autrefois des maisons où il était permis de parler et de penser; où les Muses étaient en société avec les Grâces'). She contrasted the way those salons fed and fortified the soul with the present-day rapid succession of pastimes, eating, gambling, the theatre, warning that 'when luxury/licentiousness and money hold sway, true honour loses its value', *ibid.* ('Mais à présent l'amusement d'une journée? Quelle multitude de goûts se succèdent les uns aux autres! La table, le jeu, les spectacles. Quand le luxe et l'argent sont en crédit, le véritable honneur perd le sien').

42 The original canvas was destroyed but two autograph versions survive, one in the collection of the Musée des Beaux-Arts, Dijon, and the other at Versailles.

43 The painting is in a private collection. That Raoux understood the stages of vestal life is

clear from a painting in the State Museum of Braunschweig, Germany which depicts an older vestal with nun-like drapery tending the altar fire, assisted by a younger initiate, a child similar to Mademoiselle de Pressoy, but more idealised and demure. Neither figure looks out at the viewer, in distinction to Raoux's portraiture convention. It should be noted that Raoux could just as readily deliver sexual innuendos, as in the case of *Girl with a Bird on a String*, 1717, Ringling Museum, Sarasota, which reflects seventeenth-century Dutch equations of caged birds with female availability. See Eric Zafran, *The Rococo Age*, exhibition catalogue (High Museum of Art, Atlanta, 1983), p. 110.

44 *La Méchanceté des filles. Où se voit leurs ruses & finesses, pour parvenir à leurs desseins*, Troyes; reprinted in *Miroir des femmes*, pp. 136–7. ('Les louanges de la Virginité ont été racontées par tous les siécles, où cette vertu a toujours reluit comme une perle précieuse qui donne lustre & prix à la personne Vierge & chaste; ainsi les Romains portoient grand honneur aux Vierges Vestales & consacrées à la Deésse Vestale avec voeu de Virginité, pour être plus capables d'entretenir & consacrer le feu sacré, & si aucune commettoit stupre, elle étoit condamnée à finir sa vie entre quatre murailles.

Mais pour une centaine de filles qui gardent comme un précieux trésor leur virginité, il y en a mille aujourd'hui qui ne recherchent que les occasions de la perdre: les causes de ce malheur sont entr'autres, la trop grande liberté, l'oisiveté, la recherche des plaisirs, les compagnies, les mauvais & lascifs discours, la braverie, l'éfronterie, le trop d'aise & le mépris des remonstrances.')

45 Among the women with whom the portrait has been identified is Madame de Vintimille, one of the mistresses of Louis XV; Registration file, North Carolina Museum of Art. This identification was proposed by Jean Seznec and Jean Adhémar in Diderot, *Salons*, I, p. 41.

46 *Ibid.*, p. 65. ('Voici une Vestale de Natier; et vous allez imaginer de la jeunesse, de l'innocence, de la candeur; des cheveux épars, une draperie à grands plis, ramenée sur la tête et dérobant une partie du front; un peu de pâleur; car la pâleur sied bien à la piété (et à la tendresse). Rien de cela, mais à la place, une coiffure de tête élégante, un ajustement recherché, toute l'afféterie d'une femme du monde à sa toilette, et des yeux pleins de volupté, pour ne rien dire de plus.')

47 *La Fausse Vestale, ou l'Ingrate Chanoinesse* (Cologne, 1707). The novel is subtitled 'Nouvelle Galante'.

48 Diderot's novel *La Religieuse*, published posthumously in 1796, relates the scandals of lesbianism within a convent. Its heroine, Suzanne, much like the vestal Cornelia of *Histoire secrète des vestales*, has been taken to the convent against her will.

49 *Essai sur le feu sacré et sur les vestales* (Amsterdam, 1768).

50 *Ibid.*, p. 89.

51 See Silvana Tomaselli, 'The Enlightenment debate on women', *History Workshop*, 6 (1984), pp. 101–20; and M. Bloch and J. H. Bloch, 'Women and the dialectics of nature in eighteenth-century thought', in C. McCormack and M. Strathern (eds), *Nature, Culture, and Gender* (Cambridge, Cambridge University Press, 1980).

52 For an account of salon culture see Dena Goodman, 'Enlightenment salons: the convergence of female and philosophic ambitions', *Eighteenth-Century Studies*, 22: 3 (1989), pp. 329–67. Noted *salonnières* included Madame de Lambert, Madame du Deffand, Madame de Tencin, and Madame Geoffrin.

53 On the issue of transgression, see Joan B. Landes, *Women and the Public Sphere in the Age of the French Revolution* (Ithaca, Cornell Unversity Press, 1988), pp. 21–38; also Gutwirth, *The Twilight of the Goddesses*, pp. 86–95, who quotes a description of one woman's salon behaviour (the Maréchale de Luxembourg) by Madame du Deffand: 'She dominates wherever she goes and always makes precisely the impression she wishes to make', p. 88.

54 Unfortunately nothing is known about circumstances leading to this portrait. Danielle Gallet notes that Madame de Pompadour had played the roles of Fire and of a vestal in her theatrical productions; *Madame de Pompadour et la floraison des arts*, p. 108.

55 *Essai sur le feu sacré*, p. 68.

56 *Ibid.*

57 Diderot, *Salons*, I, p. 134. ('Cela, une vestale! Greuze, mon cher, vous vous moquez de nous; avec ses mains croisées sur sa poitrine, ce visage long, cet âge, ces grands yeux

tristement tournés vers le ciel ... c'est une mère de douleurs, mais d'un petit caractère et un peu grimaçante.')

58 La Font de St Yenne, *Réflexions*, pp. 25–6. ('Elle n'a pas douté que la jeunesse d'Hébé la vengeroit des insultes du Tems le moins galant & le plus impoli de tous les Dieux ... Après tout, est-il une erreur plus pardonnable au beau Sexe? Si l'enfer des jolies femmes c'est la viellesse, au sentiment d'un des plus beaux esprits de la Cour de Louis XIV [La Rochefoucauld] pourquoi les Arts & sur tout la peinture, ne s'efforcera-t'elle pas de leur cacher le déclin d'un état qui fait tout leur bonheur, & de leur éloigner, ou même leur dérober entièrement, si la chose est possible, la vuë de leur plus grand supplice?')

59 It is beyond the scope of this essay, but useful to note that the theme of the vestal, disconnected from portraiture, persisted to the end of the century, its emphasis shifting precisely in accord with the changing status of women in France, and ending in scenes of vestals being tortured or punished, most notably in the painting by Henri-Pierre Danloux, *The Supplication of a Vestal*, 1790, now in the Louvre, which shows the victim being forced into the underground tomb in which she would be sealed.

PART II

The social self

3

Sovereign bodies: the reality of status in seventeenth-century Dutch portraiture

JOANNA WOODALL

Seventeenth-century Holland produced an unprecedented number and range of portraits. One might immediately think of individuals: the subjective interiority perceived in Rembrandt's images and Frans Hals's candid impressions of personal interaction. At the same time, there is a sense of anonymity, the black and white picture of innumerable upright citizens by less famous and unknown artists. The resulting taxonomy includes life-sized figures, three-quarter lengths, busts with and without hands, heads and even miniatures, all illusionistically attired in ebony satin, starched ruffs, paint-white lace. Such images may connote status and occupation: wealthy merchants and traders, recognised preachers, playwrights, painters, attractive young women and wise old birds. Single figures thus acquire pendant partners and enter into groups: family gatherings, guild officers, governors of charitable institutions, members of the civic guard, even participants in anatomical dissections. All are characteristic and distinctive products of Dutch Golden Age culture.

The appearance of such pictures has frequently been related to the altered character of Dutch society consequent upon the Revolt of the Netherlands. This change began with riots and iconoclasm in 1566 and developed into a full-scale rebellion against the authority of the absentee Catholic monarch, Philip II of Spain. By the turn of the century it had resulted in the establishment of a complex, Protestant-dominated polity: the United Provinces of the Netherlands. Lacking a monarch, the noble estate was led by the princes of Orange. Members of this family monopolised the office of Stadholder which, previously the king's lieutenant in each province, now became the highest office in the decapitated noble hierarchy. The Stadholder established a court in The Hague and his influence was based on command of the army – the traditional preserve of the aristocracy.

The Stadholder's power was, however, limited by the representative assemblies of the seven provinces, in which the voice of the cities had been significantly strengthened. In 1581, for example, the province of Holland decided to increase the cities' representation from six to eighteen, while the noble estate retained its single vote. The political power of these cities was supported by their economic success, built upon the opportunities provided by war, immigration, religious toleration and colonial expansion. In 1648, the Republic achieved official, international recognition as a sovereign state in the Treaty of Münster.

During the second half of the nineteenth century, the traits of a heroic, realist, bourgeois culture were recognised in the wealthy, urban society which became established through the Revolt.[1] For the French critic Eugène Fromentin, whose influential *Les Maîtres d'autrefois* was published in 1876, seventeenth-century Holland was unquestionably bourgeois and inextricably linked with a an exact, sincere realism epitomised by portraiture:

The problem was this: given a *bourgeois* people, practical, not inclined to dreams, very busy withal, by no means mystic, of anti-Latin tendency, with broken traditions, a worship without images, parsimonious habits – to find an art to please such a people, an art whose fitness should be apparent to them, and which should represent them ... [T]here remained nothing for such a people to propose to themselves but a very simple and daring thing ... to paint its own portrait.[2]

This link between bourgeois values and a realism identified with portraiture has proved a powerful and long-lived explanatory framework.[3] In 1990, Perry Chapman posited an individualism 'associated with rationalism, empiricism, secularisation and the rise of the bourgeoisie' as central to the understanding of Rembrandt's self-portraits.[4] According to D. R. Smith in 1983, sitters in marital portraits also attained increasing scope for the expression of individuality through a widening range of choices about how to characterise their unions.[5] Ann Jensen Adams's forthcoming study of Dutch seventeenth-century portraiture assumes the distinction between public and private identity upon which bourgeois subjectivity is founded.[6]

These are very sophisticated studies, which take into account the history, conventions and inherited connotations of the genre. They have, however, tended to concentrate on the complex relationships between these shaping factors and the presumed reality of bourgeois values in seventeenth-century Holland. Yet recent historical research has exposed considerable continuities between the aristocratic values which preceded the Revolt and attitudes and behaviour in seventeenth-century Holland.[7] Historians have, in addition, problematised the received model of a vigorous burgher culture in the first half of the century succumbing to a more passive, aristocratic way of life amongst the citizen elite after about 1650.[8] A distinction has been drawn between the Dutch term *burgerlijk* and the French term *bourgeois*. While the former is a limited adjective derived from *burger* (or citizen), the latter denotes a fully fledged class and its ideology.[9]

In this chapter, I consider the implications of this historical work for the interpretation of portraiture.[10] If a bourgeois society did not emerge in Holland fully formed, like Minerva from the head of Jupiter, how does this affect our understanding of the images of the Dutch burghers who had themselves portrayed in their thousands?[11] How did the inherited conventions and connotations of portraiture relate to the uneven and long-term changes in various fields of representation which subsequently became characterised as the formation of bourgeois identity?

Portraiture and nobility

Although portraiture has become closely identified with the rise of bourgeois individualism, during the second half of the sixteenth century a connection can be discerned between portraiture and concepts of nobility. Around 1550, for example, the humanist and painter Francisco de Holanda specified that very few people

merited the honour of portrayal. In a manuscript written at the Portuguese court he claimed that these were: illustrious princes, kings and emperors, princesses and queens of virtue and wisdom, men famous in arms, art and letters, or of singular liberality and virtue, 'and nobody else at all'.[12] Similar ideas can be found in G. P. Lomazzo's Italian treatise, published in 1584.[13] The numerous contemporary collections of portraits depicting family ancestors and 'famous men' also reveal an acute consciousness of social exclusivity and honour.

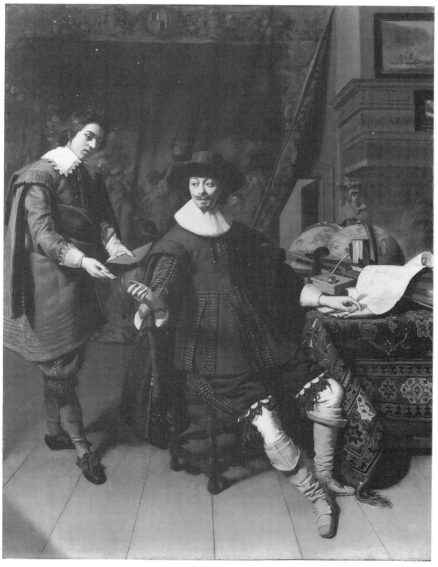

17 Thomas de Keyser, *Constantijn Huygens* (1596–1678), 1627. Oil on panel, 92 x 68 cm. Probably painted in Amsterdam, although Huygens is shown in his role as secretary to the Stadholder Frederick Hendrick.

The basis of de Holanda's classification was the sitter's possession of a special, absolute quality: illustriousness, wisdom, fame, liberality, masculine or feminine virtue. Such qualities were conventionally associated with respected roles in society and formally recognised by conferment of a noble title. In 1588, for example, the Haarlem humanist Hadrianus Junius distinguished three sorts of nobility: of birth (those who traditionally exercised rule), of virtue (those who served the state), of *ars* or skill (scholars and artists who promoted the general interest).[14] This broad definition of nobility was therefore connected with the exercise of sovereignty and the maintenance of the sovereign social body. It articulated an autonomous identity which transcended material and personal concerns and transient, local existence. Nobility in this sense encompassed all those whom de Holanda considered eligible for portrayal. Both a noble title and a portrait were signs of a self whose sovereignty justified earthly and perhaps heavenly immortality.

On the face of it, nobility seems an unlikely justification for portrayal in seventeenth-century Holland because the political and economic hegemony of the aristocratic order had been definitively challenged. In particular, the repudiation of the Spanish monarchy ended the possibility of legal ennoblement. Yet the subjects and formats of much of the portraiture produced during this period suggest that those who could still claim entrance to the pantheon of portraiture through the established portals did not hesitate to do so.

For example, the Stadholder and remaining titled nobility continued to be depicted wholesale and visually identified with the courtly decorum, military command and landed estates of traditional, hereditary aristocracies. The Stadholder's secretary Constantijn Huygens was not of noble birth, but Thomas de Keyser's 1627 portrait of him (Figure 17) represents him as a veritable *homo universalis* according to Junius's criteria of nobility. His receipt of a document thematises his work on behalf of the state, thus chararacterising him as a man of virtue. While the items displayed around him articulate his claim to renown within the sphere of *ars*, his dress alludes to hunting, a prerogative of the hereditary nobility. Noble *ars* also seems articulated in the portraits of artists which proliferated during this period, particularly those in which there is no evidence of manual work.

Such portrayals might be seen as relics of a court society, out of step with the dominant social, economic and political realities of urban Holland. What about images of people who are not immediately recognisable to us as worthy of immortality according to the established criteria: the Dutch citizens who were portrayed in such great numbers? The Amsterdam burgher elite is a useful exemplar of this group for two related reasons: they were the richest and most powerful citizens in the Netherlands and their biographies and images have already been quite fully researched.[15] They, if anyone, could have afforded not to perpetuate the values articulated by de Holanda's and Junius's categories. So did they, in their increasing prosperity and political confidence, simply abandon and forget conventional ideas about who was worthy of immortalisation in paint?

I suggest, rather, that their portraits were initially conceived and comprehended with reference to traditional concepts of portraiture, inherited and adapted from the aristocratic ideology which predominated before the Revolt. Portraiture remained a claim to an elevated, autonomous identity within interlinked social, political and spiritual hierearchies, although the *content* of that identity was responsive to the citizens' different circumstances. Espousal of 'aristocratic' values was thus compatible with *burgerlijk* forms of self-presentation, even remarkably

modest-looking images which are now regarded as private or personal. Portraiture positioned the sitter both within the burgher elite and in relation to the hereditary nobility. However, there was no immediate sense of an irreconcilable division between established aristocratic identity and the complex of values which ultimately came to be defined as distinctively bourgeois.

Strategies of portrayal I: noble emulation

Some members of the Amsterdam elite chose to represent themselves using portrait formats identified with the hereditary nobility. For example, Cornelis van de Voort's[16] portrait of *Laurens Reael* of *c.* 1620 (Figure 18) is very similar to sixteenth-century images of members of the Habsburg court by, for example, Titian and Antonis Mor. Both the format and iconography can also be related to contemporary portraiture at the Stuart court.[17]

Traditionally, this form of self-presentation articulated a claim to immortality in terms of the prerogatives of the hereditary nobility: the exercise of sovereignty and bearing of arms. A cane indicated the judicial authority of a ruler[18] and the full-length, life-sized format, with legs astride, hand on hip, curtain, pedestal and covered table was widely associated with images of sovereigns. Gold chains were signs of honour, conventionally distributed by a sovereign. The helmet signified the military prowess upon which the noble order was founded, and wearing a sword was a prerogative of the titled aristocracy.[19]

It may seem surprising that an Amsterdam citizen should make such claims. However, the United Provinces was neither a centralised industrial democracy, in which the political autonomy of cities is extremely limited, nor an *ancien régime* monarchy, in which the cities constituted the third and lowest estate within the socio-political order. Seventeenth-century Amsterdam was a powerful sovereign body whose economic and colonial hegemony were rapidly increasing; it could bear comparison with Venice and even the city-states of the ancient world. Office-holders in Amsterdam, who themselves constituted sovereign bodies or 'regents',[20] were men to be reckoned with. They might well consider themselves worthy of the illustriousness and fame previously reserved for the hereditary aristocracy.

Bearing this in mind, Reael's characterisation as a renowned soldier, authoritative ruler and even titled nobleman is explicable in terms of his biography (1583–1637). From 1611 until 1619 he was a distinguished officer of the East India Company, first as a military commander and then as governor-general of the Indies. The Republic had delegated responsibility for colonial government as well as trade to the East India Company. The latter was thus a sovereign body, capable of honouring Reael with the gold chains depicted in his portrait, which was probably commissioned upon his safe return to Holland.[21] Reael subsequently continued to build his reputation within the military and political spheres. In 1625 he again participated in sovereignty as vice-admiral of the Netherlandish naval force and director of the East India Company. In 1626 he actually obtained a noble title, dubbed a 'Golden Knight' as ambassador at the coronation of Charles I of England.[22]

However, Reael's portrait was not 'realistic', in that it was not an unmediated, comprehensive reflection of his social position at the date when it was painted. The image not only represents Reael's achievement by 1620, but apparently realises his ambition for a noble title long before he actually attained one. In addition, Reael's

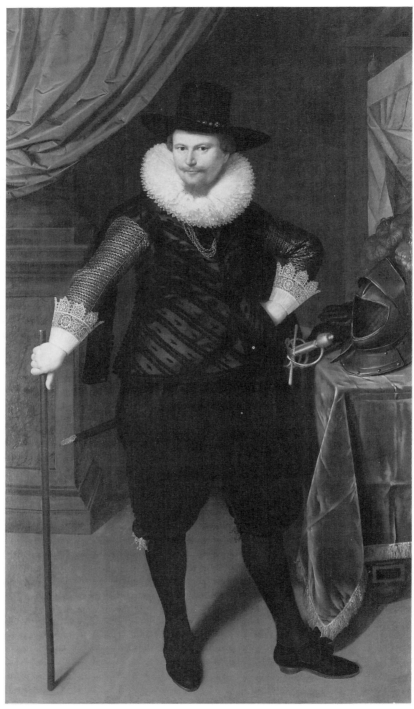

18 Cornelis van der Voort, *Laurens Reael* (1583–1637), *c.* 1620. Pendant to Figure 19. Oil on canvas, 223 x 127 cm. Reael had been governor-general of the Dutch East Indies.

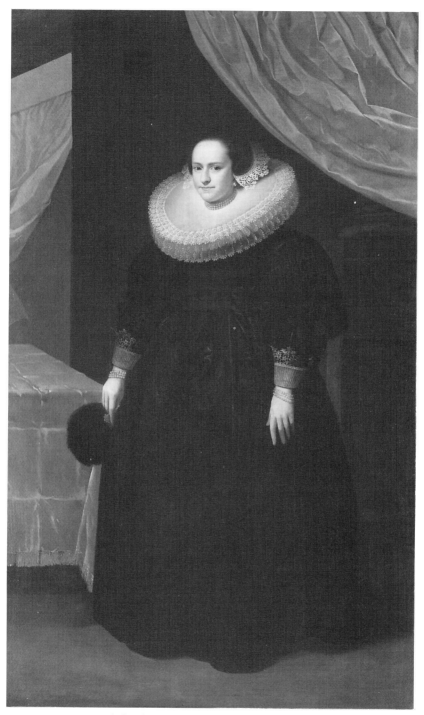

19 *Suzanna Moor* (1608–1657), artist unknown. Pendant to Figure 18 and probably painted to commemorate Moor's marriage to Reael in 1629. Oil on canvas, 223 x 127 cm. The discrepancy in date between the two images reduces the twenty-five year difference in age between the two sitters.

reputation as a gifted man of letters is supressed in favour of the 'royal' aspects of his identity (that is, judicial and military authority). Yet because portraiture was already widely theorised as the exact reproduction of actual appearance,[23] this conventional, idealised and partial picture is rendered an accomplished fact for posterity.

In early seventeenth-century Amsterdam, the connotations of Reael's grandiose image would also have differed from its meaning in a court society. In particular, the similarity of Reael's name to the Spanish word *real* (meaning both 'royal' and a monetary coin) was liable to have been noticed by contemporaries. The Dutch had a marked propensity for word-play and Reael was born in a house called 'in the golden Sovereign'.[24] Consciously or unconsciously, the illustrious military and political achievements of a rich Amsterdam citizen named 'Royal' have been set in the place of the birth and wealth of a sovereign.

The established language of portrayal could thus signify in different, perhaps uncontrolled ways when employed in radically new circumstances. Semiotic inflation and instability were also the consequence of the decision to pair Reael's image with a companion portrait of Suzanna Moor (Figure 19), whom he married in 1629.[25] While the characterisation of Reael as a sovereign was adaptable to his depiction as a husband, marital pendants were more characteristic of burgher portaiture than images of illustrious princes. The ceiling beams, bed and doorway translated an eternal realm of natural, genealogical superiority into a contemporary, domestic domain.[26] In this environment, the covered table became a piece of household furniture as well as a courtly prop, the helmet an anachronistic ornament as well as a serious military accoutrement.

Portraiture as realism was an immensely useful way of representing a particular, desired position as if it were actually the case. However, emulation of the self-presentation of the hereditary nobility had potential disadvantages. Established forms might acquire new and equivocal significance in relation to the changed circumstances and requirements of a Dutch citizen. Furthermore, if imitation is the sincerest form of flattery, emulation implied the superiority of the hereditary elite, at least in war and international politics. Reael's image thus seems to support Henk van Nierop's argument that the noble order's prestige and influence in these fields survived surprisingly intact into the seventeenth century.[27] However, the consequent risks of ambivalence and subordination may have encouraged some to attempt more positive and distinctive definitions of citizen identity.

Strategies of portrayal II: *burgerlijk* distinction

Two portraits which seem to epitomise bourgeois values are Bartholomeus van der Helst's[28] pendant portraits of Andries Bicker and his wife Catarina Gasneb Tengnagel, which is dated 1642 (Figures 20 and 21). Andries Bicker (1586–1652) was the most powerful man in Amsterdam between 1627 and 1650. He was ten times burgomaster and the leader of the dominant anti-court faction. Stupendously wealthy, he and his three brothers were said to have divided up world trade between them, with Andries concentrating on exotic spices and Russian furs.[29]

Yet van der Helst's paintings seem to be what would now be termed private images. There are no attributes or accessories of office; the gloves and book suggest leisured gentility. The formats look modest in comparison with that used for Reael, and the figures' close proximity represents the sitters as accessible to the

viewer. Andries is shown with a level gaze and a slight smile, while the slightly higher viewpoint, upturned corners of lips and eyes and pertly starched lace borders give his dimpled wife a meek yet lively air. The highly differentiated, transparent surface of the pictures enhances their conviction as unmediated reflections of their subjects' actual situation.

Above all, the sitters are represented in marriage, a relationship which is now understood primarily in emotional and domestic terms. They seem to confirm Laurence Stone's thesis that the conception of marriage was transformed during the early modern period. A 'loose core at the centre of a dense network of lineage and kinship relations' in traditional, noble-dominated society supposedly became a union of two individuals based on mutual attraction, love and emotional dependence in the modern, bourgeois society which replaced it.[30]

Although influential, Stone's interpretation has been widely problematised and challenged.[31] Two poems written by the Amsterdam poet Jan Vos (1610–1670)[32] suggest that our intuitive grasp of van der Helst's portraits is also historically inadequate. The texts appear among a series of laudatory verses on pictures in the edition of Vos's collected poems, published in 1662:

<div align="center">

The Honourable Lord
Andries Bicker
Lord of Engelenburg
Burgomaster, Councillor and Director of the East India
Company in Amsterdam, & c.

</div>

Thus men see the alert eye of the head of the free cities.
The flourishing country goes to rest upon such a sentry.
His care protects us in war and in peace.
He is vigilant here in the North through council for the eastern coast.
He who lives wholly for others is to be entrusted with everything.
Did Fabricius despise gold? Did Cato speak for the community?
Did Brutus strive to cut the people out from slavery?
Those who know Bicker, find the three in one.
Fame with reason trumpets in the ear of the Moors:
This one is born not for himself, but for the country.

<div align="center">

Madam
Katrina Bickers
Wife of the Honourable Lord Andries Bicker & c.

</div>

This is Katryn: but it is vain to live through colour.
Her nature conquers the arrows of Death.
Virtues are inscribed in the mind of the people.
So she follows Englenburg, her true bedfellow:
He seeks to look out for the country through care, just as she does her house.
Through concern for State and home all adversity is averted.[33]

It is not stated that these poems relate to van der Helst's paintings, although they are the only known images of Bicker and Tengnagel. The tenor of the Bicker poem in particular is not immediately reconcilable with the personal and emotional values perceived in the portraits. Rather, Vos's rhetoric explicitly conforms to the ideas about 'noble' portraiture articulated by Francisco de Holanda. Primacy is given to Bicker's seigneurial title and power is entrusted to him because it will be exercised in the general interest. Virtues and fame comparable with those of

illustrious Roman citizens (and even a trinitarian God) imply that his identity transcends time and place.

What then is the relationship between Vos's verbal characterisation of Bicker and van der Helst's visual one? Perhaps text and image functioned in separate spheres, the poems merely operating a humanistic convention of eulogistic lines inspired by images?[34] Yet Vos often mentioned specific, local painters at the head of this sort of verse, connecting the poems with at least a generic idea of contemporary portraiture. Moreover, the humanist concept of *ut pictura poesis*[35] and the

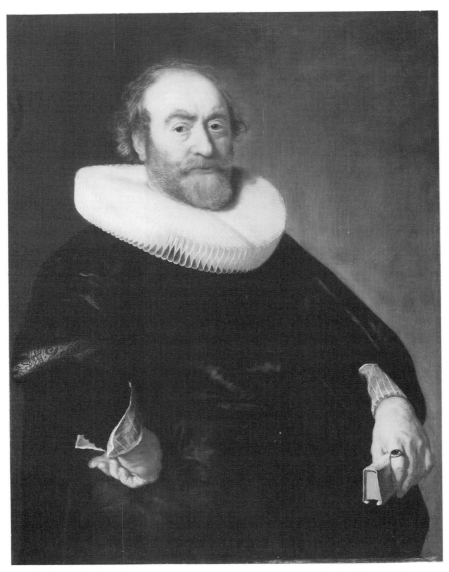

20 Bartholomeus van der Helst, *Andries Bicker* (1586–1652), probably 1642. Pendant to Figure 21. Oil on panel, 93.5 x 70.5 cm. A liberal protestant and leader of the anti-court faction, Bicker was one of the richest and most powerful men in Amsterdam between 1627 and 1650.

practice of placing verses on sitters directly beneath portrait prints suggest that verse and visual portraiture were seen as complementary discourses.[36]

Their apparent incompatibility may result from *our* imposition of anachronistic distinctions between private and public spheres onto seventeenth-century Amsterdam. In particular, we may assume that an image of Bicker as a husband has nothing to do with his representation as a leading politician. Yet Vos's poem on Catarina Tengnagel suggests that domestic and political life were closely connected in readers' minds. The two domains are juxtaposed and an analogy is drawn

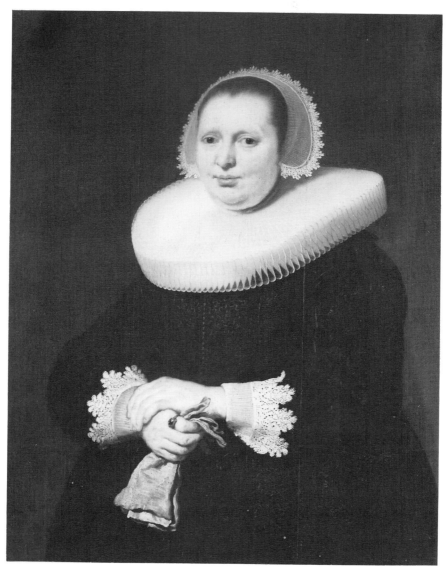

21 Bartholmeus van der Helst, *Catarina Gasneb Tengnagel* (1595–1652), 1642. Pendant to Figure 20. Oil on panel, 92.5 x 70 cm. Wife of Andries Bicker.

between statecraft and housework – both requiring constant care from their respective, gendered guardians. Schama has argued that the concept of the home as both microcosm and foundation of the political and economic orders was widespread, quoting Dr Johan van Beverwijk's *On the Excellence of the Female Sex* (1643): 'The first community is that of marriage itself; thereafter in a family household with children, in which all things are common. That is the first principle of a town and thus the seed of a common state.'[37]

Bearing these analogies in mind, and remembering the patriarchal character of family life during this period, a father-figure becomes recognisable in both van der Helst's and Vos's representations of Andries Bicker. He was, in effect, a city-father, and Catarina Tengnagel's contented security is the happy social consequence of dependence upon such a man. It is notable that the pendants were apparently commissioned in 1642, when Bicker's political dominance was temporarily threatened.

In the woman's portrait, some viewers may recognise the long gloves and the way in which the hands are clasped as allusions to marriage.[38] Tengnagel's status as Bicker's wife likewise forms the basis of her characterisation by Vos. Similarities may also be noticed between Vos's and van der Helst's characterisations of Bicker. The sitter's military bearing[39] can be compared with Vos's description of him as a sentry, and Vos's repeated use of words concerned with looking is paralleled by the direct gaze and compositional emphasis upon the eyes.

Readers of Vos familiar with Roman history might see the swathed 'mantle' and notable modesty[40] of Bicker's portrait in relation to Republican Rome's famously austere citizens, Fabricius, Cato and Brutus.[41] In 1614, a published description of Amsterdam had likened the burgomasters to consuls[42] and martial and Stoic virtues were to be an important theme of the decoration of the burgomasters' chamber of the new Town Hall.[43] Cato's contempt of foreign luxury and defence of public liberty against tyranny may be associated with Bicker's political identification with the anti-court faction in Amsterdam,[44] although he did not actually enact his militantly oppositional stance when the Stadholder Willem II threatened to attack Amsterdam in 1649.[45]

Strategies of portrayal III: a harmonious marriage

Pickenoy's[46] magnificent full-length pendant images of Cornelis de Graeff (1599–1664) and his wife Katarina Hooft (d. 1691) (Figures 22 and 23) skilfully marry courtly values with a self-consciously *burgerlijk* position. De Graeff was Andries Bicker's brother-in-law and rival for domination of the Amsterdam patriciate. He too was a liberal, but more moderate in his opposition to the Hague court. Whereas Bicker made his fortune in trade, de Graeff's ancestry within the Amsterdam governing elite already stretched back three generations. His 'aristocratic' persona is evident in his leisured foreign travel, learned pursuits and enthusiasm for hunting. His name means 'the Count' and in 1610 his father bought the title to Zuid Polsbroek from the Count of Aremberg.[47]

Again there are poems by Jan Vos on portraits of the couple.[48] Without necessarily being descriptions of Pickenoy's or perhaps any specific pictures, they provide a frame of reference within which the images can be historically understood:

The Honourable Lord
Cornelis de Graeff
Free lord of Zuid Polsbroek, Burgomaster,
Councillor & c. in Amsterdam.

When Graeff is in his grave shall he thus be represented:
But the brain that Minerva gave him, for the welfare of Holland,
That shall men recognise through the pencil of his Fame.
Wisdom will not allow itself to be shut up in the grave.
As is shown by the renown of his father throughout the free cities.
Nothing is more venerable than the virtues of the authorities.

Madam
Katarina Hooft
Wife of the Lord of Zuid Polsbroek & c.

Will you Katryn, try to brush Death aside through colours?
Death has no part in virtue, which is eternal.
Another lives, oh art! through the power of your pencil:
But Polsbroek's wife shall make your pencil live.
Just as her husband makes the Ij famous through wise leadership.
No one can show her noble nature through any colour.
Virtue is not preserved by any art, but by itself.
An honest Reputation outlasts the glory of a laurel crown.[49]

The two basic themes of Vos's characterisations are the display of skill and renown in politics and in art, respectively the consequences of masculine and feminine virtue. These themes are also discernible in Pickenoy's virtuoso portraits. An articulated interior and strongly differentiated illumination place de Graeff firmly in the rational world of time and space, his measured deliberation evident in the precise placement of his feet upon the regularly ordered tiles. Meanwhile, Hooft is located in an aesthetic realm, a statuesque figure enveloped by diffuse, flattering light and embraced by a niche-like space. Generalised classical pillars and a draped curtain replace specifics. While de Graeff stands fixed and upright, like the pillar behind him, the gorgeously decorated female figure seems to move imperceptibly through conceptual space, brushing the air with her fan.

Reason and art were established gender positions within aristocratic ideology and the portraits' similarity to royal and courtly exemplars forms the basis of the characterisation. Identity is produced primarily through resemblance to one's pictorial 'ancestors' – in role, if not in blood. Yet de Graeff and Hooft are also distinguished from hereditary nobles. For example, while de Graeff's left hand looks as if it is resting on a sword-hilt in a conventional military stance, there is apparently no sword there. In wearing his hat, de Graeff makes reference to a privilege which, confined in Habsburg society to royalty and noble grandees, had become for the Dutch Republic a symbol of freedom from social oppression. While the couple's clothes and accessories are as refined and opulent as those of royalty, they are not to be confused with contemporary court attire.

Jan Vos similarly identifies the couple as courtly citizens. Reference to de Graeff's famous father invokes the genealogical principle, but this is immediately connected with the 'free cities' and the venerable virtues of the (civic) authorities. De Graeff's political skill is placed in the service of the province of Holland and ultimately Amsterdam's waterway, the Ijsel. His weapons are intelligence and wisdom, rather than the military force of the established noble order.[50] In his

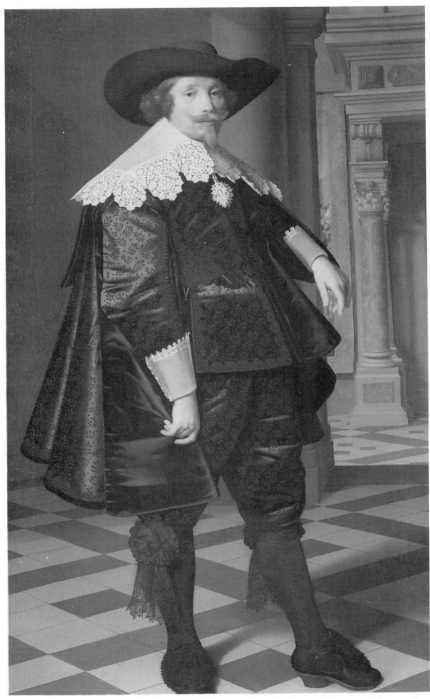

22 Nicolaes Eliasz, generally known as Pickenoy, *Cornelis de Graeff* (1599–1664), *c.* 1635. Pendant to Figure 23. Oil on canvas, 184 x 104 cm. Brother-in-law of Andries Bicker (Figure 20) and his rival for domination of the Amsterdam ruling elite, he pursued 'gentlemanly' rather than business interests. His misformed jaw due to a childhood injury is not evident in his portrait.

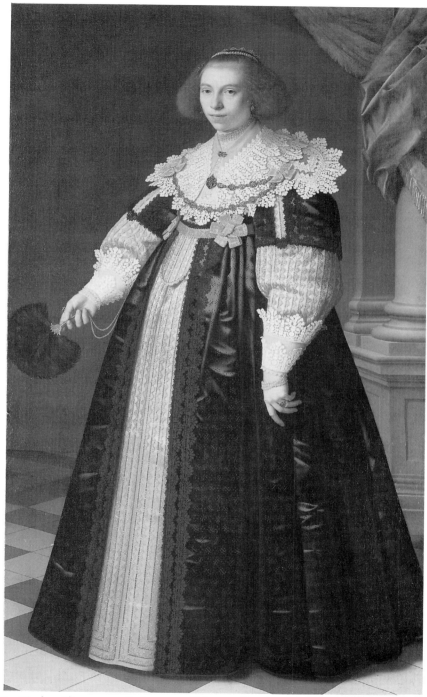

23 Nicolaes Eliasz, generally known as Pickenoy, *Katarina Hooft* (d. 1691), *c.* 1635. Pendant to Figure 22. Oil on canvas, 184 x 104 cm. Probably painted to commemorate Hooft's marriage to de Graeff. Hooft's recorded dynamism and strong-mindedness are not evident in her portrait.

characterisation of Hooft, Vos ensures that natural, active, honest feminine virtue finally wins out over art(ifice) as the source of immortality. Thus, although virtue remains close to the traditional *concept* of nobility as a personal yet eternal quality,[51] its *content* is altered and moulded to justify ideal, gendered citizens.

The setting of Pickenoy's figures renders de Graeff recognisable as a princely ruler, but represents his sovereignty as domestic and familiar. The monumental columns and courtly furnishings of a royal audience chamber are combined with the black and white tiles of a Dutch interior. Contemporary viewers probably identified Pickenoy's depicted halls with de Graeff's actual dwelling, an 'elegant house with an exquisitely decorated interior' on the prestigious new 'Lords' canal'.[52] Such patrician palaces were simultaneously family homes, spaces for the display of refined taste and venues for the reception of official visitors, friends and clients.

Like the Reael pendants (Figures 18 and 19), Pickenoy's paintings may have commemorated the couple's marriage.[53] For members of the patrician elite, marriage was apparently not only the social bedrock but also a qualification for the assumption of political responsiblity. Reael married aged forty-six, the year before he joined the Amsterdam council (the use of an earlier portrait as a marital pendant helps mask the twenty-five year age gap between the couple). De Graeff's rapid remarriage in 1635 after the death of his previous bride suggests that being married was an urgent priority. He entered politics in 1636, becoming a councillor in 1639, after the demise of his father. In Pickenoy's splendid portraits, we thus see the image of an heir apparent and his consort.

Like the paternal relationship between Bicker and Tengnagel, de Graeff's conjugal love for his richly endowed wife provides an apt metaphor for an ideal relationship between a city ruler and the citizenry. The concept of the individual body as a signifier of the body politic was familiar from monarchic regimes, and cities and provinces were traditionally personified by the figure of a beautiful young woman. 'Love' in this sense is comparable with de Graeff's status as 'amateur', his knowledge, patronage and ownership of beautiful works of art. His considerable activity as a collector is indicated by the edge of the tapestry visible next to the pillar in Pickenoy's portrait.[54] In a similar way to the splendid furnishings of de Graeff's hall, the precious work of art that is Katarina Hooft bears witness to her husband's identity as a discerning, protective patrician.

In conjuction with Vos's poems, the Bicker–Tengnagel and de Graeff–Hooft pendants articulate a socio-political identity in which the masculine element is dominant. A feminine other complements and enriches a characterisation centred on the sovereign male. Paternal and conjugal love become characteristic virtues of the citizen ruler, proof of an identity which transcends exclusively personal and material concerns.[55] The Bicker pendants employed a self-consciously austere, Stoic and familial characterisation. In those of his rival de Graeff, elevated status was claimed by reference to the established social hierarchy, but intelligence and discernment were emphasised above martial virtues. Both positions were achieved without recourse to anti-naturalistic symbols or emblems which would have undermined the claim of the paintings to reflect the way things actually were.[56]

Citizen and courtly attire

The black and white apparel, austere formats and rather rigid poses characteristic of Dutch citizen portraiture form a striking contrast with the colourful modes, elaborate settings and elegantly relaxed postures which have become identified with noble self-representation. This difference seems to reflect an opposition between bourgeois and aristocratic values. Yet in the earlier seventeenth century, black and white was not a humble or puritanical wardrobe. While the Calvinist minister Willem Teellinck considered such dress as 'modest and demure' in 1626,[57] it was expensive and recognised as rich.[58] Furthermore, Amsterdam regents were not in principle disclaiming nobility by adopting this aesthetic, which had been a feature of self-representation at the Spanish court since the previous century.[59]

It is also clear that, while Amsterdam portraits remained overwhelmingly loyal to black and white until the later 1640s, colourful fashions associated with the court had long been worn on certain occasions by at least the younger and more liberal members of the elite. In Jacob Cats's popular moralising poem *Marriage* of 1625, for example, appropriate dress is a topic of debate between respectable, recently wed Sybille and flighty young Rosette. While Sybille shuns ostentation, even if one is rich, Rosette enthusiastically emulates the newest fashions:

> Hey! isn't it a beautiful thing,
> And a great delight for a maiden,
> And doesn't it look awfully chic,
> To step out in the city in courtly clothing?[60]

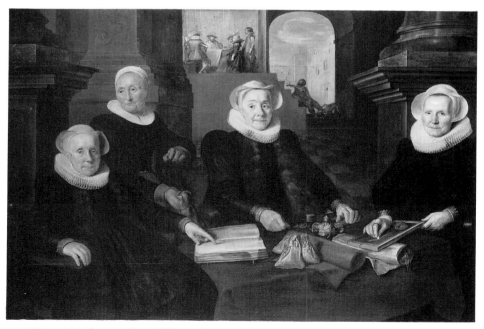

24 Werner Jacobsz van den Valckert, *Three Governors and the Matron of the Amsterdam Leperhouse*, signed and dated 1624. Oil on panel, 134 x 192 cm. The small festive scene in the background is brightly coloured and more sketchily painted than the rest.

At issue is thus not why members of the Amsterdam elite wore 'bourgeois' attire, but rather why in their portraiture they so long eschewed the new 'van Dyckian' and pastoral modes of portrayal which became popular at the Hague court from around 1630.[61] These depicted sitters dressed in light-coloured satins, typically assuming *contraposto* or *mouvementé* poses, frequently in the open air. Generalised costume, swathed drapery and sometimes the adoption of mythicised roles set the figures at one remove from spatio-temporal actuality. Such iconography, and at times virtuoso handling of the pictorial surface, expressed the courtly virtues of grace, ease and 'naturalness'.[62]

The discussion between Sybille and Rosette helps to explain why colourful court fashions were shunned in citizen portraiture. For Sybille, wearing sober black and white was indicative of her true virtue.[63] It can thus be associated with the serious, 'noble' connotations of portrayal. In Werner van den Valckert's *Three Governors and the Matron of the Amsterdam Leperhouse* of 1625 (Figure 24),[64] for example, mature women dressed in black and white are contrasted with a merry company in elaborate, colourful dress. The monumental and absolute value of individualised women is opposed to the diminutive, sketchily painted generic group. Both are gathered around tables: the merry company to partake in a sensory feast, the portrayed women to settle accounts and distribute a monetary sacrament at a secular altar. Responsible older women turn their backs on transient pleasures and selfish consumption in favour of love of the community.

In van den Valckert's image, both the dress and the mimetic depiction of the women can be associated with their claim to immortality – to the transcendent virtue which justified individual commemoration. Paradoxically, therefore, the very concerns which *linked* citizen portraiture with established concepts of nobility produced a visual *distinction* between the respectable burgher and the conspicuous, irresponsible consumption associated with youth and the court. It was in fact not opposition to noble values per se, but rather the Amsterdam elite's double claim to authority over its 'immature' fellow citizens and independence from the Hague court, which necessitated a distinctive portrayed identity.

Independence from the Hague court was important because of the political rivalry between the Stadholder and his circle in The Hague and the citizen elite, centred in Amsterdam. In 1974, J. L. Price argued that this was the dominant theme in Dutch history during the first half of the seventeenth century.[65] The Stadholder Frederick Hendrick is reputed to have remarked that he had no greater enemy than the city of Amsterdam.[66] While the anti-court Bicker faction dominated civic and provincial politics, portrayed imitation of current court fashions would have constituted an unwonted acknowledgement of the hereditary aristocracy's prior claim to power. In particular, both pastoral and van Dyckian portraiture, which frequently used exterior settings, alluded to the land, to which the hereditary nobility undeniably had a superior claim.[67]

The historical moment at which Amsterdam citizens abandoned conservative, black and white portraiture supports the view that their previously distinctive portrayed identity resulted from competition with the Stadholder for sovereignty. From the mid-1640s they increasingly began to have themselves portrayed according to the pictorial conventions which had prevailed for some two decades at the Hague court. Govert Flinck[68] and Bartholomeus van der Helst, who took up the new modes, replaced Rembrandt[69] as Amsterdam's most fashionable portraitists. The adoption of these modes coincides with the negotiation of the Peace of

Münster (1648), whereby the Dutch Republic was finally recognised as a legitimate member of the family of European sovereign states. Their complete acceptance followed the defeat and death of the Stadholder Willem II in 1650, inaugurating a Stadholderless period during which the Amsterdam regents for the first time openly dominated the political arena.

Taken together, these events meant not only that the sovereignty of the Dutch polity was formally secured, but also that this sovereignty was explicitly centred on

25 Bartholomeus van der Helst, *Gerard Andrieszoon Bicker* (1622–1666), possibly 1642? Oil on panel, 94 x 70.5 cm. Son of Catarina Tengnagel (Figure 21) and Andries Bicker (Figure 20). The similarity in size and support, and use of the same portraitist, suggest that all three works may have been painted in 1642, when Gerard was twenty. If so, the different choice of dress between the two generations is striking.

the citizen elite, rather than the hereditary nobility.[70] It was at this point that Cornelis de Graeff definitively took over from Bicker as Amsterdam's political leader. Under his aegis, citizens adopted contemporary courtly modes of representation with impunity, because the court was no longer perceived as a potent rival for power and status.

Loyalty to black and white modes of dress and established portrait formats had not been an ideal solution, because they referred back to the Habsburg court society which preceded the Revolt. The preacher Willem Teellinck for one asked what following Italian and Spanish fashions was, 'other than a pitiful sign that we will quickly bring the Spanish tyranny back upon ourselves'.[71] During a period of unprecedentedly rapid, potentially uncontrollable change, the conservative choice perhaps emerged for want of a viable alternative. In representing their elite

26 Bartholomeus van der Helst, *Lieutenant-Admiral Aert van Nes* (1625?–1693), signed and dated by van der Helst, 1668. The background scene is attributed to Ludolf Bakhuysen. Pendant to Figure 27. Oil on canvas, 139 x 125 cm. An anonymous contemporary satire poked fun at the 'half-woman like' presentation of admirals like van Nes. Tension between the mode deployed and the intended meaning is also evident in the pointing gesture, which seems to indicate the mental virtue necessary to win the battle in the background.

identity, the patriciate was caught between the old (and defeated) Spanish devil and the changeable seas of youth and the court. Black and white had the virtue of connoting stability, discipline and control.

My 'rivalry' argument does not accord with the thesis of a general 'aristocratisation' of patrician society formulated by H. van Dijk and D. J. Roorda in 1971.[72] Having noticed that high mobility into the governing citizen elite immediately following the Revolt seriously declined by the eighteenth century, they argued that this was reflected in aristocratisation in all spheres of activity. In particular, the patrician group distinguished itself from the majority of ordinary burghers by marrying within its own circle, moving into a passive, *rentier* role in economic life and adopting an aristocratic, country house lifestyle. C. H. E. de Wit pointed out that this process seemed to quicken during periods when there was no Stadholder.[73]

27 Bartholomeus van der Helst, *Gertruida den Dubbelde van Nordwijk* (1647–1684), signed and dated by van der Helst, 1668. The background scene is attributed to Ludolf Bakhuysen. Pendant to Figure 26. Oil on canvas, 139 x 125 cm. Van Nordwijk was married to van Nes on 29 January 1665, the day of his promotion to vice-admiral.

Belief in 'aristocratisation', like belief in affectionate marriage, seems to have originated in part from an understanding of portraiture as the unmediated reflection of a generic, totalising social reality. In 1962, for example, Roorda used a vivid comparison between van der Helst's portraits of Andries Bicker (Figure 20) and his eldest son Gerard,[74] 'an excessively fat and incapable debauchee' (Figure 25), to document his hypothesis. To be fair, Roorda did ask what an isolated example proves, and went on to qualify his position, but his conclusion remained that, after about 1650

there were dark sides ... Such a close relationship between economic and political power probably never existed again ... Anxious to avoid the greater risks involved in trade, the regent class began to invest a gradually increasing proportion of its capital in landed property. In this way it lost its character as a *burgher* elite, adopting a more purely seigneurial style of life, and those fashionable refinements so clearly to be seen in the portraits ...[75]

Roorda's conception of a virtuous, bourgeois republic giving way to aristocratic degeneracy has subsequently been modified by historians.[76] There is no evidence from fields of representation other than 'realist' painting (portraiture and genre) that the Amsterdam citizenry was opposed to nobility per se during the first half of the century, then rapidly reconciled to an aristocratic lifestyle around 1650. Peter Burke, for example, has shown that withdrawal from trade and commerce and investment in land occured no more rapidly after mid-century than before.[77] Leading citizens bought seigneuries and happily accepted titles from foreign courts throughout the century. For L. Kooijmans, the developed patrician lifestyle was a means of distinguishing this group from its inferiors, not a strategy of assimilation to the hereditary aristocracy.[78]

Noticeable changes in the appearance of Amsterdam portraiture around 1650 were thus a strategic alteration in one particular field of representation. While they realised the Amsterdam ruling elite's consistent socio-political aspirations to be seen as equal to the hereditary aristocracy, they did not imply the removal of all sense of difference. They were motivated by specific, significant alterations in political circumstances, and the desire to keep up to date with French fashions,[79] rather than a fundamental, self-conscious shift in attitude towards nobility.

Conclusion

This series of case studies reveals that the 'reality' constituted by Dutch portraiture during the first half of the seventeenth century cannot be identified with either external appearances or positions within a fully fledged bourgeois ideology. Rather, by adapting received, 'noble' conceptions, categories and conventions, leading Amsterdam citizens used the realist mode of portraiture to claim positions equal to, but distinct from, both the hereditary nobility and each other.

In doing so, they began to define and elaborate elite identities which did not depend upon noble blood. They acknowledged 'interior' virtues such as intelligence, genius and constancy, which became the foundations of bourgeois individuality. Rembrandt's represention of this interiorised conception of self seems always to have been appreciated by some and later became generally recognised and admired. However, in the mid-seventeenth century, van der Helst's attempts to reconcile *burgerlijk* virtue with 'aristocratic' visual codes (Figures 26 and 27)[80] were apparently more popular with the majority of Amsterdam patricians.

The persistence of aristocratic forms and values was not just ideological iner-tia. Rebellion against royal authority and the Protestant ideal of equality before God weakened the floodgates against political inundation by the wider populace. By remaining true to established premises of elite identity, the newly emancipated burgher elite helped to secure their position against this pressure from below. Aristocratic ideas and conventions of portrayal had successfully naturalised a com-plex of different hierarchies. Leading Amsterdam citizens, who themselves claimed a privileged place within these hierarchies, could not afford completely to abandon this heritage.

Even 'bourgeois' innovations reveal a concern to construct new foundations of authority. For example, Dutch portraiture visualised paternal, conjugal and communal love in ways which justified the exercise of authority over presumed inferiors. Emphasis on 'interior' virtues simply naturalised the authority of differ-ent categories of (masculine) individual. While the huge number of Dutch portraits is indicative of the unprecedentedly wide distribution of sovereignty, their uniformity subsumed them within a limited, recognisable body.

Notes

1 L. de Vries, 'The changing face of realism', in D. Freedberg and J. de Vries (eds), *Art in History. History in Art* (Santa Monica, Getty Centre, distributed by Chicago University Press, 1991), pp. 209–44, pp. 210–11, 217; F. S. Jowell, 'The rediscovery of Frans Hals', in S. Slive, *Frans Hals*, exhibition catalogue (London, Royal Academy of Arts, 1989), pp. 61–86, pp. 64–76.
2 H. Gerson (ed.), *The Masters of Past Time by Eugène Fromentin* (London, Phaidon, 1948), p. 97.
3 For example, D. Regin, *Traders, Artists, Burghers: A Cultural History of Amsterdam in the 17th Century* (Assen, Van Gorcum, 1976), pp. 54, 128–9; L. de Vries, 'Realism', esp. p. 216.
4 H. P. Chapman, *Rembrandt's Self Portraits. A Study in Seventeenth Century Identity* (Princeton, Princeton University Press, 1990), p. 4.
5 D. R. Smith, *Masks of Wedlock. Seventeenth Century Dutch Marriage Portraiture* (Ann Arbor, UMI, Studies in the Fine Arts: Iconography no. 8 (1978), 1983), pp. 167–8.
6 A. J. Adams, *Public Faces, Private Identities* (New York and Cambridge, Cambridge University Press, forthcoming).
7 H. F. K. Van Nierop, *The Nobility of Holland: From Knights to Regents*, trans. M. Ultee (Cambridge, Cambridge University Press, 1993).
8 J. Aalbers and M. Prak, *De Bloem der Natie. Adel en Patriciaat in de Noordelijke Nederlanden* (Amsterdam, Boom Meppel, 1987).
9 L. Althusser, 'Ideology and ideological state apparatuses (notes towards an investiga-tion)', in *Lenin and Philosophy and Other Essays*, trans. B. Brewster (New York, Monthly Review Press, 1971), p. 162.
10 My arguments develop a lecture published in *Dutch Crossing*, 42 (1990), pp. 34–68.
11 R. Ekkart, 'Painted immortality. Portraits in the Mauritshuis', in H. R. Hoetink (ed.), *Art Treasures of Holland. The Royal Picture Gallery Mauritshuis* (Amsterdam and New York, Meulenhoff/Landshoff, Harry N. Abrams Inc., 1986), pp. 81–2.
12 *Manuel Denis (Diniz), De la Pintura Antigua por Francisco de Holanda (version castellana por Manuel Denis)*, ed. E. Tormo y Monzo (Madrid, Real Academia de San Fernando, afterwards Academia de Bellas Artes de San Fernando, 1921), pp. 255–6.
13 *Trattato dell'Arte della Pittura, Scultura, ed Architettura di Gio. Paolo Lomazzo*, 3 vols (Rome, Biblioteca Artistica, 1844), II, pp. 367–8.
14 H. Iunius, *Batavia. In qua praeter gentis et insulae antiquitatem, originem, decora, mores, aliaque ad eam historiam pertinentia, declaratur quae fuerit vetus Batavia etc.* (Leiden, 1588), pp. 318–19 (Dutch edition, Delft, 1609). Junius's view were not atypical: Van Nierop, *The Nobility of Holland*, pp. 29–31.

15 J. E. Elias, *De Vroedschap van Amsterdam 1578–1795*, 2 vols (Haarlem, n.p., 1903–5); E. W. Moes, *Iconographia Batava: beredeneerde lijst van geschilderde en gebeeldhouwde Portretten van Noord-Nederlanders in Vorige Eeuwen* (Amsterdam, n.p., 1897–1905); G. Schwartz, *Rembrandt, His Life, His Paintings* (London, Viking, 1985); articles by I. H. van Eeghen and S. A. C. Dudock van Heel, especially in *Jaarboek Amstelodamum* and *Maandblad Amstelodamum*.

16 Antwerp? *c.*1576 – Amsterdam 1624.

17 O. Millar, *The Tudor, Stuart and Early Georgian Pictures in the Collection of Her Majesty the Queen*, 2 vols (London, Phaidon, 1963). E.g. attr. to J. van Doort, *Charles I*, cat. 113, I, p. 84, II, pl. 60; Daniel Mytens, *Charles I* , cat. 118, I, pp.85–6, II, pl. 48.

18 J. Held, 'Le Roi à la chasse', *Art Bulletin*, 40 (1958), p. 148.

19 J. Christyn, *Jurisprudentia Heroica de Jure Belgarum circa Nobilitatem* (Brussels, Balthazar Vivien, 1668), p. 98.

20 Holders of city-based governing office. R. Kistemaker and R. van Gelder, *Amsterdam. The Golden Age 1275–1795* (New York, Abbeville, 1983), pp. 107–10 and *passim*.

21 G. Luiten *et al.* (eds), *Dawn of the Golden Age. Northern Netherlandish Art 1580–1620*, exhibition catalogue (Amsterdam, Rijksmuseum, 1993–4), pp. 598–9.

22 Elias, *Vroedschap*, I, pp. 391–6 (no. 127); Luiten *et al.*, *Dawn of the Golden Age*, pp. 598–9: P. Burke, *Venice and Amsterdam. A Study of Seventeenth Century Elites* (London, Temple Smith, 1974), pp. 74, 76.

23 De Vries, 'Realism', pp. 212–13.

24 'In den gouden Reael'. Elias, *Vroedschap*, I, p. 39. For puns: Burke, *Venice and Amsterdam*, p. 93.

25 Elias, *Vroedschap*, I, p. 391. Baptised 1608, still living 1657. Not painted by Van der Voort.

26 The pendants remained in the Reael family. No changes to the composition were noticed in Luiten *et al.*, *Dawn of the Golden Age*, pp. 598–9,

27 Van Nierop, *The Nobility of Holland*, pp. 220–1. Cf. Chapman, *Rembrandt*, p. 5; De Vries, 'Realism', p. 216.

28 Haarlem 1613 – Amsterdam 1670.

29 *Nieuw Nederlandsch Biografisch Woordenboek*, ed. P. C. Molhuysen and P. J. Blok, 10 vols (Leyden, Sijthoff, 1911–37), X (1937) cols 60–2. Elias, *Vroedschap*, I, pp. 346–8 (no. 110). For factional politics: J. Israel, *The Dutch Republic, Its Rise, Greatness and Fall 1477–1806* (Oxford, Oxford University Press, 1995), pp. 393–546.

30 L. Stone, *The Family, Sex and Marriage* (London, Weidenfeld and Nicolson, 1977), p. 85.

31 For example, S. Marshall, *The Dutch Gentry, 1500–1650. Family, Faith and Fortune* (New York, Greenwood Press, 1987), p. 9 and *passim*.

32 *Nederlandsch Biografisch Woordenboek*, III, cols 1347–9. G. Weber, *Der Lobtopos und des 'lebenden' Bildes. Jan Vos un sein 'Zeege der Schilderkunst' von 1654* (Hildesheim, G. Olms, 1991).

33 J. Vos, *Alle de Gedichten van den Poëet Jan Vos, Verzamelt en uitgegeven door J.L. [Jacob Lescaille]* (Amsterdam, Jacob Lescaille, 1662), pp. 150–1. My translations.

34 J. Emmens, 'Ay Rembrandt, maal *Cornelis* stem', *Nederlands Kunsthistorisch Jaarboek*, 6 (1956), pp. 133–65.

35 R. Lee, *Ut Pictura Poesis. The Humanistic Theory of Painting* (New York, Norton, 1967 edn), Introduction.

36 Cf. C. Pace, '"Delineated lives": themes and variations in seventeenth century poems about portraits', *Word and Image*, 2 (1986), pp. 1–17.

37 S. Schama, *The Embarrassment of Riches: An Interpretation of Dutch Culture in the Golden Age* (London, Collins, 1987), pp. 385–6; Johan van Beverwijk, *Van de Wtnemenheyt des Vrouwelicken Geslachts*, 2nd edn (Dordrecht, 1643), pp. 206–12.

38 Pieter de Jode's titlepage to J. Cats, *Houwelick dat is De gantsche gelegentheyt des Echten-Staets ...* (Middelburg, Jan Pietersz. van de Venne, 1625); B. M. du Mortier, 'De handschoen in de huwelijkssymboliek van de zeventiende eeuw', *Bulletin van het Rijksmuseum*, 32 (1984), pp. 189–201; E. de Jongh, *Portretten van echt en trouw. Huwelijk en gezin in de Nederlandse kunst van de zeventiende eeuw*, exhibition catalogue, Haarlem, Frans Halsmuseum (Zwolle, Waanders, 1986) and *Kent en Versint. Eer datje Mint. Vrijen en Trouwen 1500–1800*, exhibition catalogue (Historisch Museum Marialust, Apeldoorn, 1989).

39 J. Spicer, 'The Renaissance elbow', in J. Bremmer and H. Roodenburg (eds), *A Cultural History of Gesture: from Antiquity to the Present Day* (Cambridge, Polity Press, 1991), pp. 84–128, esp. p. 98.

40 The conservative millstone ruff is indicative of the simplicity of the Bickers' dress. Contrast Rembrandt's portrait of the fur-trader Nicholas Ruts, s. and d. 1631 (New York, Frick collection).

41 J. Lemprière, *Lemprière's Classical Dictionary*, 1st edn 1788 (London, Bracken Books, 1994), pp. 123, 147–8, 168.

42 J. I. Pontanus, *Historische Beschrijvinghe der seer wijt broemde coop-stadt Amsterdam* (Amsterdam, Iudocum Hondium, 1614), p. 290.

43 First stone laid 1648. A. Blankert, *Kunst als regeringszak in Amsterdam in de 17de eeuw* (Lochem, Mij. De Tijdstroom B.V., 1975), pp. 13–18.

44 'Cato' may refer to Cato 'Censorius' or Cato 'Uticensis'. Lemprière, *Classical Dictionary*, pp. 147–8. Kistemaker and Van Gelder, *Amsterdam*, p. 109.

45 Regin, *Traders*, pp. 164–5.

46 Nicolaes Eliasz, called Pickenoy (Amsterdam 1590/1 – Amsterdam 1654–6). S. Slive, *Frans Hals*, p. 9 questions the attribution.

47 *Woordenboek*, II, cols 490–7. Elias, *Vroedschap*, I, pp. 422–3 (no. 144).

48 De Graeff awarded Vos the contract to glaze the new Town Hall and was the dedicatee of his poem, *Zeege der Schilderkunst* (cf. n. 32).

49 Vos, *Alle de Gedichten*, pp. 194–6. My translations.

50 Vos, *Alle de Gedichten*, p. 141. Cf. lines 468–80 of Vos's *Zeege der Schilderkunst*, which concern portraiture. Lines 476–7: 'He who has a brain is impelled to virtue / In the hope of his earthly immortality'.

51 Cf. C. Chauchadis, *Honneur, morale et société dans l'Espagne de Philippe II* (Paris, CNRS, Centre Régionale de Publications de Toulouse Amérique Latine-Pays Ibériques, 1984), ch. 1, esp. p. 17.

52 Elias, *Vroedschap*, I. no. 144, p. 422 citing Melchior Fokkens, *Beschrijvingh der ... koop-stadt Amsterdam* (Amsterdam, 1662), p. 73: 'een cierlijk Huis van binnen kostelijk getimmert' 'Lord's canal' = *Herengracht*.

53 Cf. Rembrandt's *Maerten Soolmans*, s. and d. 1634, and *Oopjen Coppit* (Paris, private collection), shown by Marieke de Winkel to be marriage portraits (unpublished paper, 1994).

54 A. C. Dudock van Heel, 'Het maecenaat de Graaf en Rembrandt', *Maandblad Amstelodamum* (Amsterdam, Genootschap Amstelodamum), 56 (1969), pp. 150–5 and 249–53.

55 Cf. J. Barrell, 'The public prospect and the private view: the politics of taste in 18th century Britain', in S. Pugh (ed.), *Reading Landscape. Country – City – Capital* (Manchester, Manchester University Press, 1990), pp. 19–40, pp. 19–20.

56 De Graeff's misformed jaw, the result of an childhood accident, is not evident in Pickenoy's portrait. *Woordenboek*, II, cols 490–7.

57 W. Teellinck, *Den Spieghel der Zedigheyt, Aen de Gemeynte Christi binnen Middelbergh* (Amsterdam, 1626), p. 37.

58 I am indebted to Marieke de Winkel for her generous advice and information on dress. E. van Reyd remarked that in about 1596 Hollanders went 'Raik in 't swart' (richly in black), *Historien der Nederlandsche Oorlogen* (Arnhem, 1626), p. 275. Cf. I. Groeneweg, 'Regenten in het zwart: vroom en deftig?', *Nederlands Kunsthistorisch Jaarboek*, 46 (1995), pp. 199–251.

59 Cf. J. Schneider, 'Peacocks and penguins: the political economy of European cloth and colours', *American Ethnologist*, 5 (1978), pp. 413–47.

60 Cats, *Houwelijk*, p. 22; cf. Sybille's position, p. 21. My translation. Merry companies by Dirk Hals, Jan Miensz, Molenaer etc., and strictures against coloured dress in Teellinck, *Den Spieghel*, p. 37, also show that it was being worn by some people.

61 Leading portraitists: Van Honthorst, Hanneman, Jan Mytens. A. Kettering, *The Dutch Arcadia: Pastoral Art and its Audience in the Golden Age* (Montclair, Allanheld and Schram, 1983).

62 Cf. J. Muller, 'The quality of grace in the art of Anthony van Dyck', in A. K. Wheelock *et al., Van Dyck: Paintings*, exhibition catalogue (Washington, Brussels and London, National Gallery of Art and Thames and Hudson, 1991), pp. 27–36.

63 Cats, *Houwelijk*, p. 21.

64 The Hague? *c.* 1585 – Amsterdam? *c.* 1627.

65 J. L. Price, *Culture and Society in the Dutch Republic during the Seventeenth Century* (London, Batsford, 1974), ch. 2, esp. pp. 16, 22–5.

66 Quoted in Burke, *Amsterdam and Venice*, p. 45, no date or source given.

67 Barrell, 'Public prospect', pp. 30–1.

68 Cleves 1615 – Amsterdam 1660.

69 Leiden 1606 – Amsterdam 1669.

70 The 1649 execution of Charles Stuart and inauguration of the interregnum in England doubtless also enhanced the Dutch burghers' confidence.

71 Teellinck, *Spieghel*, p. 40. Cf. his previous injunction against wearing colours (p. 37) – a sartorial dilemma.

72 H. van Dijk and D. J. Roorda, 'Sociale mobiliteit onder regenten van de Republiek', *Tijdschrift voor Geschiedenis*, 84 (1971), pp. 306–28.

73 L. Kooijmans, 'Patriciaat en aristocratisering in Holland tijdens de zeventiende en achtiende eeuw', in Aalbers and Prak, *De Bloem der Natie*, pp. 93–103, p. 93.

74 Elias, *Vroedschap*, I, pp. 346–7 (no. 110): 1622–1666, m. Alida Coninck 1656.

75 D. J. Roorda, 'The ruling classes in Holland in the seventeenth century', in J. S. Bromley and E. H. Kossman (eds), *Britain and the Netherlands* (Groningen, J. B. Wolters, 1964), pp. 109–32, pp. 127–8. Cf. his references to 'black and white' portraiture, pp. 120, 123.

76 Burke, *Venice and Amsterdam*; Aalbers and Prak, *De Bloem der Natie*; Van Nierop, *The Nobility of Holland*; A. T. van Deursen, *Plain Lives in a Golden Age*, trans. M. Ultee (Cambridge, Cambridge University Press, 1991).

77 Burke, *Venice and Amsterdam*, pp. 57, 60.

78 Kooijmans, 'Patriciaat en aristocratisering', esp. pp. 98–100.

79 Cf. W. Franits, 'Young women preferred white to brown: some remarks on Nicolaes Maes and the cultural context of late seventeenth-century Dutch portraiture', *Nederlands Kunsthistorisch Jaarboek*, 46 (1995), pp. 395–415.

80 S. S. Dickey, 'Bartholomeus van der Helst and Admiral Cortenaer: realism and idealism in Dutch heroic portraiture', *Leids Kunsthistorisch Jaarboek* (Nederlandse Portretten. Bijdragen over de Portretkunst in de Nederlanden uit de Zestiende, Zeventiende en Achtiende Eeuw), 8 (1989), pp. 227–46, pp. 241–2, n. 34, acutely noting that the pointing gesture may indicate constancy.

4

Medical men 1780–1820

LUDMILLA JORDANOVA

The centrality of portraiture for the social construction of identity can be vividly illustrated by the history of occupations, especially those that had to assure themselves and others of their value. There is no better example of this than the medical profession, which in the eighteenth and early nineteenth centuries was not in fact a single body but an assortment of diverse individuals with varied trainings, status and incomes. Nonetheless, even in the absence of a single licensing body, there was a growing sense of collective identity, which was nurtured by the belief that medicine, properly practised, followed certain rules and conventions. Some of these concerned the nature of medical knowledge, while others related more to the medical man himself – to his deportment, manners, and personal style. His character was of central importance not just for his success as an individual practitioner but for the reputation of his chosen occupation. One of the most important reasons for the broader medical significance of 'character' was the controversial nature of medicine itself. Satires on medics were commonplace; they were frequently depicted as vain, greedy, incompetent and immoral. Practitioners were extremely sensitive to such charges, and were active not just in repudiating them but in creating alternative images. Two related devices for generating another view of medicine were biography and portraiture. Portraiture is of particular interest not just because it constitutes a rich, yet little exploited source for the history of medicine as an occupation, but also because in the late eighteenth and early nineteenth centuries it can be interpreted as a coherent visual response to the vicious attacks on doctors by caricaturists.

There have been few times in human history when scepticism about organised medicine was absent. In the eighteenth century practitioners were especially vulnerable, however. Their numbers grew, with the result that competition for patients was intense and economic insecurity was a constant threat. Surgery was perceived as brutal. The growth of man-midwifery elicited powerful emotional responses from those who saw it as a sexual and moral danger to the nation. The increasing practice of dissection raised fears about transgressing the boundary between life and death. Many people felt that medicine was promising far more than it could actually deliver. Since there was no effective licensing system, 'quackery' was always a source of anxiety. This concern was felt more by practitioners

than by patients, since the latter were happy to try whatever remedies offered hope. The unseemly squabbles between practitioners who thought of themselves as regular professionals and those they designated 'quacks' could hardly fail to bring the field into disrepute.[1] It is in this context that portraits of medical practitioners from the late eighteenth and early nineteenth centuries need to be viewed. They presented the body of the practitioner both to his peers and to a general audience and constituted images that served to defuse the dangers of medicine by showing it to be rooted in reliable men.

It would be misleading, however, to suppose that there was a single model for medical portraiture in this period. In fact there were a number and they shifted over the period. While it will not be possible to trace here all the types of medical portraits or to chart their transformations, some preliminary general remarks are appropriate. A marked growth in the numbers of portraits took place in the medium of print, a reflection of the increase in printed matter generally and in medical publications specifically. Thus a significant proportion of practitioners were depicted, not only the elite, fashionable or famous. Over the eighteenth century, however, many portraits continued to display the great learned doctors, often accompanied by a bust of Hippocrates and a selection of books. By the very end of the century other images of medical heroism were beginning to emerge in which specific visual signs of medicine itself were included. By the second or third decade of the nineteenth century such heroism was less bookish and more associated with scientific achievement and/or clinical prowess. Gradually, presenting medics as classical figures became less attractive. To say that portraits depicted 'reliable' men sounds rather dull, even incompatible with the growing interest in heroism, but the adjective is apt for that time. Practitioners had to be reliable in the sense of safe, well-mannered, dependable. It was also their knowledge that aspired to be reliable, that is, to be based on observation, to accord with the most modern scientific insights. Hence the notion of 'reliable man' applied to both the general practitioner and the medical innovator. And *man* is the operative word. Regular practitioners, apart from midwives, were indeed men, and were depicted as such, that is, as politely manly, while any indications of coarseness were to be strenuously avoided.[2]

In presenting my material in this way I am assuming that groups, such as occupations, seek shared social identities that serve their sense of themselves as a distinct constituency and that operate as vehicles for their aspirations.[3] However, I resist explaining this principally in terms of interests, social mobility and professionalisation, preferring to stress the role of representations in offering possibilities for individual and collective identification. The notion of 'identification' may be worth considering in more depth. I have in mind three distinct yet related meanings. First, the subject of the portrait had to be identifiable, that is, not just capable of being named, but also of being located in a framework that specified his place in medicine. It was important to know whether an individual was a great teacher, a local benefactor, a revered clinician, or a contributor to medical knowledge. It was not that these were mutually exclusive roles, but they were significant niches in eighteenth-century medicine. Second, then, the subject had to be identified as having made an appreciable contribution. This was of increasing importance over the century. Whereas in the early eighteenth century noted doctors were often literary figures, scholars, or local worthies, by its end their specifically medical achievements were of enhanced importance. Thus individuals

could still be celebrated as writers or locals, but there was a growing need to chart, quite precisely, the manner in which they had contributed to their chosen profession. This was bound up with the idea that medical men were set apart both by their sustained concern to improve the well-being of humankind and by their ability to actually deliver these goods based on their medical knowledge. Third, the subject was to be identified *with*, in the sense that portraits were exemplary. I believe this remained the case, even where the individual portrayed was not acknowledged as a great man. Medical portraits, while not only seen by other practitioners, served an important function within a peer group.[4] They made up a kind of visual repertoire, so that an individual could form a sense of his occupation through the faces of his fellow practitioners, most of whom he never met, saw or worked with. And when viewing images of medical heroes, he could imagine himself in their place.

The account I have just given of 'identification' in relation to medical portraits necessarily rests on a general assessment of the social and cultural position of medicine in a specific historical context. In a sense the argument remains speculative since, by their very nature, direct evidence on these matters is rare. Nonetheless the account I am giving in this chapter draws upon a sophisticated historiography that works to give eighteenth and early nineteenth-century medicine a full and rich cultural presence.[5] This provides historians with a sense of the imagery required to give medical practitioners more status, a better reputation with the general public, and a desirable social identity. For occupational identities to have any effect they have to be represented in a form that meets highly specific criteria, over which the group in question usually has little control. To the extent that medical practitioners had a formal collective identity, it was through corporations, of apothecaries, surgeons and physicians, but these excluded many practitioners, and were widely seen as anachronistic, corrupt, or irrelevant. Medics were not held in high regard in popular culture – they were the butt of jokes and satire, and vulnerable to associations with butchery, grave-robbing and quackery (Figure 28). Socially they were extraordinarily diverse, some were rich and titled (but generally only knighthoods), others were relatively poor and lived modestly, while levels of education and expertise, however these are measured, varied dramatically. The quite self-conscious attempts to forge a new collective identity involved promoting the idea that more or less uniform standards of expertise, care, morality and ethics could be guaranteed. In the late eighteenth and early nineteenth centuries, the means of doing this were less institutional than they were personal. New identities were to be carried in individual practitioners, who literally embodied a new professionalism. In seeing the individual, one was to call to mind the value of the group, the manner in which it made manifest its social worth.

A significant proportion of medical practitioners were being portrayed by 1800. It is true that over the century some had been depicted because they were also or mainly writers, savants, members of coteries, or whatever, but in terms of the total number of images produced, these are the minority. In the medical world of the eighteenth century, publication was valued, especially if it conformed to certain tacit criteria – not for profit, based on observation and clinical experience, dedicated to advancing medicine both as knowledge and as humanitarian endeavour. Sometimes portraits were used as frontispieces to publications, or more often to collected works. Sometimes they adorned the pages of magazines, such as the *Gentleman's Magazine* or the *European Magazine* (see Figure 29). Sometimes they

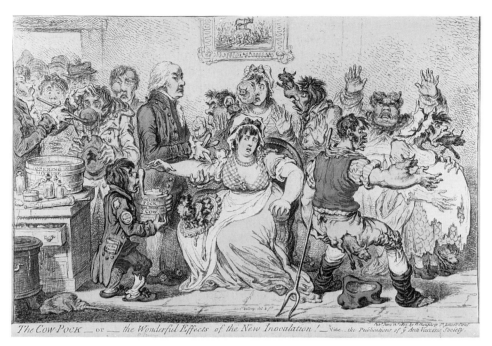

The COW-POCK — or — the Wonderful Effects of the New Inoculation! — Vide. the Publications of y Anti-Vaccine Society.

28 James Gillray, *Edward Jenner among Patients in the Smallpox and Inoculation Hospital at St Pancras*, 1802. Coloured etching, 24.8 x 34.9 cm.

were designed for or were allocated to an institutional home. And an increasingly important outlet was collected biographies. Furthermore, it seems reasonable to suppose that a wide range of individuals bought portraits in print form for their own personal use. By the end of the century, portraits of medical men existed in large numbers and in many media.

Yet, there was also a tendency to rely on established formulae. This is hardly surprising, given that medicine was a highly unstable activity, desperately seeking legitimation, through its past as much as through its present.[6] Portraits of Hippocrates, Galen and other ancients abound, and written accounts insisted that it was indeed possible to know what they had looked like. Various classicising devices were common, although they became less so in the early nineteenth century. Nonetheless they persisted, and the effacement of contemporary details that they permitted was, I contend, extremely important for medicine, especially given its vulnerability to satire, since they invested doctors with a universal aura of quasi-ancient wisdom. The continued identification of medical practitioners with their ancient predecessors helped achieve some of their cultural aims, but laid them open to the charge of being archaic, that is, not modern, and medicine, like other forms of natural knowledge, was deeply committed to its conspicuous modernity, that is, to the representation of its own 'modernness'.

Medical identities were being built around a middle-class ideology, of merit, education, first-hand observation, of progress and reform.[7] This ideology was presented as if it were classless. However, these values, especially when embodied in medical practitioners, could smack of rationalism and materialism, that is, of attempts to subvert an old established order based on rank and established

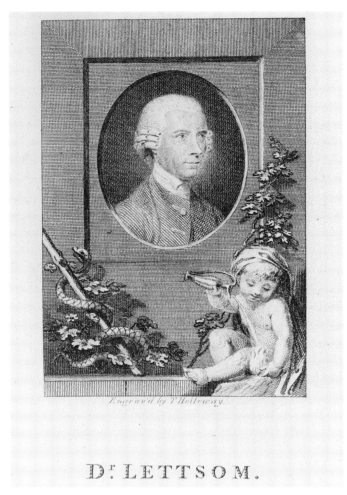

D.ᴿ LETTSOM.

29 T. Holloway, *John Coakley Lettsom* (1744–1815), line engraving from the *European Magazine*, 1787, 17.3 x 11.2 cm. Lettsom was a well-known medical practitioner, a Quaker and philanthropist.

religion. The fear of medical materialism, heightened by the French Revolution and the prestige of French clinical medicine, was focused not so much on the philosophical or even the political positions practitioners espoused as on a rather vague sense of moral threat. It was no matter that in reality most doctors were conventional in their religious, political and philosophical views; their practice touched so many taboo areas, and was increasingly felt to do so in the 1790s, that their modernity was dangerous, or potentially so. And they had no established place in a traditional hierarchy to fall back on. Medical practitioners were somewhat anomalous in the social order. I believe this situation accounts for a number of the most notable features of medical portraiture in the period.

Most portraits in print form were of head and shoulders only, and although it is possible to see that they depict a specific person, the individuality was generally kept within strict bounds. In so far as claims were made through portraits for the

importance of the represented person and their chosen field, universalist notions were employed. The appeal to universal values can be demonstrated by portraits of Edward Jenner (1749–1823) (Figure 30), who was a medical hero not only in his own time, but for succeeding generations. It was Jenner who developed vaccination, a much safer and easier procedure than inoculation. The prevention of smallpox was one of the few great medical triumphs of the eighteenth century, and, despite being controversial, these preventive procedures were invested with enormous emotional significance since they helped people to avoid the facial disfigurement that had been such a common experience and to protect their young children against a disease that was often fatal to them.[8] Jenner was one of the individuals of the period who was most often represented; the Wellcome Institute collection, for instance, contains forty-five portraits. Not all of these were produced in his lifetime – his nineteenth-century afterlife is notable. Jenner is an important case because he could easily be identified with an innovation that benefited humanity as a whole, thereby facilitating the production of a generalised philanthropic imagery that celebrated the modernity of medicine and its practitioners, yet in a safe way. Those portraits bearing inscriptions bear out the point: 'Les médecins et les administrations reconnaissants – Monument à Jenner' and 'A Edward Jenner – La France Reconnaissante'.[9]

The celebration of individuality, even eccentricity, was possible in a small number of cases, in which hero status could plausibly be conferred, but the precise nature of the heroism had to be carefully controlled and monitored. Some clues to these processes may be found in the specificity of the accoutrements included. As James Northcote (1746–1831) put it in relation to his second portrait of Jenner (1803), ' I have introduced the bones and joints of a Cows hoof and in a glass case the Cows hoof injected, all which is to show what were his peculiar Studies'. In this portrait, which shows Jenner resting his head on his hand, that is, as a thoughtful, studious man, parts of a cow stand for vaccination. Jenner's achievement was celebrated as both a universal benefit and a specifically British achievement. Indeed, Jenner became part of a national pantheon; this is made clear in his inclusion in *Men of Science Living in 1807–8*, purchased by the National Portrait Gallery in 1896, and produced in the 1850s. It was not information that Northcote was conveying, rather he evoked Jenner's specific form of heroism. His painting was offered to the National Portrait Gallery in 1859; for its owner it was 'an excellent likeness of my deceased friend and ... a memorial of one of the great benefactors of mankind'.[10]

Although celebrating too many medical heroes might have posed problems – it debases the coinage of genius – clearly more than one was needed if medicine was to acquire the public image and social power to which so many practitioners aspired. We should note that associations between medicine and nation constitute an important element in the story since, by the early nineteenth century, the idea that scientific achievement reflected well upon, and indeed grew out of, a national setting was current.[11] It does not seem too fanciful to suppose that, even if it was not made explicit, suitable figures were in effect chosen for the role of medical hero, and that those who emerged most strongly did so precisely because their image could carry, or be made to carry, the complex and contradictory demands I have sketched in here. By the early nineteenth century, a number of living candidates had emerged who embodied qualities their peers wished to emulate – respectable, learned, rich, beneficent, socially accepted and rewarded, with a faint

dash of romance – but the most powerful hero figure by a considerable margin was the safely dead John Hunter (1728–1793). I shall use portraits of him, and of his older brother William (1718–1783), to explore further some of the themes I have already mentioned. The Hunters constitute an unusually rich case study with regard to portraiture. Both were much represented, both were interested in the visual arts and were substantial collectors, both were successful and well-known in the medical world, although in significantly different ways.

William Hunter was a surgeon, anatomist, midwife, and physician; he held a royal appointment, collected coins, medical objects and paintings, notably by Chardin, and produced one of the most visually splendid medical publications of the eighteenth century. His obstetrical atlas of 1774 was in a sense a collection of

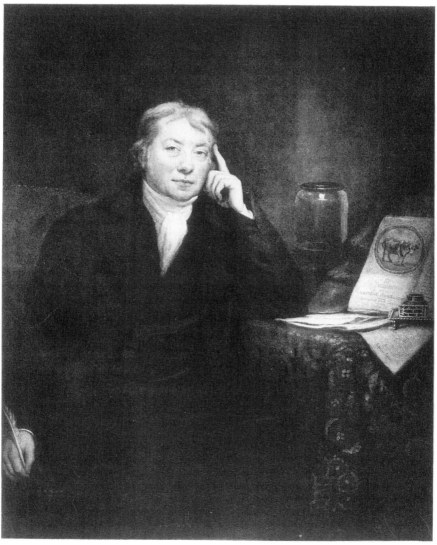

30 *Edward Jenner* (1749–1823), photogravure after J. Northcote's 1803 portrait, no artist or date known. 23.75 x 18.5 cm (mount 44.8 x 34 cm).

portraits, since every plate was based on the dissection of a single individual, with meticulous attention being paid to detailed particularities (see Figure 31). Although the dissected subjects were not named, they were numbered, allowing the various images of a particular woman to be identified. William Hunter was also the first professor of anatomy at the Royal Academy.[12] There is a gorgeous portrait of him by his friend Allan Ramsay (1713–1784) (Figure 32), of which the exact date of composition is unknown, but it is suggested by Alistair Smart to be 1764, to coincide with Hunter's appointment as Physician Extraordinary to Queen

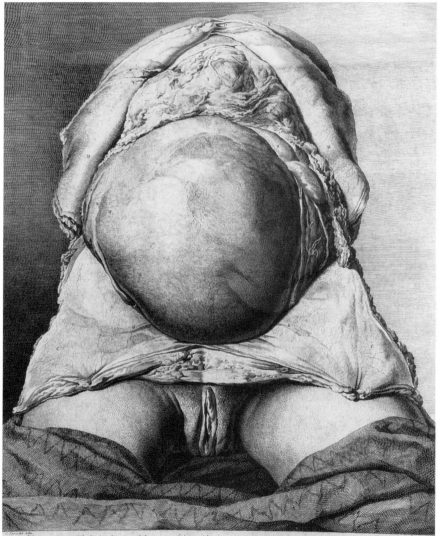

31 William Hunter, *Anatomia Uteri Humani Gravidi*, 1774, plate 1. Line engraving by F. S. Ravenet from a drawing by Jan van Rymsdyk, 53.5 x 42.5 cm.

Charlotte.[13] Commentary on this portrait has found in it what is already known about Hunter, such as his austerity and his love of Chardin. Looked at contextually, it appears somewhat different. Hunter was a well-known figure in mid-eighteenth-century London (he had moved there in 1741), not just because of his material success, but because he practised the most notorious part of medicine, man-mid-wifery. Gossip surrounded him, much of it fuelled by himself, concerning his role in helping women of the aristocracy get rid of unwanted children. As an active anatomist, his dissecting activities were also considered somewhat dubious.

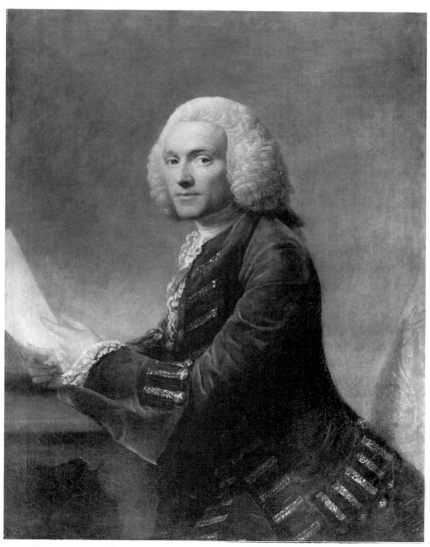

32 Allan Ramsay, *William Hunter* (1718–1783), *c.* 1764. Oil on canvas, 95.9 x 74.9 cm. It is possible to see multiple identifications here: Ramsay and Hunter with Chardin, a painter they both admired; Ramsay with Hunter, his friend, a fellow Scot and an art collector; and Hunter with polite culture.

Although Hunter was himself 'respectable', the figure of the man-midwife attracted violent emotions. Those who deplored the involvement of men in birth heaped on them dramatic accusations, which hinged precisely on their masculinity – they were seducers of vulnerable if silly, fashion-conscious women. Such seductions allegedly endangered national well-being. Hence in their negative image, men-midwives embodied male desire and greed.[14] William Hunter was vulnerable on precisely these counts: a self-made man, financially ambitious, known to offer assistance to a decadent aristocracy. Looked at from this vantage point, Ramsay's portrait is a masterpiece of denial. There are no medical or scientific accoutrements here, no marks of occupation, but a sensuality of surfaces and textures that happen to be associated with William Hunter. Ramsay offered a vision in which the complexities and conflicts of Hunter's life and of his profession played no part. There are many other portraits of William, painted, printed and in the form of medals, and most share these characteristics, even if they are not as glorious, visually speaking. In one, there is a medical accoutrement, an écorché, the acceptable cultural face of medicine, since it evokes the study of art as well as of anatomy, not everyday medical practice. In another there is a hint of a bone.[15] These are the exceptions.

In the mid-eighteenth century such images served their purpose, since they encouraged the viewer not to dwell on specific qualities associated with medicine, but on more general features that happened, contingently, to be displayed by a medical practitioner. In terms of making specific claims on behalf of a social group, this imagery had distinct weaknesses. That is, unless some qualities were present that could be associated with medicine, then claims about progress, reform, modernity deriving uniquely from this particular form of natural knowledge could not be advanced. Such claims rested, in fact, on asserting the close affinities between medicine and the authority and certainty of science. In other words, if power were to be rooted in science as a kind of knowledge that was socially and epistemologically restricted, a form of imagery would be required to promote the specialness of scientific medicine. Such imagery also had to manage the subversive potential within medicine, the taboos upon which it touched.

In his portrait of John Hunter, Sir Joshua Reynolds (1723–1792) (Figure 33) was exceptionally successful in doing just this. In some ways, Reynolds responded acutely to the material he was given. John Hunter had built his self-imagery more around his general scientific than around his specifically medical or clinical skills. He constructed a comparative anatomy museum almost as an open memorial to his own achievements, and by extension to those of his profession – surgery. A careful distinction was implicit here between surgery and medicine, although it could be dispensed with when it was advantageous to do so. In the nineteenth century John Hunter was idolised as a great scientist, as the creator of scientific medicine, as a national hero.[16] Reynolds provided the raw visual material for this nineteenth-century cult, which has continued into the twentieth century. His painting was made into prints many times: the Wellcome collection contains at least sixteen versions, produced between the 1780s and the 1840s.[17]

The appeal of the Reynolds portrait lay in three characteristics. First, John Hunter was somewhat notorious for his lack of charm, and for his aggressive professional behaviour. As the *Dictionary of National Biography* put it: 'Hunter was impatient, blunt and unceremonious, often rude and overbearing'. The Reynolds portrait played down this side of him; the biographical article further

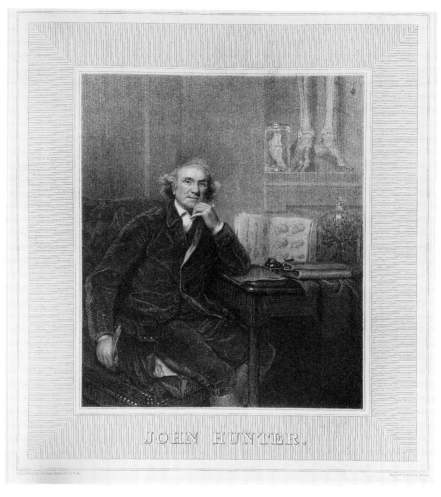

JOHN HUNTER.

33 J. Shury, *John Hunter* (1728–1793), 1829. Stipple engraving, after the painting by Sir Joshua Reynolds, 1786, 14.3 x 11.6 cm.

noted his 'short neck', and 'strongly marked ... features', but continued, 'the fine portrait by Sir Joshua Reynolds (painted in May 1785) ... was a happy and sudden inspiration due to Hunter's falling into a reverie '![18] Incidentally, their dating may be wrong; others have suggested it was painted in 1786. Reynolds refashioned John Hunter, softening his character, in ways that fitted neatly with contemporary assumptions about men of science. Second, the portrait used a format that was increasingly favoured by those who depicted major scientific and medical figures over the next four decades or so: a full-length or three-quarters seated position, next to a table, with head on hand. What this achieves is a pensive, contemplative quality, with its own form of denial. This is not a man of action, but a man of thought.[19] It was only from the mid-nineteenth century that medical figures could be represented as heroically active, as commanding, physically and symbolically, a terrain securely their own, such as the interiors of working laboratories or hospitals. Reynolds's formula associates Hunter with other kinds of men, such as

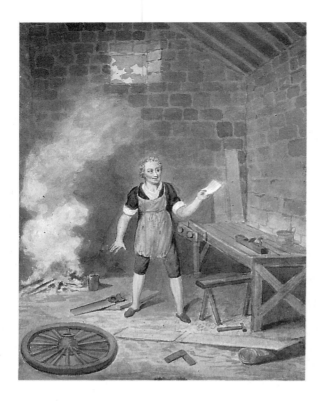

34 *The Invitation*, watercolour, presumably by Jesse Foot, p. 20 from the Grangerised version of his *Life of John Hunter*, published in 1794, Grangerised 1822, 24.5 x 19.7 cm. 'A wheel wright or a carpenter he [John Hunter] certainly was, until the event of William Hunter becoming a public lecturer in anatomy, changed the scheme of his future occupations, and determined him to accept the invitation of his brother: to lay down the chissel, the rule and the mallet, and take up the knife, the blow pipe and the probe' (Foot, *Life*, 1794, p. 10).

churchmen and lawyers; he is presented as more of head than of hand, that is, the safer, more intellectual sides of medicine are emphasised.[20] At the same time, and this is the third feature, Reynolds managed to convey quite brilliantly the specificity of Hunter's endeavour, in the open comparative anatomy book and the skeleton above all, without giving the slightest suggestion of butchery, grave-robbing, experimentalism, or the horrors of dissection. Reynolds evoked Hunter's innovative knowledge without suggesting its transgressive potential or the dubious practices upon which it might have been based.

Reynolds supplied the medical world with an icon, or rather with an image possessing the capacity to become an icon, since, for this to occur, much else was required. John Hunter's followers were exceptionally assiduous in cultivating his scientific heroism in the decades after his death, but they did so to some extent against the grain. They had to nurture and shape his scientific reputation, to manage his personal legacy. The energy this required becomes spectacularly evident through the activities of Jesse Foot (1744–1826), John Hunter's first biographer, who published a life of him in 1794, only a year after his death. Its relentless insistence on cutting Hunter down to size, on making his shortcomings painfully evident, on resisting the idealisations of him, would earn it a place in the history of medical biographies, but the extraordinary Grangerised version of the book that Foot himself produced in 1822 renders it of quite exceptional interest.[21] The three folio volumes consist of pages from the book, a wide range of printed illustrations, including many portraits, hand-coloured prints, and a series of crude, original watercolours, narrating some of the more ridiculous episodes from John Hunter's

life, that were, I hypothesise, executed by Foot himself (Figure 34). We can treat this object as a manifestation of a medical unconscious – it is full of visual associations, and actuated by a kind of fury beyond reason. The huge number of portraits it contains, often several of the same person, are a rich historical source. If any figure is mentioned in the text, even in passing, their portrait is likely to be included. While Foot was hardly typical, his book does indicate something of the range of medical portraiture available at the time, and of the intense interest in medical personalities, which was indeed widespread. The sheer numbers of medical portraits, and the fact that many, perhaps most, were produced by well-known printers and engravers, reveals something of the commercial possibilities of medical portraiture.

And, since medicine has been so orientated towards its own history, and to creating and recreating major figures, the value of printed medical portraits endured. Printed catalogues of portraits available commercially in the early twentieth century were organised by occupation, such as 'doctors and chemists', and offered images of figures from earlier centuries.[22] Prints of both the Hunters, and of Jenner, were still available at that time. Yet the afterlife of William's images was much shorter and less potent than that of John's. The latter became the focus of collective identity; his image was able to stand for the social and political aspirations of a professional grouping. This was possible because his persona became inextricably linked to science, which had a talismanic quality. John Hunter's images did not do this in a vacuum, but in a context that reinforced what some individuals, but not others, stood for.

Portraiture played a central role in the quest for a collective medical identity. Since those who could afford such professional help experienced it individually, mostly in their own homes, the body-image of the doctor was of fundamental importance. The intimacy of their relations with patients and the widespread assumption that practitioners were harbingers of death, placed a heavy representa-tional burden upon them. They had to be (seen as) expert, but not free-thinking, radical, materialists. They had to be (thought of as) men who could control their sexuality. They had to be (imagined as) personally trustworthy, moved not by self-interest but by humanitarianism. It was a precondition of the medical power and heroism of the mid and later nineteenth century that an image of practitioners be constructed that fulfilled all these criteria. At the same time as these qualities were rooted in individuals, they had to be transferable, made general to the group, who could then claim to themselves both universal humane values and special expertise. The negotiations in visual culture that secured medical success were clearly complex. At this historical moment, portraiture constituted one of the most important arenas within which these negotiations took place.

Notes

The research upon which this paper is based was generously funded by the Wellcome Trust, to whom I wish to express my heartfelt gratitude. The assistance of staff in the Iconographic Collection and Early Printed Books Collection at the Wellcome Institute for the History of Medicine, and in the Wellcome Centre Medical Photographic Library, is much appreciated. I am also endebted to Joanna Woodall for her helpful comments on an earlier draft. Marcia Pointon has been a constant source of inspiration, help and encouragement for which I thank her most warmly.

1 R. Porter, *Health For Sale. Quackery in England 1660–1850* (Manchester, Manchester University Press, 1989).

2 The research upon which this article is based was carried out at the Wellcome Institute Library in London and the National Library of Medicine near Washington, DC. Both libraries have rich iconographic collections and these can be searched by computer and brought up on a screen, which enables the researcher to examine large numbers of portraits. The Wellcome Trust also owns a number of painted portraits. I have drawn heavily on R. Burgess, *Portraits of Doctors and Scientists in the Wellcome Institute of the History of Medicine* (London, Wellcome Institute of the History of Medicine, 1973). Burgess gives dates of birth and death for each subject and from this I compiled a series of cohorts for the period that I am principally concerned with. The focus has been on practitioners who were active between about 1775 and 1825. Each cohort was composed of individuals born in a particular decade of the eighteenth century. I was then able to look at images of them in the London and Washington libraries. The material presented here is a tiny fraction of what is available.

3 Recent reviews of 'professionalisation' – the main concept through which shared social identity has been explored in the history of science and medicine – are: J. Morrell, 'Professionalisation', in R. Olby *et al.* (eds), *Companion to the History of Modern Science* (London, Routledge, 1990), pp. 980–9, and T. Gelfand, 'The history of the medical profession', in W. Bynum and R. Porter (eds), *Companion Encyclopedia of the History of Medicine* (London, Routledge, 1993), II, pp. 1119–50.

4 This function is best evoked by the notion of 'emulation', which was common in medical and scientific discourses of the period.

5 I have discussed a number of these works in an essay review: L. Jordanova, 'Has the social history of medicine come of age?', *Historical Journal*, 36 (1993), pp. 437–49. In addition to works cited elsewhere in the footnotes see: R. Porter, *Disease, Medicine and Society in England, 1550–1860* (Basingstoke, Macmillan, 1987, 1993); L. Loudon, *Medical Care and the General Practitioner, 1750–1850* (Oxford, Oxford University Press, 1986); A. Cunningham and R. French (eds), *The Medical Enlightenment of the Eighteenth Century* (Cambridge, Cambridge University Press, 1990).

6 Legitimation of eighteenth-century medicine through its past is most evident in histories of medicine written by practitioners: R. J. J. Martin, 'Explaining John Freind's *History of Physic*', *Studies in History and Philosophy of Science*, 19 (1988), pp. 399–418; L. Jordanova, 'Reflections on medical reform: Cabanis' *Coup d'Oeuil*', in R. Porter (ed.), *Medicine and the Enlightenment* (Amsterdam, Rodopi, 1995), pp. 166–80; M. Neuberger, 'Francis Clifton and William Black, eighteenth century critical historians of medicine', *Journal of the History of Medicine and Allied Sciences*, 5 (1950), pp. 44–9; C. Webster, 'The historiography of medicine', in P. Corsi and P. Weindling (eds), *Information Sources in the History of Science and Medicine* (London, Butterworth Scientific, 1983), pp. 29–43. John Coakley Lettsom (see Figure 29) was the author of such a history: *History of the Origin of Medicine: An Oration, Delivered at the Anniversary Meeting of the Medical Society of London, January 19, 1778, and printed at their request. To which are since added various historical illustrations* (London, J. Phillips for E. & C. Dilly, 1778).

7 R. French and A. Wear (eds), *British Medicine in an Age of Reform* (London and New York, Routledge, 1991); A. Desmond, *The Politics of Evolution: Morphology, Medicine and Reform in Radical London* (Chicago, Chicago University Press, 1989); I. Loudon, 'Medical practitioners 1750–1850, and the period of medical reform in Britain', in A. Wear (ed.), *Medicine in Society: Historical Essays* (Cambridge, Cambridge University Press, 1992), pp. 219–47.

8 On portraiture, disfigurement and smallpox see M. Pointon, 'Killing pictures', in J. Barrell (ed.), *Painting and the Politics of Culture: New Essays on British Art 1700–1850* (Oxford, Oxford University Press, 1992), pp. 39–72; on smallpox see P. Razzell, *The Conquest of Smallpox: The Impact of Inoculation on Smallpox Mortality in Eighteenth Century Britain* (Firle, Caliban, 1977).

9 Burgess, *Portraits*, numbers 1527.17 (Belgian woodcut, undated) and 1527.45 (French woodcut of a statue, undated, although inscription is dated 1865).

10 R. Walker, *Regency Portraits* (London, National Portrait Gallery, 1985), I, p. 281 (quotation from Northcote), pp. 605–8 (*Men of Science*), p. 281 (quotation from the donor), and II, plates 516–24 (*Men of Science*).

11 That this was so is evident from Babbage's concern that England was losing out: C. Babbage, *Reflections on the Decline of Science in England, and on Some of its Causes* (Shannon, Irish University Press, [1830] 1971). The concern recurred during the Second World War – Sir Richard Gregory's book for the *Britain in Pictures* series is well illustrated with portraits: *British Scientists* (London, William Collins, 1941). Many sources from the period 1780–1820 addressed the relationships between science and a sense of nationhood, either implicitly or explicitly, see L. Jordanova, 'Science for the nation?', paper given to the Imagining Nations conference, University of York, April 1995.

12 W. Bynum and R. Porter (eds), *William Hunter and the Eighteenth-Century Medical World* (Cambridge, Cambridge University Press, 1985); C. H. Brock, *Dr. William Hunter's Papers and Drawings in the Hunterian Collection of Glasgow University Library: A Handlist*, Cambridge Wellcome Texts and Documents (Cambridge, Wellcome Unit for the History of Medicine, 1990); C. H. Brock, 'The many facets of Dr. William Hunter (1718–83)', *History of Science*, 32 (1994), pp. 387–408; M. Kemp, *Dr. William Hunter at the Royal Academy of Arts* (Glasgow, University of Glasgow Press, 1975); W. Hunter, *Anatomia Uteri Humani Gravidi* (Birmingham, Baskerville, 1774).

13 A. Smart, *Allan Ramsay 1713–1784* (Edinburgh, Scottish National Portrait Gallery, 1992), p. 139.

14 Two particularly vociferous attacks on men-midwives are P. Thicknesse, *Man-midwifery Analysed: and the Tendency of that Practice Detected and Exposed* (London, R. Davis, 1764); S. Fores, *Man-midwifery Dissected: or the Obstetric Family-instructor* (London, S. Fores, 1793).

15 Burgess, *Portraits*, number 1477.4 (with écorché) and 1477.8 (with bone).

16 S. Jacyna, 'Images of John Hunter in the nineteenth century', *History of Science*, 21 (1983), pp. 85–108; S. Cross, 'John Hunter, the animal economy, and late eighteenth-century physiological discourse', *Studies in the History of Biology*, 5 (1981), pp. 1–110.

17 Burgess, *Portraits*, pp. 179–80.

18 *Dictionary of National Biography* (London, Oxford University Press, 1949–50), X, p. 290.

19 L. Jordanova, 'Melancholy reflection: constructing an identity for unveilers of nature', in S. Bann (ed.), *Frankenstein, Creation and Monstrosity* (London, Reaktion Books, 1994), pp. 60–76.

20 J. Ingamells, *The English Episcopal Portrait 1559–1835. A Catalogue* (London, Paul Mellon Centre for Studies in British Art, 1981); M. Baker, 'Portrait busts of architects in 18th century England', in C. Hind (ed.), *New Light on English Palladianism* (London, The Georgian Group, 1990), pp. 14–30.

21 J. Foot, *The Life of John Hunter* (London, T. Becket, 1794); the Grangerised version is in the Special Collection of the Early Printed Books section, Wellcome Institute Library, London; on Grangerising, see M. Pointon, *Hanging the Head. Portraiture and Social Formation in Eighteenth-Century England* (New Haven and London, Yale University Press, 1993), pp. 53–78.

22 For example, *Catalogue of an Interesting Collection of Historical, Literary and Family Portraits. Including Collections under separate headings of Botanists, Doctors and Chemists, Legal, and Navigators and Voyagers, also Autograph Letters on Sale, at Moderate Prices* (London, A. Maurice, n.d. [after 1900]).

PART III

Likeness and identity

5

Photographic likeness

J O H N G A G E

Until twentieth-century psychoanalysis and its modern theoretical offshoots – so well represented in the essays in this collection – discarded the notion that human character may be inferred from external, and especially facial, characteristics, the representation of 'likeness' was seen as one of the most important tasks of portrait art. Thus, in his official tribute to the lately deceased Gainsborough, given at the Royal Academy in 1788, Sir Joshua Reynolds pointed ruefully to the gift for 'strik-ing resemblance' for which his rival had been celebrated, and which was usually denied to Reynolds himself; and he identified the formal means by which Gainsborough had demonstrated this gift in a particularly vivid way:

The likeness of a portrait ... consists more in preserving the general effect of the coun-tenance, than in the most minute finishing of the features ... Gainsborough's portraits were often little more in regard to finishing or determining the form of the features, than what generally attends a dead colour [under-painting]; but as he attended to the general effect, or whole together, I have often imagined that this unfinished manner contributed even to that striking resemblance for which his portraits are so remarkable ... It is presupposed that in this undetermined manner there is the general effect; enough to remind the spectator of the original; the imagination supplies the rest, and perhaps more satisfactorily to himself, if not more exactly, than the artist with all his care could possibly have done.[1]

Reynolds is here assuming that judgements of likeness are available only to the immediate circle of the subject portrayed; but it is clear that, even for posterity, the search for authentic likenesses of historical figures has always stimulated the collecting of portraits. We need look no further than the careful sifting of icono-graphical evidence in the modern catalogues of the National Portrait Gallery in London. Yet Reynolds also suggested that viewers who knew Gainsborough's subjects personally would project this knowledge onto the vacant schemata of his painted heads, which often make us see a generalised and 'family' likeness in so many of his unrelated figures. This capacity for projection may also account for the great popularity of the humblest of portrait-types available in Gainsborough's time, the silhouette, which by its very nature offered the minimum of information about the features, and yet so often gave a striking impression of life.[2]

Although many silhouettes were cut free-hand, the making of this type of

usually profile portrait was soon simplified by mechanical devices which made it one of the most significant ancestors of the portrait photograph; a mechanisation which in both cases was assumed to guarantee precision of likeness, but which also, precisely because they were mechanical, were seen to remove these humble styles of portrait from the realm of art. The portrait had long occupied an ambiguous position in the history of visual art because it did not simply use imitative skills in the service of higher imaginative ends. Its end was itself imitation, and mechanisation seemed to put this end more firmly within the range of the least skilled artisan.[3] Among the devices for taking portraits which precede the development of the portrait photograph were the Physiognotrace, introduced in Paris by G. L. Chrétien in the 1780s, which produced modest profile portraits related to the silhouette, and the Graphic Telescope, patented by the painter and scientist Cornelius Varley in 1811, which could take profile, three-quarter and full-face views, and was thus particularly useful in the making of studies for bust portraits in three dimensions.[4]

The sense of authenticity conferred by these 'objective' techniques and their photographic successors did not displace but simply reinforced the process of projection. One of the many 'dodges' described to the journalist Henry Mayhew by a street photographer in the East End of London in the 1850s was to fob off customers in a hurry with ready-prepared images of other people. The 'mechanical' process and some persuasive patter could thus make a young woman enthusiastically accept the photograph of an old widow as a likeness of herself, and a sailor that of a carpenter. The photographer explained his success in terms very reminiscent of Reynolds on Gainsborough: 'The fact is, people don't know their own faces. Half of 'em have never looked in a glass half a dozen times in their life, and directly they see a pair of eyes and a nose, they fancy they are their own.'[5]

It is true that the use of mechanical devices was not always seen as intrinsically antithetical to artistic pretensions, yet it remains that it was the 'portrait-like' element in the portrait – the demand for exactness – which made it uncongenial to generations of portrait artists whose ambitions lay elsewhere. Gainsborough, for example, felt that the 'Face-business' would drive him crazy, and longed to escape from his portrait commissions to study landscape in the country.[6] The photograph was similarly launched, around 1840, on a rhetoric of 'naturalism' which, in spite of the manifest artificiality of photographic representation and the aesthetic concerns of many photographers from the beginnings until our own day, is still widely thought of as its most significant characteristic. From Henry Fox Talbot's *Pencil of Nature* to Roland Barthes's 'message without a code', photography has been promoted chiefly as a neutral tool of exact reproduction.[7] And this has led to the devaluation of the photograph as an aesthetic object very much on the same lines as the portrait itself had earlier been devalued. As Roger Fry wrote in his introduction to an anthology of portrait heads by the Victorian photographer Julia Margaret Cameron:

The position of photography is uncertain and uncomfortable. No one denies its immense services of all kinds, but its status as an independent art has always been disputed. It has never managed to get its Muse or any proper representation on Parnassus, and yet it will not give up its pretensions altogether.[8]

These positions in the understanding of portraiture and the portrait photograph are nevertheless particularly rich in paradox, for if the best portrait was the

most 'like', what was it like? And what did that paradigm of visual objectivity, the portrait photograph, add to the notion of 'likeness'?

The generation of Reynolds and Gainsborough was in a good position to give a positive answer to the first question because theirs was not only the first period when portraiture began to be a serious topic of aesthetic enquiry,[9] but it was also the period when the ancient science of physiognomy began to draw its raw material very substantially from images of real people. The *Essays on Physiognomy* (1789–92) of the Swiss pastor and moralist J. C. Lavater, which had begun their long publishing history in German in the 1770s, drew on some very early strands in this science, including the interpretation of character as a function of four 'humours' or temperaments – choleric, sanguine, phlegmatic and melancholic – and the rather more visually interesting comparison between human and animal features. But the most novel thrust of Lavater's publication was in the analysis of the portraits of known individuals which, where they were not his contemporaries, friends and collaborators such as the German poet Goethe or the Anglo-Swiss artist Henry Fuseli, he was able to assemble readily enough because of more than a century of intensive portrait-making in the form of easily collectable prints.[10]

But Lavater's physiognomical approach to character analysis was also congenial to the generation of Reynolds and Gainsborough because it was an idealising approach. Lavater made much use of the silhouette (Figure 35) because the silhouette was usually limited to a profile view of the head and shoulders, and the profile view was, for him, the most significant view, since it revealed those features most salient for the interpretation of character, the brow, the nose and the chin, whose size, angle and shape could be measured against an ideal scale (Figure 36). The profile view is rather rare among eighteenth-century painted portraits – one notable example is Reynolds's thoroughly classicising full-length of Mrs Lloyd (1776; private collection)[11]– although it is common enough in relief-sculpture and, of course, on coins and medals where distancing was usually a function of respect.

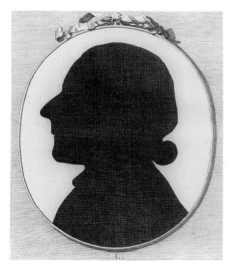

35 *Silhouette of Johann Caspar Lavater*, from J. C. Lavater, *Essays on Physiognomy*, London 1792, II, facing p. 225.
36 *right]* J. C. Lavater, Analysis of Figure 35, from *ibid.*, p. 226.

37 Francis Galton, *Composite Portraits of Three Sisters, c.* 1880.

One of the many reasons for this rarity was precisely what commended the profile so much to Lavater: that it offered the head for objective study, undisturbed by the mobility of features so expressive of social interaction; the glances of the eyes and the movements of the mouth by which, for the most part, we learn to recognise our fellow human beings.[12] So Lavater was setting up a highly specialised concept of 'likeness'.

It was also a highly classicising one. Not only did it highlight the more or less permanent and stable features which interested other contemporary commentators on the classical beauty of the human head,[13] it also devalued the mouth and the jaw – the basest animal features – and even the eye which had, since classical times, been especially appreciated as the 'window of the soul'. In this Lavater's physiognomical system had the backing of most eighteenth-century painted portraiture. If the distant profile view was a rarity, the mobile, socially interactive glance was hardly less so: the features were usually composed, and the attention of the spectator was not often directly engaged. The many portraits of that early super-star, the actor David Garrick – a subject of Angela Rosenthal's essay in this collection – are revealing in this respect: in character Garrick was often given a distinct expression, but as a private person, although he sometimes looks out directly towards the viewer, their eyes rarely connect, and he has no more than a faintly mocking smile.[14] It was perhaps with Garrick in mind that Gainsborough complained in a letter to the Earl of Dartmouth that the portrait painter was obliged to convey character without recourse to the actor's repertory of expression:

Had a picture voice, action, etc. to make itself known as Actors have upon the Stage, no disguise would be sufficient to conceal a person; but only a face confined to one view and not a muscle to move to say, 'Here I am' falls very hard upon the poor Painter who perhaps is not within a mile of the truth in painting the Face only.[15]

Nor did Lavater's system make use of the signs of age or illness which must have confronted him so often in eighteenth-century subjects, perhaps because the portrait images he drew on also made so little reference to them.[16] Portrait artists can hardly be expected to have revealed what cosmetics were often – perhaps usually – at pains to disguise.[17]

Photography might well have been thought to tip the balance decisively away from this idealising conception of likeness. Portrait painting worked by an additive method in which features were progressively painted into the image until it was agreed that a satisfactory likeness had been created, and, as the case of Reynolds and Gainsborough has suggested, the concept of 'satisfactory' was a very fluid one. Photography, because of its more passive procedures, provided from the outset a more or less complete tally of surface features, some of which, in order to constitute an ideal 'likeness', would have to be – and often were – edited out at some stage of the process, by a cunning lighting of the subject, or focusing of the lens, or by using a particular type of photographic emulsion, or by controlling the exposure or development times or, as a last resort, by more or less extensive retouching after the image had been fixed. It is clear that even the earliest and least manipulable of the commercial photographic processes, the daguerreotype, offered no 'standard' degree of surface detail;[18] and practitioners of later and coarser techniques, such as the calotype, were able to work with very broad, soft-focused effects. Not to mention the general unfeasibility of colour photography before the early twentieth century. So just as the format, poses, lighting, backgrounds and accessories of the early photographic portrait were borrowed from the traditions of painted portraiture, so, in practice, it did not seek to transcend or even to modify the idealistic notion of likeness laid down long before the development of the photographic technique.

As it happens, one of the earliest attempts – perhaps *the* earliest attempt – to harness the specific potential of the photographic method in the interest of a wholly new conception of 'likeness' was also conceived within the framework of an idealising aesthetic. In the 1870s and 1880s Francis Galton, the statistician, inventor and, most notoriously, the father of eugenics as a social programme, developed an ingenious method for the identification of types, of 'family likenesses' within various groups and classes of people: siblings (Figure 37), members of the same profession, notably convicted criminals, sufferers from the same diseases and members of some ethnic groups. Galton's method was to superimpose the photographic negatives taken from sometimes dozens of individuals in each group, and re-photograph the resulting 'composite portrait' in order to establish the common features which might help to identify members of these various families or classes beyond the boundaries recognised hitherto.[19] Galton began his investigations with convicts in the prison service, where the use of photographs for identification had been common for some time; and his interest in the taxonomy of criminal types belongs to a substantial tradition of physiognomical typing for the purposes of social control.[20] What his ultimately inconsequential experiments demonstrate is that the profile view is less susceptible to generalisation than the full-face which, even when made up of tens of individual components, may still have a convincingly individual look.

Galton was also interested in identifying the individual (he was a pioneer in the technique of fingerprinting); and he later experimented with what he called the 'analytic portrait', which reversed the methods of the composite portrait by using

multiple negatives to cancel out common features and isolate those peculiar to each individual or, in one of the few surviving examples (Figure 38), those peculiar to a particular expression of the face. He attributed the signal failure of this line of enquiry to the fact that the resulting images did not give 'an intelligible idea of the peculiarities, the non-essentials being as strongly marked as the essentials, and the whole making a jumble'.[21]

So Galton had a strong *a priori* sense of salience in the features of his subjects for analytical portraits; and his repeated observations that the composite portraits were 'more regular and handsome' or 'refined and ideal' than their individual components points to a mind schooled in the eighteenth-century aesthetic of idealism.[22] Galton was a cousin and a close friend of Charles Darwin, who was himself

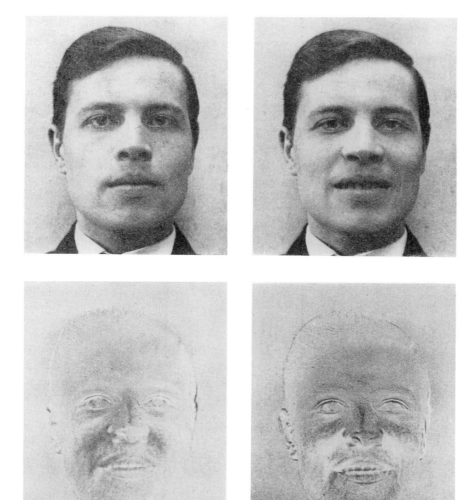

38 Francis Galton, *Analytical Portrait*, from K. Pearson, *The Life, Letters and Labours of Francis Galton*, Cambridge, II, 1924, p. 312.

familiar with (and influenced by) Reynolds's neoclassical theory of the 'central form', as it had been outlined especially in Discourse III of 1770.[23] It may well have been Darwin, who had himself made an important physiognomical use of the photograph in his 1872 book, *The Expression of the Emotions in Men and in Animals*, who kindled his cousin's interest in the significance of these central, typical features. What Galton did was to use the modern, ostensibly individualising technique of photography to validate an essentially neoclassical view of the face, and to reinforce the notion that 'likeness' meant likeness to a type.

That Galton's composite portraits in profile are relatively unconvincing suggests again that we as spectators are readier to frame our ideas of likeness – of what constitutes resemblance – on the basis of the features we observe in social intercourse, rather than from what we learn by the dispassionate scrutiny of profiles which, especially if they are our own, we may discover inadvertently with horror and disbelief. But social transactions tend to focus on the eyes and, as Angela Rosenthal has demonstrated vividly in her discussion of Vigée-Lebrun (see Chapter 7), eye contact is dangerous. In portrait-representations before the era of photography this contact had been rare, confined for the most part to the mirror-images of the self-portrait, which became especially obsessive in Romantic art, or, in an engaging sub-genre of the portrait miniature, to the many representations of a single eye of the beloved.[24] What the photographic camera did was to replace the susceptible eye of the artist with a purely mechanical 'eye'; the photographic artist, who could operate the shutter at a distance, need no longer be in direct or prolonged contact with the subject. The psychological problem of negotiating social space and time, which had led earlier portrait painters and sculptors to make sittings many and short, was no longer a problem. Certainly the photographer no longer had any need to look the subject in the eye. All the personal risk of close confinement with another person, perhaps of the opposite sex, was now displaced from the artist onto the viewer, and ceased to be a risk because the spectator had not a person, but only the image of a person, to contend with.

Thus from the earliest days photography brought a sense of liberation to the portraitist, and one of the most striking evidences of this is a new type of confrontational portrait (Figure 39), especially cultivated among artists and writers and, for example in a remarkable group of male heads taken in the 1860s by Julia Margaret Cameron, across the genders. These isolated and closely framed heads imply a proximity which would have been unthinkable without the psychological distancing of a mechanical device. And yet, as Cameron's work as well as many modern examples show, direct confrontation in the photographic portrait has been perfectly compatible with an abstract treatment of surface through soft focus and the use of very grainy film.[25]

In this century the confrontational portrait has become a very common type both in photography and in painting. But apparent intimacy has not brought any inevitable penetration of character; rather it has helped, again, to redefine what it is we mean by 'likeness'. The German photographer Helmar Lerski (Figure 40) and the American photo-realist painter Chuck Close (Figure 41) have both provided the viewer with more than enough detail to make an identification, were there to be an opportunity for comparison. But at the same time they have both deprived the viewer of the means of making a judgement of resemblance, of reading the head as a portrait. Lerski's and Close's figures do not usually even have identifiable names. Lerski's *Köpfe des Alltags* (Everyday Heads) of 1931 were made under highly

artificial studio lighting and with two-hour sittings, in order to present the head as a sort of still-life. Most of his subjects were hired through the Berlin Labour Exchange.[26] Close, working in the radically formalistic atmosphere of 1960s America, argued that his vast and overwhelming painted images of his friends, which might take as much as a year to complete, were less images of people than of the photographs, which he attempted to represent with the greatest possible fidelity, down to the slight out-of-focus blurring at the edges of the forms. Likeness, said Close, was only a by-product of the way he worked.[27] And yet these images give us an unprecedented range of information about the individual surface features of these men and women. We can follow each shift of contour, each line and crease; we can note where a matt area of skin changes to shine; we can almost count the hairs, the pores or the puckers of the lips. This is a view of the head usually

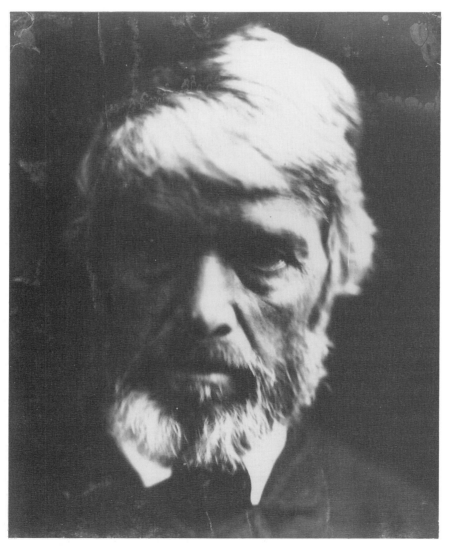

39 Julia Margaret Cameron, *Thomas Carlyle*, 1867.

40 Helmar Lerski, *Frau eines Chauffeurs* (Chauffeur's Wife), *c.* 1928.

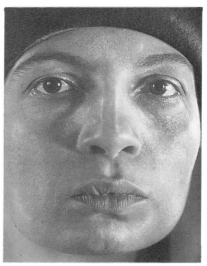

41 Chuck Close, *Robert*, 1973–4. Acrylic on canvas, 9 x 7 ft.

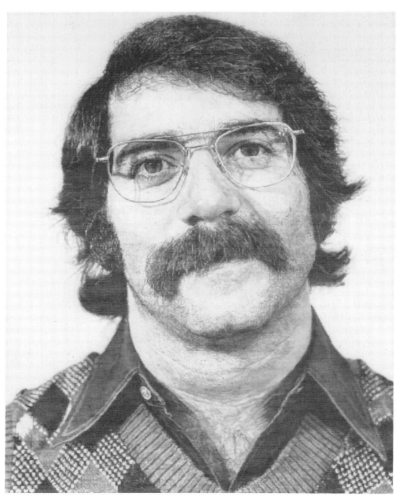

permitted only to lovers or hairdressers, beauticians, doctors or undertakers, whose job it is to gloss over these unrelenting facts. Lerski's heads give us a sense of extraordinary intimacy, but, unlike lovers, we are not able to look into their eyes; and Close's frontal, passport-like poses are equally uninviting.[28] They deny us that sense of person which is perhaps the fundamental requirement of access to the figure through portraiture, and they thus make the assessment of likeness an irrelevance.

This new repertory of surface effects domesticated by photography was soon appropriated by a whole range of portrait painters. Shiny noses, eyelashes, blotchy complexions, freckles: all have become the stock-in-trade of twentieth-century portraiture, and must be seen as essential ingredients of modern 'likeness'. It is as if, like the picture of Dorian Gray in Oscar Wilde's story, all the residual blemishes of character have been drained out of the sitters and into their representations. But, if they help to identify, these surface features throw little light on 'identity' beyond showing that, in contrast to the spectators of earlier centuries, we no longer interpret them as outward signs of inner deficiencies, and they need no longer be concealed.

The human head is the chief vehicle of social intercourse, through expressive conversation; and we usually expect the representations of heads to embody such lively qualities of the features as would be conveyed to us in real life. This is what we interpret as 'likeness', and what turns an effigy – a mere aggregation of surface features, as in a wax-work – into a portrait. The unprecedented advantages of the photograph as an aid to identification have thus had little direct impact on the notion of likeness, and portrait photographers have usually used far more traditional means of coaxing an identity from the subjects presented to them. Even Dorian Gray's portrait showed his progressive deterioration of character not so much by the accretions of the ageing epidermis as by changes of expression.

Notes

1 Sir Joshua Reynolds, *Discourses*, ed. R. Wark (New Haven and London, 1975), p. 259.

2 For a brief history, S. McKechnie, *British Silhouette Artists and their Work, 1760–1860* (London, 1978).

3 For some early criticisms, J. Loquin, 'La lutte des critiques d'art contre les portraitistes au XVIII^e siècle', *Archives de l'Art Français*, 7 (1913), pp. 309–20.

4 For the Physiognotrace, H. Gernsheim, *L. J. M. Daguerre* (New York, 1968), pp. 62–3; for the Graphic Telescope, M. Pidgley, 'Cornelius Varley, Cotman and the Graphic Telescope', *Burlington Magazine*, 114 (1972), p. 782; A. Potts, *Sir Francis Chantrey, 1781–1841, Sculptor to the Great* (London, National Portrait Gallery, 1980), no. 20.

5 H. Mayhew, *London Labour and the London Poor*, 2nd edn (London, 1861–2; repr. 1967), III , p. 209. Many of the swarm of popular street-photographers had begun their careers as silhouette cutters: see 'The penny profile cutter', *ibid.*, p. 12.

6 Gainsborough wrote to a patron in 1770, 'the nature of face painting is such, that if I was not *already cracked*, the continual hurry of one fool upon the back of another, just when the magot bites, would be enough to drive me crazy ...' (M. Woodall, *The Letters of Thomas Gainsborough*, London, 1963, p. 167). See also the letter to William Jackson about landscape painting, *ibid.*, p. 115.

7 H. Fox Talbot, *Select Texts and Bibliography*, ed. M. Weaver (Oxford, 1992), p. 48, and p. 61 for the manipulation of the image. For the unreality of photographs, J. Snyder, 'Picturing vision', in W. J. T. Mitchell (ed.), *The Language of Images* (Chicago, 1980), pp. 224–34. R. Barthes, 'The photographic message', in *Image, Music, Text*, selected and trans. S. Heath (London, 1977), p. 7. Barthes is of course talking of photo-journalism, but he underestimated the artifice of this genre, too. For his later, less categorical stance: *Camera*

Lucida: Reflections on Photography, trans. R. Howard (London, 1982), pp. 76, 100–3.

8 R. Fry, 'Mrs Cameron's photographs', in *Victorian Photographs of Famous Men and Fair Women*, with introductions by Virginia Woolf and Roger Fry (London, 1926), p. 9. Fry claimed that Cameron's sensitive artifice made nonsense of this characterisation of photography.

9 The most thoroughgoing early examination of portraiture in English is perhaps in chapters XV and XVI of Hogarth's *Analysis of Beauty* (London, 1753).

10 Lavater's large collection of portrait prints, with his commentaries on them, is now preserved in the Austrian National Library in Vienna. For the extensive section devoted to Goethe, S. Schulze (ed.), *Goethe und die Kunst*, exhibition catalogue (Frankfurt, Schirn Kunsthalle/Weimar, Schlossmuseum, 1994), nos 141–57. For the fashion for portrait-print collecting in the eighteenth century, M. Pointon, *Hanging the Head: Portraiture and Social Formation in Eighteenth-Century England* (New Haven and London, 1993), pp. 53–78. For useful modern assessment of Lavater's work in English, J. K. Stemmler, 'The physiognomical portraits of Johann Caspar Lavater', *Art Bulletin*, 75 (1993), pp. 151–68.

11 See N. Penny (ed.), *Reynolds*, exhibition catalogue (London, Royal Academy, 1986), no. 103.

12 On recognition, see especially E. H. Gombrich, 'The mask and the face: the perception of physiognomic likeness in life and in art', in *The Image and the Eye* (Oxford, 1982), pp. 105–36. See also P. J. Benson and D. I. Perrett, 'Extracting prototypical facial images from exemplars', *Perception*, 22 (1993), pp. 257–61; E. Brown and D. I. Perrett, 'What gives a face its gender?', *ibid.*, pp. 829–40.

13 See, for example, A. Cozens, *Principles of Beauty relative to the Human Head* (1778), reprinted in K. S. Sloan, *Alexander and John Robert Cozens: The Poetry of Landscape* (New Haven and London, 1986), pp. 63–8. Lavater singled out Cozens for his unnatural and characterless treatment of the classical profile in *Essays on Physiognomy*, II, 1792, pp. 380f.

14 For a useful anthology of Garrick portraits, E. Wind, *Hume and the Heroic Portrait* (Oxford, 1986), pls 27–34.

15 Woodall, *Letters of Thomas Gainsborough*, pp. 51–3.

16 The Scottish portraitist Allan Ramsay was one of the very few eighteenth-century artists to show some of his subjects 'warts and all'; and in the cases of Dr Richard Mead or Mary Adam, as in the case of Lely's portrait of Oliver Cromwell which established the idea, there may have been some private justification for this treatment (see A. Smart, *Allan Ramsay 1713–1784*, exhibition catalogue, London, National Portrait Gallery, 1992, nos 28, 41). The frequent inclusion of wrinkles and blemishes in bust sculpture was probably a function of their derivation from Roman portrait conventions. Pointon (*Hanging the Head*, pp. 141–51) has raised the important question of smallpox scars in the case of Lady Mary Wortley Montagu but, as I have suggested in a review of her book (*Art History*, 16 (1993), p. 665), the identification of 'authentic' portraits of Lady Mary is still problematic.

17 One of the many desiderata in the history of portraiture is a thoroughly documented study of cosmetics. For a recent survey, P. Rovesti, *Alla Ricerca dei Cosmetici Perduti* (Venice, 1975).

18 See the very different treatments of Edgar Allen Poe and Samuel Morse in nearly contemporary plates: Gernsheim, *Daguerre*, pls 114–16.

19 Galton described his method at length in *Inquiries into Human Faculty and its Development* (London, 1883, repr. 1907), pp. 221–41.

20 See, for example, the remarkable collection of early nineteenth-century portrait busts, made for physiognomical purposes, in the Dundee Art Museum. This aspect of Galton's work has been studied by D. Green, 'Veins of resemblance: photography and eugenics', in P. Holland, J. Spence and S. Watney (eds), *Photography/Politics: Two* (London, 1986), pp. 9–21.

21 F. Galton, *Memories of my Life* (London, 1908), pp. 261–3.

22 *Ibid.*

23 Darwin cites the neoclassical theorist G. E. Lessing on the distinction between beauty and expression in *The Expression of Emotions in Men and in Animals*, 2nd edn (London, 1890), pp. 15–16.

24 An example of an (anonymous) English eye-miniature in the Victoria and Albert Museum is reproduced in J. Murdoch *et al.*, *The English Miniature* (New Haven and London, 1981), col. pl. 35d.

25 See, for example, Hugo Erfurt's portrait of the painter Max Beckmann, in London, Hayward Gallery, *Neue Sachlichkeit and German Realism of the Twenties*, 1978–9, no. 287.

26 On Lerski and his methods see K. Macpherson (1931) in D. Mellor (ed.), *Germany: The New Photography 1927–33* (London, 1978), pp. 65–8.

27 See his interview of 1972 in E. H. Johnson (ed.), *American Artists on Art, from 1940–1980* (New York, 1982), pp. 160–4. Close's early photo-realist heads were painted in black and white; for Close, see now Robert Storr, *Chuck Close*, New York and London, 1998

28 Close said, 'I don't want the eyes to follow you like in a traditional portrait, but I also don't want them to be staring through people. If the camera is about six feet away from the subject, it turns out about right.' *Ibid.*, p. 161.

6

Photographic portraiture in central India in the 1980s and 1990s

CHRISTOPHER PINNEY

The whereabouts of the town of Nagda is most easily described in terms of its position mid-way between Bombay and Delhi on the Western Railway broad-gauge line. Nagda has six main photographic studios and it is here that the portrait photographs discussed in this chapter were collected. Precisely parallel to the railway line runs Jawahar Marg which takes one from the station, along the southern flank of the bazaar section of Nagda. About 500 yards from the station, past numerous shops selling tea, clothes, bicycles, hardware and irrigation pumps, is the Venus Studio. Run by two Brahman brothers from the nearby sacred centre of Ujjain, there is a good selection of promotional material on display in their shop front. On most days a life-size cardboard cut-out of a European woman in a tennis skirt holds a box of Konica film and invites customers to enter their premises. Inside, displayed along with samples of their studio work, are a number of very fine prints distributed by Midas Colour laboratories who compete for most of the local colour printing. Some depict glamorous wealthy women of the type normally only to be seen on the screen of the nearby Prakash Talkies. Others show equally beautiful women adorned as village belles, in elaborate quasi-tribal jewellery and embroidered clothes, who curl themselves around earthenware pots, or bathe under cascading waterfalls. The Venus Studio proprietors are sometimes required to photograph urban clients in poses that imitate film stars but the predominantly village resident clients prefer to be photographed full-pose against their painted studio backdrop of Kashmir's Dal Lake or the ruins at Mandu to be found on the facing wall. Both the promotional images and the local use of landscape backdrops, however, testify to the use of photography as a theatrical idiom capable of representing persons with endlessly diverse exteriors, and situated in equally diverse places.

Until the arrival of colour processing after 1987, the main income of Nagda's five main photographic studios came from the photographing and processing of wedding images. Colour films are now despatched to Ujjain for processing and, with the exception of one studio, the photographer's interventions are confined to the production of the negative. The exception is that of the recently established Sagar Studio whose creative proprietor experiments with double exposures on colour negative film. Figure 42 is one of these experiments which reproduces imagery he had seen in Hindi films.[1]

42 Double exposure portrait by Sagar Studios, Nagda, *c.* 1993. Original in colour.

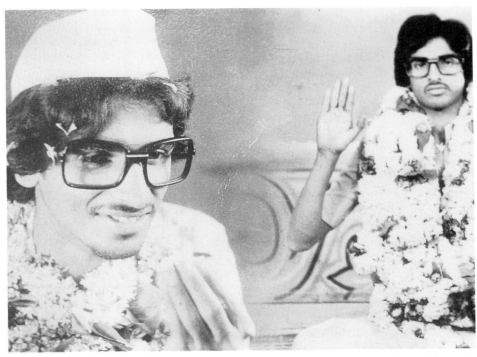

43 Double exposure portrait by Suhag Studios, Nagda, *c.* 1980. Original printed in sepia.

A further 500 yards along Jawahar Marg, past the Civil Hospital and Nagda's main liquor shop, is another, older, photographer's premises – those of Suhag Studio. Here Suresh Panjabi, who has been in business for the last two decades, produces from his files a series of exceptional images which depict himself in a variety of double poses. In Figure 43 he represents himself on the left as a politician wearing a hat – a *Gandhi topi* – associated with the Congress Party, which denotes moral probity. On the right of the image he adopts a pose associated with Ramakrishna, a nineteenth-century Calcuttan sage. In other self-portraits the photographer adopts 'poet' and 'dreamer' poses inspired by the mid-1970s Hindi film *Kabhie Kabhie* (Sometimes). The Suhag Studio has been responsible for many of the albums of black and white wedding photographs which many Nagda traders and factory employees (as well as wealthier village landlords) are always pleased to show visitors. These wedding albums compiled by Nagda photographers before the recent switch to colour processing consist of up to 200 or 300 black and white photographs in which great use is made of montage and the collapse of space and time. The bride and groom zoom around India, from the Tower of Victory in Chittaurgarh to the India Gateway in Delhi, to the local Birla Temple.[2]

Like the double or split portraits which are also to be found in these albums (Figure 44), these place a person beyond the space and identity which certain forms of western portraiture, for instance, enforce. They contrast markedly with the dominant Renaissance chronotope within which, to recall Jacques LeGoff's characterisation, 'the portrait was triumphant; it was no longer the abstract image of a personage represented by symbols or signs materializing the place and rank

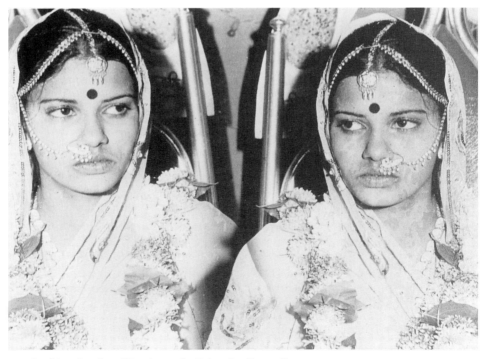

44 Double printed wedding image by Suhag Studios, 1983.

assigned him by God, but rather the rendering of an individual captured in time, in a concrete spatial and temporal setting'.[3]

Trick techniques of negative montage which are so common in black and white Nagda portraiture testify to the lack of any desire to 'capture' sitters within bounded spatial and temporal frames. The absence of both portraiture and landscape in early Indian painting is instructive in this context. The replication of bodies and faces brought about by doubling and tripling fractures not only the spatial and temporal correlates that are implied by a perspectival window that takes its surface as a mere 'picture plane'.[4] It also, more significantly for our purposes here, suggests a different conceptualisation of the subjects who are made to appear within this perspectival window. It is as if there is a homology between the spatial and temporal infractions of this representational window and the fracture of these local subjects that prevents what LeGoff describes as the 'rendering of an individual captured in time'.

The preference for 'doubles' and 'poses', I will suggest, reflects (and in turn engenders) the lack of a centred, visible 'personality'. In Nagda, photographic portraiture does not necessitate the exploration of the relationship between 'character' and externality within a concrete spatial (and temporal) setting, but is, rather, more likely to represent bodies and faces as infinitely multiple and contingent. Something of the surprising contrast between a dominant western practice and aspects of this local Indian practice is pre-figured in M. K. Gandhi's recollections of his period in England, in the late 1880s, studying at the Bar. Gandhi approached Dadabhai Naoroji[5] for advice as to what an aspirant lawyer should read to succeed in his profession. Naoroji responded that 'a vakil [lawyer] should know human nature. He should be able to read a man's character from his face.'[6] To this end he suggested that Gandhi read Lavater's and Shemmelpennick's books on physiognomy. Gandhi records:

I was extremely grateful to my venerable friend. In his presence I found all my fear gone, but as soon as I left him I began to worry again. 'To know a man from his face' was the question that haunted me, as I thought of the two books on my way home ... I read Lavater's book and found it more difficult than Snell's *Equity* and scarcely interesting. I studied Shakespeare's physiognomy, but did not acquire the knack of finding out the Shakespeares walking up and down the streets of London. Lavater's book did not add to my knowledge ...[7]

In a similar way, Nagda inhabitants are reluctant to concede that one can 'know a man by his face' but this reflects more than failed casual experiments of the sort undertaken by Gandhi: it is a reflection of a pervasive dualism in which a contingent and mutable external surface is contrasted with a moral character which can be made visible only through action. The customers of Nagda's photographic studios are hugely concerned that their faces should appear free of blemish and shadow, but this is to facilitate a simple recognition of a likeness of the living body of the person depicted rather than any more ambitious revelation of internal character.

David and Judith MacDougall's recent ethnographic film, *Photo Wallahs*, presents a detailed account of practices of disguise and posing in the north Indian hill station Mussoorie, although some of the exegesis suggests differences from Nagda interpretations. In Mussoorie, Indian tourists arrive on Gun Hill by cable car and gaze at the Himalayas, dress as tribals, sheikhs, or parodies of western guitar-strumming hippies. Bodies can be dressed in a limitless range of identities

– as Pathan frontiermen, Kashmiri women, gun-wielding dacoits, and village women posing coyly with decorated earthenware pots. One photographer, H. S. Chadha,[8] offers a client most of the national styles of turban (Rajasthani, Punjabi, Gujarati). This cosmopolitan sartorial excess recalls Appadurai's observation that through its inclusion of regional items much middle-class Indian food simulates a national cohesion[9] and we may suppose that the clients of Mussoorie photographers aspire to a similar ideal. Edibility and wearability stand as parallel idioms of national integration. It is as if contemporary Indians, rejecting aspects of colonial ethnicisation through physique, costume and other external signifiers, have arrived at a strategy of mutual mimicry, a reciprocal consumability in which – in front of the camera at least – identities are suspended and inverted. Individual images – in which the sitter is clothed in some particular stereotypical garb – can only be understood as part of a much wider repertoire of contingent identities which construct a curiously non-essentialist vision of the nation.

Photographic images of splitting and transformation can be understood against a background of arguments about the existence of 'individuals' within South Asian society. Louis Dumont has long suggested that in India what he terms the basic 'sociological unit' – the Western individual – is entirely lacking[10] since it is subordinated to the interests of the whole. This position has been convincingly challenged by Mines[11] and McHugh.[12] McKim Marriott has argued that South Asian persons would be better conceptualised as 'dividuals', rather than 'individuals' since they are 'permeable, composite, partly divisible and partly transmissible'.[13] Such ethno-sociological 'monist'[14] views also suggest that the moral interior can be read from the exterior. I would not seek to deny the partial validity of such perspectives – for some conditions such as leprosy, or incombustible corpses are recurrently explained by Indians within such a paradigm. But these perspectives may also in part reflect anthropologists' closeness to Brahmanic sources, for ritual specialists are much more likely to claim skills in reading exterior surfaces than lay people. Ascetics are particularly adept at this and most inhabitants in Nagda would accept that an ascetic of any true worth would be able to read the mind and intentions of all those s/he meets. It is this x-ray vision which frequently renders speech unnecessary when devotees encounter ascetics of great power.

But this faith in the visibility of the interior and the readability of exterior signs is not shared by most people in Nagda. The striking dualism they espouse stresses the occlusion of character and the mystery of external surfaces. The majority of people in Nagda are clear that these portraits are only capable of depicting the external characteristics of the sitter, his or her *vyaktitva*. What *vyaktitva* refers to is best denoted by the term 'the signs of being a person'. In Hindi *vyakti* denotes a person, and *vyaktitva* signifies 'person-ness', although it is usually misleadingly translated as 'personality', 'individuality', or 'self'.

In central Indian photographic portraiture the body (*sarir*) is a ground for the physical and visual aspects of *vyaktitva* (complexion, sharpness of features, dress sense – usually ranked in this order of importance).[15] The aspects of *vyaktitva* which a photograph cannot capture might be described as general etiquette – whether a person is a noisy eater, whether they are prone to break wind in public. What photographs are nearly always completely unable to capture, however, is the internal moral character and biography of a sitter, his *charitra*. *Charitra* reveals itself only through actions (*karma*), through past history and future eventualities.

Whereas for the eighteenth-century physiognomist Johann Caspar Lavater, 135

Socrates's immense ugliness posed a problem for the science of physiognomics (he concludes, after numerous pages of discussion, that he is the exception that proves the rule), the inhabitants of Nagda would not be surprised by this disjunction between the external surface and the moral interior. For them it would simply be evidence that one cannot read *charitra* from *vyaktitva*. This is expressed through several idiomatic expressions such as *bahar se kuch aur andar se kuch aur* (one thing outside and something else inside), and *sakal se sidha, lekin kam mem terha* (direct in appearance, but crooked in deeds).

A Jain shop-owner stressed this difference: *vyaktitva* had to do with the exterior surfaces of a person, and was to do with a mixture of the body (*sarir*) and the soul (*atma*) working together. Thus one could at a glance discern the *vyaktitva* of a living person or his/her photo and conclude, for instance, that such-and-such a person did indeed have the *vyaktitva* of, say, a Collector or other important official. In this context *vyaktitva* denotes 'deportment', 'demeanour', or social 'appearance'. Quite distinct from *vyaktitva* there was also the question of *charitra* which was an essentially internal moral quality or character which was only apparent in deeds, that is, in those activities and existential moral decisions which photography – by and large – could not lay bare. So, photographs will reveal only *vyaktitva*, not *charitra*, or they will only reveal the *charitra* of 1 or 2 per cent of photographic subjects. The other 99 per cent will look like the film actors who make themselves look like *mahatmas* and saints, although in fact they are all really *dacoits* (bandits). The quality of dacoitness is a manifestation of *charitra* and can be known only as a result of circumstance – by talking and living together.

One might also draw attention here to the observation that in Hindi films disguises are nearly always successful. Usually accomplished by remarkably convincing latex masks worn by the villain, there are no clues of mannerism or voice which serve to reveal the deception. An outstanding example would be the Manmohan Desai film *Mard* (Hero) starring Amitabh Bachchan. At one point in the film both Amitabh, the hero of the title, and his father are convinced by each other's doubles staged by their imperialist enemies and thus goaded to engage in a gladiatorial father–son duel. When Amitabh goes to rescue his father who is chained to a grindstone in a British concentration camp, it is only his perspicacious horse – endowed with extra-natural insight – who senses the deception.

The significance of the distinctions made between *vyaktitva* and *charitra* must also be understood in the context of the widespread acceptance within India of the transience of the body and its status as a contingent receptacle for the soul. Khare has described the expression of this view by Chamar[16] intellectuals in Lucknow, for whom it articulates a political yearning: 'a person's body and caste are his exterior [*upari*] and temporary [*nasvana*] sheaths [*caddar*], while the soul is the imperishable one, which neither dies nor can be higher or lower, but is always equally present in every living being'.[17] Khare suggests that this Untouchable view overlaps in a limited way with the Kanya-Kubja Brahmans whom he had earlier studied, thus suggesting that this is an ideology that has wide currency, and in Nagda such views are commonly enunciated across a range of different castes.

One important consequence of this conceptualisation of the relationship between the evanescent body and the eternal soul is an attenuation of the link between visible and invisible qualities. Because the visible is not deemed to be anchored – in most cases – by an invisible realm of character (for there is usually a disjunction between the two), the external body is thus freed from the constraints

with which it is shackled in the western tradition of painted portraiture. What can be captured in a photographic studio is a person's general physiognomy rather than the face as a trace of an interior character. In Nagda, photography works at second remove, with the physiognomy of, say, a deceased relative, making possible the remembrance of an individual which then in turn permits the recollection of the behaviour and actions of that individual. In one western tradition of portraiture[18] there is an attempt to do away with this relay mechanism such that certain physiognomic inflections and nuances are perceived to directly transmit a highly compressed transcript of the sitter's individuality. In Nagda the mode of recognition demands a hieratic clarity – a full-face image with no shadow whose physical recognition is the starting point for the recollection of that individual's life.

Roland Barthes's celebrated search for epiphanic images of his deceased mother recounted in *Camera Lucida*, which has served for some critics as paradigmatic of a western phantasy about photography,[19] contrasts sharply with Nagda memorial photography. Barthes describes his quest as not simply for 'just an image', but for a 'just image'[20] which revealed the 'truth of the face [he] had loved'.[21] The manner in which Barthes describes the image of his mother which finally achieved what he calls 'the impossible science of the unique being'[22] exemplifies in a hyperbolic form one strand of a western portrait tradition with which Nagda practices have almost nothing in common. Barthes searches through images with a growing discontent:

I never recognized her except in fragments, which is to say that I missed her *being*, and that therefore I missed her altogether. It was not she, and yet it was no one else. I would have recognized her among thousands of other women, yet I did not 'find' her. I recognized her differently, not essentially. Photography thereby compelled me to perform a painful labour; straining toward the essence of her identity.[23]

Barthes finally finds a photograph of his mother as a child which 'collected all the possible predicates from which my mother's being was constituted'[24] and proceeds to unravel from the compressed cipher of her face her true 'being'. It is not too simplistic to claim that for most of the inhabitants of Nagda known to me, photography is everything which Barthes desires it should *not* be. It *is* about differential identity rather than 'essential' identity, it *is* about 'just an image' rather than the obsessive search for a 'just image'.

I would suggest that in Nagda, the studio photographer rarely finds himself asked to picture a subject in the sense of a single being whose totality can be transcribed by a photograph. There are no 'true beings' here waiting to be transcribed. What the Nagda photographer is presented with, by contrast, is a series of bodies, a series of surfaces, objects, planes and angles which can be made to assume different qualities.

These local photographic images need to be understood against a wider backdrop of popular Hindi film and calendar art, within what Appadurai and Breckenridge have termed an 'inter-ocular field'.[25] There is a recurrent concern within popular Hindi movies with the 'good and bad brother' and collectively these films constitute what is known as the 'lost and found' genre[26] in which two caricatures of *dharma* and *adharma* (duty and the negation of duty) struggle against each other. The clichéd form is a contest between the upright chief policeman of Bombay and a gang boss flooding the city with guns, gold and drugs who finally discover as they lie dying in the arms of their widowed mother that they are in fact brothers separated at birth. As Sudhir Kakar notes: 'In many movies, the "split" in

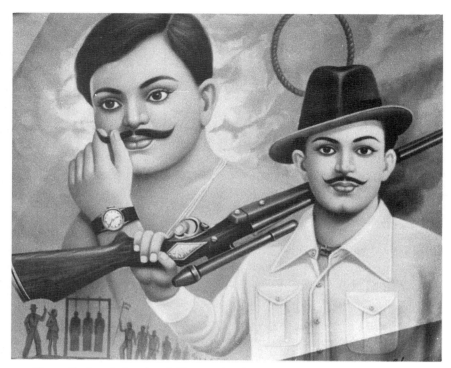

45 Bhagat Singh and Chandra Shekhar Azad. Colour calendar image by H. R. Raja, *c.* 1980.

the self is highlighted by the brothers getting separated during childhood, the developmental fate of each remaining unknown to the other, till the final climactic scene in which the confrontation between the brothers takes place and the two selves are finally integrated.'[27] A variation on this can be seen in the film *Ghazab* (Oppression) released in 1982 and recently reissued. This stars Dharmendra in the classic double role playing a doomed weak brother in the first half of the film and an avenging strong brother in the second half who rights the wrongs done earlier to his sibling. My notes after seeing this film:

... playing Vijay, his muscular Bombay brother, he returns in the second half to settle the score although he is ultimately only able to do this with the help of the deceased brother (now a ghost, referred to as *atma bhai sahab* – 'respected soul brother').

... near the finale Vijay takes his brother's energy (*sakti*) into his own body. Through trick photography we see a literal merging of the two bodies. Vijay's biceps bulge, his shirt rips apart and all the villains are then vanquished ...

'Splitting', however, is merely one aspect of a much larger spectrum of fragmentation. Threes for instance are almost as popular as doubles: the best filmic example is *Amar, Akbar, Anthony* in which three brothers separated as babies are raised by families of different faiths. In popular calendar art there are numerous images which replicate representations of the *trimurti* (the 'three forms' of Brahma, Visnu and Siva). Such arrangements depict the three branches of the armed forces, Kali, Ramakrishna and the Mother, and political trios such as Subhash Chandra Bose, Bhagat Singh and Chandra Shekhar Azad.

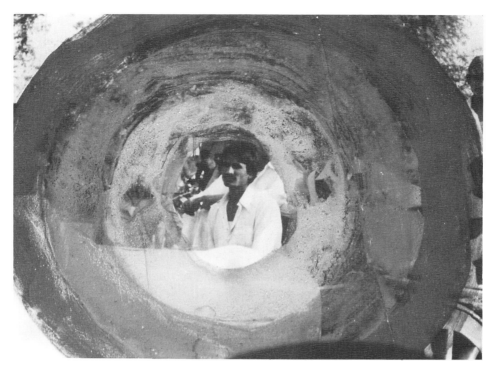

46 Colour print of Hira overpainted by an unknown Nagda photographic studio.

Both Bhagat Singh and Chandra Shekhar Azad are famous and celebrated for their terrorist actions in 1931. Today in India they are immensely popular figures and their image together with that of Subhas Chandra Bose (whose Indian National Army fought with the Japanese to rid India of its British colonisers) can be seen far more often than that of western heroes such as Gandhi. Chandra Shekhar Azad was a Brahmin, Bhagat Singh was raised a Sikh. For many Britons in India, conditioned by early anthropology's anthropometric obsessions, this would have suggested a fundamental difference, a separation that could be testified to by sartorial, physiognomic and physiological incompatibility. In the popular Indian representation however (such as Figure 45) they appear identical – Indian brothers distinguished only by the presence of a hat or a wristwatch and sacred thread. Images of Singh and Azad became hugely popular in the 1930s and many proscribed images dating from this period can be seen in the Proscribed Indian Books collection in the India Office, London. Figure 45 is a calendar image painted by H. R. Raja, a Muslim artist based in Meerut who appears to have first developed this physiological similitude and to have elaborated the theme in many hundreds of paintings in the last two decades.

Raja's image suggests an oppositional practice, a political critique of the divisiveness of British policy and much of its imperial science. It also, however, demonstrates how the face in contemporary Indian representations can be erased of its physiognomy, its epiphanic qualities effaced in favour of more compelling arguments. Inasmuch as the similarity of action and political identity (they were both fighters for the freedom of India) is signified by their identical bodies, this supports a monist interpretation. More persuasively, however, it might be argued 139

that sameness can be exported between different bodies and faces because there is no internalised and coherent subject of portraiture.

That photographic portraiture in central India is not centred on a physiognomic personality is perhaps also demonstrated by certain practices associated with memorial portraiture. A long-term acquaintance of mine, Hira, a scheduled caste Chamar, was recently killed by a train and his mother took some group photographs which included Hira to a Nagda Studio where his figure was isolated and emphasised by the application of concentric rings of blue, red and yellow, which are often used as divine haloes in chromolithographs of deities. These rings were painted on before the image was rephotographed with an enlarging lens (Figure 46). This is one example of the manipulation of the photographic image available to very poor bereaved villagers. In Nagda, by contrast, wealthier bereaved families have access to an altogether more complex process.

Many of the painted memorial photographs to be seen in shops and homes in Nagda are the work of Nanda Kishor Joshi (Figure 47), an itinerant Brahman artist

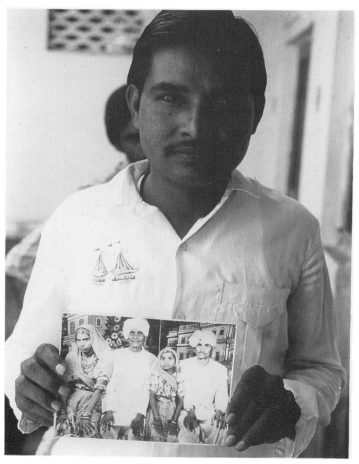

47 Nanda Kishor Joshi holding a photograph which will form the basis
of a memorial portrait.

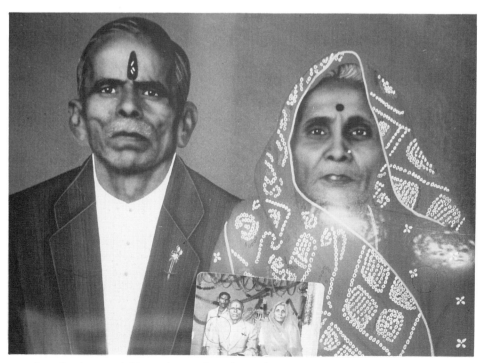

48 Order form for 'Hemu Art Center' and original photograph given to
Nanda Kishor Joshi.

49 Completed memorial image by Nanda Kishor Joshi together with its original
photographic referent.

from Beawar, Rajasthan who visits Nagda several times yearly in search of commissions. The majority of these are for memorial 'photos' of deceased family members. Nanda Kishor Joshi's artistry is concerned with perfecting the past, rendering the transient flux recorded in photographic emulsion into more permanent, more true forms. Everything about Nadga photographic practices suggests that no value is placed on photography's documentary ability to record the random and inconsequential. On the contrary, photography is prized for its ability to record idealised staged events characterised by a theatrical preparedness and symmetry. Nanda Kishor Joshi's economic niche is to be found precisely in the space between photography's indexical randomness and Nagda people's demands for images constructed according to a significantly different aesthetic.

When clients give him a photograph (he prefers black and white) of the deceased, he also completes a form of 'particulars' (Figure 48). In this is recorded the desired colours of (in this order): hair, head-dress, shirt, coat, jacket, sari, blouse, ornaments, eyes, *bindi* or *tilak*,[28] trousers, petticoat. Following this there is a section for 'special instructions' and for the name which is to be written on the portrait. The form finally notes that these images are best seen from approximately eight feet away.

The original photograph – often extremely small – is scaled up by Nanda Kishor Joshi to the required size of the new portrait (Figure 49) and the 'special instructions' are incorporated in the final work which, once mounted and framed behind glass, costs in the region of Rs. 300–450.[29] Nanda Kishor[30] stresses the flexibility which his style of world-making offers:

whatever a person wants can be put in the photo ... make the clothes this colour, even put new clothes in – if no *kurta* is worn, no coat is worn, then a coat can be given, if there is no *topi* [a cap, in this context mostly worn by Jains], a *topi* can be provided, a *pagri* [turban] made – Marwari, Rajasthani, Panjabi, Gujarati, Ratlami [styles of *pagri*] – whatever design a person wants can be provided.

Nanda Kishor shows me his current commissions. He points out various additions in his coloured portraits: 'a Jodhpuri *pagri* ... *kangressi topi* [the cap associated with Congress Party politicians] ... a gold chain around a Jain's neck ...', complete transformations from *kurta* in the original photo to a Jodhpuri coat covering his throat. Others asked for *tilaks* (a ritual mark in the centre of the forehead) or they might say 'there's a *pagri*, give me a *kangressi topi* ... give me a white shirt ... give me a moustache'. One man had been killed by a train and his father wanted a photo but with more hair and the skin colour lightened; another wanted a red *pagri*; another wanted a face 'shaved'.

Sri —— of Nagda had given him a coloured photo – 'He's alive [*zinda hai!!*], not deceased.'

He wants his *pagri* the same colour as in the photo, but needs shaving and he wants a closed Jodhpuri coat. No. 867 a Porwal [middle ranking trader caste] ... his *topi* is too high on his head, it will be lowered a little. The collar on his *kurta* is open a little too much ... it will be closed a little. One woman, with severe *khol* [vitiligo – lightening of the skin] ... the original colour will be restored and a *bor* [a brass ornament] placed in her hair ... both her eyes will be straightened ... she's old and one eye is going over there and one over there.

The transformation of the past is perhaps starkest where Nanda Kishor has to rely on post-mortem photography. Photographs are often taken by relatives and studios

after death when studies from life exist, but they are given to Nanda Kishor only when they are the sole image available. In such cases the physical manifestations of death can be turned back, mouths can be closed, and eyes opened as the *yadgari* (memento) takes shape.

The contrasts with Barthes's search for the 'just image' of his mother are illuminating. Nanda Kishor's images lack the compressed epiphanic transcript that Barthes desperately searched for, and his clients do not yearn for an 'impossible science of the unique being': their quest is for the 'merely analogical, provoking only ... identity'.[31] This must in part be because of their function – they are public icons, often displayed in shop fronts and worshipped monthly on the *tithi* (lunar day) of the ancestor's death and annually during a more elaborate ritual procedure in *pitra paksya* (ancestors' fortnight). But they also have to do the work of remembrance and will often be the only images of the deceased which are carefully kept. Similarly, Nanda Kishor Joshi's painted photographs suggest a striking answer to the question posed in the eighteenth century by Johann Caspar Lavater: 'where is the art, where is the dissimulation, that can make the blue eye brown, the grey one black, or if it be flat, give it rotundity?'[32]

Coomaraswamy would have described these images as 'effigies' rather than 'portraits'.[33] This is not merely because he argued that 'portraits' are 'likenesses of a person still living', but also because, as he perceptively noted, 'portraiture in the accepted sense is history'. This recalls LeGoff's characterisation of the true subject of portraiture as an individual configured in a 'concrete spatial and temporal setting'.[34] The dominant tradition of western portraiture in oils has given expression to such a chronotope framed by a perspectival window and much western photography has in many ways reproduced the conventions established within this earlier tradition of painting.

Portrait photography in Nagda is not imprisoned by such a representational chronotope but, rather, has its own quite distinct constraints. Photography, rather than providing a perspectival window in which to ground persons, is, in this Indian context, a means through which individuals can be displaced. Clifford Geertz once highlighted a crucial facet of 'western' conceptualisations of the person as its 'organiz[ation] into a distinctive whole and set[ting] contrastively both against other such wholes and against its social and natural background'.[35] Nagda photography displays little evidence of this for, as we have seen, photography is used as a means to set aspects of a person against aspects of that same person. Rather than seeking to provide a ground in which solidity can be conjured up through oppositions with similarly grounded individuals, photography appears as a tactic for self-enquiry. The space in which this occurs is not the technological picture plane that some photography shares with western oil painting, but the flat space of the photographic positive in which doubles or triples of the same displaced individual can be conjured.

Notes

1 Eyes, both divine and human, are frequently the subject of complex sequences in popular cinema and reflect the centrality of vision in Hindu ritual encounters. The commonly used term *darsan* translates as 'seeing and being seen by the divine'. Cf. D. Eck, *Darsan: Seeing the Divine Image in India* (Chambersburg, Anima Books, 1985).
2 For an example see C. Pinney, 'The lexical spaces of eye-spy', in P. I. Crawford and D. Turton (eds), *Film as Ethnography* (Manchester, Manchester University Press, 1992), p. 42.

3 J. LeGoff, *Time, Work and Culture in the Middle Ages* (Chicago, University of Chicago Press, 1980), p. 36.
4 E. Panofsky, *Perspective as Symbolic Form* (New York, Zone Books, 1991), p. 27.
5 Naoroji represented Finsbury in the House of Commons as the first Indian Member of Parliament and was also President of the Indian National Congress.
6 M. K. Gandhi, *An Autobiography* (Ahmedabad, Navajivan Publishing House, 1991), p. 70.
7 Gandhi, *Autobiography*, p. 70.
8 D. MacDougall, 'Photo hierarchicus: signs and mirrors in Indian photography', *Visual Anthropology*, 5 (1992), p. 104.
9 A. Appadurai, 'How to make a national cuisine', *Comparative Studies in Society and History*, 30 (1988), pp. 3–24.
10 L. Dumont, 'The functional equivalents of the individual in caste society', *Contributions to Indian Sociology*, 7 (1965), p. 99.
11 M. Mines, 'Conceptualizing the person: hierarchical society and individual autonomy in India', *American Anthropologist*, 90: 3 (1988), pp. 568–79.
12 E. L. McHugh, 'Concepts of the person among the Gurungs of Nepal', *American Ethnologist*, 16 (1989), pp. 75–86.
13 M. Marriott, 'Interpreting Indian society: a monistic alternative to Dumont's dualism', *Journal of Asian Studies*, 36: 3 (1976), p. 194.
14 Here, monism denotes a denial of the duality of mind and matter and the proposal that physical and psychical phenomena are interpenetrating.
15 As we saw earlier with reference to a 'Collector', these features may also be indicative of social and professional status.
16 A scheduled caste (formerly 'Untouchable') whose traditional occupation is leather-tanning.
17 R. S. Khare, *The Untouchable as Himself: Ideology, Identity, and Pragmatism among the Lucknow Chamars* (Cambridge, Cambridge University Press, 1984), p. 53.
18 I mean here the dominant tradition that presents the face as a transcendent sign (cf. J. Koerner, 'Rembrandt and the epiphany of the face', *Res: Anthropology and Aesthetics*, 12 (1986), pp. 5–32) but I also acknowledge the presence of other western traditions (e.g. the 'swagger' portrait) which have greater similarities with the twentieth-century central Indian images discussed here.
19 For example, J. Tagg, *The Burden of Representation: Essays on Photographies and Histories* (London, Macmillan, 1988), pp. 1–3.
20 R. Barthes, *Camera Lucida: Reflections on Photography* (London, Fontana, 1984), p. 70.
21 *Ibid.*, p. 67.
22 *Ibid.*, p. 71.
23 *Ibid.*, pp. 65–6.
24 *Ibid.*, p. 70.
25 Cf. A. Appadurai and C. Breckenridge, 'Museums are good to think: heritage on view in India', in Ivan Karp *et al.* (eds), *Museums and Communications: The Politics of Public Culture* (Washington, Smithsonian Institution Press, 1992).
26 Cf. R. Thomas, 'Indian cinema: pleasures and popularity', *Screen*, 26: 3–4 (1985), pp. 116–31.
27 S. Kakar, 'The ties that bind: family relationships in the mythology of Hindi cinema', *India International Centre Quarterly*, 8: 1 (1981), p. 7
28 Marks on the forehead.
29 Approximately £6–9 at 1995 exchange rates. Though a small sum for many prosperous Nagda traders, it might be contrasted with agricultural labour rates of around Rs. 20–25 per day.
30 The following are based on my translations of extensive taped interviews in 1991 and 1992.
31 Barthes, *Camera Lucida*, pp. 70–1.
32 J. C. Lavater, *Essays on Physiognomy* (London, William Tegg, n.d.), p. 84.
33 A. Coomaraswamy, 'The part of art in Indian life', in R. Lipsey (ed.), *Coomaraswamy, Selected Papers* (Princeton, Princeton University Press, 1977), I, p. 89.
34 LeGoff, *Time*, p. 36.
35 C. Geertz, 'From the native's point of view: on the nature of anthropological understanding', in R. A. Shweder and R. A. LeVine (eds), *Culture Theory: Essays on Mind, Self, and Emotion* (Cambridge, Cambridge University Press, 1984), p. 126.

PART IV

The portrait transaction

7

She's got the look! Eighteenth-century female portrait painters and the psychology of a potentially 'dangerous employment'

ANGELA ROSENTHAL

On Tuesday 18 April 1775 James Boswell recorded in his diary an exchange with Samuel Johnson:

Our conversation turned on a variety of subjects. He [Johnson] thought portrait-painting an improper employment for a woman. 'Publick practice of any art, (he observed,) and staring in men's faces, is very indelicate in a female'.[1]

Although rarely put so explicitly, Samuel Johnson's opinion concerning the female portraitist corresponded to a widely held view. Portraiture, as Johnson observed, is a public art practice. It entails a social encounter between the artist and his or her sitter as well as, in the eighteenth century, guests, friends and relatives.[2] Moreover, the meeting necessitates a particularly (in)tense visuality: the eye/I of the artist fixes the sitter, 'staring' and recording.

Eighteenth-century European, metropolitan society developed an elaborate ideal of femininity, constituted by notions of private, domestic virtues, and culturally regulated through literature, conduct books and other media.[3] Within the discourses governing female behaviour, dominant gaze polities were more rigorously defined along gendered lines.[4] The ideal woman could not direct a prolonged, searching look at a man without impropriety. That is, women who did not conform to such cultural limits were excluded from polite society, and considered either uncultured, unnaturally powerful or immoral.

Within such an imbalanced visual economy, portraiture was a problematic professional pursuit for women to whom such ideals of comportment were thought to apply; and because the behavioural codes focused upon the ocular submission of women to men, especially troublesome to the female portraitist was the heterosexual encounter. This is not to say that the homosexual encounter was seen as unproblematic. But these problems were suppressed in the dominant discourse; anxiety was more explicitly expressed regarding the heterosexual portrait event.[5]

Yet at the same time that portraiture as a profession was perceived as too public a practice for genteel women, the genre was also, paradoxically, especially associated with them. In contrast to the explicitly public functions of history painting, portraiture was always concerned with individual likeness. In this respect it was perceived to appeal particularly to the vanity of female sitters. Women artists

were thought to lack the ability to abstract, a quality required in rational pursuits such as history painting.[6] But this assumed deficiency regarding abstraction implied a heightened mimetic ability. Unable to pull away from reality, women were granted a privileged proximity to it. Moreover, in the course of the eighteenth century portraits came to be valued for their effectiveness in framing sitters in terms of individual and private virtues – a domain coded as feminine. It was along these lines that August von Kotzbue (1805) praised Angelica Kauffman:

> The female artist entirely lacks the power for heroic subjects ... To the contrary, in portraiture she possesses her greatest strength; and perhaps females are, if they want to become paintresses, particularly suited to this branch of art, since truly they have received from nature a fine instinct to read physiognomy and to convey and to interpret the mobile gestural language of men. It is a gift which nature has preferred to grant them as a weapon of the weaker.[7]

In the eighteenth century, women wielded this weapon in increasing numbers.[8] The international success of portraitists like Rosalba Carriera (1675–1757) early in the century, and later Dorothea Therbusch (1721–1782), Adélaïde Labille-Guiard (1749–1803), Elisabeth Vigée-Lebrun (1755–1842), Catherine Read (1723–1778) and Angelica Kauffman (1741–1807), flew in the face of the moralists' objections to a woman 'staring in men's faces'. Eight years after Johnson asserted the impropriety of the female portraitist to Boswell, he himself sat for his portrait (Figure 50) to Frances Reynolds (1729–1807), sister of Joshua Reynolds (1723–1792), for 'perhaps the tenth time and I sat nearly three hours', as he wrote to Mrs Thrale.[9]

To grasp the socio-historical and cultural importance of the female portraitist in the eighteenth century it is necessary to address the apparent contradiction she embodies, between a domestic art of mimesis and a dangerous, indecorous visuality. A critical awareness of the historically specific formation of the gaze can help explain this paradox: why, in a society with a developed ideal of womanhood associated with the private sphere, did women emerge in public as portrait painters?

In suggesting a way to answer this question, the portrait, rather than being considered as an end-product, disconnected from its production, will be seen as a process. Rather than a *reproduction* of a pre-existing self, the portrait is seen as the *production* of sitter and artist, and of the relation between them determined by mobile factors such as class, race, age, and gender. Attention is shifted from the stasis of the supposedly finished work towards the intersubjective encounter from which it emerged, and via the gaze, specifically towards the gender positions embedded in the image and its reception. The portrait painter's studio is understood, moreover, as a cultural space for the discursive formation of sexual and social identities. Societal expectations regarding gender and vision problematise this space and the heterosexual portrait event. But it was, oddly, precisely this problematic construction that enabled female portrait painters to produce in their studios particular social encounters, and in their art a new means of representing a virtuous masculinity.

This essay first considers the psychosexual discourses concerning the exchange of gazes in the portrait studio in comparison to the life-class. I shall then set William Hazlitt's perception of the encounter between the male portraitist and his female sitter in his essay, 'On sitting for one's picture', beside Elisabeth Vigée-Lebrun's record of the reverse gender role positioning – the two studio situations highlighting differing tensions.

The next part of the essay moves away from the discourse on the inter-subjective studio-encounter towards the reception of a portrait. An extract from a text on the Salon of 1767 by the French art critic Denis Diderot, in which he discusses a portrait of himself by the German artist Anna Dorothea Therbusch, reveals how the female portraitist's sex might determine the reception of her work.

The final part of the essay concerns itself with a single portrait event: the painted document of the intersubjective exchange between Angelica Kauffman and the actor David Garrick. I argue that this painting bears traces of the culturally coded tensions generated by an encounter between a female portraitist and her male sitter.

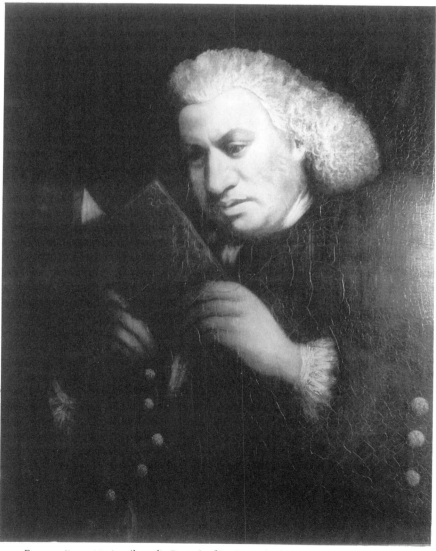

50 Frances Reynolds (attributed), *Portrait of Dr Samuel Johnson*, c. 1783. Oil on canvas, 76.2 x 63.5 cm.

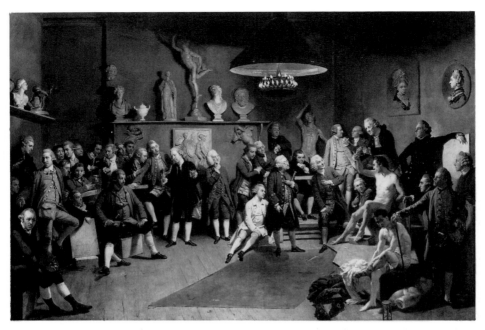

51 Johann Zoffany, *The Assembly of the Academicians of the Royal Academy*, 1771.
Oil on canvas, 100.7 x 147.3 cm.

For our understanding of the portrait event it is particularly relevant to compare the gaze-control and the gendered power structures of the portrait studio to the life-class. Both the academic life-class and the portrait situation demanded the direct encounter of the painter and his/her model and thus entailed the latter's awareness of being object to the gaze of the former. Yet there is a considerable difference. For in the academic life-class the model's dependence upon the artist is hierarchically and economically pre-structured. Representational, and therefore ocular, power is possessed by the painter who pays his model to serve as the object of investigation. Tamar Garb has argued for the nineteenth century that 'the primary reasons for excluding women from the life-classes was in fact for the protection and preservation of masculinity'.[10]

Johann Zoffany's painting of *The Assembly of the Academicians of the Royal Academy* (1771, Figure 51) is not only an icon of exclusion – of Angelica Kauffman and Mary Moser, the two female founding members relegated to portraits in the background – but the painting can also be read as bearing signs of an unconscious anxiety about female transgression. I am referring to the triumphant and provocative placement of the stick of Richard Cosway, the gentleman in the right-hand corner. Falling square on the belly – or womb – of the fragmented, naked female sculpture, the stick cannot be dismissed as incidental. Rather, the violence of the gesture against female form can be read on a psychic level as a sign of male anxiety, and particularly anxiety concerning woman's mastering and desiring gaze.

In contrast to the life-class, where the control of the gaze and the power over the definition of gendered positions were so rigorously seen as pertaining to the male artist, the portrait studio was a cultural space where such power was, to a greater
150 degree, subject to negotiation. Economic power shifts toward the represented, with

concomitant effects upon the social, psychical and visual economies of the studio. The portrait was not a result of the ideally autonomous academic eye, but a product of the exchange between two subjects: the artist and the sitter.[11]

Of the known eighteenth and early nineteenth-century texts, commentaries and satires dealing with the psychological situation of the portrait painter's studio and its suggestions of licentiousness and vanity, William Hazlitt's 'On sitting for one's picture' is of particular relevance in this context.[12] Hazlitt recognises that the portrait event was in effect a reciprocal process, in that both painter and sitter were responsible for the success or failure of the work. He characterised the ideal interaction as possessing a 'mild sense and tone of equality'.[13]

This balance is disturbed, however, by a woman. Hazlitt writes:

The relationship between the portrait-painter and his amiable sitters is one of established custom; but it is also one of metaphysical nicety, and is a running double entendre. The fixing an inquisitive gaze on beauty, the heightening a momentary grace, the dwelling on the heaven of an eye, the losing one's-self in the dimple of a chin, is a dangerous employment. The painter may change to slide into the lover – the lover can hardly turn painter.[14]

As opposed to the sociability of the exchange between men, the (male) portrait painter runs a risk before a female sitter. This sensual experience of portrayal is, significantly, reserved for the male viewer-artist. It is he who, in beholding the charms of his implicitly female sitter, transforms her into his object of desire. Portrayal of a woman is not merely the taking of an impression of the sitter, nor only the construction of her identity, but is also, as Peter de Bolla has formulated, a 'construction of his [the artist's] own selfhood through the resistance to and articulation of his desires'.[15] In order to proceed as a painter, he must control such desires and resist temptation. This self-control can, however, be achieved through his art. By transferring his sexual impulses directly onto the canvas, the painter creates an image upon which he can now project his desires and wishes.

In a Pygmalionesque vein, Hazlitt writes:

The health and spirit that but now breathed from a speaking face, the next moment breathe with almost equal effect from a dull piece of canvas, and thus distract attention: the eye sparkles, the lips are moist there too; and if we can fancy the picture alive, the face in its turn fades into a picture, a mere object of sight. We take rapturous possession with one sense, the eye ...[16]

Displaced, the erotic prerogative of the male artistic gaze is endorsed through aesthetics. Moreover, Hazlitt's discourse on the studio prohibits any response to his desiring gaze from the supposed female sitter. Her gaze was not directed at him but turned upon herself: 'the finest lady in the land is as fond of sitting to a favourite artist as of seating herself before a looking-glass'.[17] Although directed away from the male artist, her gaze can also be one of pleasure, albeit a narcissistic one. Hazlitt concludes that this pleasure can be more fully satisfied by a portrait painting than an actual mirror: 'as the glass in this case [referring now to the artist] is sensible of her charms, and does all it can to fix or heighten them'.[18]

The construction of a narcissistic female sitter, caught in self-love, equips the artist with a reflective armament – a highly polished discursive shield – with which to deflect the potentially disturbing female gaze, and permits him immediate and voyeuristic access to his object of depiction and desire.

Reversing the gender roles of artist and sitter, this reflective shield becomes,

however, transparent. The *male* sitter cannot wish away the female artist's probing eye. As with Johnson, the reversal of these assumed heterosexual gender roles and gazes in the portrait studio disturbs Hazlitt: 'the sitting to a lady for one's picture is a still more trying situation, and amounts (almost of itself) to a declaration of love'.[19]

Sigmund Freud and Sandor Ferenczi, in essays concerning the 'Medusa's Head', address the issue of the threat posed by female visuality directly in psycho-analytic terms, drawing a connection between the gaze and sexual potency. For Freud and Ferenczi it is not the gaze of the woman as such, but rather the man's awareness of his being the object of a lustful and judgemental female eye, that presents a threat of loss. In Freud's terms this threat of loss means castration anxiety, against which the man can only protect himself by reconfirming his masculinity. Medusa is thus a symbol of castration anxiety. With her petrifying looks and phallic snakes, she disempowers her male subject.[20]

In the writings of the eighteenth-century French portraitist Elisabeth Vigée-Lebrun we can discern traces of such a powerful and threatening female vision not to be found in Hazlitt's text. In 1833 Vigée-Lebrun, reflecting upon her long and successful career, began to write her autobiographical *Souvenirs*, her textual self-portrait. In this text she recorded, or rather (re)constructed, the studio dynamic between herself and her male sitters, describing the ocular exchange from the other side of the conceptual shield. She relates how the portrayal of a man ('especially if young') requires viewing him, standing upright, for a few moments 'before one begins to capture the general characteristics and outer appearance'.[21] This preliminary objectification of the male sitter served to redress the cultural norms of gaze polity, positing the male as bearer, and woman as object of the gaze.

In order to reduce the psychic tension brought about by this reversal of social conventions, the male sitter in Vigée-Lebrun's portrait studio might thus have felt compelled to re-establish his masculinity by reclaiming ocular power. And indeed Vigée-Lebrun relates that while she painted them 'several admirers of my face threw amorous glances at me'.[22] Confirming her ability to attract the erotic atten-tion of her male sitters – the essence of womanhood as defined in positive terms by Jean-Jacques Rousseau in *Emile* – interfered with Vigée-Lebrun's control of the gaze polity in the studio.

This slippage of power over the gaze away from the female artist is com-mented upon by Thomas Rowlandson in a satirical drawing entitled *The Mutual Attempt to Catch a Likeness* (Figure 52).[23] In the drawing a female artist portrays a male sitter – the phrase of catching a 'likeness' refers to the practice of portrait painting. She is deeply absorbed in her activity, turning her 'Medusan' gaze away from her living model towards the stone of an antique bust above her sitter's head. Taking advantage of her averted glance, the unattractive and significantly older, corpulent lawyer takes pleasure in the artist's charms, her revealed breasts receiv-ing the erotic attention of his gaze.[24] Like Hazlitt's ideal sitter, and Vigée-Lebrun's flirtatious sitters, Rowlandson's lawyer – possibly a 'judge' of female beauty – can-not but view the situation as sexual. Denied power over the gaze, men reassert their ocular control, and therefore their masculinity, as lovers. This, in turn, denies the female artist power over the gaze: her attempt to catch a likeness is impaired.

The reclamation of ocular control for the female portrait painter – such as Elisabeth Vigée-Lebrun, Angelica Kauffman, and others – required of her a definitive riposte. In order to do this, she had to bring her gaze into harmony with contemporary ideals concerning the language proper to the female gaze. Both

conduct literature and popular novels (through the paradigmatic etiquette of their heroines) addressed the ideal gaze-response of women.[25]

The Whole Duty of Women, a popular comportment primer, warns its female readership that 'the Language of the Eyes [is] the most significant and the most observed'.[26] Women, therefore, should have a 'perpetual Watch upon their Eyes', and 'remember that one careless Glance gives more Advantage than a hundred Words not enough considered'. Moreover, proper moral behaviour ('modesty') is defined as prohibiting a woman responding to a male gaze in like terms: 'The Female Sex ought to maintain a Behaviour towards Men, which may be secure to themselves without offending them ... Looks that forbid without Rudeness, and oblige without Invention.'[27]

Vigée-Lebrun's text is informed by such recommendations. She writes:

You can easily imagine that many admirers of my appearance had me paint theirs in the hope of gaining favour with me; but I was so absorbed in my art that nothing could distract me. Moreover, the moral and religious principles my mother had taught me shielded me well from the seductions with which I was surrounded.[28]

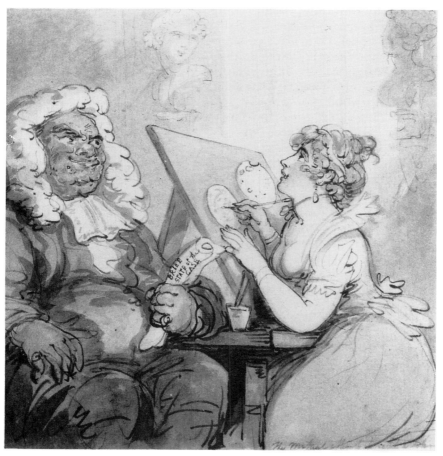

52 Thomas Rowlandson, *The Mutual Attempt to Catch a Likeness*, c. 1790. Brown ink and watercolour on paper, 23.8 x 23 cm.

Lebrun, in order to forestall any further reversal of control, bleaches her own gaze, sanitising it morally. But before returning in her text to the studio situation, she seizes moral high-ground and amasses proactive vindications of her own practice. In this excursus, she explains that she never read anything but the school books of her brother and prayer books. Poignantly, she records that the first novel she read was Richardson's *Clarissa*, but by then, she explains, she was already married.[29] Moreover, she makes it clear that the space in which she worked was always sanctioned by maternal presence. Having cleansed her gaze of all sexual impropriety, the artist then mentions a strategy she employed to maintain her control over the ocular exchange:

With regard to the gentlemen, as soon as I realised they wished to make eyes at me, I painted them with gaze averted; which prevents the sitter from looking at the painter. At the least movement of their pupils in my direction, I would say: 'I'm doing the eyes.' That would annoy them a little, as you can imagine; my mother, who was always with me and whom I told about this, laughed secretly.[30]

While Hazlitt's implied male artist, displacing his own desires onto the canvas, armed himself with a conceptual mirror against the female gaze, the female artist, in contrast, protected herself against the visual advances of her male sitters, effacing her Medusan gaze through moral self-fashioning, and finally subterfuge.

Vigée-Lebrun's claim that she painted her forward male sitters with 'gaze averted' does not suggest that her goal was to gain voyeuristic access to the male sitter and thus reverse the configuration in Rowlandson's studio scene. Rather, in deflecting male eyes, the artist blunted their passion, and then registered this deflection in the portrait.

By controlling and displacing the visual advances of her male sitters, Vigée-Lebrun creates an image of manhood which conforms to her desires and wishes – or at least to those which were expected from a woman who had internalised the rules of popular opinion as registered in the conduct literature: that is, a man whose erotic passions are defused.

The effectiveness of such an image should be clear. The intersubjective exchange produced the image of an individual male sitter as 'civilised' regardless of whether he had incorporated these ideals and virtues himself. Thus, a pictorial representation of internalised virtue existed before these qualities were actually internalised by men in society, the portrait painting allowing the depicted man to recreate himself according to these ideals. The constructed civility of the female portraitist's studio which rendered such civilising images was, however, only seemingly stable: the annoyance of the male sitter and the secret laughter of the conspiring women in Vigée-Lebrun's studio speak of continuing tension. The psychic anxieties of the ocular reversal were not dispelled. Vigée-Lebrun, moreover, seems to have been aware of the fact that her visual power was not without a darker, uncivil aspect; she writes in her *Souvenirs*:

One day somebody said to me, 'when I look at you and think of your fame, I seem to see your head encircled by radiating beams of light'. 'Ah', I added, sighing, 'there are however little snakes among the beams'.[31]

Both the civilising and disorienting aspects of the studio are present in Denis Diderot's discussion of his sitting for his portrait to Anna Dorothea Therbusch in Paris.[32] Writing of the Salon of 1767, the 57-year-old Diderot felt it necessary to

comment upon Therbusch's portrait of himself. Diderot is only briefly concerned with the completed painting which shows him 'naked to the belt'.[33] Rather, owing to his nudity, he is at considerable pains to explain the circumstances and intersubjectivity of the portrait sitting itself, and thus to promote an 'appropriate' reception of the image. Indeed, his text is an elaborate justification of his actions and moral position in relation to the painting and its development. Such a textual vindication was necessary. Diderot himself writes of how the 'poor philosopher [Diderot], whose lively interest was interpreted against him ... was denounced and regarded as a man who had slept with a not exactly pretty woman [Therbusch]'.[34] The 'poor philosopher's' defence turns upon two factors: the immanent quality of the artist's work and his version of the intersubjective exchange in the studio.

Thus, we learn from Diderot's discussion of Therbusch's genre painting, *A Man with a Glass in His Hand*, that the technique of the artist is bold and manly and that she is 'courageous to appeal to nature and study her'.[35]

Analogously, it is her scientific interest which leads her to study anatomy, for (Diderot is careful to record) 'she was not of the opinion, that vice alone should have the right to undress a man'.[36] Thus couched in comfortably masculine and rational language, Therbusch's painterly style could stand as proof of the propriety of her practice. Immediately afterwards, Diderot reveals what one did not find in Therbusch's studio; she did not correspond to his ideal of 'beauty' and she did not attempt to attract the senses through 'coquettish behaviour'.[37] Diderot also tries to exclude the possibility of an erotic reception by explaining that he, regardless of her behaviour, had already overcome his drives during the portrait event, upon which he comments at length. He (re)wrote, thus:

When the head was done, the neck was of concern, which was hidden by the collar of my suit – this disturbed the artist a little. In order to undo this irritation, I went behind a curtain and undressed myself and appeared before her as an academy model. 'I did not dare to propose it to you', she said to me, 'but you have done well, and I thank you'. I was naked, entirely naked. She painted me and we chatted with a freedom and innocence worthy of the first centuries. Since the sin of Adam, we cannot command all our bodily parts like our arms: there are some which are willing when the son of Adam is not, and those that are unwilling when the son of Adam is willing indeed. I would have – if this incident had occurred – recollected the words which Diogenes spoke to the young fighter: 'My son, do not be afraid, I am not as wicked as him there'.[38]

Diderot takes care to note that it was not the request of the artist that resulted in his disrobing, but rather his own charitable volition. He was not placed under academic scrutiny, but placed himself before the artist's eye. His ensuing commentary upon his corporeal control is offered as proof of his mental and moral strength. In sitting, naked, to Therbusch for his portrait, Diderot would have it that he put himself to the test. The image, revealing Diderot only 'naked to the belt', does not show him 'entirely naked', as his comments suggest. The absence in the painting resulted in an ambiguity no doubt uncomfortable to Diderot. In overcoming his drives, and controlling the uncontrollable, he could characterise himself as a philosopher, albeit one to be pitied, and insert himself into the history of those thinkers who also set their minds against and over matter. But in so doing, he contradicted his explicit denial of eroticism in the encounter, which he framed as an academic exercise.

In 1764, three years before Diderot sat for Therbusch, the famous English actor David Garrick (Figure 53) while travelling in Italy was portrayed by the Swiss-

born artist Angelica Kauffman at Naples.[39] The painting, which is now at Burghley House, has been treated in two different ways. First, as an important historical document: exhibited at the Free Society in 1765, it heralded Kauffman's arrival in London in 1766 where she remained for the next fifteen years. In the second place, the work has been subject to iconographic analysis. Desmond Shawe-Taylor has drawn attention to the Dutch roots – specifically in the work of Frans Hals (Figure 54) – of Garrick's pose: regarding the viewer over the back of his chair.[40]

Here the painting shall be examined not as an idiosyncratic marker of personal contact, but as the result of an intersubjective exchange, and as a fixing of cultural and psychic tensions. As beholders and interpreters, the position of the female artist constructing the exchange is offered to us as a privileged site for reception. This is not to argue that the viewer's position is absolutely predetermined by the image. Receptions can be plotted on many possible axes, including

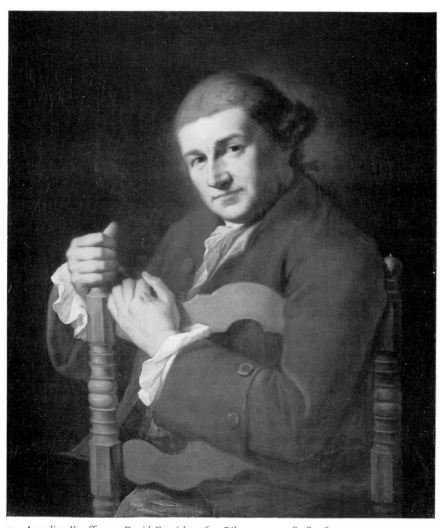

156 53 Angelica Kauffman, *David Garrick*, 1764. Oil on canvas, 83.8 x 69.2 cm.

sexual preference, age, class, and race. I am, in this instance, concerned with the 'being' of the female viewer in the painting.[41]

At first sight, the painting appears to deny the possibility of such an interpretation. Apparently devoid of narrative cues and structure (despite a certain iconographic heritage), the image seems to lack the social texture upon which interpretation can take purchase. These absences can, however, become legible if read against those references that are normative to protraiture.

By casting Garrick in a dramatic role and portraying Garrick as 'Kiteley', Joshua Reynolds chose an obvious solution to the problem of portraying the renowned actor.[42] In this painting, the character approaches the beholder as the jealous husband from Ben Jonson's play, *Every Man in His Humour*.[43] The sitter is thereby characterised by his profession. Garrick acts for the viewer, who is asked to imagine herself as witnessing a performance.[44]

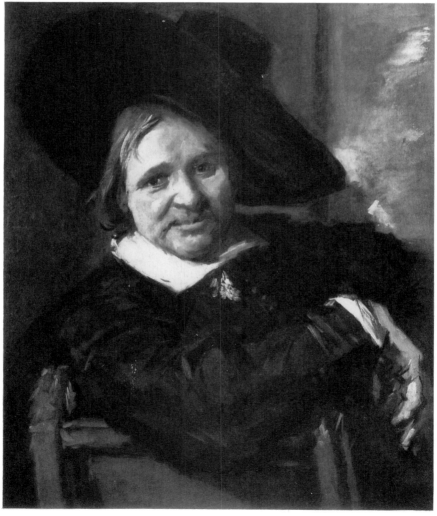

54 Frans Hals, *Seated Man with a Tilted Hat*, c. 1660–5. Oil on canvas, 79.5 x 66.5 cm.

The contrast to Kauffman's portrait is telling. In her painting, no hints of Garrick's profession are to be detected. Furthermore, Kauffman did not choose to depict Garrick in a 'particular and special function in his life', as Reynolds does in another portrait of Garrick, this time not as an actor but as a writer of prologues (Figure 55). In this calm portrait – here shown in a mezzotint by Thomas Watson after the painting – Reynolds depicted the actor seated in front of a desk with sheet of paper upon which the word 'Prologue' is discernible, a glass of ink, a quill and two books.[45] But it is not the lack of a particular theatrical role or reference to Garrick's profession that makes Kauffman's portrait exceptional. Thomas Gainsborough, in a portrait in the National Portrait Gallery in London (Figure 56), also liberates the actor from any particular professional or avocational role. But the image does anchor Garrick socially in a manner not seen in the Kauffman. As Edgar Wind pointed out, Gainsborough manages to represent Garrick in a public role, in 'his position

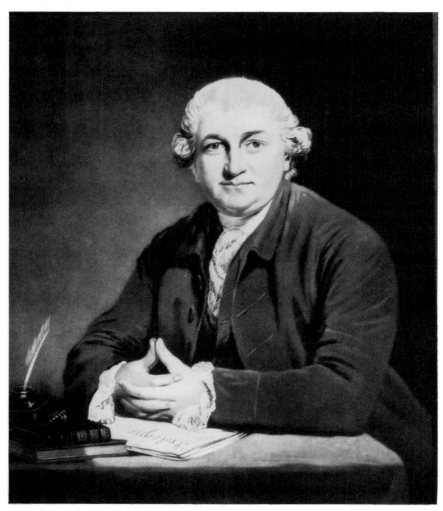

55 Thomas Watson, after Joshua Reynolds, *David Garrick as a Prologue Writer*, published 1779. Mezzotint.

as a man of society'.[46] Gainsborough's 'Garrick', elegantly dressed and wearing a grey, powdered wig, bends slightly forward over a ledge, addressing us – the viewers – with a friendly smile. The thumb of his left hand rests between the pages of the small book, which, it seems, he has just closed in order to initiate a conversation. Closing the book, he opens himself to the viewer. His raised right eyebrow and the light smile playing upon his lips suggest a readiness to converse, perhaps about the lines he had just read. Garrick's ready smile and suggested openness help characterise him as a true Shaftesburian gentleman, capable of 'polite conversation' and willing to conduct well-mannered interchange with his social peers.[47]

It was for this reason, and not only to effect a certain physical mimetic success, that Gainsborough explained in a letter that the portrait was conceived, and was to be seen, at eye-level.[48] It is the striking immediacy of the image that draws spectators, men and women alike, into a polite, civil society.

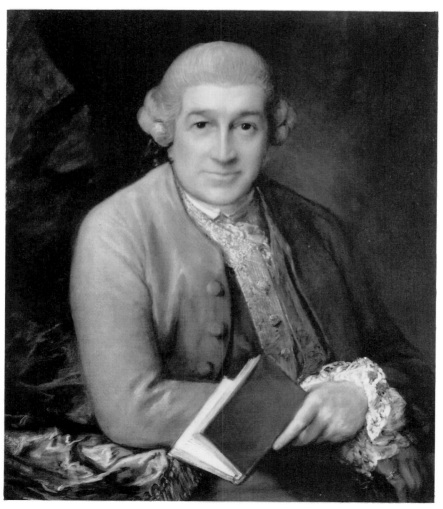

56 Thomas Gainsborough, *David Garrick*, exhibited 1770. Oil on canvas, 75.6 x 63.2 cm.

Kauffman also represents Garrick in striking immediacy, but she removes him from this 'civil' field of reference. Her painting can rather be seen as a deconstructive process, in which societal conventions and expectations are reversed so as to reveal their artificiality or superficiality. Kauffman strips Garrick of societal conventions and presents an apparent lack. It is precisely this 'voidedness' that aims at registering the presence of a supposedly more authentic self, a man existentially and naturally present. Needless to say, this nature is hardly natural, and is itself artificially wrought.[49]

The room, which would allow us to fix and define Garrick in the fictive world of the image, is swallowed up in the atmospheric gloom. Only the back of the chair serves to register a break between the viewer's space and the depicted space, anchoring Garrick in the latter. Nonetheless, the back of the chair is pulled so close to the picture plane that Garrick's arm, resting over its back, creates the illusion that he emerges from the canvas and into our space. As mentioned above, Shawe-Taylor has drawn attention to the Dutch, and especially Halsian roots of the motif of a sitter confronting us, arm slung over the back of a chair.[50] But in which way does Kauffman's image differ from this proposed prototype? Frans Hals's *Seated Man with a Tilted Hat* (Figure 54) now in Kassel can be taken as representative of the genre. In this image the male sitter is cast as an amicable companion, while casting his glance out at the viewer. The stability of the chair upon which the man rests his arm is not certain. It perhaps tilts, playing off the flamboyantly cocked hat that dominates the top third of the picture plane. The play of angles and the shimmering paintwork combine to supplement the acknowledged immediacy of the relationship between sitter and beholder. Not only immediate, the exchange is also momentary – caught in the redundancy of eternal ephemerality and orality.

Kauffman construed a visual dialogue with her sitter which, though intimate and immediate, can be characterised as conforming neither to the polite society of Gainsborough, nor to the banter of Hals. The dialogue crafted by Kauffman is of another order. In her portrait, the face of Garrick, though illuminated clearly, is modelled in mild gradations. The tilt of his head does not, as in the Hals image, add to the instability of the represented body; rather, Garrick's head balances the turn of his torso: his pose is static. The dialogue into which the viewer is drawn is hardly a conversation except in the most metaphorical sense. Garrick's penetrating gaze fixes his opposite in an ocular and emotive exchange.

The composed and steady visage of the actor is at odds with what we hear of the man from other sources. Fanny Burney recorded a conversation with Samuel Johnson, in which the latter described Garrick's face as 'never at rest; when he speaks one minute, he has quite a different countenance to what he assumes the next; I don't believe he ever kept the same look for half an hour together in the whole course of his life'.[51]

Kauffman, unlike Reynolds and Gainsborough, has gone out of her way to eliminate the lively mutability of her sitter. Timeless, motionless and contemplative, Kauffman's 'Garrick' does not seem to play a role. Rather, 'he' appears to be just sitting for his portrait. This is itself, however, very much a form of acting. Here the sitter is, as Hazlitt points out, 'as anxious to make good a certain idea' he has of himself, as if he was 'playing a part on the stage'.[52] Goldsmith complicates the issue in respect to Garrick when he writes in his *Retaliation*: 'On the stage he was natural, simple, affecting;/'Twas only that when he was off, he was acting'.[53]

David Garrick in this portrait painting can be seen as performing, I suggest, the

role of a man sitting for his portrait to a female artist, and it is as such that Kauffman portrayed him.

As an actor, Garrick was accustomed to being object of the audience's attention. But while performing a role on stage Garrick was controlling the gazes of his public. Shielded in the anonymity of vicarious enactment, such gazing that touched his own subjectivity was unthreatening. In the studio, under the light of professional scrutiny by a female artist, the gaze he had to bear was pure, immediate and direct. Although Garrick is depicted as gazing straight out at the beholder, and thus as an active participant in the imagined visual exchange, the consciousness of his objectification by the female artist appears to be a formative and constitutive part of the image.

That this particular drama was not without tension ought to be clear from the discussion of Johnson, Hazlitt, Vigée-Lebrun, Diderot and Therbusch. But in Kauffman's rendition of the drama one can read beneath the serene surface, a troubling and inexorable psychic undertow.

What is then troubling? At least one contemporary, writing in the *Public Advertiser* of 15 May 1765, thought the likeness disabled through the very size of the sitter as represented: 'This gentleman is Mr. Garrick of whom the portrait would be a very good likeness if it was not larger than life.'[54] The painted figure, however, is not especially large, but rather life-size. There is no pressing problem of size, but perhaps of scale. Kauffman appears to have suppressed the diminishing effects of distance.

Troubling, then, is the spatial proximity fostered between Garrick and the viewer. Moreover, precisely at that boundary between the personal spaces of the participants in the dialogue, Kauffman's portrait registers a tension. Compared to the relaxed, careless hand of the sitter in Hals's portrait (Figure 54), Garrick's hands are remarkable for their taught expressiveness. They do not communicate in rhetorical gestures, but cluster about the chair-back. Belying his calm countenance, his hands are more garrulous. Reaching over the wooden barrier, his left arm in the image clamps, not tightly, but decisively, upon the chair. His hands grip the wood, his left reinforcing the horizontal element, and his right buttressing the vertical. It is not a casual pose. Given what has been said about the potential disempowerment of the male sitter before a female portraitist, the fence-like chair-back seems comforting to Garrick. With his hands he steadies the material barrier, his shield. It is, however, a permeable defence. Sandwiched between the plane defined by the chair and the wooden stretcher of the canvas itself, Garrick is pictured in an uncomfortable virtual squeeze.

Penetrating the chair-back is a small piece of Garrick's blue waistcoat, pushing out beyond the wooden frame, teasing us with the possibility that his left leg actually passes through the chair-back. Seen not simply as a formal pictorial element, the vertical frame with which Garrick struggles, and the knob which he grasps tightly with his right hand and thumb, is not without phallic overtones (as such it is analogous to the expressly phallic scroll held by the lawyer in Rowlandson's drawing [Figure 52] discussed above). Garrick's subjecthood, as represented, is constructed on the psychic scaffolding of the chair.

The spatial compression implied by the chair is accompanied by analogous psychic dynamics. On the one hand, the depicted Garrick is brought into that dangerous intimacy feared by Johnson, Hazlitt and others, while on the other, he is contained and, like Diderot, armed against his own erotic response. Lacking a narrative – 'detextualized' – the image constructs a visual dialogue, founded almost

exclusively upon ocular exchange. If the portrait is constructing the subjectivity of the sitter, it is here built upon the relationship to the person beyond the frame, in this instance a viewing position modelled by the female artist. This lack or hollowness can, in Freudian terms, be designated as a fear of castration, and is determined in this case by the lack of control felt by a male sitter before the scrutiny of a female artist.

Fortunately we have another document concerning the studio situation. Extant is a stanza composed by Garrick and dated 1764. The verse was published in the English press in 1767. The lines address Kauffman, and were, presumably, sent to her in reference to 'their' portrait. The poem furnishes us with a record – a textual image – of the other voice in the studio dialogue:

> While thus you paint with ease and grace,
> And spirit all your own,
> Take, if you please, my mind and face,
> *But let my heart alone.*[55]

Recalling Hazlitt's claim that sitting for a woman was almost an open declaration of love, Garrick's response to sitting for Kauffman refashions the artist as the active partner, seeking Garrick's heart. In so doing, the retextualisation of the image redresses, for Garrick, a vestigial imbalance, and thus restores equilibrium to the system.

The immediacy of the intersubjective studio event is caught in the syntactical meeting between the first-person, direct speech of the narrator/Garrick and the female artist addressed. 'Take, if you please, my mind and face'. Deprive me of these, Garrick writes, but not of my 'heart'. Garrick's self-fashioning, as the victim of the female eye, which robs him of mind (rationality) and face (identity), and threatens to deprive him of something he calls heart, obscures the production of the self effected by the painting. Hazlitt, too, thought the act of portrayal to include a certain disempowerment, a loss of subjectivity:

the second time a person sits, and the view of the features is determined, the head seems fastened in an imaginary vice, and he can hardly tell what to make of the situation. He is ... tied down to certain lines and limits chalked out upon the canvas.[56]

Sitting for a female portraitist, Garrick is specific in telling what is, for him, under threat: not his already commercialised face, nor really his rational mind, rather it is his heart. In textualising this potential loss of control over his emotions, Garrick refigures the studio situation as one steeped in traditional amorous tropes. In doing so, Garrick reframes his disempowerment in a familiar topos, unthreatening to his sexual identity. Diderot, facing a similar problem, sought first to defend the scientific, academic gaze of Therbusch, and thus nip all improper rumour in the bud, and then to bind himself to a philosophical mast and thus protect himself from the inevitable ocular challenge of the sirenic female portraitist. Garrick, in composing the poem, followed Diderot's second response.

Sitting for a female portraitist, the male sitter ran a risk. The studio situation was defined as sexually wrought, and the female artist as potentially dangerous. But why, then, was the danger worth enduring?

The studio meeting between a female portraitist and a male sitter was not only 'trying' (as Hazlitt described it), it also provided the potential for the type of intersubjective exchange seen in the eighteenth century as formative of the

civilised man: a man not defined by exterior attributes, but through internal qualities, moulded by a new form of 'feminine' heterosexual desire. Kauffman's portrayal of Garrick, I argue, bears formal traces of this civilising struggle.

In confronting the medusan danger of the female portraitist, male sitters could be seen both as vulnerable, and yet able to withstand the potential danger of the situation. Portrayal by a female portrait painter objectified this intersubjectivity, and represented men as freed from their erotic 'nature'.

Notes

This paper has profited from the comments of Andreas Haus, Viktoria Schmidt-Linsenhoff, Alexander Perrig, Joanna Woodall, John Brewer and especially Adrian Randolph. All translations, unless otherwise noted, are my own.

1 J. Boswell, *Life of Johnson*, ed. G. B. Hill, 2nd edn, 6 vols (Oxford, Clarendon Press, 1934–64), II, p. 362.

2 On eighteenth-century studio practices see D. Mannings, 'At the portrait painter's. How the painters of the eighteenth century conducted their studios and sittings', *History Today*, 27 (1977), pp. 279–87; M. Pointon, 'Portrait-painting as a business enterprise in London in the 1780s', *Art History*, 7 (1984), pp. 186–205; and M. Pointon, *Hanging the Head. Portraiture and Social Formation in Eighteenth-Century England* (New Haven and London, Yale University Press, 1993), pp. 36–52.

3 Among other texts see K. Hausen, 'Die Polarisierung der "Geschlechtscharaktere" – Eine Spiegelung der Dissoziation von Erwerb- und Familienleben', in W. Conze (ed.), *Sozialgeschichte der Familie in der Neuzeit Europas, Neue Forschungen* (Stuttgart, 1976), pp. 363–93; B. Duden, 'Das schöne Eigentum – Zur Herausbildung des bürgerlichen Frauenbildes an der Wende vom 18. zum 19. Jahrhundert', *Kursbuch*, 47 (March 1977), pp. 125–40; N. Armstrong, *Desire and Domestic Fiction: A Political History of the Novel* (Oxford and New York, Oxford University Press, 1987); U. Prokop, 'Die Konstruktion der idealen Frau', *Feministische Studien*, 1 (1989), pp. 86–96; and V. Jones (ed.), *Women in the Eighteenth Century. Constructions of Femininity* (London and New York, Routledge, 1990).

4 See, for example, T. Kleinspehn, *Der Flüchtige Blick. Sehen und Identität in der Kultur der Neuzeit* (Reinbeck bei Hamburg, Rowohlt, 1991), pp. 160–84.

5 Other positionalities are discussed in my book *Angelika Kauffmann: Bildnismalerei im 18. Jahrhundert* (Berlin, Reimer Verlag, 1996).

6 J. Barrell, *The Political Theory of Painting from Reynolds to Hazlitt* (New Haven and London, Yale University Press, 1986), ch. 12, esp. pp. 66–8.

7 *Erinnerungen von einer Reise aus Liefland nach Rom und Neapel*, 3 vols (Berlin, H. Fröhlich, 1805), II, pp. 401–2.

8 Statistical examinations have shown that the number of female portrait painters increased in the eighteenth century. Anne Sutherland Harris pointed out that most of the women who achieved fame and public recognition were born into or had early contact with artistic circles. See A. Sutherland Harris and L. Nochlin (eds), *Women Artists: 1550–1950*, exhibition catalogue (New York, 1977), p. 20 n. 38, and p. 41. See also V. Schmidt-Linsenhoff, 'Gleichheit für Künstlerinnen?', *Sklavin oder Bürgerin. Französische Revolution und neue Weiblichkeit, 1760–1830*, ed. V. Schmidt-Linsenhoff, exhibition catalogue (Frankfurt a. M., 1989).

9 Boswell, *Life of Johnson*, IV, p. 229 n. 4. Boswell also wrote in his journal: 'JOHNSON. Miss Reynolds ought not to paint. Publick practice of staring in men's faces inconsistent with delicacy', (*Private Papers of James Boswell from Malahide Castle in the Collection of Lt.-Colonel R. H. Isham*, ed. G. Scott and F. A. Pottle, 18 vols [Mount Vernon, NY, W. E. Rudge, priv. print, 1928–34, VI, p. 41). Yet Johnson was of the opinion that Frances Reynolds's mind was 'very near to purity itself' (Boswell, *Life of Johnson*, II, p. 362).

10 T. Garb, 'The forbidden gaze', *Art in America*, 79 (1991), p. 148.

11 On intersubjectivity and portraiture, see the contributions of David Lomas and Marcia Pointon in this volume. See also Pointon, *Hanging the Head*, p. 188; and Rosenthal, *Angelika Kauffmann*, chs 4–6.

12 W. Hazlitt, 'On sitting for one's picture', in *The Complete Works*, ed. P. Howe, 21 vols (London and Toronto, J. M. Dent and Sons, 1930–4), XII, essay 11, pp. 107–16. Recently, Peter de Bolla, *The Discourse of the Sublime: Readings in History, Aesthetics and the Subject* (Oxford, Basil Blackwell, 1989), pp. 219–21, attended to this text in conjunction with his discussion of perspectival theory in the eighteenth century and the 'production and ownership of the self'. De Bolla, however, is not concerned with the gender reversal mentioned by Hazlitt which is central to my argument.

13 Hazlitt, *The Complete Works*, XII, p. 110.

14 *Ibid.*, XII, p. 112.

15 De Bolla, *The Discourse of the Sublime*, p. 221.

16 Hazlitt, *The Complete Works*, XII, p. 113.

17 *Ibid.*, XII, p. 108.

18 *Ibid.*, XII, p. 108.

19 *Ibid.*, XII, p. 114. Here, it is not the female portrait painter who 'declares' herself when portraying a male sitter, but, to the contrary, it is the male sitter who expresses his love when sitting to a female portraitist. De Bolla, *The Discourse of the Sublime*, p. 221 – who quotes this passage – is not concerned with the gender specific differentiation of male and female ocular control. This might be the reason why he misreads Hazlitt's text at this point (without discussing this quotation any further) when he writes: 'Hazlitt states that a woman painter at work on a portrait of a man is performing nothing less than a declaration of her intentions towards her subject.'

20 'The fearful and alarming staring eyes of the Medusa head have also the secondary meaning of erection.' Sándor Ferenczi, 'Zur Symbolik des Medusenhauptes', *Zeitschrift für Psychoanalyse*, 9 (1932), p. 69; trans. as 'On the symbolism of the head of Medusa', in S. Ferenczi, *Further Contributions to the Theory and Technique of Psycho-Analysis*, reprint of 2nd edn (New York, Brunner and Mazel, 1980), LXVI, p. 360. See also S. Freud, 'Das Haupt der Medusa', *Gesammelte Werke*, 5th edn (Frankfurt a. M., Fischer, 1972), XVII, pp. 47–8; trans. as 'Medusa's head', *Complete Psychological Works of Sigmund Freud*, Standard Edition (London, 1955), XVIII, pp. 273–4. See also Garb, 'The forbidden gaze', pp. 146–52.

21 Vigée-Lebrun's means of managing the portrayal of male sitters was addressed directly in her practical 'Conseils pour la peinture du portrait' (published 1837 as appendix to the last volume of the *Souvenirs*). In the continuation of the text it becomes clear that the man has to stand upright while being watched by the artist (E. Vigée-Lebrun, *Souvenirs*, ed. C. Herrmann, 2 vols [Paris, Des Femmes, 1984], I, p. 323).

22 *Souvenirs*, I, p. 39.

23 Brown ink and watercolour, 23.8 x 23 cm, *c.* 1790, Christie's, 15 November 1988 (97).

24 Pointon, *Hanging the Head*, commentary to ill. 61, p. 43, referred to the scroll with the inscription 'BRIEF STATE of the CASE' in the hand of the sitter who is thus character-ised as a lawyer. His wig, dark clothes and white cravat seem to refer to this profession. 'BRIEF STATE of the CASE' might, however, not only refer to a law-case but also to the momentary situation in the studio – particularly since the phallic overtones of the posi-tioning and handling of the scroll cannot be denied.

25 The potential of the gaze was ordered in a system of language which clearly expressed gender, but also class and race distinctions to the middling and upper classes of society; decorous control of the eyes defined a woman's virtue and thus status in polite society.

26 Anonymous [W. Kendrick], *The Whole Duty of Women, by a Lady, Written at the Desire of a Noble Lord* (London, 1737), ch. 7, 'of the Manners of BEHAVIOUR towards MEN', p. 86. This was a very popular conduct book and was reprinted many times and in differing versions during the course of the eighteenth century.

27 *Ibid.*, p. 86.

28 Vigée-Lebrun, *Souvenirs*, I, p. 38. It is interesting to note that Vigée-Lebrun employs two strategies of vindication: one traditionally evoked by women ('moral and religious laws'), and the other by men ('work'). Similarly, Herder expressed this gendered split between the moral conduct of a woman and the industry of a man. Writing to Friedrich Ludwig Wilhelm Meyer from Weimar, on 7 December 1789, Herder writes: 'Mad. Angelica ... is,

what her name expresses, the most respectable worthy woman one can possibly imagine; with the industry, mind and studiousness of fifty men' (cited in E. Thurnher, *Angelika Kauffmann und die deutsche Dichtung* [Bregenz, Eugen Ruß, 1966], p. 161).

29 Novels, though popular, were not always considered to be appropriate literature for young women. In this respect, Samuel Richardson's *Clarissa, or, The History of a Young Lady* (London, S. Richardson, 1748) was somewhat exceptional. Following upon the success of his first novel, *Pamela*, Richardson's *Clarissa* was widely read throughout Europe, becoming the *sine qua non* of bourgeois women and the measure of ideal feminine deportment.

30 Vigée-Lebrun, *Souvenirs*, I, p. 39.

31 *Ibid.*, I, p. 95.

32 Anna Dorothea Therbusch's portrait of Diderot has not survived, although prints after the painting do exist.

33 D. Diderot, *Salons*, ed. J. Seznec, 2nd edn, 3 vols (Oxford, Clarendon Press, 1983), II, p. 252, 'Ses portraits sont faibles, froids, sans autre mérite que celui de la ressemblance, excepté le mien qui ressemble, où je suis nu jusqu'à la ceinture, et qui, pour la fierté, les chairs, le faire, est fort au-dessus de Roslin et d'aucun portraitiste de l'Académie ... La poitrine était peinte très-chaudement, avec des passages et des méplats tout à fait vrais.' Diderot's sitting to Therbusch has been discussed previously in conjunction with the question of the exclusion of women artists from life-class; see P. Gorsen in P. Gorsen, G. Nabakowski and H. Sander (eds), *Frauen in der Kunst*, 2 vols (Frankfurt a. M., 1980), II, ch. 2, pp. 91–102. Gorsen, however, overlooks the fact that the structural relationship between female artist and male 'model' corresponds to the relations of the portait studio, and not to that of the life-class. Ellen Spickernagel also addresses the Diderot–Therbush scene in her discussion of the symbolic difference between male and female bodies in the art of the eighteenth century. She is thus not concerned with Diderot's text as a reconstruction of the studio situation between female artist and male sitter; see E. Spickernagel in *FrauenBilderMännerMythen. Kunsthistorische Beiträge*, Papers of the 3rd Women Art Historians' Conference, Vienna, 1986, ed. I. Barta *et al.* (Berlin, Reimer, 1987), pp. 107–14. For Diderot's comments on the gendered reception of art see also E. Spickernagel, '"Ich sehe das, was Du nicht siehst". Anleitungen zur geschlechtsspezifischen Wahrnehmung bei Diderot und Greuze', in U. Krenzlin (ed.), *Lebenswelt der Kunsterfahrung. Beiträge zur neueren Kunstgeschichte (Wolfgang Hült zum 65. Geburtstag)* (Berlin, 1990), pp. 88–97.

34 Diderot, *Salons*, II, p. 254.

35 *Ibid.*, II, p. 250.

36 *Ibid.*, II, p. 250.

37 *Ibid.*, II, p. 250. In fact, Diderot 'explains' why Anna Dorothea Therbusch was not so successful in her art: 'Ce n'est pas le talent qui lui a manqué, pour faire la sensation la plus forte dans ce pays-ci, elle en avait de reste, c'est la jeunesse, c'est la beauté, c'est la modestie, c'est la coquetterie; il fallait s'extasier sur le mérite de nos grands artistes, prendre de leurs leçons, avoir des tétons et des fesses, et les leur abandonner.'

38 *Ibid.*, II, pp. 252–3.

39 Kauffman's *Portrait of David Garrick* (oil on canvas, 82 x 69 cm) is signed on the reverse: 'Angelica Kauffmann pinxt Ano 1764 at Naples'; and inscribed on a lable on the reverse: 'David Garrick Esqre painted at Naples 1764 by Angelica Kauffmann'. For an overview of Kauffman's work in different media see W. W. Roworth (ed.), *Angelica Kauffman: A Continental Artist in Georgian England* (London, Reaktion Books, 1992).

40 *Genial Company. The Theme of Genius in Eighteenth-Century British Portraiture*, exhibition catalogue (Nottingham, University Art Gallery, 1987), p. 40.

41 See W. Kemp (ed.), *Der Betrachter ist im Bild. Kunstwissenschaft und Rezeptionsästhetik* (Cologne, DuMont, 1985). As has been pointed out by feminist critics, Kemp does not take female viewers (*Betrachterinnen*) fully into account.

42 David Mannings (catalogue entry in *Reynolds*, ed. N. Penny, Royal Academy of Arts, London, 1986, p. 325) has pointed out that the painting of Garrick in the character of 'Kiteley' evokes 'the intimacy of the early Georgian theatre in which the performer stood well forward of the proscenium arch surrounded by a small audience close enough to watch his facial expressions'.

43 Shearer West, *The Image of the Actor. Verbal and Visual Representation in the Age of* 165

Garrick and Kemble (London, Pinter, 1991), has drawn attention to the fact that the role per se is not obvious from the image, which offers a rather polyvalent reading of Garrick's expression. The knowledge of the actor's role as 'Kiteley' as well as the generalised expression of his face, however, allow for a viewer's projected response. Thus, we can read the turning of 'Kiteley's' glance to the right and his tense, concentrated countenance as the psychological appearance of a jealous man. See Mannings in *Reynolds*, ed. N. Penny, cat. no. 69 and colour ill. 114.

44 Pompeo Batoni's *Portrait of David Garrick* refers to the actor's profession more obliquely by depicting him with a book of mimicry. Reynolds's *David Garrick between Tragedy and Comedy* imagines Garrick between personifications of the theatrical genres of comedy and tragedy. It is theatrical, without being the rendition of a particular performance. See W. Busch, 'Hogarths und Reynolds' Porträts des Schauspielers Garrick', *Zeitschrift für Kunstgeschichte*, 47 (1984), pp. 82–99; and D. Mannings, 'Reynolds, Garrick and the choice of Hercules', *Eighteenth-Century Studies*, 17 (1984), pp. 259–83.

45 See E. Wind, 'Humanitätsidee und heroisiertes Portrait in der englischen Kultur des 18. Jahrhundert', *Vorträge der Bibliothek Warburg* (Leipzig and Berlin, 1930–1), p. 204; and Shawe-Taylor, *Genial Company*, p. 40.

46 See Wind, 'Humanitätsidee und heroisiertes Portrait', p. 203.

47 For Shaftesbury's concept of 'politeness', see L. Klein, 'The Third Earl of Shaftesbury and the progress of politeness', *Eighteenth-Century Studies*, 18: 2 (1984), pp. 186–214. See also D. Solkin, 'Great pictures or great men? Reynolds, male portraiture and the power of art', *Oxford Art Journal*, 2: 9 (1986), pp. 42–9; and by the same author *Painting for Money. The Visual Arts and the Public Sphere in Eighteenth-Century England* (New Haven and London, Yale University Press, 1993), pp. 3–31.

48 T. Gainsborough, *The Letters of Thomas Gainsborough*, ed. M. Woodall (Bradford, 1963), p. 77 (letter of about 1772).

49 In this context it is necessary to reflect upon the difference between an assumed 'authentic' person Garrick (beyond a role) and Garrick acting out a role. I am not trying to claim that Kauffman depicted an 'authentic' Garrick. Rather I argue that existence beyond roles is impossible. On this issue see H.-G. Gadamer, *Truth and Method* (New York, Crossroad, 1975), pp. 245–74. The question of what makes a character was heavily discussed in eighteenth-century philosophy and society.

50 Shawe-Taylor, *Genial Company*, p. 41.

51 *The Diary of Fanny Burney*, ed. L. Gibbs, 2nd edn (London and New York, 1966), p. 12.

52 Hazlitt, *The Complete Works*, XII, p. 109.

53 Cited in J. Musser, 'Sir Joshua Reynolds's *Mrs. Abington as "Miss Prue"*', *South Atlantic Quarterly* (Spring 1984), p. 185.

54 *Whitley Papers*, Department of Prints and Drawings, British Museum, under 'Kauffman', p. 834.

55 Cited by P. Fitzgerald, *Life of David Garrick*, 2nd edn (London, Sinpin, Marshall, Hamilton, Kent, 1899), p. 326. See also M. Knapp, *A Checklist of Verse by David Garrick* (Charlottesville, VA, 1955), p. 32, no. 205; and P. Walch, 'David Garrick in Italy', *Eighteenth-Century Studies*, 3 (1970), p. 527 ('such a harmless flirtation being nothing new to the public image of either of the principals'). Kauffman and Garrick biographers have either taken the poem as proof of an amorous relationship between the actor and the 23-year-old artist, or have taken pains in disproving (or at least dismissing) such a liason. Others, focusing on the product of their meeting – the painting itself – have dispensed with the poem altogether, setting it aside as anecdotal. See, for example, Fitzgerald, *Life of David Garrick* , p. 326; V. Manners and G. C. Williamson suggest that the poem shows 'that he [Garrick] himself does not appear to have been dissatisfied with the result [of the painting]. It also implies some flirtation on the part of Angelica' (*Angelica Kauffmann, R.A., Her Life and Her Works* [London, John Lane, 1924; New York, Hacker Art Books, 1976], p. 19). See, moreover, A. Hartcup, *The Portrait of an Eighteenth-Century Artist* (Melbourne, London and Toronto, William Heinemann, 1954), pp. 39–40.

56 Hazlitt, *The Complete Works*, XII, p. 109.

8

Inscribing alterity: transactions of self and other in Miró self-portraits

DAVID LOMAS

The condition of the subject S ... is dependent on what unfolds in the Other O. What is being unfolded there is articulated like a discourse (the unconscious is the discourse of the Other), whose syntax Freud first sought to define ...

Jacques Lacan[1]

To speak of portraiture as a transaction is to insist upon the constitutive role of an intersubjective relation of self and other in generating the portrait image. In the usual event that a person pays another to produce a likeness, one can readily appreciate that, in addition to the financial transaction that takes place, artist and sitter are implicated in a transaction of a more subjective character which may have an effect on how the person is represented. But in the case of a self-portrait, both artist and depicted subject are one and the same person and hence such considerations would seem not to apply. Drawing upon a psychoanalytic model of subjectivity, I want to extend the notion of a portrait transaction to include self-portraiture which, no less than in the case we have just examined, I will argue is the outcome of a dialectic of self and other. To claim, as psychoanalysis does, that otherness is from the outset inscribed within the self is to assert that the subject is divided – is not, in other words, *in-dividual*. The subject is neither identical with itself nor with the portrait that each of us paints of ourselves, that consoling fiction of an autonomous ego invested with attributes of 'permanence, identity and substantiality'.[2]

The Surrealist artist Max Ernst interrogates and subverts just such a notion of the self, and of the self-portrait, in a photocollage (Figure 57) that served as an invitation to an exhibition of his work in 1935. The collagist has taken a pair of scissors to his own face, portraying himself as if seen in a mirror, but one that has been shattered somehow.[3] Writing fills the spaces amongst the broken pieces of the reflection; where physiognomic theories of character would have us read the lines of the face, here we are obliged to read between the lines if we are to know anything about the subject. Is it not the realm of the unconscious, this 'between-the-lines', which is structured like a language? One is reminded that the technique of automatic writing was understood by the Surrealists as fracturing an illusory unity of the self. A voice emanating from an 'other scene' (as Freud terms the unconscious), the automatic message gave proof of an irreducible heterogeneity

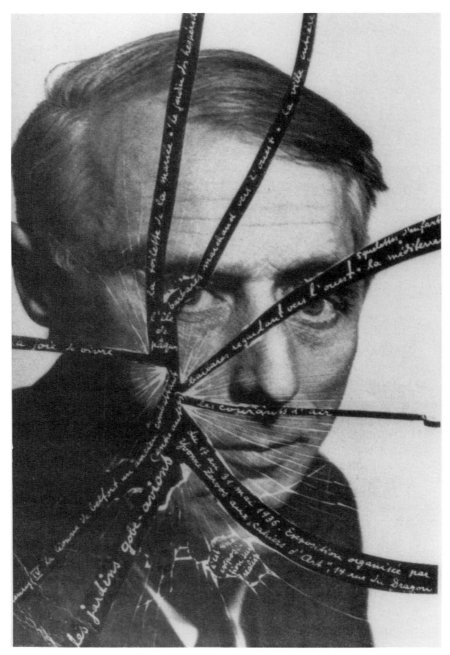

57　Invitation for Max Ernst exhibition, Paris, 1935.

within the self – a view endorsed by the Surrealists' avid reading of psychoanalysis; 'a method I esteem and which I believe seeks nothing less than to expel man from himself' was how André Breton appraised it.[4]

The French psychoanalyst Jacques Lacan, who was more than just peripherally associated with the Surrealist movement in the 1930s, does little more than

formalise their haphazard intuitions in stating that 'the subject S ... is dependent on what unfolds in the Other O'. In this chapter I explore how that abstract schema might translate into an art historical approach to the portrait image. Using the example of three very remarkable self-portraits produced by Joan Miró in the years 1937 to 1942, I analyse the face as the site, or space, of a dynamic transaction between self and other.

Dissolving into the strange

To expel man from himself: Miró's *Self-Portrait 1* (Figure 58) bears eloquent testimony to the strength of that desire.

Unable to return to Spain because of the Civil War, Miró had been stranded in Paris for more than a year when he announced to his New York dealer, Pierre Matisse, in a letter dated 3 November 1937, that he had embarked on a self-portrait bust 'three times larger than natural size'.[5] The scale of his ambition was evidently to match as he confidently assures the dealer to whom the picture would later be consigned for sale that 'it will be the most sensational thing I have ever done'.[6] Throughout the winter of 1937–8 as Miró laboured at this task, a steady flow of correspondence kept Matisse abreast of each new development. By February (1938), after several false starts, Miró confides that he is at last on the right track and promises to send a photograph. The following month he is so pleased with the work that in order to preserve it he decided to have a tracing made, allowing him the option of continuing to work on the traced copy should he wish to. *Self-Portrait 1*, as it now stands, is a mainly monochrome drawing in pencil and crayon with touches of oil colour. A strictly frontal head with pursed lips and intent, riveting stare nearly fills the large canvas. The eyes are like blazing stars and the face is consumed by flames. With Europe itself on the verge of an apocalyptic conflagration, Miró has condensed into his image the 'self-portrait' of an entire epoch. One could scarcely dispute the assessment of James Thrall Soby, one-time owner of the work, that 'this beyond question is one of the major portraits of our time'.[7]

A need to inspect and record his features with utmost precision at a time of undoubted personal distress and uncertainty caused Miró to take the rather unusual step for a portrait painter of employing a concave shaving mirror as he worked on *Self-Portrait 1*.[8] This produces a magnified image, but one that is also very distorted, which, as Soby has speculated, might account for some of the oddities of the resulting self-portrait. Miró's head looms before us so abruptly foreshortened that hairs on the tip of his nose are hugely enlarged, a single light-hearted note in the picture. The aberrations one sees at the edges of such a reflection have also been incorporated and convey a striking effect of centrifugal rupture of the facial contour. Goethe alerts us to the potentially disconcerting aspect of a face viewed in this manner in an essay he wrote on Leonardo's *Last Supper*, of which Miró probably was not aware. Asserting that the human countenance is only beautiful if contained within strict parameters of size, Goethe instructs the reader:

Make the experiment, and look at yourself, in a concave mirror, and you will be terrified at the inanimate, unmeaning monstrosity, which, like a Medusa, meets your eye. Something similar [he adds] is experienced by the artist, by whose hands a colossal face is to be formed.[9]

Something similar, one could imagine, was experienced by Miró at whose hands a self-portrait three times natural size was to be formed. If it were a desire to apprehend (etymologically, to 'lay hold of') himself, warts and all, that drove Miró to utilise a concave mirror, the net effect of doing so was quite the reverse: it was to put him, at least momentarily, beyond the grasp of recognition. For an uncanny instant it was as though he were someone (or something) other, an exorbitant movement in which he was literally propelled outside of himself.[10] *Self-Portrait 1* stands as a record of that putative moment of rupture and self-estrangement. A self-portrait, it is a portrait of the self as other.

Quite a contrary effect was produced by Parmigianino in his celebrated *Self-Portrait in a Convex Mirror* of 1524 (Kunsthistorisches Museum, Vienna), which one might otherwise look to as an art historical precedent. The optical distortions induced in that instance by a convex mirror plainly do nothing to disturb the composure of the juvenile Parmigianino whose air of absolute self-possession is underscored by the left hand with which he embraces himself. Not dissimilar in its mode of address is Miró's own youthful *Self-Portrait* (Figure 59) of 1919. Painted on the eve of his departure for Paris, it is an image that speaks, on every level, of artistic ambition. Accordingly, in the stylised curves of the small globular face and open neckline are reiterated heart shapes that betray a narcissistic investment in an idealised image of what Miró himself would like to be; as a common expression has it, the likeness *captures* the subject.[11] In *Self-Portrait 1*, on the other hand, that intimacy with one's self which the term 'identity' presupposes has irretrievably broken down and along with it the cohesiveness of the self-image. Also gone is the earthy solidity and presence of the earlier self-portrait, an effect due to the large furrowed expanse of shirt in a fiery terracotta colour which half recalls the Catalan landscape.

Freud, in the essay on 'The "uncanny"', recounts an incident that occurred on a train journey when he caught sight of his face reflected in a swinging glass door and for an instant failed to recognise it as his own. Indeed, he recalls having felt a hearty distaste for the bearded stranger lurching toward him and wonders now if his reaction was not 'a vestigial trace of the archaic reaction which feels the "double" [the mirror reflection] to be something uncanny [*unheimlich*]'.[12] Some insight into the uncanny character of *Self-Portrait 1*, as I have described it, can be had from a note jotted down in 1942 or thereabouts as Miró contemplated resuming work on the picture (referring in all likelihood to the traced copy which, by then, had probably been made). 'Think about William Blake when doing the self-portrait', he writes.[13] Already, by that date, André Masson had embarked on a series of visionary portraits which took their cue from the Blake–Varley sketchbook containing Blake's transcribed visions of assorted historical or imaginary personages. An ink drawing by Masson of the pre-Socratic philosopher Heraclitus (Figure 60) whose hair is in flames is obviously close in conception to Miró's self-portrait.[14] While Masson, a longstanding acquaintance of Miró, could have seen *Self-Portrait 1* in the studio, another explanation for the family resemblance between the images is that they derive from a common ancestor, a drawing of great renown by Blake himself. *The Man Who Taught Blake Painting in his Dreams* of 1819 (Figure 61) is one of the best known of Blake's visionary portraits and, as he was a self-taught artist, it is generally assumed to be a self-portrait, the Orientalised features notwithstanding. Using a wiry, incisive line, Blake portrays the head in full-face thereby heightening the impact of his visionary stare. What appear to be flames (of inspiration?) arise

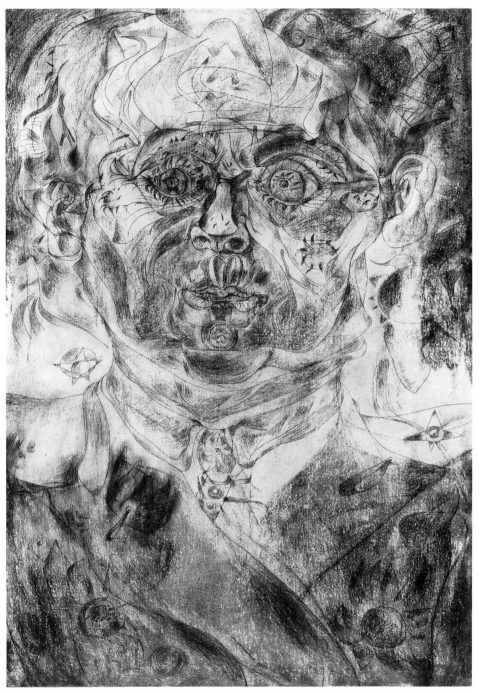

58 Joan Miró, *Self-Portrait 1*, October 1937–March 1938. Pencil, crayon and oil on canvas, 146 x 97 cm. The dominant hue in this very sombre image is a smouldering, sulphurous yellow.

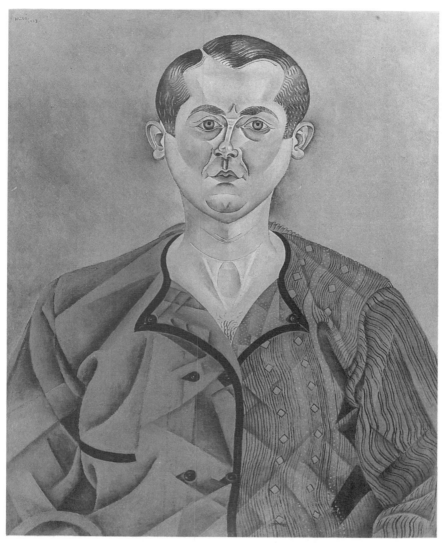

59 Joan Miró, *Self-Portrait*, 1919. Oil on canvas, 85.4 x 73 cm. Picasso had evidently
acquired this very fine portrait by April 1921. The face is treated in a manner indebted to
Catalan Romanesque art, as has been suggested is also the case in *Self-Portrait 1*.

from the forehead and merge with contiguous locks of hair. Miró had an oppor-
tunity to see this very memorable image at first-hand early in 1937 at an exhibition
of Blake and Turner held at the Bibliothèque Nationale in Paris and the visual
evidence alone convinces me that quite independently of Masson, and well before-
hand, Miró had struck upon the idea of representing himself in the guise of Blake,
a much venerated Surrealist precursor.

Consider for a moment the mental note: 'Think about William Blake when
doing the self-portrait.' Such a mask doubtless struck Miró as the most economical
way of signalling his identity as a visionary artist. As a painter-poet, Blake would
have had particular appeal for Miró who in his own work sought to achieve a

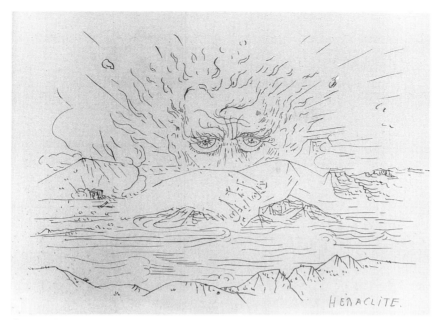

60 André Masson, *Visionary Portrait of Heraclitus*, 1939. Ink on paper, 50 x 65.7 cm. Alchemical illustrations are a likely visual source for the motif of flaming hair in Miró's portrait as well as Masson's.

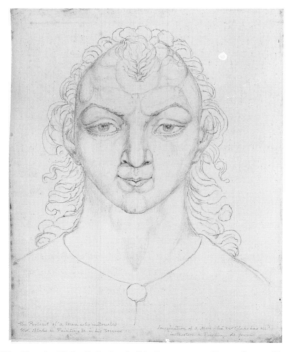

61 *The Man Who Taught Blake Painting in his Dreams* (Replica) after William Blake, *c.* 1819. Pencil on paper, 26 x 20.6 cm. There are three versions of the Blake drawing of which this one, now thought to be a copy by the engraver John Linnell, was shown in Paris early in 1937.

synthesis of painting and poetry (in fact, he later made use of a process of relief-etching pioneered by Blake that enabled images and hand-written text to be combined on a single etching plate). The remark, however, is perplexing because it poses a question of whose self it is that is represented. What does it mean to paint a self-portrait with another artist *in mind*? It is as if, in the words of the poet Arthur Rimbaud, 'Je est un autre.'

It transpires that yet another ghost haunts the space of *Self-Portrait 1*. Van Gogh, an ego ideal dating from Miró's earliest days as a painter, is paid reverent homage in the *Still-Life With Old Shoe* (The Museum of Modern Art, New York), painted in Paris between January and May of 1937. Strident expressionist colours and a discarded boot alongside the rudiments of a peasant repast clearly allude to the Dutch artist, as Miró helpfully confirmed in an interview years later. In *Self-Portrait 1*, which followed close on its heels, Miró (speaking figuratively now) steps into the boots of van Gogh: the sunflower on his lapel is a token of this identification. Held within the precincts of the 1937 Paris World's Fair was a blockbuster van Gogh exhibition which opened in June and ran until October. The catalogue for the event was published as a special issue of the popular art magazine *L'Amour de l'Art* and contained an essay by René Huyghe, curator of paintings at the Louvre, who predictably dwelt at length on van Gogh's tragic persona. A caption to one of the numerous self-portraits (Figure 62) comments on a background of swirling, flame-shaped arabesques that can be imagined as embroiling the artist, and in his catalogue essay Huyghe powerfully evokes 'torches of fire, into which trees, houses, rocks, metamorphose and ascend to the sky rejoining fires of neighbouring worlds'.[15] As *Self-Portrait 1* was commenced in the month of October, it seems fair to suggest that the van Gogh exhibition gave Miró the initial spark.

Matters prove to be more complicated, however. Miró wrote in a letter to his dealer on 5 February 1938 that, having 'destroyed' the portrait several times, 'I now feel that I am on the right track. It will be drawn in a few days, and then I will have it photographed and send you a print.'[16] It therefore seems probable that *Self-Portrait 1* underwent substantial changes before assuming its present shape some time in the new year. Adding weight to this hypothesis is a caricatural drawing of 21 September 1937 inscribed on the reverse side 'Study for a portrait – self-portrait'. If, as seems likely, this is an early study for his self-portrait, then as it evolved Miró has clearly jettisoned its comical spirit in favour of a far more serious conception. A contributory factor in this *volte face* was, indubitably, the publication of a short text by the writer Georges Bataille, entitled 'Van Gogh Prometheus'. It appeared in December 1937 in the first issue of *Verve*, a new avant-garde magazine, which also happened to contain several graphic works by Miró. Bataille's text, an avowedly idiosyncratic review of the recently closed van Gogh exhibition, takes as its starting-point a statement by van Gogh cited in the catalogue: 'There are circumstances where it is better to be the vanquished than the victor, better Prometheus than Jupiter.' This furnishes Bataille with a pretext to return to the topic of sacrifice which he had first broached in connection with van Gogh in an essay of 1930 that bore the lugubrious title of 'Sacrificial mutilation and the severed ear of Vincent van Gogh'. It was published in *Documents*, a journal Bataille edited that was notable for its involvement not only of avant-garde artists and writers (many of whom were disaffected former Surrealists), but also of several professional ethnologists. Bataille's essay marshalls evidence from a broad range of ethnographic as well as psychiatric sources in order to demonstrate that van

Gogh's self-mutilation, in spite of its basis in mental illness, was no less an 'expression of a veritable social function, of an institution as clearly defined, as generally human as sacrifice'. The act of cutting off an ear is compared with mutilations carried out in initiatory and other rites; both are said to spring from a desire to rupture limited being, from 'the necessity of throwing oneself or part of oneself *out of oneself*' which 'in certain instances can have no other end than death'.[17]

The valorisation of loss over and against the modern norms of utility and conservation is a theme that Bataille returns to repeatedly in the 1930s. He contends that our lives are impoverished by the dominance of our instincts of self-preservation which shore up the defensive ramparts of the ego only to confine and imprison us. With bourgeois individualism in his sights, Bataille refers

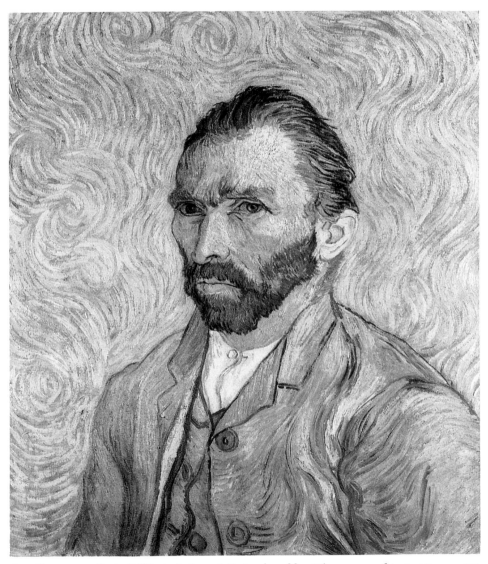

62 Vincent van Gogh, *Self-Portrait*, August–September 1889. Oil on canvas, 65 x 54 cm. 175

contemptuously to 'all that confers on (many) faces the repugnant aspect of defensive closure'. Life can only hope to achieve an incandescent intensity when it risks itself, burns and consumes itself. This argument is pursued in 'Van Gogh Prometheus', with Bataille maintaining that van Gogh identified himself with one of the pivotal motifs in his painting, a radiant, explosive sun:

Van Gogh, who decided by 1882 that it was better to be Prometheus than Jupiter, tore from within himself rather than an ear, nothing less than a SUN ... Van Gogh began to give to the sun a meaning which it had not yet had. He did not introduce it into his canvases as part of a decor, but rather like the sorcerer whose dance slowly rouses the crowd, transporting it in its movement. At that moment all of his painting finally became *radiation, explosion, flame*, and himself, lost in ecstasy before a source of *radiant life, exploding, inflamed [en flammes]*.[18]

Self-Portrait 1 renders this sovereign moment as the artist (van Gogh–Miró) 'lost in ecstasy before a source of *radiant* life' becomes himself explosive, inflamed. Miró translates into visual form Bataille's recasting of a Promethean myth of the artist in terms of self-sacrifice. The flames kindled on the forehead of Blake, the Romantic poet, have grown into a self-immolating fire.

An event that gave a decisive impetus to the theme of ecstatic fusion with the cosmos – underlining its derivation from an aesthetic discourse of the sublime – was the epiphany Masson experienced during a night in January 1935 when he was lost in the mountains of Montserrat near to Barcelona. Traumatic memories of having been left for dead under a night sky on the battlefield of the Somme were revived in him by his saga that night, explaining the almost visceral sense of dread mingled with awe at the sublimity of the vista. Masson later recalled: 'It was doubly vertiginous, the cliff and the sky with spinning stars, the sky itself appeared to me like an abyss, something I had never felt before – a vertigo of height at the same time as the vertigo of depth. And I felt myself amidst a sort of maelstrom, a tempest, and quite hysterical. I believed I was going mad.'[19] Two paintings inspired by the event and a poem also by Masson were carried in the Surrealist journal *Minotaure* in June 1936 with a commentary by Bataille who declares expansively: 'No limit, no measure can be given to the violence of those in whom a vertigo is liberated by the vault of the sky.'[20] Writing again towards the end of the decade, Bataille remarks that 'the faces drawn by André Masson have ... invaded the clouds or sky. In a sort of ecstasy, which is none other than their precipitate exaltation, they annihilate themselves.'[21] One would be hard put to give a more accurate description than this of Miró's anguished self-portrait.

All the salient features of *Self-Portrait 1* outlined thus far – the rupture of ego boundaries, the sacrifice of oneself, becoming 'other' – are consistent with the nature of visionary experience as it was bequeathed to Surrealism. M. H. Abrams, in his classic study, *Natural Supernaturalism*, traces within Christian theology a gradual process whereby the biblical Apocalypse is internalised, 'transferring the theatre of events from the outer earth and heaven to the spirit of the single believer'.[22] Typically, in accounts of religious conversion experiences the moment of revelation comes to be portrayed as a death and rebirth of the individual, for which Paul's conversion on the road to Damascus stands as a paradigmatic instance. Rimbaud's famous declaration in the 'Letter of a seer', the 'I is an other', is hence merely an extension into the secular domain of poetry of an age-old religious belief. Miró, it was seen, in his rebirth as a visionary, becomes literally other by

virtue of his projective identifications with Blake and van Gogh, both of whom embody, albeit differently, the visionary ideal.[23]

Michel Leiris wrote of André Masson's resort to self-portraiture whilst in exile during the war years that 'In the midst of this total debacle ... what seemed to Masson the most effective way of finding his feet again was an objective self-examination, self-definition by means of portraiture.'[24] That surely holds true as well for Miró who was deeply affected by the events of the Spanish Civil War. No less momentous for artists, however, were the upheavals that occurred in the narrower arena of cultural politics, and it may be argued that the highly dramatised accent on loss of self in *Self-Portrait 1* is related to the predicament in which Miró found himself, as an artist, in 1937. Once accused by Breton of cherishing the sole desire 'to give himself up utterly to painting and painting alone',[25] Miró began echoing the rhetoric of the Left which was vocal in denouncing such an artistic stance. He speaks piously of wanting 'to go beyond easel painting ... and to bring myself closer ... to the human masses I have never stopped thinking about'[26] and in recorded interviews is at pains to make known his fervent wish to 'plunge into the reality of things', the motive for which is obscure unless it be viewed as a concession to a social realist agenda which demanded not just a politically engaged art, but one that was accessible and in touch with reality. For the first time in 1937 Miró turned his hand to overtly propagandistic art, carrying out a mural commission (*The Reaper*, now destroyed) for the Spanish Republican Pavilion at the Paris World's Fair, further evidence that he had been compelled to shift ground in response to the new political exigencies.

The Left-sponsored realism debates in Paris in the mid-1930s demonstrate that portrait painting was drawn into the fray, with the alleged neglect of this traditional, humanist genre by modernism being wielded as a stick to beat it with. Louis Aragon, an erstwhile Surrealist and now one of the staunchest advocates of socialist realism, gave voice to the new orthodoxy:

The *portrait* is an essentially realist genre, and can scarcely be accomodated by modern theories which condemn realism. I would simply say of these theories that it suffices to condemn them to note that they are incapable of doing justice to a human phenomenon like the existence of the *portrait*.[27]

That Aragon's address, 'Socialist realism and French realism', was made in October 1937 could indicate that Miró's turn to self-portraiture at precisely this moment was not unconnected with this sea-change. The most spectacular case of an avant-garde artist reviving portraiture as part of a return to realism was that of another former Surrealist, Alberto Giacometti, who did so in a Cézannist portrait of his mother in 1937. It is, moreover, fascinating to consider that as work proceeded on *Self-Portrait 1* through the winter of 1937–8, all the while Miró posed with his daughter Dolorès for a portrait by the artist Balthus (Figure 63). Wearing the same suit and tie as in his self-portrait, Miró is seated nearly square on, one arm extended rigidly to his knee while the other supports the waist of his daughter who leans nonchalantly against his thigh, her right hand resting on top of his. Their intimacy seems as unaffected as the stylistic idiom, a sober naturalism Aragon might well have approved of. Balthus captures well a sense of the disquiet of the epoch, a trait for which the new figuration was much praised, by isolating the wistful father and daughter in a setting that is unrelieved in its drabness. Sitting for this portrait would have given Miró ample time to reflect upon his own artistic

stance, and while it is plainly obvious that he does not meekly submit to the dictates of the prevailing realism, neither could he blithely switch off from the political demands now being made on artists. Miró was surely not alone in being under considerable strain at this juncture; similar pressures had certainly helped to precipitate Picasso's much talked about cessation of painting during 1935.

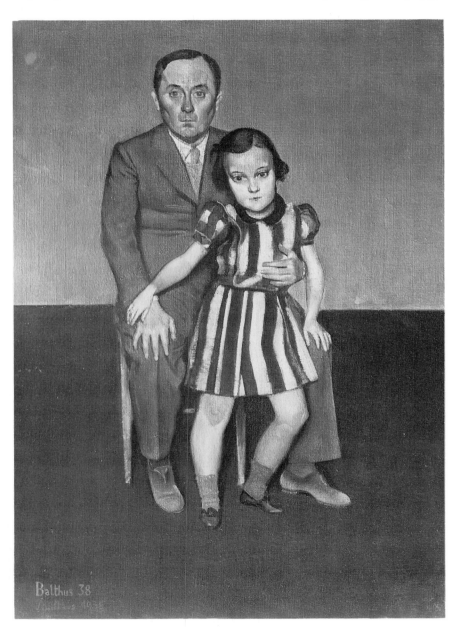

63 Balthus, *Portrait of Miró with his Daughter Dolorès*, October 1937–January 1938. Oil on canvas, 130.2 x 88.9 cm. Balthus produced several portraits of fellow artists around this time, most notably his *Portrait of André Derain* of 1936. He also painted the dealer Pierre Matisse in 1938.

World events aside, for artists of a modernist persuasion this really was the apocalyptic end of an era. *Self-Portrait 1* vividly registers this dissolution (fading, evaporation) of a once solid and secure artistic identity.

Before abandoning work on *Self-Portrait 1*, in February 1938 Miró produced a diminutive watercolour, *Woman in Revolt* (Figure 64), arguably the most rebarbative image in his entire oeuvre. The subject of a peasant woman defiantly brandishing a sickle as she flees a burning village was a stock one in realist painting of the time, but the disturbing incongruity of a phallus stretched across the picture plane in effect shifts the register of Miró's image away from external reality to the plane of psychical reality. One might compare this grotesquely deformed organ which floats free of its normal anatomical moorings to the elongated, anamorphic skull occupying a similar place at the foreground of Holbein's *The Ambassadors* (National Gallery, London). Lacan, in a richly suggestive reading, cheekily dubs this odd *memento mori* the 'phallic ghost' on account of its elongated morphology and asserts that it intrudes a spectre of lack, i.e. castration, into a scene otherwise dominated by the nearly palpable presence of people and their possessions. 'Holbein makes visible for us here something that is simply the subject as annihilated,' Lacan writes, 'annihilated in the form that is ... the imaged embodiment of ... castration.'[28] A quota of castration anxiety no doubt also lurks within *Self-Portrait 1*, inasmuch as the distorted mirror reflection used by Miró has, as Goethe reminds us, a terrifying Medusan aspect. For Freud, the terror of the

64 Joan Miró, *Woman in Revolt*, February 1938. Watercolour, pencil and charcoal on paper, 57.4 x 74.3 cm. Pentimenti are evident in the drawing of the left leg which indicate that the phallic extension has been grafted onto a more naturalistic figure. Miró had attended life-classes as part of his *retour au réalité* in the year preceding this work.

Medusa is none other than a fear of castration, and such a fear is liable to be provoked whenever the subject is threatened with loss of its illusory wholeness and integrity.

Miró wrote to his dealer early in March 1938, saying 'my portrait is already drawn ... I have now turned the canvas against the wall and will leave it there for several days so that I can begin painting with fresh eyes. I think this will be the most important work of my life. I might do a tracing to preserve the drawing, which in itself is something of considerable breadth.'[29] When he did finally return to the traced copy of *Self-Portrait 1* in 1960 (Fundació Joan Miró, Barcelona) Miró literally defaced it with daubed graffiti. His comical over-painting delicately mocks the grandiose pretensions of the earlier portrait seen peering out from underneath; at the same time, it defuses and recuperates an alien image of himself which was, in more than one respect, out of character. *Self-Portrait 1*, I claimed, marks a moment of rapprochement with Bataille during a phase of the latter's work that culminated with his book *Inner Experience* in which the poetic would be equated with the uncanny: it is 'the familiar dissolving into the strange, and ourselves with it'.[30]

Intersubjectivity and effacement

Miró's experience of sitting for a portrait by Balthus at the same time as he painted his own self-portrait was in a sense recapitulated in the etched *Portrait of Miró*, begun in March 1938 and finished in September of that year. The result of a collaboration with Louis Marcoussis, a former Cubist painter whose print-making studio Miró shared, it straddles quite intriguingly the usually separable genres of portrait and self-portrait. More than a minor footnote to *Self-Portrait 1*, the *Portrait of Miró* is far-reaching in its visualisation of the self as decentred within an intersubjective field.

65 Joan Miró and Louis Marcoussis, *Portrait of Miró* (second and final states), February and November 1938. Etching and drypoint, 45 x 33 cm. The first two stages were signed by Marcoussis alone; succeeding states have both artists' names.

The first states of the etching show an *artiste-peintre* with the tools of his trade poised in front of a canvas (Figure 65a). A sleight of hand is involved here, since the visual conventions deployed are those of a self-portrait, but in fact it was Marcoussis who was responsible for creating this likeness. Miró then set to work covering the plate in automatist fashion with a profusion of graffiti-like marks, some of which are plainly reminiscent of *Self-Portrait 1*: flames, stars and so forth. Comic-book creatures which go on to populate the slightly later *Constellation* series appear to leap out from Miró's imagination. He weaves a number of written inscriptions into this densely layered imagery, including an automatic poem about colours that recalls Rimbaud's poem 'Voyelles'. It appears fleetingly on the artist's palette in the thirteenth state only to disappear again. In the penultimate state lines radiate out from several nodal points creating in the final image (Figure 65b) a dense criss-cross web – a final irony too because it is Miró's contribution that nearly effaces the portrait of him.

The significance of collaborative exercises like this one far exceeded any simple curiosity value for the Surrealists. At the very origin of the Surrealist movement lies a collection of automatic texts, *Les Champs magnétiques*, created by André Breton and Philippe Soupault writing in tandem with each other. With that formative experience still fresh in his mind, Breton, writing in the 'Surrealist Manifesto', was adamant that 'the forms of Surrealist language adapt themselves best to dialogue', and further, that Surrealism had devoted all its efforts to 'reestablishing dialogue in its absolute truth'.[31] This view of Surrealist automatism as a form of dialogue is in remarkably close agreement with Lacan's later insistence upon the essentially dialogical character of psychoanalysis: 'What happens in an analysis is that the subject is, strictly speaking, constituted through a discourse, to which the mere presence of the psychoanalyst brings, before any intervention, the dimension of dialogue.'[32] Lacan's view of psychoanalysis, that 'it proceeds entirely in this relationship of subject to subject', changes somewhat as he comes under sway of Saussurean linguistics in the 1950s, causing him to give far greater weight to language as an independent factor in the equation.[33] Shoshana Felman remarks that psychoanalysis 'is not a dialogue between two egos, it is not reducible to a dual relationship between *two* terms, but is constituted by a third term that is the meeting point in language'.[34] Lacan introduces a new term, the Other (O), to denote the field of language and the unconscious, and to distinguish it from the one-to-one relation with the other person (o) in the analytic encounter. This all-important distinction is displayed in the intersecting axes of the L-schema (see p. 182). The first axis (o–o') comprises the dual relation between subjects; situated in the register of the imaginary, it subsumes what Lacan had earlier described under the mirror stage, namely those identifications which constitute the ego.[35] A second axis, set at a tangent to the first, joins the subject S – which explicitly does not coincide with the ego – and the Other O. This is the symbolic axis. Whereas the imaginary other is the source of all the subject's self-deceptions (its *méconnaissance*), the symbolic Other is 'the locus from which the question of his existence [truth, desire] may be presented to him'.[36]

Turning now to the *Portrait of Miró*, one can appreciate that each artist's contribution has created a clash of spaces and stylistic registers that corresponds precisely to the axes of the L-schema. Marcoussis's image of Miró which represents him as a coherent, specular subject – the result of pure deception, recall – belongs to the Lacanian order of the imaginary. Seen in isolation, it appears lively

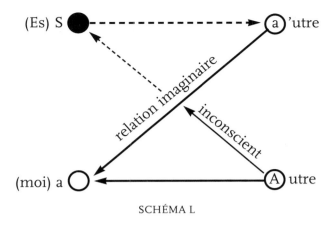

SCHÉMA L

and naturalistic, but when all twenty states were shown together at the Galerie Jeanne Bucher in June 1939 that impression would have been annulled by sheer repetition. Rather like a row of Marilyns by Andy Warhol, it must then have looked more akin to a death mask. Indeed, Lacan contends that 'formal stagnation' marks all the 'portraits' which the subject produces of itself in the imaginary.[37] The task of the analyst is to erase these false icons, 'to suspend the subject's certainties until their last mirages have been consumed', and thereby free up desire.[38] The dense network of visual and linguistic signs which Miró added to the plate comprises a grid interposed between us and the illusionistic image of him. This, the equivalent of the symbolic axis, is set at a tangent to the first and cuts across it, in effect effacing that which we mistakenly took for the subject. Caught up in the network of signifiers, Miró's subjectivity manifests as a playful procession (*défile*) of signs from one provisional state of his portrait to the next. Because desire is always a function of lack (or loss), this dance in the face of death is destined to be, just as the caption says, '*une cirque de mélancholie*'.

Lacan consigns portraiture to the realm of the imaginary, and refers to it only as a regrettable instance of those static *imagos* in which the subject seeks to alienate its desire. The art of the portraitist and the art of the analyst are thus construed as at loggerheads with one another. While pitting them against each other served Lacan well in his tireless campaign against ego psychology,[39] the notion of portraiture as a transaction implies a parallel with the psychoanalytic situation of the transference that may be no less fruitful or valid. The presence of a subterranean link is hinted at, in fact, by an *Oxford English Dictionary* definition of transaction, one qualified as obsolete but possibly needing to be exhumed, namely: 'the action of passing or making over a thing from one person, thing, or state to another; transference'. The transaction–transference analogy alerts us to the web of desires that are etched across every face and to the speech that whispers in the folds and interstices of the portrait image. It diverts attention away from his majesty the ego, resplendent and whole, to the fainter traces of a subject-in-process.

Once previously, in 1933, Marcoussis's etching studio had been the setting for a Surrealist joint venture involving Man Ray as photographer and Meret Oppenheim, a female artist in the group, as Surrealist muse. The best known of these photographs shows Oppenheim posed naked beside the etching press, her inked forearm and palm raised, one can imagine, as if to imprint directly on the

photographic plate. '*La femme* guards in her hand the life line of her lover' states Breton in *Nadja*.[40] The body of the Surrealist muse is a mere text, or pretext, for the male Surrealist to 'read' his desire; femininity a reflective mirror in which he narcissistically recognises himself. The entire logic of the Man Ray photograph – black ink on white skin, the phallic handle of the printing press obscuring the sex of the female subject – is a logic of the Same which disavows difference and otherness. It is a salutary reminder, if one were needed, that claims which are valid in one situation we should perhaps be wary about extending to Surrealism in general.

Post-face

The punning connection that Lacan makes between the words 'lettre' (letter), 'l'être' (being), and 'l'autre' (the other) in order to underscore the subject's dependency on the signifying chain of language, its status not as origin of a message but as the recipient of one whose source is in the field of the Other, strikes me as being very pertinent to the last self-portrait (Figure 66) that I want to discuss. Deceptively cursory in appearance, it is drawn onto a ragged envelope addressed to Miró at 4 Pasage del Credito in Barcelona – his birthplace and where, in a sort of return to origins, he had again taken up a studio. *Self-Portrait on an Envelope* has a mournful, elegiac character, not surprisingly given the circumstances of its creation. It belongs to a cluster of self-portrait drawings made in 1942 after the capitulation of France had forced Miró's hasty return to Catalonia, the latter once proudly independent but now firmly under the yoke of Francoist Spain.

More akin to a written autobiography than to a painted self-portrait, Miró has composed his image almost entirely in the past tense. A mood of retrospection is

66 Joan Miró, *Self-Portrait on an Envelope*, 1942. Pencil on envelope, 12.4 x 17.5 cm. Whilst intensely preoccupied with self-portraiture during 1942, as notebook entries from that period attest, Miró's activities in the genre were confined to small-scale works on paper.

evident in the way he harks back repeatedly to the motifs and sign language associated with his work of the early 1920s: quoted, almost to the letter, is one of his best-loved pictures from that period of a dog barking at the moon, whilst an appended inscription tells us that the grooves of the postal mark symbolise a tilled field, a reference back to his landmark picture of 1923. Superimposed upon this Catalan landscape is the undulating contour of the artist's torso, metaphorically conjoining them – something that we noted was implicit way back in the *Self-Portrait* of 1919 but which, by 1942, had assumed far greater poignancy. During the reign of terror that followed the Civil War, when it is estimated that upwards of four thousand people were summarily executed, any public expression of Catalanness was brutally suppressed and even to speak in Catalan was a punishable offence.

One could be excused for feeling short-changed by Miró who in a work such as this conspicuously fails to deliver the value for money of an Old Master like Holbein. But on this occasion the portrait transaction, so to speak, works to our advantage as two heads are offered for the price of one: in addition to the portrait of the artist there is another of General Franco in the form of a stamp. Miró makes plain his opposition to the regime by tipping the envelope upside down, a deliberate gesture that sets his own features against those of the dictator (the political sentiments expressed in them may explain why these drawings remained for years in Miró's possession and were never exhibited during his lifetime).

That a Catalan identity was, publicly at least, dead and buried may have some bearing on a marginal detail of the composition that we have yet to address: the black border on the envelope, used traditionally to notify someone of a death. With a deft economy of means Miró utilises this border as a makeshift frame. But it also means that his own self-portrait is addressed to him from the place of the other ('l'autre') in the form, bizarrely, of a death notice ('lettre'). The margin is therefore central to the signification of Miró's self-image which acknowledges his dependence as a subject on a limit or horizon that envelops him.[41] With less ostentation than Holbein, but more conviction perhaps, he affirms that being ('l'être') is permeated to its very core by the heterogeneity of death and absence. Miró succeeds in re-presenting a void ('manque-à-être') which it has always been the task of portraiture to mask with an illusion of self-presence.

With his customary mix of flamboyance and incisive brilliance, Lacan once spoke of Surrealism as 'a tornado on the edge of an atmospheric depression where the norms of humanist individualism founder'.[42] What the foregoing analysis of self-portraits by Joan Miró has sought to demonstrate is that, at certain moments anyway, Surrealism entered into a vital transaction with the O/other, the full cost of which for a humanist conception of the self has yet to be counted.

Notes

1 Jacques Lacan, *Ecrits. A Selection*, trans. Alan Sheridan (London: Tavistock, 1977), p. 193.
2 *Ibid.*, p. 17.
3 In a similar fashion, psychoanalysis shatters the presumed transparency of the subject to self-reflexion: 'it is a question of recentring the subject as speaking in the very lacunae of that in which, at first sight, it presents itself as speaking', writes Lacan. That is because 'the subject in question is not that of reflexive consciousness, but that of [unconscious] desire'. Lacan, *The Four Fundamental Concepts of Psycho-Analysis*, trans. Alan

Sheridan (London: Peregrine, 1986), pp. 83 and 89. I would see these remarks as pertaining to the Ernst image under discussion as well as to Surrealism in general.

4 André Breton, *Nadja* [1928], *Oeuvres complètes* (Paris: Gallimard, 1988), I, p. 653.

5 Joan Miró, *Selected Writings and Interviews*, ed. Margit Rowell (London: Thames and Hudson, 1987), p. 157.

6 *Ibid.*

7 James Thrall Soby, *Joan Miró* (New York: The Museum of Modern Art, 1959), p. 93.

8 Miró, *Selected Writings*, p. 257.

9 Johann Goethe, *Goethe on Art*, trans. John Gage (London: Scolar Press, 1980), p. 185.

10 In a brilliant reading of the Freudian uncanny that impinges on my interpretation of *Self-Portrait 1* here, Julia Kristeva emphasises it as a moment of '*destructuration of the self*' in an experience of otherness. Kristeva, *Strangers to Ourselves*, trans. Leon S. Roudiez (London: Harvester Wheatsheaf, 1991), p. 188.

11 Lacan's mirror stage describes the subject's narcissistic 'capture' in an ego-ideal as seen here. See 'The mirror stage as formative of the function of the I', in Lacan, *Ecrits*, pp. 1–7.

12 Sigmund Freud, 'The "uncanny"' [1919], *Standard Edition of the Complete Psychological Works of Sigmund Freud*, ed. James Strachey (London: Hogarth Press, 1955), XVII, p. 248. Julia Kristeva comments that: 'the archaic, narcissistic self, not yet demarcated by the outside world, projects out of itself what it experiences as dangerous or unpleasant in itself, making of it an alien *double*, uncanny and demoniacal. Kristeva, *Strangers to Ourselves*, p. 183'.

13 In Miró, *Selected Writings*, p. 190.

14 'Fire lives in the death of earth, air in the death of fire, water in the death of air, and earth in the death of water' is one of the adages ascribed to Heraclitus. Masson discovered Heraclitus via Nietzsche and, like him, felt strong affinities for a philosophical system that affirms 'perishability and destruction ... combat and contrast', as he writes in a letter to Georges Bataille in 1936. His image is, in consequence, a partial self-portrait.

15 *L'Amour de l'art* (April 1937), p. 27. One wonders if van Gogh (or Miró for that matter) could have known about a sixteenth-century miniature by Nicholas Hilliard of *A Man Against a Background of Flames* (Victoria & Albert Museum, London).

16 Miró, *Selected Writings*, p. 158.

17 Georges Bataille, 'Sacrificial mutilation and the severed ear of Vincent van Gogh' [1930], in *Visions of Excess: Selected Writings, 1927–1939*, trans. Alan Stoekl (Minneapolis: University of Minnesota Press, 1986), pp. 61–72. Both quotations are on p. 67.

18 Georges Bataille, 'Van Gogh Prometheus' [1937], *October*, 36 (Spring 1986), p. 59.

19 Cited in Jean-Paul Clébert, *Mythologie d'André Masson* (Geneva: Pierre Cailler, 1971), pp. 49–51.

20 Georges Bataille, 'Le bleu du ciel', *Minotaure*, no. 8 (15 June 1936), p. 51.

21 Georges Bataille, 'Les mangeurs d'étoiles', in Jean-Louis Barrault *et. al.*, *André Masson* (Rouen: Wolf, 1940), pp. 25–8.

22 M. H. Abrams, *Natural Supernaturalism. Tradition and Revolution in Romantic Literature* (New York: Norton, 1971), p. 47.

23 Identification is generally conceived of as a process of incorporation, or introjection, analogous to the physical ingestion of an object. What seems to be at stake in Miró's rapport with Blake and van Gogh is the reverse of this: a forceful projection of the subject outside of himself. For a lucid account of the concept of identification in psychoanalysis see J. Laplanche and J. B. Pontalis, *The Language of Psychoanalysis* (London: Karnac, 1988), pp. 205–8.

24 Michel Leiris, 'Portraits', in Michel Leiris and Georges Limbour (eds), *André Masson and His Universe* (London: Horizon, 1947), p. 198.

25 André Breton, 'Surrealism and painting' [1928], in *Surrealism and Painting*, trans. Simon Taylor (London: Macdonald, 1972), p. 36.

26 Miró, *Selected Writings*, p. 162.

27 Louis Aragon, 'Réalisme socialiste et réalisme français', in *Ecrits sur l'art moderne* (Paris: Flammarion, 1981), p. 57.

28 Jacques Lacan, 'Anamorphosis', in *The Four Fundamental Concepts of Psycho-Analysis*, pp. 79–90.

29 Miró, *Selected Writings*, p. 158.

30 Georges Bataille, *Inner Experience*, trans. Leslie Anne Boldt (Albany, New York: State University of New York Press, 1988), p. 5.

31 André Breton, 'Manifeste du surréalisme' [1924], in *Oeuvres complètes*, I, pp. 335 and 336. In a more poetic vein, Paul Eluard reflects on his collaboration with Breton in writing the texts of *L'Immaculée Conception*: 'To be two to destroy, to create, to live, is to be all, to be the other to infinity and no longer oneself.' In 'Note à propos d'une collaboration', *Cahiers d'Art*, 5–6 (1935), p. 137.

32 Jacques Lacan, 'Intervention on transference', in *Feminine Sexuality, Jacques Lacan and the Ecole Freudienne*, ed. Juliet Mitchell and Jacqueline Rose, trans. Jacqueline Rose (London: Macmillan, 1982), p. 62.

33 On this question, see Jacques Lacan, *Speech and Language in Psychoanalysis*, translated, with notes and commentary, by Anthony Wilden (Baltimore and London: The Johns Hopkins Univ. Press, 1981). This volume contains a very valuable essay by Anthony Wilden, 'Lacan and the discourse of the Other', on the multiplicity of meanings of the O/other in Lacan's discourse.

34 Shoshana Felman, *Jacques Lacan and the Adventure of Insight: Psychoanalysis in Contemporary Culture* (Cambridge, Mass. and London: Harvard University Press, 1987), p. 56.

35 The L-schema doesn't only pertain to situations involving two persons because every individual is 'a participator ... stretched over the four corners of the schema' (Lacan, *Ecrits*, p. 194). The axis o–o' thus evokes the spatial symmetry of the relation between the ego and its narcissistic, reflected 'double'.

36 *Ibid.*, p. 194.

37 *Ibid.*, p. 17.

38 *Ibid.*, p. 43.

39 As far as Lacan is concerned, ego psychology is misguided in its attempts to strengthen the ego defences. All that can be achieved by its 'sincere portraits' and 'rectifications' is to further alienate the subject in an imaginary construct. *Ibid.*, p. 42.

40 André Breton, *Nadja* [1928], *Oeuvres complètes*, I, p. 877.

41 Reality appears only as marginal, affirms Lacan. Strictly speaking, the Real is unrepresentable, but as death it nonetheless haunts the symbolic: 'reality, foreclosed as such in the system, and entering into the play of the signifiers only in the mode of death' (*Ecrits*, p. 196).

42 Jacques Lacan, 'Actes du Congrès de Rome', *La Psychanalyse*, 1 (1956), p. 251. Cited by David Macey, *Lacan in Contexts* (London: Verso, 1988), p. 46.

PART V

Identity and truth

9

Kahnweiler's Picasso; Picasso's Kahnweiler

MARCIA POINTON

I have often wondered by what miracle painting has gone so far ahead, and how it happens that literature has let itself be out-distanced. In painting today, just see how the '*motif*', as it used to be called, has fallen into discredit. A *fine subject*! It makes one laugh. Painters don't even dare venture on a portrait unless they can be sure of avoiding every trace of resemblance. If we manage our affairs well, and leave me alone for that, I don't ask for more than two years before a future poet will think himself dishonoured if anyone can understand a word of what he says.

André Gide, *Les Faux Monnayeurs* (1925)[1]

The words are Strouvilhou's. He addresses his friend Count Passavant on the subject of contemporary art and literature. In Gide's fictional atomisation of a moment and a class of Parisian society, the man who speaks these words is a master of stratagems and a producer of counterfeit coins, the circulation of which threatens to disrupt the established relations of family, class and society. His companion, Passavant, typifies the decadence and superficiality of old artistic and aristocratic traditions. In this conversation, the portrait and its ability to convey resemblance stand as a yardstick for communication itself. Portraits that lack resemblance and therefore, by implication, refuse identification will be followed by poetry that is incomprehensible. Strouvilhou who spreads deceit by passing counterfeit coins (the image that is central to the novel) will lead literature into opacity. The counterfeit coin (and coins are, of course, a form of portrait) here has an analogue in the idea of the portrait without resemblance – a portrait in which likeness is masked or even eradicated. In engaging with the world of Strouvilhou and Count Passavant, Gide's characters risk loss of identity and loss of meaning; they enter a space where nothing can be valued and nobody trusted. They enter a modern world in which the relationship between sign and referent, between portrait and subject, between coin and monetary value, has been ruptured.

The point of reference for Strouvilhou's invocation of the 'portrait without resemblance' is undoubtedly the Cubist portrait; Braque and Picasso working in Paris at the end of the first decade of the century produced a series of arresting images of named individuals, each of them pushing portraiture's traditional obligation to 'likeness' and 'identity' to its limits. In 1909 Picasso began work on his portrait of Vollard, a sitter whom Cézanne had already tackled in an innovative

portrait of 1899.[2] In 1910 he completed his portrait of Vollard and executed two further portraits: of the poet Uhde and of his friend and dealer, Daniel-Henry Kahnweiler (Figure 67).[3] Kahnweiler was a German immigrant in Paris; Picasso was a Spanish immigrant in the same city. Kahnweiler was born in Mannheim in 1884; Picasso was born in Malaga in 1881. Both artist and sitter are male. Kahnweiler was not only Picasso's dealer but also someone who wrote persistently about the artist who depicted him. His testimony has overwhelming importance in the writing of the history of art and his word has become effectively an authorisation and an authentication for the dissemination of 'Picasso' as concept and artistic package to the world at large, particularly after the Second World War.[4] Picasso, for his part (and I am implying here a 'deal' or contract, of which more later), depicts Kahnweiler three-quarter-length in a balanced triangular composition. The lower part of the body is omitted and the area of face and hands are picked out by effective organisation of light and colour. What we see is, arguably, a mask (a patterned surface which suggests a face without offering a likeness). The motif has not so much fallen into discredit, as Strouvilhou claims, but become detached from those representational clues that ensure it is readily meaningful. In the struggle that viewers experience in endeavouring to 'recognise' Kahnweiler, a bottle, a sculpture from New Caledonia, and a fob watch have all been identified.[5]

Here, then, is an account of modernism in which the portrait plays an important role. Indeed, modernism and the portrait might be said to be impacted, welded together. It is an account that hinges on the issues of resemblance and truth (for which the test is recognition). The identity of the individual as portrayed depends upon the process of recognition. Within this account, Picasso's portrait of Kahnweiler may be said to have a particular historiographic resonance. For Pierre Daix, it is the 'dernier portrait avant la sortie du cubisme'.[6] For the American installation artist, Michael Asher, Picasso's *Kahnweiler* became a means in 1982 of exploring the paradigmatic relationship of viewers with works in galleries. He selected this portrait because of the degree to which it had been reproduced on postcards, in books and on posters.[7] So, to sum up, we are dealing here with several overlapping concepts:

1. an artwork by a named artist which happens to be a representation of another human being with whom the artist was personally acquainted and with whom he had a business relationship;
2. a representative image within the historiography of modernism (typically formulated as Cézanne to Synthetic Cubism);
3. a portrait and, as such, an image pertaining to a genre characterised by particular traditions and conventions.

The second of these concepts will be with us as we proceed through this chapter – it is the inevitable cultural condition within which any examination of Picasso's *Kahnweiler* takes place and I will allude to its importance as I go. Let us look more closely at the first concept on my list. Here we have the portrayal of an individual who is (as dealer and writer) implicated in a special relationship with Picasso the artist. So how might this relationship be explained? I want to focus on two existing accounts of how identity and truth are understood to be produced within and through the relationship that the act of portrayal stages. One directly concerns Picasso's portrait of Kahnweiler. The other is more general in its frame of reference but offers an important model for how we might approach the problem of portraiture. In the first of these, Michael Baxandall, who is concerned with how

the critic at a different point in time can understand the painter's goal, proposes a split between what he terms 'the charge' (the order to effect something) and 'the brief' (the taking into account of matter specific to the commission and the deployment of resources to accomplish the charge). Picasso's brief is unsurprisingly summed up by having to deal with two-dimensional surfaces as space for three-dimensional objects, the consideration of the relative importance of form and

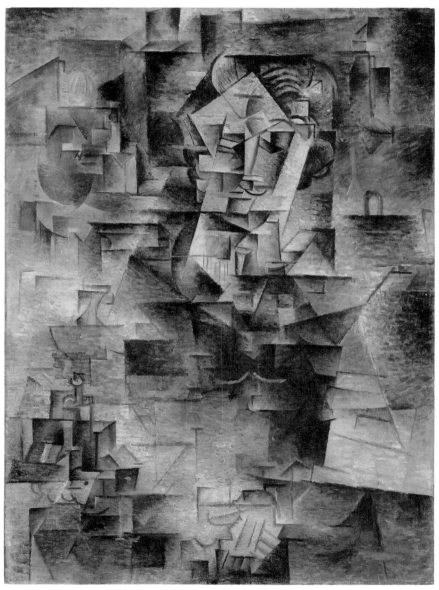

67 Pablo Picasso, *Daniel-Henry Kahnweiler*, 1910. Oil on canvas, 100.6 x 72.8 cm. Since it entered the collection of the Art Institute of Chicago just after the Second World War, this image has been one of the great icons of modernism. As a depiction of the artist's friend and dealer it raises fascinating questions concerning both the nature of the contract to portray and the history of portraiture within modernism.

colour, and the question of fictive instantaneousness (how can the painter present the time it takes to make something that appears to present one look). The charge, Baxandall argues, cannot be summed up by 'intentional visual interest'; it resides in 'the body of previous accounts'.[8] By this, he means artistic influence which occurs in a market which is defined in liberal, ahistorical terms as 'a relation in which two groups of people are free to make choices, which interact on each other'. Baxandall regards the arts as 'positional games' but beneath the novel terminology lies a conventional account of pictorial production addressing the relationship of Picasso's work to that of Cézanne, his involvement in the dealer system, and his preoccupation with the means and processes of his own artistic production.[9]

Baxandall reaches no new conclusions and, in core, Picasso's portrait of Kahnweiler, in Baxandall's account, could be replaced without loss or inconsistency by any still-life Cubist painting by Picasso executed *c.* 1910 and bought by Kahnweiler. He therefore neither addresses what makes this image specific to two individuals nor questions the ways in which Braque and Picasso anthropomorphised still-life painting and 'stilled' portraits (blurring the distinctions between the 'alive' aspirations of portrait representations and the 'dead' qualities of *nature morte*). It is highly significant that Baxandall at one point admits that he has been following Kahnweiler's Picasso (an implicit recognition of the seepage between the category 'artist' and the category 'sitter' that is occurring in our apprehension when we try to consider this particular case of portrayal). But attention is deflected from this question of the *effect of the sitter* as Baxandall goes on to propose a formalised structure in which the artist is actor and the model observer. This enables him to compare Picasso's and Kahnweiler's accounts of the historical moment of portrayal:

There may be a danger of equivocation here. A 'problem' – practical or geometrical or logical – is normally a state of affairs in which two things hold: something is to be done, and there is no purely habitual or simply reactive way of doing it. There are also connotations of difficulty. But there is a difference between the sense of problem in the actor and in the observer. The actor thinks of 'problem' when he is addressing a difficult task and consciously knows he must work out a way to do it. The observer thinks of 'problem' when he is watching someone's purposeful behaviour and wishes to understand: 'problem-solving' is a construction he puts on other people's purposeful activity. The intentional behaviour he is watching does not always involve an awareness in the actor of solving problems. Indeed, when the observer is of a different culture from the actor – not Kahnweiler's but the historian's case ... – he may put the construction of problem-solving on behaviour which is habitual: the culture has taught the actor the trick of solving unreflectively a problem he does not know exists. An attention to 'problems' in the observer, then, is really a habit of analysis in terms of ends and means. He puts a formal pattern on the object of his interest.[10]

Although Baxandall states that both possibilities are correct, although different, he does not anywhere in this deeply humanist account of Picasso's portrait of Kahnweiler, return to what he calls the historian's case, perhaps because culture has taught the observer/historian the trick of evading the issue of his own investment in the investigation. More importantly, the effect of this very questionable model (what sort of actor are we talking of here and what has happened to the audience?) is to drive a wedge between artist and model who in this case is also critic and dealer, thus stressing supposed differences at the expense of the relational nature of their discourses.

The conclusion to the framework Baxandall proposes here is equally provocative but ultimately unsatisfactory for, rather than being led to reconsider the portrait, we are invited to understand that Picasso's active relation (i.e. the actor's, as opposed to Kahnweiler's, the observer's) was always to the present moment and to the 'level of process and emerging derivative problems on which he spent his time'. Kahnweiler, on the other hand, 'is telling us something about what happened in the market relationship' and (in a lapse from Baxandall's customary rigour) 'it is impossible to believe Picasso did not pick it up'.[11] I want to draw attention here to the importance of the idea of time as a recognisable (if unquantifiable) component in the relationship between portraitist and sitter as represented in general as well as in this particular instance. Moreover, it is perhaps appropriate to remind ourselves that the very notion of modernism – within which this portrait has been seen to be implicated – is temporal. The implication in Baxandall's account is that the time of the artist (present moment) is distinct from the time of the sitter (sequential and something to do with selling and buying). By splitting the time of the artist from the time of the sitter, Baxandall leaves no space for the interactive relationship between the portraitist and his subject as an object of observation (for the purposes of portrait painting). The complicity inherent in that act becomes apparent, I suggest, when that subject acts as author, releases the portrait as a series of narratives about modernism and therefore about time. Likeness is authorised only within, and as part of, those narratives. The relay thus established is one within which we, as historians and observers, also function.

The second account of how likeness and truth are produced within an act of portrayal employs a very different kind of analytic. Eschewing what are, in Baxandall's analysis, basically humanist-inspired arguments about motivation, it concentrates rather on agency as an unstable and shifting factor. In this account, portraiture sets up a perpetual oscillation between observer and observed. Artist and sitter are both affected by the event of portrayal which has, as its outcome, an image which is recognised to involve the naming of two individuals, rather than one. Thus the portrait of Kahnweiler cannot be treated like, say, a Cubist still-life from the same period. Paul de Man describes this agonising process in relation to the work of the anthropologist, but his observations may equally apply to the artist:

Every change in the observed subject requires a subsequent change in the observer, and the oscillating process seems to be endless. Worse, as the oscillation gains in intensity and in truth, it becomes less and less clear who is in fact doing the observing and who is being observed. Both parties tend to fuse into a single subject as the distance between them disappears.[12]

The notion of an oscillation which eventually effectively conflates subject and object is, I suggest, apposite for a consideration of Picasso's portrait of Kahnweiler. It makes possible the conceptualisation of an interactive relationship between artist and subject of a portrait. This relationship is staged also, as we shall see, through the evocation of the mask in what is culturally defined as a portrait of a named individual; this alliance of subject and mask speaks of ambivalence, of a procedural oscillation. It is this coming together of the blatantly fictitious and the empirically truthful that epitomises the double-edged quality of portraiture. Picasso portrays Kahnweiler in a fiction – a fiction that draws on the conspicuous inventiveness of the mask as well upon the familiar mimetic conventions of the genre of portrait. And as the portrait subject is here also biographer (and auto-biographer),

by recognising these structural relations we have a framework for explaining the empowerment of Kahnweiler. The explicit combination of reality and fiction – the avoidance of *all but* the slightest trace of resemblance, to go back to my opening passage – empowers Kahnweiler to portray his portraitist and, by so doing, to insert his own self-portrait into the arc of the oscillating pendulum. In addressing Picasso's portrait of Kahnweiler we need to recognise that the market conditions of its production are part of the text, contributing to the development of a visual grammar and determining our access to the image. These conditions cannot be dealt with in the manner of Baxandall by reference to a pattern of choices which are identified and then set aside to 'free' the painting as a narrative of problem-solving.[13] Nor does the explanation that the Parisian dealer system allowed Picasso a special kind of independence to develop Cubism[14] provide a satisfactory model because it denies the dynamic of the relationship between artist and subject/object that de Man's analytic so effectively conveys.

Dealing with these theoretical questions has led me to raise the question of the characteristics of portraiture as a genre. These cannot, of course, be dealt with in an ahistorical manner, so bearing this in mind I shall move to consider the third of my concepts for Picasso's *Kahnweiler*: the idea that as a portrait of a named individual it must work according to certain traditions and conventions. One hypothesis on portraiture claims that the portrait obeys – at the same time as it can in some cases help to determine – the general laws of stylistic development shown in all aspects of the art creations of a given region and period. This argument, put forward by James Breckenridge for one,[15] underpins Baxandall's account of Picasso's *Kahnweiler*. Accounts that seek to accommodate the portrait into a universal economy of style distract attention from the specific conditions of portrait production and the conventions that are a consequence of those conditions. In 1910, as Gide's invocation of the portrait to make a point about meaning and communication in art forms generally demonstrates, the genre of portraiture held a powerful and problematic position in the network of classifying types through which artists, critics, historians and consumers organise cultural productions like portraits. One of the most influential humanist historians of the twentieth century, Sir Ernst Gombrich, chose as late as 1945 to see the portrait as paradigmatic of those imitative forms of representation whose unity and coherence were threatened by modernist innovations such as Cubism, stating 'There will be no portrait left of modern man because he has lost face and is turning back towards the jungle.' Gombrich thought that the scale of global disaster of the Second World War was paralleled by – and perhaps by implication connected to – the disaster that seemed to threaten the classical western tradition of painting.[16] The portrait in the early twentieth century might, therefore, be reasonably said to have been situated at the intersection of conflicting discourses about representation.

It is well known that Picasso experimented with an almost unprecedented range of media and genres. He has been characterised as an adventurous modernist, overturning rules and subverting genres in a challenging and playful way. For Adam Gopnik, for example, writing in 1983, the transformation in Picasso's art from 1905 to 1907 is possibly the most astonishing transformation in art history *tout court*. He accounts for what he terms 'the revolution in Picasso's portraiture' in these years by reference to a psychomachia between sketch book and easel with the sketch book as the place where caricature reigns.[17] By invoking the psychomachia (a

medieval term for a philosophical dispute between opposing spiritual tendencies

in the mind of an individual), I take Gopnik to mean that the important tension in Picasso's portraiture is a self-referential one: the tension between a drive towards exaggeration in the form of caricature and a drive towards 'truth' as imitation in the portrait painted in oil. Gopnik assimilates the language of caricature to the language of African masks and uses this to explain the moment of Cubist portraiture as a leap forward through creative linkage of high and low art forms (portraiture being seen here as a 'high' genre and caricature as 'low'). This collapsing of the mask into caricature takes us off on a wrong tack. I shall challenge the evolutionist thrust of Gopnik's argument by linking *Kahnweiler* to other portraits and by examining how the juxtaposing of the notion of a mask (as a category rather than an object) with the notion of a portrait affects the way we view Picasso's painting of his friend and dealer.

Picasso's *Kahnweiler* was painted in Paris in 1910 – an individual sitter, a particular location at a particular moment. By insisting on this I am refusing the idea of modernism as a free-floating, a-national, non-historicist discourse. I am also issuing a reminder that Picasso's portrait results from a specific contractual moment: a moment of class, nationality and professional identity. It shares this with other portraits produced in Paris: for instance the portraits of Ingres produced in the same place but in the previous century. While their appearance may – at first sight – differ, there are things in common between the work of Ingres and that of Picasso and these things in common are not simply a matter of style or technique.[18] Nor are they a matter merely of composition.[19] The antecedents for *Kahnweiler* are generally taken to lie with Cézanne at a crucial point of interchange for Analytical Cubism. I wish to suggest that other conventions, other rhetorical strategies also determine the appearance of this portrait and that they relate directly to the oscillatory relationship between artist and subject/dealer/writer. The depiction of male subjects three-quarter-length with attention notably concentrated on face and hands, and with a single object like a book or a piece of sculpture picked out at lower left or lower right,[20] is not a format unique to Ingres but it is highly prevalent in his work and culturally prominent imagery of this kind was readily available to Picasso. The balanced triangular format of Picasso's portrait of Kahnweiler relates to the organisation of a sitter's identity around high-lighted face and hands, the severance of the lower part of the body, and the distribution of weight into the lower half of the canvas, that we can clearly see in Ingres's portraits of Charles-Joseph-Laurent Cordier (1811) and of M. Bertin, the elder (1832) (Figure 68), both of which are in the Louvre.

This latter portrait, commonly regarded as one of Ingres's most psychologically penetrating and highly 'realistic', was, and is, after Rigaud's image of Louis XIV, probably France's best-known national portrait. Bertin was the founder of the *Journal des Débats* and represents in cultural terms the ideal of French bourgeois masculine strength and any allusion to this popular icon has implications for the oscillatory relationship that produced both Picasso's *Kahnweiler* and Kahnweiler's Picasso. By drawing attention to this link between Picasso's painting and a type of portrait by Ingres (as well as an individual sitter portrayed by the man popularly regarded as France's most distinguished nineteenth-century portraitist) I am reinstating both the 'Frenchness' and the 'portraitness' that are mobilised in the coming together of Spanish Catalan artist and German Jewish dealer. Picasso's and Kahnweiler's fragile relations with French culture are evinced in the subsequent attacks on Cubism as Germanic and non-French.[21] Situated in Paris

immediately prior to the First World War, it is the portrait as genre and the academic French tradition (a tradition to which Cézanne, as precursor of Picasso, is also indebted) that are called upon as a language of grand gesture in an image that was through these invocations 'canonised' and ensured an afterlife.

It is to this afterlife that we must now turn. I have referred to the portrait contract in this instance as complicitous. What then might this mean and what has it to do with the notion of a portrait's afterlife? Picasso and Kahnweiler could not have predicted the future in any precise way at the time of the portrait's production, though they may well have sensed an imminent threat to aliens resident in Paris, as well as to their possessions, including portraits. On the other hand, we need to recognise that the oscillatory relationship that conceptually fuses Picasso and Kahnweiler also precipitates a narrative. At one level it is reasonable to suppose that consciously or unconsciously it was hoped that this portrait – like others – would bring returns (cultural and symbolic if not monetary). At the outbreak of war, Kahnweiler's possessions were sequestrated and he left the country. Yves-Alain Bois suggests that Kahnweiler's scrupulousness prevented his writing while he was dealing, thus delaying his account of Cubism until his exile in the years 1915–20. In declaring Kahnweiler 'the only critic to give an intelligent account of cubism, after he had been a privileged witness to its beginnings', Bois not only insists upon the scholarly integrity of his subject but also affirms the reputation that Kahnweiler, through Picasso, established for himself.[22] It would, of course, be equally tenable to argue that it was precisely exile and sequestration that provided Kahnweiler with the space to write *Der Weg zum Kubismus*. Kahnweiler's qualifications to write what turned out to be a Kantian account of Cubism (as a movement that reveals ideal forms) in German while living in Switzerland should also not be passed by without comment. In German, the title specifies a road to Cubism; the English translation replaces the idea of a journey with the notion of a spontaneous eruption – *The Rise of Cubism*. And the translated text contains many shifts and restructurings of this kind.[23] Thus the moment of 'privileged witness' which is marked by the portrait of Kahnweiler with its unified claims to the authority of genre and nation gives onto an untidy confusion of languages other than French, countries other than France, unstable translations and variations in nuance. Paradoxically then, the portrait, *Daniel-Henry Kahnweiler*, initiates and authorises the unitary account of Cubism *and* simultaneously enforces a separation between the unity of artist and sitter/dealer/writer that the portrait produces. The autonomous and self-declamatory paint-surfaces of *Kahnweiler* provoke in the sitter/dealer/critic a series of declarations in a humanist (verbal) tradition that serve to dismantle the very qualities of genre and nation (portraitness and Frenchness) upon which the unity of the image as produced in 1910 was predicated. Kahnweiler's success in this enterprise has been remarkable and is due in no small part to the fact that alongside 'portraitness' *Kahnweiler* insists on absence of facial syntax and hence (as I have already suggested) upon the mask with its capacity for suggesting the oblique and the hidden. It is, after all, not resemblance or likeness that persuades us that Picasso's canvas represents Kahnweiler; its denotative clues are minimal and we must depend upon naming, upon the conventions explored above, and upon the intervention of Kahnweiler's voice to realise the image as portrait.[24]

Masks are not about recognition or about appearance. They stage desire – the will to acquire, or to imagine, what lies behind the mask. I shall conclude this chapter by moving from the 'truthful' discourses of resemblance that, as we have

seen, are established by the generic (portrait-like) qualities combined with the sitter's imbrication in the portrait's production and afterlife. I shall not focus on the recognition of African art as an aid to artistic problem-solving – one of modernism's heroic moments of discovery – but on the idea of the mask as disguise, as the very antithesis of portraiture.[25] European culture since the eighteenth century has tended to regard the mask as the enemy of 'true' portrait depiction which, in Lavater's words, 'is the communication, the preservation of some individual'.[26] Portraiture, in short, is understood to aspire to unmasking and revelation.[27] The 'true' portrait in order to preserve must imitate but not copy or corrupt. Masks are

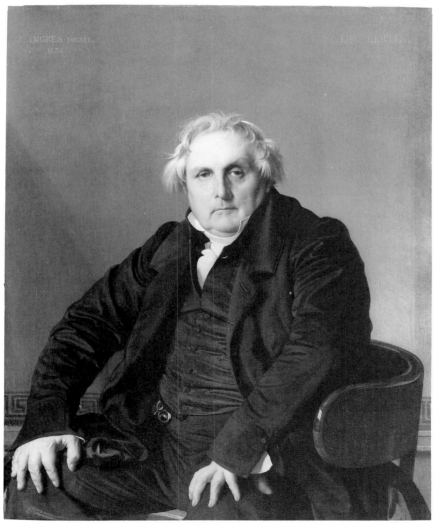

68 Jean Auguste Dominique Ingres, *Monsieur Bertin*, 1832. Oil on canvas, 116 x 95 cm. This image of the bourgeois editor of one of France's best-known newspapers by an artist who has come to represent, for French audiences, the survival of the classical tradition, is often regarded as quintessentially French and is much loved for its apparently direct address to the viewer.

connected with deceit, danger, violence and disorder in a long European tradition which simultaneously incorporates the idea of desire and mystery, as for example in Venetian carnival masks. In the twentieth century masks are associated with imperialist cultural appropriation and with the threatening non-European 'other'.[28] Masks enable human beings to disguise themselves as animals, and men to disguise themselves as women. Moreover they are silent; the masked mummers do not speak.[29] At a theoretical level, the mask has been understood as enabling an exteriorisation of spirit, leading to that transcendence of the body as limit and object of representation that has been seen as a condition of modernism itself.[30]

In concentrating on the mask as *idea* as well as *object*, I wish to relate it structurally to the portrait and ask how this relationship might open up a philosophical and representational contradiction. Just as the oscillatory portrait deal that I identified earlier precipitates a narrative (a story of Picasso/Kahnweiler/Cubism), so the mask juxtaposed conceptually with the portrait raises the notion of a moment anterior to the actuality of the portrait as object produced in historically specific circumstances. It enables us – legitimises or even, perhaps, impels us – to engage dialogically with the portrait and its sitter. The mask and the portrait brought together stage the moment of (phantasised) unmasking that is also the moment of release, the attainment of desire in the carnival's conclusion. The mask is thus both the mechanism for the arousal of desire and the impediment to its attainment. In terms of the fairy-tale account, the princess falls in love with the toad and by that love he is unmasked and becomes a prince which is her reward. The story is resonant because what I want to suggest here is not a real behind the mask but rather to invoke a double, the replica which, as Lyotard suggests, desire fashions of what it lacks.[31] The process of replication that masking involves licenses a theatricalisation of the surface, inviting participation in a process of inscription; the toad is generic but the prince must have a name. The name of Kahnweiler is inscribed on that surface only to produce a desire for what is anterior to it, the original moment of engagement in the portrait process. Mask therefore becomes yet one more rhetorical strategy in the complex and collusive process of author(ising) Cubism.

Yet it is also more than this. I shall conclude, as I began, by examining a literary text. Hermann Broch's *Esch the Anarchist*, set in 1903, is Book II of *The Sleepwalkers* (written in Vienna 1928–31) and the passage I discuss demonstrates the structural relationship between the portrait and the mask as one that (like Gide's counterfeit coins) has particular purchase in the cultural politics of Europe in the period immediately prior to the First World War.[32] In this account, we shall see a resolution of desire through the destruction of the mask that has provoked that desire. Esch, a thirty-year-old clerk, professionally unsuccessful, socially angry, and sexually voracious, has conceived a powerful desire for the widow, Frau Hentjen, who owns the bar he frequents in Cologne. Mother Hentjen's clientele are sailors but she takes her place each day between the buffet and the huge mirror that hangs behind it with an expressionless, mask-like face and an air of disdain for all around her.[33] On the mantelpiece her deceased husband's photograph, 'yellow with age, gazed out over the Eiffel Tower between the restaurant licence and a moonlit landscape, all three in fine black frames with gold scroll-work. And although with his little goat's beard Herr Hentjen looked like a snippet of a tailor, his widow had remained faithful to him'.[34] Frau Hentjen's world is articulated

through culturally freighted representations: the model of the Eiffel Tower, the

licence, the photograph, the landscape. The portrait takes its place in this line-up of objects that stand in for something other than themselves (for Frenchness, for statutory authorisation to run a restaurant, for the romantic).

The summation of Esch's anarchy occurs when, now Frau Hentjen's illicit lover, he threatens to challenge representation. Driven to desperation by her expressionless opacity he determines to tear at the immobility and imperviousness that he experiences as her mask. He threatens her with a discourse in which things are called by their real names; at the same time he insists that the photographic portrait of the dead husband be destroyed. The crisis erupts precisely around this portrait and the power that it carries, and its destruction is crucial for the lowering of Frau Hentjen's mask and the attainment of Esch's desire:

'Is that portrait going to be removed?' She did not know at first of what he was speaking, and when she did she did not quite understand for a moment: 'The portrait? ... oh, the portrait? why? don't you like it?' In despair before her inability to understand he said: 'No, I don't like it ... and there's a lot of things besides that I don't like.' She replied complaisantly and politely: 'If you don't like it I can easily hang it up somewhere else.' She was so unutterably stupid that it would probably take a thrashing to make her understand. However, Esch restrained himself: 'The portrait must be burned.' 'Burned?' 'Yes, burned. And if you pretend to be so stupid much longer, I'll set fire to the whole place.' She recoiled from him in terror, and, pleased with the effect of his threat, he said: 'You should be glad; it isn't as if you had any great love for the place.' She made no reply, and even if her mind was probably blank, and she only saw the flames rising from her roof-top, yet it was as though she were trying to conceal something. He said sternly: 'Why don't you speak?' His harsh tone completely paralysed her. Could this woman not be driven by any means to drop her mask? Esch had risen and now stood threateningly at the entrance to the alcove as though to prevent her from escaping. One would have to call things by their real names, otherwise one would never make anything out of this lump of flesh.[35]

The power of the photograph as talisman was explored in a now classic essay by Roland Barthes. Frau Hentjen's late husband's photograph is a Barthesian *spectrum avant la lettre*.[36] We are also familiar with the terrible necessity of destroying portraits.[37] For Esch photographic portraiture (illusionism notwithstanding) as manifest in the portrait of Frau Hentjen's husband (situated on the mantelpiece between other representations) encapsulates the outrageous refusal of the mask to deliver truth. It is particularly interesting to observe the way in which the purpose of the iconoclastic act is one of displacement. Esch cannot destroy Frau Hentjen's mask (though he does threaten to thrash her) because it is precisely that 'expressionless' facade which holds him gripped in psychic thrall. Yet he cannot bear *not* to penetrate the mask. Destroying the photograph with all its terrible longevity and its pretence (its subject clearly a tailor despite the goatee beard) is a mechanism which will, Esch intuits, unlock the historical process that links the widow to her past and thus enable him to break through her mask to own the reality presumed to lie behind it.

This search, the desire to recognise and in turn be recognised, which drives Esch to the point of madness, is defined by Walter Benjamin when he writes of the experience of the aura which 'rests on the transposition of a response common in human relationships to the relationship between the inanimate or natural object and man. The person we look at, or who feels he is being looked at, looks at us in turn. To perceive the aura of an object we look at means to invest it with the ability

to look at us in return.'[38] The view put forward by James Beckenridge that 'portraiture will always be judged, to some extent, by its success in conveying something specific about the model to its viewer'[39] needs reformulating in the light of the mask's function as the mechanism of desire, of the search for recognition. Photography, with its claims to authenticity and veristic representation, has to be disposed of before the mask, the place where desire stages its resolution, can be grappled with. Thus Picasso photographed his friend and dealer, Kahnweiler, in his studio at around the time he painted his portrait. The photographic portrait is invoked in accounts of the oil-on-canvas portrait[40] but only in order to be disposed of *en route* in the search for Picasso/Kahnweiler. Portrayal, as Broch demonstrates through the character of Esch the anarchist – and as Benjamin may be taken to reiterate – is less about recognition than about desire. The Cubist portrait's insistence on the mask focuses attention on that play of desire and offers an explanation for both the particular physical qualities of *Kahnweiler* as object and the ways in which it communicates historically as a portrait.

Notes

Many colleagues have given generously of their time to discuss with me the issues raised by Picasso's *Kahnweiler*. In particular, I am indebted to Mark Crinson, Thomas Crow, David Lomas, Peter Nicholls, Adrian Rifkin, Andrew Stephenson and Joanna Woodall. An early draft of this chapter was presented at a seminar at the University of Sussex in 1992. As an 'incomer' to twentieth-century art-historical studies, I have benefited from these discussions; for any infelicities I am alone responsible.

1 André Gide, *Les Faux Monnayeurs* (1925), trans. D. Bussy, *The Coiners* (London, 1950), p. 356.
2 Musée du Petit Palais, Paris.
3 The portrait of Vollard is in the Pushkin State Museum of Fine Arts, Moscow; that of Wilhelm Uhde is in the collection of Joseph Pulitzer Jr, St Louis; the portrait of Kahnweiler is in the Art Institute of Chicago.
4 See particularly D. H. Kahnweiler, *Der Weg zum Kubismus* (Munich, 1920), translated into English as *The Rise of Cubism* (New York, 1949); *Confessions esthetiques* (Paris, 1963); *My Galleries and Painters* (London, 1971). R. A. Kibbey, *Picasso. A Comprehensive Bibliography* (New York and London, 1977), includes fifty-seven entries for Kahnweiler, almost all of which are prefaces or forewords.
5 P. Daix, *La Vie de peintre de Pablo Picasso* (Paris, 1977), p. 112; conversation with Mark Crinson, 1994.
6 *Ibid.*, p. 112.
7 See A. Rorimer, 'Questioning the structure: the museum context as content', in M. Pointon (ed.), *Art Apart: Art Institutions and Ideology across England and North America* (Manchester, 1994), p. 260.
8 M. Baxandall, *Patterns of Intention. On the Historical Explanation of Pictures* (New Haven and London, 1985), p. 43. All references are to ch. 2, 'Intentional visual interest: Picasso's Portrait of Kahnweiler'. For a perceptive, witty and extended discussion of Baxandall's uncertainties, see A. Rifkin, 'Brief encounters of the cultural kind', *Art History* 9: 2 (June 1986), pp. 275–8.
9 This agenda is no different from that covered in the more interesting and historically informative account offered two years earlier by Francis Frascina, *Cubism: Picasso and Braque* (Open University, 1983).
10 Baxandall, *Patterns of Intention*, pp. 69–70.
11 *Ibid.*, p. 71.
12 P. de Man, *Blindness and Insight: Essays in the Rhetoric of Contemporary Criticism*, 2nd edn, revised, introd. W. Godzich (1971) (Minnesota, 1983), p. 10.

13 Baxandall, *Patterns of Intention*.

14 Frascina, *Cubism*.

15 J. D. Breckenridge, *Likeness: A Conceptual History of Ancient Portraiture* (Evanston, 1968), ch. 1.

16 E. H. Gombrich, *A Propos Portrait Painting* (London, 1945), unpaginated.

17 A. Gopnik, 'High and low: caricature, primitivism, and the Cubist portrait', *Art Journal* (Winter 1983), pp. 371–6, note especially p. 372.

18 It is known that Picasso, an admirer of Ingres, studied at the Louvre at this period. His debt to Ingres is summed up by draughtsmanship, line and a fascination with distortion and multiple views of the body. See, for example, R. Penrose, *Picasso: His Life and Work* (London, 1958), pp. 191–2.

19 The impact of Ingres on Picasso's portraiture is most readily apparent in portraits of Olga painted between 1917 and 1921 in which fans, patterned fabrics and jewellery are used to position a contemplative and immobile human figure. See, for example, *Portrait of Olga in an Armchair* (Musée Picasso, Paris). A portrait of Olga of 1921 is virtually a copy of Ingres's *Comtesse d'Haussonville* (Frick Collection and Musée Picasso). These features are maintained in a painting like *La Lecture* of 1932 (Musée Picasso) with its curving forms, serene visage, and elongated arms set against a patterned fabric and the geometric panelling of an interior.

20 Ingres's *M. de Norvins* (National Gallery, London) is posed next to a classical head of a personification of the Roman State (comparable to the statue in Picasso's *Kahnweiler*); *M. Leblanc* in the Metropolitan Museum, New York, holds a book in his right hand.

21 See K. Silver, *Esprit de Corps: The Great War and French Art 1914–1925*, University Microfilms Int. Ph.D., 1981. (See, especially, pp. 6–7, where Silver establishes that Cubism was never a flattering form of portraiture. Once war was declared, Kubisme (using the 'k' unfamiliar in French) was given a German identity.)

22 Y.-A. Bois, 'Kahnweiler's lesson', in *Painting as Model* (Cambridge, Mass., 1990), pp. 66–7.

23 Baxandall chooses to quote Kahnweiler's celebrated description of the 'discoveries' of Cubism, a passage which Francis Frascina had already invited *his* readers to peruse. A different passage from Kahnweiler's book makes my point about shifts in the process of translation that merges the notion of body into the more neutral term 'form': 'Years of research had proved that closed form did not permit an expression sufficient for the two artists' aims. Closed form accepts objects as contained by their own surfaces [nimmt den körper hin alsumschlossene von Seiner Oberfläche], viz., the skin; it then endeavours to represent this closed body [geschlossenen körper], and, since no object is visible without light, to paint this "skin" [diese 'Haut'] as the contact point between the body and light where both merge into colour. This chiaroscuro can provide only an illusion of the form of objects [die Form der körper]. In the actual three-dimensional world [der dreidimensional körperwelt] the object is there to be touched even after light is eliminated. Memory images of tactile perceptions can also be verified on visible bodies [sichtbaren körpern]. The different accommodations of the retina of the eye enable us, as it were, to "touch" three-dimensional objects [dreidimensionalen Gebilden] from a distance. Two-dimensional painting is not concerned with all this. Thus painters of the Renaissance, using the closed form method, endeavoured to give the illusion of form by painting light as colour on the surface of objects [des körpers]. It was never more than illusion ["Vortäuschung"]' (*Der Weg zum Kubismus*, Munich, 1920, pp. 27–8).

24 It is, in this context, interesting to note how frequently Picasso's photograph of Kahnweiler is set alongside the painting, as though to offer an assurance by positioning this other, 'real', image of the authenticity of Picasso's *Kahnweiler*. See, for example, Baxandall, *Patterns of Intention*, pl. 27, pl. 30; Frascina, *Cubism*, fig. 13, in which the image is cropped.

25 Every writer on Picasso addresses the question of his interest in African masks. Picasso and Braque had access to ethnographic collections, and African masks are invoked by writers on Cubism to help explain the innovations in problem-solving in relation to the representation of three-dimensional objects on a two-dimensional surface. Michael Leiris, the distinguished French anthropologist, contributed to the lavishly produced presentation volume *Pour Daniel-Henry Kahnweiler* (Stuttgart, 1965; London 1966), but

Kahnweiler, asked in 1978 (at the age of ninety-four) whether African sculpture had influenced Cubism replied: 'Looking for new painting possibilities one day they [Braque and Picasso] both arrived at similar results. External influences did not play any part. One day they discovered that their Cubist work showed a certain affinity with African art' (Gerhard Weber interviewing Kahnweiler, 'Daniel-Henry Kahnweiler: growing up with the Cubists', *Art Monthly*, 16 May 1978, p. 14). Yves-Alain Bois is among the most cogent and sophisticated in mapping the characteristic arbitrary relationship of mask to face onto linguistic theory as it evolved in the early years of the twentieth century in circles known to Kahnweiler (Y.-A. Bois, 'Kahnweiler's lesson', pp. 85–8). However, despite the originality of many aspects of Bois's account, the importance of the mask for Picasso is ultimately still understood to lie primarily in its formal properties.

26 J. C. Lavater, writing in response to the question 'what is portrait painting?', *Essays on Physiognomy*, trans. T. Holcroft (London, 1862), p. 171.

27 See, for example, E. H. Gombrich, 'The mask and the face', in E. H. Gombrich, J. Hochberg and M. Black (eds), *Art, Perception and Reality* (Baltimore and London, 1972).

28 A. Lommel points out that in Europe masks have simply become a question of disguise but that 'in other areas the mask personifies something or somebody (a principle, a power, a spirit) and is not meant to disguise', *Masks. Their Meaning and Function* (London, 1972), p. 213.

29 The classic study of this subject is still E. Welsford, *The Court Masque. A Study in the Relationship between Poetry and the Revels* (Cambridge, 1927).

30 See, for example, P. Nicholls, 'Consumer poetics. A French episode', *New Formations* (May 1991).

31 J. F. Lyotard, 'Several silences', in *Driftworks*, ed. R. McKeon (New York, 1984).

32 It is a text that has also interesting implications for the portrait question in the work of artists such as Klimt and Schiele.

33 Broch's description is reminiscent of Manet's *Bar at the Folies Bergères* (Courtauld Institute Galleries), with its representation of a woman in command of mirror images and (seemingly) disdainful of realities, an image that speaks of the illegibility of the social.

34 H. Broch, *The Sleepwalkers* (*Die Schafwändler*) (1962), trans. W. and E. Muir (London, 1986), p. 163.

35 *Ibid.*, p. 319.

36 See R. Barthes, *Camera Lucida. Reflections on Photography* (London, 1982), p. 9.

37 The most celebrated such episode in recent times is the destruction of Graham Sutherland's portrait of Sir Winston Churchill by Lady Spencer Churchill as reported at length in *The Times*, 13 January 1978.

38 W. Benjamin, 'On some motifs in Baudelaire', *Illuminations*, ed. H. Arendt, trans. H. Zorn (1955) (London, 1973), p. 190. I am grateful to Mark Crinson for drawing my attention to this passage.

39 J. Breckenridge, *Likeness*.

40 See n. 23.

IO

Rembrandt / Genet / Derrida

SARAH WILSON

It is this, the text (Genet) that traps, fleshes, reads the reader, judgment, criticism. Like Rembrandt. Paradigmatic scene.

Jacques Derrida, *Glas*, 1974[1]

A portrait is not only both object and representation. It exists during its creation, as perception, and in memory, in reproduction, in description and as text; in its own time, through time and beyond time. And as writing, as literature, as a text, it may enter other texts. The case of the French playwright Jean Genet, looking and writing about Rembrandt, while writing and posing for Giacometti, generated a nexus of texts which in turn entered the writing of Jacques Derrida – as a paradigmatic instance of deconstruction.

Genet's encounter with Rembrandt's portraiture and his experience of portraiture as both interlocutor and model for Alberto Giacometti, was for long a lost moment in both art history and the exclusively literary arena of Genet studies.[2] A lost moment, too, in the history of deconstructivist thought and method – it was an experience stolen (in a Promethean mode), then simultaneously celebrated with overwhelming pomp and circumstance and buried in Jacques Derrida's two texts called *Glas* of 1972–4.

Derrida's pitting of Genet against Hegel in the second published version of *Glas* symbolised, he claimed, the tolling bell (in French 'glas') of all certitudes – moral, ethical, semantic. 'What is left of absolute knowledge? Of history, philosophy, political economy, psychoanalysis, semiotics, sexuality, linguistics, poetics? of work, of language, of sexuality, of the family, religion, the State etc.?', Derrida would ask.[3] The burial within this text of Genet's encounter with Rembrandt (and hence Giacometti) is not only a burial of a primary source but a burial of the problematic relationship between word and image that Derrida himself had broached gingerly, via Plato and Mallarmé, in 'La Double Séance' (the text which sits between Genet's 'Rembrandt' and *Glas*). *Glas* celebrates the triumph of the Text, the supremacy of the Word, in a timeless ravelling of sources, without beginning or ending, a Pyrrhic celebration which envelops and thus sacrifices the individuality, visuality, the Catholicism, the sexual anguish and the recollection of lived experiences in real time that once were those of Jean Genet.

Genet travelled to London in 1952 and Amsterdam in September 1953 to study Rembrandt's work.[4] There had been a major Rembrandt retrospective at the Orangerie des Tuileries, Paris, in 1947; details as to Genet's first encounter with the artist and subsequent museum visiting are frustratingly scarce. Did he visit 'Rembrandt et son temps' at the Ecole des Beaux-Arts, or the Rembrandt drawings show in Paris in 1955?[5] The 350th anniversary of Rembrandt's birth was marked in 1956 with a major joint retrospective in Amsterdam and Rotterdam, his engravings shown at the Bibliothèque Nationale, Paris, and exhibitions in Moscow, Leningrad, Budapest, Weimar, Berlin. More museum visiting on Genet's part took place during later peregrinations around northern Europe with his tight-rope dancer boyfriend, Abdallah Bentaga, during 1957, when in November he went on a pilgrimage specifically to Amsterdam, Antwerp and The Hague; Rembrandt's Holland, its light and landscape were as important to know as his works.[6] The first published text, 'Le Secret de Rembrandt', appeared in the newspaper *L'Express*, on 4 September 1958; during several months in London (and Norwich) he worked on the Rembrandt book again in 1962.

Why the unlikely fascination with Rembrandt? Genet's story was that of the illegitimate, adopted, changeling boy, institutionalised at the age of fifteen, who created a universe of homoerotic love and meaning out of the degradation of prison life. As literature his experiences became one of the most powerful and most subversive 'oeuvres' in postwar France. The relationship between beauty, desire, incarceration, orgasm and death are central to Genet's writing; besides writing itself, photography and film played important roles in his work. A tension was constantly and deliberately generated between the low – the utterly abject –

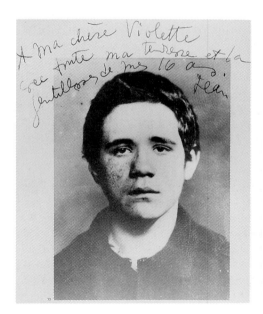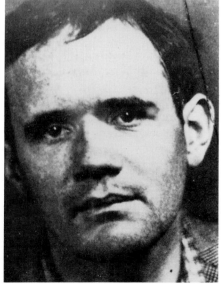

69 Jean Genet in 1927 aged sixteen, a 'colonist' at Mettray. This is presumably an official mugshot taken by the authorities. The photograph was dedicated to his friend the novelist Violette Leduc (author of *La Bâtarde* and *L'Asphyxie*) in 1948: 'To my dear Violette with all the tenderness and kindness of my 16 years, Jean.'

70 *right* Jean Genet *c.* 1937 aged twenty-six.

and the styles and genres of high culture. Just as the literature of Ronsard, Racine, Corneille and Victor Hugo, discovered as a boy in prison libraries, transformed Genet's writing, so his pursuit of Rembrandt involved a curious self-identification, and his 'transposition d'art' – the transmuting of portraiture into literature – would have deeply autobiographical overtones.

How Genet first encountered Rembrandt is not recorded, yet instantly he perceived, I would argue, besides the 'picture of an age' and Rembrandt's technical mastery, a physical resemblance with himself: soft eyes, the rounded nose and the promise in Rembrandt's later portraits of Genet's own physical decay. The affinity between Genet and Rembrandt as self-portraitist is striking. 'Perhaps for the first time in the history of art, a painter posing before the mirror with an almost narcissistic self-satisfaction, has left us, parallel to his other work, a series of self portraits in which we can trace the evolution of his method and the action of this evolution upon man.'[7] Rembrandt, famously, traced the growth, the 'hardening', the eventual decrepitude of his own face. As for Genet: 'Genet had been measured ... throughout his life (his body was virtually an official document, as much a record as his accumulated crimes and sentences).'[8] The relationship was constant between Genet's changing image and officialdom. *Haute Surveillance* was the title of a play of 1947.[9] Strict surveillance of criminals was essential, from the panopticon-like structures of prisons such as the Petite-Roquette, to mugshots used as part of the police identification process. Genet's *L'Enfant criminel*, 1949 (initially a banned radio broadcast), reproduces one such image of the child Genet on the first page, while the autobiographical *Journal d'un voleur*, 1949, specifically describes two mugshots of Genet the thief, taken at sixteen and thirty years old (Figures 69 and 70 are similar). The first reveals a pure, oval face, a broken nose, a warm but blasé, sad and solemn gaze; the second shows a hardened face, an accusing jaw, a dangerous look – despite the eyes, still gentle, but almost obliterated by the rigidity of the determined pose.[10]

From Genet's *Chants secrets*, which celebrated the face and the body of Maurice Pilorge guillotined in March 1939, literature as a practice was ineluctably conjoined to commemoration, death, the 'dépouille funèbre' (funereal remains). Genet's *Notre-Dame des Fleurs*, 1944, begins with the extraordinary scene of the 'chapelle ardente' (chapel of love). Photographs of beautiful men and boys form a shrine of faces torn from illustrated papers, representing the now decapitated, guillotined heads of the previous inhabitants of the cell, where as Genet said: 'I raised egoistic masturbation to the dignity of a cult.'[11]

In August 1953, he embarked on a project 'La Mort' aiming 'to synthesise all literary genres' which was later abandoned. This project on death would nonetheless have lingered in his mind when he began to think and write about Rembrandt, while, coincidentally, Genet, the man eternally 'measured' by police and State, witnessed that process dialectically inverted, transformed into art, as he sat for the gaze and the brush of Alberto Giacometti from 1954 to 1957 (Figure 71).[12] From 1947 onwards, Giacometti's work had been received and perceived in both Paris and New York through 'existentialist' eyes – those of his prefacer, the philosopher Jean-Paul Sartre. Now a triangular relationship developed between the three men, of a distinctly passionate, if not homoerotic nature.[13] Genet's writing, not Sartre's, would preface Giacometti's third solo show at the Galerie Maeght in June 1957. Published in a luxurious, large-format edition, his text was illustrated with lithographs of Giacometti's soft, almost evanescent drawings (very different from the

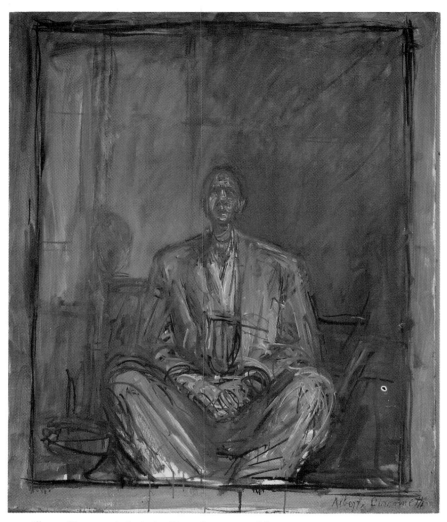

71 Alberto Giacometti, *Portrait of Jean Genet*, 1955. Oil on canvas.

small book with striking black and white photographs by Ernest Scheidegger of 1958: *L'Atelier d'Alberto Giacometti*).[14]

For Giacometti the experience of confrontation with the phenomenological reality of the sitter was posited against the impossibility of depicting that reality: a deadlock between art and life. As for Rembrandt, the most important models for Giacometti were close members of his family, his wife Annette, his brother Diego, or those with whom he had had sexually charged relationships of a kind, such as the Japanese professor Yanaihara or the prostitute Caroline, those he knew intimately, who transcended the merely physical or technical role of model. Moreover, the sitter's presence was pitted antagonistically against Giacometti's will to establish his portraits within an autonomous tradition of depictions, an ancestry of precursors stretching back from Cézanne to the old masters, where, paradoxically, in the halls of fame, individual likeness may become eventually obliterated by the style and the name of the artist: the portrait becomes 'a Rembrandt', 'a Giacometti'.

Since the late 1930s, when Giacometti abandoned Surrealism, there had been a visible dialogue in his work between realism as 'reality', as the immediately visible, and as tradition. Cézanne's influence appears, always, locked in a struggle with Giacometti's rage of lines, seemingly seeking their own obliteration. Maurice Merleau-Ponty's phenomenological essay of 1945, 'Cézanne's doubt', reinforced Giacometti's dialogue with the past, giving a philosophical lineage to the tropes of failure and heroic enterprise that were central to much of the most powerful work of the postwar period.[15]

In 1948, Sartre described Giacometti's work as collapsing time between the Lascaux cave paintings and the vanished flesh of Buchenwald victims. In contrast to the philosophical or historical tropes of Sartre and Merleau-Ponty, Genet, the intrusive author, insisted upon a more subjective 'real'. He saw portraiture as an experience fraught with the contingencies and the absurdities of 'real time', translated by snatches of conversation, *obiter dicta*, while his paragraphs were separated by eloquent blanks ('blancs'), representing passages of silence, of censure, of the times of writing. While approaching a 'truth to experience', a putative 'realism' here, Genet himself had been deeply influenced by the literary devices of the Symbolist poet Stéphane Mallarmé, in particular his mysterious abstract 'play', *Igitur* (c. 1867–70).[16] *Igitur* stood as the invisible prototype behind Genet's declaration 'Fragments', published in *Les Temps Modernes* in 1954, which Giacometti would read with great care. Sartre had spoken of Mallarmé and the simultaneous cancellation of reader and writer in *Saint Genet*; 'Fragments' ('towards a poem'), written in blocks, in columns, with notes and inserts, is a Mallarméan riposte to Sartre, a tragic apologia for homosexuality, not as the 'choice' which Sartre proposed, but as an ineluctable destiny, embracing solitude and the perversion of language.[17] Sartre claimed that life choices were reflected in art; Genet refuted him in his texts on Giacometti, Rembrandt and 'Le Funambule' (The tightrope walker), which consituted an artistic triptych; it was the 'métier', art itself, he argued, which drew life along with its own demands.[18]

Sexual tension dominates Genet's Giacometti preface, a tension displaced from that of the intense relationship between the two men. Abruptly, Genet evokes the Osiris sculpture in the Louvre crypt as he thinks of Giacometti's *Women of Venice*. Explicit about the transformation from prostitute to model in the studio, the hieratic immobility of the *Women of Venice* series fills Genet with terror and estrangement; millenial and familiar, created for the dead not the living, they are, above all, 'a victory for bronze'. Studio conversations between artist and writer are reported as such (Genet sat for over forty days for the largest of the portraits now in the Centre Pompidou collections); so are Giacometti's comments on Genet's notes and drafts. Walks in Paris, jokes between artist and model, all are described as part of the 'séance', creating a new decorum for the text. Then, brusquely, the dynamics of the reciprocal gaze of artist and model, the expression and simultaneous extinction of personality in the work of art, are related to Genet's experience, four years previously, of seeing 'un épouvantable petit vieux' (a grubby old man) on a train. This is the passage that would be transposed as the epiphanic 'other moment' of Genet's second published work on Rembrandt: 'Suddenly I had the dolorous, yes dolorous feeling that each man is worth exactly the same as another ... Anybody can be loved, I said to myself, however ugly, wicked or stupid ... A question of recognition which Giacometti has seen for many years and restores to us.' Reciprocally, Giacometti comments that Genet is beautiful: like everyone else, neither

more nor less. 'Comme vous êtes beau ... Comme tout le monde – hein? Ni plus ni moins.'[19]

The revelation in the train, a profoundly humanistic moment, had important consequences. It finally entailed Genet's abandonment of the novel for the play, of dandyism and the frivolous social world of Cocteau for the humility and self-abnegation of Giacometti's universe.[20] In this light an autobiographical dimension may now be seen to inhabit Genet's description in 'Le Secret de Rembrandt' of the artist's abandonment of pomp and worldly trappings, parallel to the broad statements with which he begins L'Atelier d'Alberto Giacometti (1958): 'Giacometti's work makes the universe even more intolerable for me; the artist knows how to remove all impediments from his vision in order to discover what's left of man when all artifices are stripped away.' 'Beauty has no other origin than the individual wound, hidden or apparent, which each man keeps within himself.'[21]

The three oil portraits that Giacometti made of Genet from 1954 to 1957 were an act of mutual recognition involving the paradoxes of intersubjectivity, representation, 'resemblance' and commemoration. Genet, the 'captive scribe', was depicted by Giacometti in the pose of a priestly Egyptian scribe in the Louvre sculpture halls, a play of the here and now with an immemorial humanity.[22] Writing was thus signified as an extra dimension of the portrait, as it was when Genet posed with books in the later drawings. The Galerie Maeght catalogue indicated that Genet's preface was part of a larger study-in-progress on Giacometti; similarly 'Le Secret de Rembrandt' as it appeared in L'Express of September 1958 – between analyses of the Algerian war and ladies' fashions – pointed to another major publication, commissioned by his publisher Gallimard, that was never to appear in Genet's lifetime.[23]

A prestigious piece, 'Le Secret de Rembrandt' was severely edited by the newspaper, which was responsible for the illustrations, captions and layout. The nine portraits reproduced were uniformly cropped, focusing on the heads: 'his son Titus', 'his mistress Saskia', 'his mother reading', 'his second wife, Hendrijke', and then the self-portraits: 'Youth' 'Age', 'his final self-portrait'. 'Agreeable to the eye or not, decrepitude is. Therefore it is beautiful.'[24] Genet equates the cruelty of Rembrandt's most precise analyses – the decomposing face of Madame Trip in London's National Gallery for example – with the artist's greatest love. The Rembrandt before 1642 is described as 'in love with splendour' – a theatrical, Biblical, Oriental splendour which would become transformed into its dialectical opposite through self-knowledge. 'All of his figures have beeen hurt, and take refuge in pain', Genet says. 'Saskia is smothered in gold and velvet ... She dies.'[25] And the process of recording decrepitude begins. Rembrandt subsequently 'attempts ... to destroy, both in his work and himself, every old sign of his vanity ... He seeks both to represent the world ... and to render it unrecognisable at the same time.' But Genet also imagines the Rembrandt of the last portraits: 'a phantom going from the bed to the easel, from the easel to the toilet – where he must have scribbled again with his dirty fingernails'. By the time of his last self-portrait (Figure 72), all passion spent, all possessions passed to Hendrijke and Titus, 'Rembrandt no longer even possesses the painting he paints. A man has just passed entirely into his work.' Again Genet posits here the extinction of personality of the artist, and with him the sitter as a person, that he would develop in his subsequent Rembrandt texts.[26]

In March 1964, in the wake of the tragic and dramatic suicide of Abdallah, Genet underwent a second severe crisis and, 'renouncing literature', subsequently tore up the bulk of his remaining manuscripts. Miraculously, he had already sent some extracts of his work on Rembrandt to his translator, Bernard Frechtman. 'Something which seemed to resemble decay ...', a text in two sections, quite distinct from 'Le Secret de Rembrandt', was published in English in a Lausanne-based review in the same month as the suicide, and in the Italian review, *Il Menabò* 7.[27] It would reappear with Genet's bitter, sensational new title: 'Ce qui est resté d'un Rembrandt déchiré en petits carrés et foutu aux chiottes' (What is left of a Rembrandt torn into four equal pieces and flushed down the toilet) in the structuralist periodical *Tel Quel* in 1967.[28] Utterly iconoclastic, the conflation – and destruction – of the visual (Rembrandt) and the textual is immediate. The *Tel Quel* title was literal: the published piece was but the vestiges, the 'dépouille' (mortal

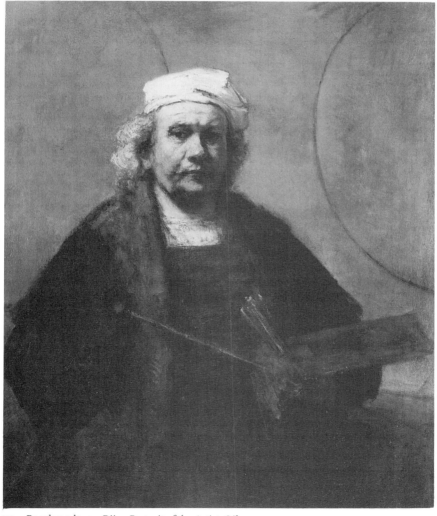

72 Rembrandt van Rijn, *Portrait of the Artist*. Oil on canvas, 114.3 x 94 cm.

remains) of the longer Rembrandt manuscript, effectively flushed down the toilet, for Genet systematically destroyed his manuscripts in this symbolic manner.[29] With the textual 'remains' that were left him, Genet contrived a solution of inestimable importance, resolving to some extent the intrinsic absurdity of criticism as an activity and the anguishing problem of the banality, the fixity, the linearity of any text attempting to structure the constellation of his visual impressions, memories and reflections upon the Rembrandt experience. Under Genet's instructions, the two texts were typeset as two columns, two separate vertical texts, one in italics, sharing one title, and functioning on the principle of interference.[30] The left-hand column expanded the train episode into a larger narrative, again posited on the identity and irreducibility of all men, concluding 'Rembrandt was the first to expose me. Rembrandt! That stern finger which thrusts aside the finery and show ... what? An infinite, an infernal transparency.'[31] Yet this larger, human identity, unerotic as unindividual, is undercut by the column's final vision of a 'congested eager penis, standing erect in a thicket of black curls, and what constitutes it ... lastly the eyes, which cry out for the transports of love as if asking to be saved or annihilated'. Genet ends with a question: 'and does all of this fight against the fragile gaze which is perhaps capable of destroying that Omnipotence?'[32] Opposite, the right-hand text is principally concerned with the artist, but this 'main' text is relegated, in italics, to the traditional position of the commentary or Biblical gloss. This Rembrandt is modified irrevocably by Genet's insistence upon Rembrandt the man. Genet in effect scatologically 'penetrates' Rembrandt's art with words. He imagines the bust-length portrait of Hendrijke in Berlin extended: she stands on a dungheap; he evokes the smell under her skirts, the cunt of the Jewish bride, concluding 'Rembrandt had to recognise himself as a man of flesh, of meat, of hash, of blood, of tears, of sweat, of shit, of intelligence and tenderness ... And I need hardly say that Rembrandt's entire work has meaning – at least for me – only if I know that what I have just written is false.' The words 'faux' and 'truquée' (contrived) coincide in the two columns at this point, recalling the opening lines of the left-hand: 'a work of art should exalt only those truths which are not demonstrable, and which are even "false"'.[33]

And Derrida? He was key contributor to *Tel Quel* and part of the group in the 1960s who thought to republish Genet's 'Rembrandt'. Many of the concerns of the 1940s would be given more explicit voice in *Tel Quel* after the reflections of more than a decade: the interface between phenomenology and classical philosophy, the problems of intersubjectivity and intertextuality, a continuing analysis of the writings of Antonin Artaud, for example. And the exploration of Mallarmé in terms of textuality, visuality and semantics was crucial.[34] Yet it is my contention that without the Genet text on Rembrandt and its interference principle, Derrida would not, perhaps, have devised, via Mallarmé alone, the spatial juxtaposition of texts which gives rise to the crucial reflections of 'La Double Séance', 1970. Just as with Genet's 'Ce qui est resté d'un Rembrandt ...', one text (Mallarmé's 'Mimique') effectively deconstructs the other (Plato's *Philebus* – Socrates's reflections on mimesis). The play between session or seminar ('séance') and portrait sitting here is perhaps the secret acknowlegement of an absent (primary) text: Genet on Rembrandt as 'Le Secret de Derrida'.[35] Derrida was the first to recognise in Genet, his contemporary, how Genet's subjective and textual anguish was at once confirmed and contradicted by the solution of abstraction and spatiality offered in Mallarmé's writing; he evidently delighted in Genet's additional 'perversion' of

Mallarmé via the phallicism of the double-column system; both factors confirmed for Derrida, in addition, Genet's status as an 'anti–Sartre', a status, moreover, fit to vie with Hegel, in *Glas*.

Glas (tolling bell, death knell) appeared first in the special Derrida number of the review *L'Arc* of early 1973, beginning with a 'mimique': ['Ce qui est resté d'un Rembrandt ...'] 'What is left of a Rembrandt torn into regular squares and flushed down the toilet is divided into two.' ['Comme le reste'] Like the rest. 'Two unequal columns, they say distyle [*disent-ils*], each of which – envelop(e)(s) or sheath(es), incalculably reverses, turns inside out, replaces, remarks, overlaps [*recoupe*] the other.'[36] It is a homage to Genet, an etymological investigation of the words 'cata-falque', 'balcon', a discussion of the column of text as a vertical coffin and so on. A two-column principle is set up imitatively (although in *L'Arc*, these read consecu-tively, not in parallel).[37] As illustrations, Derrida offered a branch of 'genet', the golden flowering broom of Morvan with which Genet identified, and which became a transmutative metaphor for Genet's abject prison world in *Notre-Dame des Fleurs*, and in counterpoint, the image of the guillotine, engine of death, which cuts the heads off Genet's pin-ups (just as the easel/guillotine slices up the body in portraiture).

Yet whereas Genet's double columns paradoxically *restore* Rembrandt, actual-ising and subjectivising the artist, the process of portraiture, the problem of style versus individuality, of looking, of every man's interior, private narrative, Derrida's first *Glas* – albeit a larger critical project – abolishes that primary, progenitive experience. The non-verbal aspects of the experience of portraiture, with its power to arouse 'bovine', stupid or alternatively transcendent emotions is never refuted by Genet. Derrida, however, ignoring Plato's questions in *Philebus* about the eidetic or painted representation (see 'La Double Séance'), was well on his way to transform everything into the Word – his own Mallarméan *Oeuvre* – the apotheosis of which was his massive publication, the second version of *Glas* of 1974.

Here, the twin columns are constituted by Hegel on the left, Genet on the right of each page: 'two colossi in their double solitude' (a solitude molested by Derrida at every possible moment). While Genet's pioneering status for the twin column is acknowledged implicitly only, Rembrandt both as progenitor and as oeuvre has disappeared in all but name (Abraham prevails). Yet the Hegel/Genet juxtaposition can obliquely comment on the concerns of the portraiture it sup-presses. As Derrida demonstrates, Hegel's edifice of abstract, law, right, morality, ethics, is posited on the stability of the family, law and state: those very portrait commissioners which structured Rembrandt's life. Hegel's thought is structured by the family, Trinity, the Judeo-Christian tradition, sourced in Saint John: 'In the beginning was the Word.' Yet just as Mallarmé 'undid' Plato in 'La Double Séance', Hegel is 'undone' by Genet, the man without a family, hostile to the bourgeoisie, Church and State. It was Genet who, in his twin encounters with Rembrandt and with Giacometti, released portraiture into subjectivity, into privacy, into obscenity even; released it from its prisoners, from commissioners, from pomp and circum-stance; Genet who posited the extinction of personality as paradoxically the autho-rial presence itself. Genet's whole oeuvre – as was his life – was posited upon the act of theft (as distinct from plagiarism or appropriation) and its links with mourn-ing, with writing as death. His double text is in itself a 'funeral rite' shot through with Eros and Thanatos. Yet there is no Eros in *Glas*; and Hegel's Protestantism, Derrida's Judaic filiations and even botany are deployed to overwhelm the intense

Catholicity of the author of *Notre-Dame des Fleurs*.[38] Should *Glas* be read as a homage or a theft? Does Derrida come to bury Genet or to praise him? Genet himself appreciated Derrida's immense subtlety in writing and interpretation, indeed he declared the necessity for all true texts to hide their compositional devices, their 'règle du jeu'.[39] Should one, more generously, see Genet's 'Ce qui est resté d'un Rembrandt ...' as the invisible (double) text to which half the enterprise of *Glas* refers, via the trope of absence and the 'mise-en-abîme' – the double mirror principle of infinitely receding reflections, a metaphor for the mind of which Derrida was so fond?

Derrida's act of homage in *Glas* is twinned with his clairvoyant theft of method. As reader, how should one hope to comprehend Derrida's amazing, bewildering, ingenious, text-invaded subjectivity – that, like Genet's reflections on Rembrandt and portraiture, cannot ever be completely shared or conventionally communicated?[40] Indeed Derrida's texts in *Glas*, 1974, form a mosaic of borrowed or elaborated constructs, whose origins mingle Mallarméan syntactical conceits and the modernist principle of textual collage[41] with the far older Jewish, Old Testament tradition of the 'melitzah',[42] the Revelation as the Word; the abhorrence of images – Derrida's Jewish origins shed much light on the original principle of his work.[43] As Jean-Bernard Moraly also concluded of *Glas*: 'The book is also a homage to the Talmud. From the Talmud Derrida had borrowed the pagination, the confrontation of texts (Michna/Guemara), and the imbrication of several discourses which seem to tatoo the page.'[44]

Yet as in Genet's plural *Rembrandt*, with its insistence on Genet himself as subject, his artistic rights to subjectivity, Derrida's *Glas* is essentially autobiographical. Derrida wrestles in *Glas* with the Judeo-Christian heritage in its entirety, with the tradition of the Talmud, of Biblical gloss and exegesis, with Hegel and the 'end of history', with writers of the brilliance of Mallarmé, Genet, Georges Bataille and implicitly Sartre – so many angels for one Jacob.[45] Derrida finally made his confession during a subsequent confrontation with visuality and representation. In his introduction to *Mémoire d'aveugle, L'Autoportrait et autre ruines*, the exhibition he selected and prefaced at the Louvre in 1990, he revealed that his sense of a 'secret election' to writing as a vocation was directly related to his brother's prowess at drawing. His own efforts were pitifully clumsy: thus a substitution took place; a deliberate strategy of fratricide. 'My hypothesis for work also signified a work of mourning. Throughout my life I have never drawn again, never even attempted to draw.'[46] Painting, a 'degenerate and superfluous expression' as it is called in 'La Double Séance', is subsumed in portraiture, a practice Derrida extravagantly, metonymically, immemorially, represented by the trope of blindness.[47] For Genet, seeing, intersubjectivity, recognition of another and of onself in another, in representation, in Rembrandt's self-portraits, was the ultimate demonstration of the artificiality, of the limits of writing, of the text, of the Word: 'It is this, the text (Genet) that traps, fleshes, reads the reader, judgment, criticism. Like Rembrandt. Paradigmatic scene.' Derrida's monolithic column system in *Glas* beckons a second Samson; in his homage to Genet he contained the clues to his own undoing.

Notes

Thanks to Jean Clair, Jean-Loup Champion, Jacques Derrida, Albert Dichy, Ian Magdera, Yehuda Safran, Edmund White.
Unfootnoted translations are by the author.

1 Jacques Derrida, *Glas*, trans. John P. Leavey Jr and Richard Rand (Lincoln and London, University of Nebraska Press, 1986), p. 219.

2 See Jean-Bernard Yehouda Moraly's 'Ce qui est resté d'un Rembrandt déchiré en petits carrés bien reguliers et foutu aux chiottes ou La critique selon Genet', *Le Français dans le monde* special number, 'Littérature et enseignement' (February–March 1988), pp. 104–9; Bettina L. Knapp, *Jean Genet* (Boston, Twayne Publishers, 1989), pp. 92–5; Thierry Dufrêne, *Giacometti. Portrait de Jean Genet. Le Scribe captif* (Paris, Adam Biro, 1991), discusses 'Le Secret de Rembrandt', pp. 32–3; Jean Genet, *Rembrandt* (Paris, Editions Gallimard, 1995).

3 Jacques Derrida, *Glas* (Paris, Editions Galilée, 1974), loose publicity flysheet.

4 Writings in French on Rembrandt were abundant; before 1960 one could list those by Marcel Brion (1940), Germain Bazin (*c.* 1940), Paul Fierens (*c.* 1943), Tancrède Borenius (1946), Otto Benesch (1947), Jean Cassou (1947, 1952, 1955), André Charles Coppier (1948), Henri Dumont (1949), E. R. Meyer, (1958), Charles Perrussaux (1960). Seymour Slive's definitive *Rembrandt and his Critics, 1630–1730* was published by Martinus Nijhoff in The Hague in 1953 and in Paris by Flammarion in 1960.

5 See *Rembrandt, 1606–1669*, Orangerie des Tuileries, July–September, 1947; *Dessins de Rembrandt*, Cabinet des dessins, Musée du Louvre, June 1955; *Rembrandt et son temps*, Ecole des Beaux Arts, May–June 1955; *Rembrandt graveur*, Bibliothèque Nationale, Galerie Mansart, July–September 1956; *Rembrandt et son école*, Institut Nedéerlandais, 12–30 March 1957.

6 See Edmund White, *Genet*, with a chronology by Albert Dichy (London, Chatto and Windus, 1993), pp. 464, 513, 515 (*c.* 1957 'While travelling in Northern Europe Genet was also constantly visiting museums, looking at Rembrandt, Vermeer and Frans Hals'). Jean-Bernard Moraly, *Jean Genet, La Vie écrite* (Paris, Editions de la Différence, 1988), mentions letters to Bernard Frechtman (presently unavailable) describing Genet's wonder in front of Rembrandts in Antwerp, Amsterdam and The Hague (p. 245). He worked on Rembrandt in Hamburg in June 1958 (Moraly, p. 247), and was in Amsterdam again with Abdallah in October and November 1958, just after the *Express* article (White, p. 516).

7 Jean Genet, 'Le Secret de Rembrandt', *L'Express*, 4 September 1958, p. 14, translated by Randolph Hough as 'Rembrandt's secret', in *What Remains of a Rembrandt Torn into Four Equal Pieces and Flushed down the Toilet* (Madras and New York, Hanuman Books, 1988), pp. 53–79.

8 White, *Genet*, p. 182.

9 See Jean Genet, *Haute Surveillance* (Paris, Cinéastes-Bibliophiles, 1947), an erotic play with three male characters in prison.

10 See Jean Genet, *L'Enfant criminel & Adame miroir* (Paris, Paul Morihien, 1949), and *Journal d'un voleur* (Paris, Gallimard, 1949), pp. 90–3.

11 See Brigid Brophy's beautiful essay: 'Our Lady of the Flowers', in Peter Brooks and Joseph Halpern (eds), *Genet. A Collection of Critical Essays* (New Jersey, Prentice Hall, Inc., 1979), pp. 69–70.

12 Giacometti produced four drawn heads of Genet on 1 September 1954; the small oil portrait of 1954 (Tate Gallery, London); the large 'seated' portrait of 1955 (Centre Georges Pompidou, Paris); two drawings of the writer seated with pen and papers, 1957, and the final, less 'finished' portrait in oils, 1957 (Galerie Beyeler, Basle), all discussed in Dufrêne, *Giacometti*.

13 One may see Giacometti bestowed as a gift from Sartre to Genet, an atonement, perhaps, for the act of appropriation constituted by Sartre's 'portrait', *Saint Genet comédien et martyr*, serialised from 1950 in *Les Temps Modernes*. 'On murder considered as one of the fine arts' – a title from De Quincey – was, significantly, one of Sartre's chapter headings. *Saint Genet* appeared as Genet's *Oeuvres complètes*, I (Paris, Gallimard, 1952).

Genet, severely traumatised, ceased writing for six years. Sartre's alignment with the Communist Party from 1952 ideologically disqualified him from further writing on Giacometti.

14 See Jean Genet, *L'Atelier d'Alberto Giacometti* (Paris, Marc Barbezat, 1958). Ernst Scheidegger's photographs of the sculpture-filled studio, Giacometti at work, close-ups of the Genet portraits etc., constitute, of course, a supplementary 'text'.

15 See Maurice Merleau-Ponty, 'La Doute de Cézanne', *Fontaine*, 47 (December 1945), and in *Sens et non-sens* (Editions Nagel, 1948).

16 Stéphane Mallarmé, *Igitur ou la Folie d'Elbehnon* (Paris, Gallimard, 1925); conventional narrative (absent) has to be 'reconstituted' by the reader. It contained the first ideas for Mallarmé's masterpiece, 'Un coup de dés ...', (A throw of the dice ...), 1897, which exemplified Mallarmé's revolutionary 'orchestral' or 'stellar' disposition of words across a double page. Robert Cohn's Yale doctorate of 1949 appeared as *L'Oeuvre de Mallarmé. Un coup de dés* (Paris, Librairie des Lettres, 1951). ('*Igitur* can be read as a fictional counterpart to Hegelian philosophical oppositions such as negation and synthesis'; see White, *Genet*, pp. 446–9.)

17 Jean Genet, 'Fragments', *Les Temps Modernes* (August 1954), pp. 193–217 (first republished in *Fragments ... et autres textes* (Paris, Gallimard, 1990), pp. 67–97); apparently conceived as an 'open letter to Decimo', Genet's lover, whom he believed to be dying of tuberculosis. In 1954, Jean-Jacques Pauvert announced *Enfers* as a forthcoming publication incorporating 'Fragments'.

18 Genet: 'Le Secret de Rembrandt', 1958, p 14: '... c'est son métier qui l'exige ou plutôt l'amène avec soi'. See Moraly, *Jean Genet*, p 114.

19 Jean Genet, 'L'Atelier d'Alberto Giacometti', *Derrière le Miroir*, 98 (June 1957), Paris, Editions Pierre à Feu, A. Maeght, p. 25. Moraly (*Le Français dans le Monde*, 1988, p. 105) dates the train episode to 1952 or 1953, and implicitly to July 1952, when, suffering from writer's block, Genet tore up his manuscripts, attempting suicide.

20 See White, *Genet*, p. 464. The train episode continues to appear, for example in *Alberto Giacometti and Tahar Ben Jalloun* (Paris, Flohic Editions, 1991) and Jean Clair, 'Le résidu et la ressemblance. Un souvenir de l'enfance d'Alberto Giacometti', *Albert Giacometti* (Musée d'Art Moderne de la Ville de Paris, 1991).

21 Jean Genet, *L'Atelier d'Alberto Giacometti* (Paris, Marc Barbezat, 1958), unpaginated.

22 See Dufrêne, *Giacometti*, pp. 5–6.

23 'Le Secret de Rembrandt', *L'Express*, 4 September 1958, pp. 14–15, and *Oeuvres complètes* (Paris, 1979), pp. 31–8, republished in *Peinture*, 18–19 (1985), pp. 57–64.

24 Jean Genet, 'Rembrandt's secret', p. 58.

25 Compare Genet's reflections on Saskia, desire and death with Derrida on the 'hymen' in 'La Double Séance', I, *Tel Quel*, 41 (Spring 1970), p. 27 – 'confusion between the present and non-present ... the between of desire and fulfilment, perpetration and memory ...'.

26 Jean Genet, 'Rembrandt's secret', pp. 54, 62, 64, 73–4, 77, 79.

27 See Bernard Frechtman, 'Something which seemed to resemble decay', *Art and Literature* (March 1964), pp 77–86 (the twin texts published consecutively); reprinted in *Antaeus*, 54 (Spring 1985), pp. 108–16. Paule Thévenin recalled in her posthumous article 'La Poésie, la mort', *Contretemps*, 1 (1995), p. 39 n. 7, the collapse of a project for an international review (Italian, German and French) to which the two texts were sent, appearing only in Italian, consecutively, with the arbitrarily-given titles: 'Il mio antico modo di vedere il mondo' and 'Il nostro sguardo' (*Il Menabò 7, Una rivista internazionale*, 1964, Einaudi). Consecutive publication of the texts remained the norm, in 'What remains of a Rembrandt ... ', in *What Remains of a Rembrandt Torn into Four Equal Pieces and Flushed down the Toilet*, pp. 9–49. See also Jean Genet, *Rembrandt. Wat overbleef van een kleine, heelregelmatige vierkantjes gescheurde en in de plee gemikte Rembrandt*, preface by Matthijs Bakker (Amsterdam, Arena, 1990) (the two texts arranged on facing pages, in italics on the right).

28 See Jean Genet, 'Ce qui est resté ...', *Tel Quel*, 29 (Spring 1967), pp. 3–11, republished in *Oeuvres complètes*, IV (1979), pp. 21–31.

29 Edmund White confirmed with Genet's friend, Monique Lange, that Genet phoned her from Milan, on 9 April 1964, recounting the destruction of the Rembrandt manuscript and two plays 'down the toilet' (*Genet*, p. 544) – possibly the fate of a far greater oeuvre.

30 See Thévenin, 'La poésie, la mort'. The literary executor of Antonin Artaud and friend of Genet and Derrida, she procured the two texts from Denys Mascolo, an editor of *Il Menabò* 7. Thévenin asked the reluctant author's permission to publish the original French, and at his express request established the two-column version for *Tel Quel*.

31 Jean Genet, 'Ce qui est resté ...', p. 10; Frechtman translation, *What Remains of a Rembrandt Torn into Four Equal Pieces and Flushed down the Toilet*, pp. 29–30.

32 *Ibid.*, p. 33.

33 *Ibid.*, pp. 48–9.

34 Following Cohn, *L'Oeuvre de Mallarmé*, Jacques Scherer's *Le 'Livre' de Mallarmé* (Paris, Gallimard, 1957), concerned the *Oeuvre* or *Livre* by Mallarmé that would be the apex of his life's work subsuming 'Un coup de dés'. It involved dicussion of the imagery of the tomb, box and block crucial for Derrida. Cohn's *Mallarmé's Masterwork* appeared in 1966, before 'La Double Séance'.

35 See Derrida, 'La Double Séance', pp. 3–43 and 'La Double Séance', II, *Tel Quel*, 42 (Summer 1970), pp. 3–45. Two points are crucial: Plato's text from *Philebus* (into which Derrida inserts Mallarmé's 'Mimique') specifically introduces the painter of visual images after the notional 'writer' who 'fills up the book of the brain' and hence mental images of the past, present and future. (See Derrida: 'a discourse on the relationship between literature and truth always comes up against the enigmatic possibility of repetition within the framework of the *portrait*', I, p. 12 n. 4). The insert of a block of text, Mallarmé's 'Mimique', introduces as well as the jump in time, space and culture, movement, dance, the trope of murder: the one-man mime show of a Pierrot tickling his wife's feet to the death – undercutting Plato's discussion of truth and representation – and finally comes Derrida's realisation that the short scene in its entirety refers to another, absent, text: an invisible palimpsest (cf. the absence of the bulk of Genet's 'Rembrandt' in *Glas*, 1974).

36 Derrida, *Glas*, (1986 translation), p. 1.

37 Derrida, 'Glas', *L'Arc*, 54 (1973), special Jacques Derrida number, pp. 4–15. The novelist and writer Catherine Clément was responsible for the layout of the issue.

38 See Mairead Hanrahan's essay, 'Sentir / penser la différence. *Notre-Dame des Fleurs* de Jean Genet', with its emphasis on Catholicism and its own deliberate splitting into two columns half way through, in Mara Negron (ed.) *Lectures de la différence sexuelle* (Paris, Editions des Femmes, 1994), pp. 169–83.

39 Genet to Jean Ristat in 'Une lettre de Jean Genet', *Les Lettres Françaises*, no. 1429, 'Hommage à Jacques Derrida', 28 March 1972, p. 14 (Genet was reading Derrida's *Le Pharmacie de Platon*).

40 *Glas* has been 'explicated' in the scholarly equivalent to an exegesis of James Joyce's *Finnegan's Wake*; Derrida's demands on the (putative) reader are similar and similarly beside the point. See John P. Leavey Jr, *Glassary* (Lincoln and London, University of Nebraska Press, 1986).

41 Compare Genet in 'Fragments', p. 205 n. 6: 'Detached from the language of words, with my cold scissors, complete blocks [of text] are also tombs.'

42 See Yosef Hayim Yarushelmi, *Freud's Moses* (New Haven and London, Yale University Press, 1991). The traditional 'melitzah' (as used by Freud's father) is discussed pp. 71ff.

43 See Derrida on his origins in *Le Nouvel Observateur*, 1983, reprinted in Robert Wood and Robert Bernasconi (eds), *Derrida and Différence* (Evanston, 1988), and the broader discussion and references in Martin Jay, *Downcast Eyes. The Denigration of Vision in Twentieth-Century French Thought* (Berkeley, Los Angeles and London, University of California Press, 1993), chapter 9: '"Phallogocularcentrism": Derrida and Irigaray', pp. 493–542.

44 The Michna is the sacred text; the Guemara the commentary. Moraly explains in his article of 1988 (p. 109 n. 10): 'the Talmud, principal object of study in Jewish colleges, is a mosaic of absolutely contradictory texts, united on the same page in different languages and characters. The two principal texts transcribe dialogues ... utterly different opinions on the same subject.'

45 The element of *lex talionis*, revenge as displacement, muddies any notions of purely textural chiasmus in *Glas*. Certainly Derrida's own struggle to displace Sartre – via Genet – as doyen of Parisian letters was crucial. See Moraly, *Jean Genet*, p. 308. My

epigraph appears within a block of text refuting Georges Bataille's proposition of Genet's 'failure': 'L'Echec de Genet' – a critique of Sartre's *Saint Genet*, from *La Littérature et le mal* (Paris, Gallimard, 1957), pp. 143–5.

46 Jacques Derrida, *Mémoires d'aveugle, L'Autoportrait et autres ruines* (Paris, Réunion des Musées Nationaux, (exhibition, Musée du Louvre), 1990), pp. 40–1. The trope of blindness traditionally used to represent the synagogue is deliberately reversed (hence representation is a 'Christian heresy'). Derrida's *La Vérité en peinture* (Paris, Flammarion, 1978) republished texts on painting after *Glas* and prior to the Louvre show, including the *Glas* and Genet-impregnated reflections on the artist Gérard Titus-Carmel ('Cartouches', 1977–8).

47 See note 45, and 'La Double Séance', p. 12 (analysing Plato), where painting is classed as a 'supplement to discursive thought', something 'which can reveal the essential picturality of the *logos*, its representativity'.

The authority of portraiture

II

Facing the past and present: the National Portrait Gallery and the search for 'authentic' portraiture

PAUL BARLOW

In 1877 John Everett Millais was working on his portrait of Thomas Carlyle (Figure 73), philosopher and historian; James Froude, Carlyle's biographer and friend, described the artist's attempts to encapsulate his subject on canvas:

A portrait of Carlyle completely satisfactory did not yet exist, and if executed at all could be executed only by the most accomplished painter of his age. Millais, I believe, had never attempted a more difficult subject. In the second sitting I observed what seemed a miracle. The passionate vehement face of middle life had long disappeared. Something of the Annandale peasant had stolen back over the proud air of conscious intellectual power. The scorn, the fierceness, was gone, and tenderness and mild sorrow had passed into its place. And yet under Millais's hands the old Carlyle stood again upon the canvas as I had not seen him for thirty years. The inner secret of the features had been evidently caught. There was a likeness which no sculptor, no photographer, had yet equalled or approached. Afterwards, I knew not how, it seemed to fade away. Millais grew dissatisfied with his work and, I believe, never completed it.[1]

What is implied here? Froude describes portraiture as a psychological drama, a point of struggle between thought and physical appearance. In the act of painting, Millais generates a series of expressions from the surface of the depicted face. As he reworks the image, he attempts to inscribe the complex identity of Carlyle into the paint surface.

Describing this, Froude's vocabulary is religious. A 'miracle' has restored the old Carlyle. The portrait is an act of grace, penetrating protective encrustations of scorn and pride to reveal lost tenderness and truth. Millais captures 'the inner secret of the features': authentic identity manifest in the body. But this redemptive insight is realised on canvas only *during* Millais's encounter with the living Carlyle, in the act of painting. The portrait as it survives today is only a relic of that moment.

This is portraiture as a sacramental act, involving a mysterious and complex transaction between artist and sitter. The final 'likeness' achieved by the artist is neither stable nor easily readable. In this chapter the origins and implications of Froude's description will be examined, in particular the way in which it epitomises the Victorian conception of the 'authentic' portrait, an idea closely associated with the writings of Carlyle himself and with the establishment of the National Portrait Gallery (NPG) in 1856.

For Victorians Carlyle was the great 'prophet' who analysed the psychology of modern industrial society with unequalled insight. By the time Millais set to work on his portrait, he was fully established in the pantheon of modern genius. Carlyle believed that portraiture could be a means to link the past and present. As a historian he had written of the great value of 'bodily likenesses' of historical figures, going on to claim that portraits transformed 'vague historical name[s]' into recognisable human beings. A worthwhile portrait need not be good art, but it

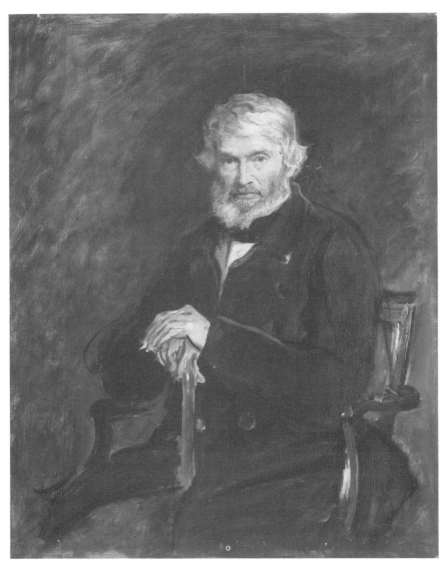

73 J. E. Millais, *Thomas Carlyle*, 1877. Oil on canvas, 116.8 x 88.3 cm. This portrait was said by Froude to have captured the 'inner secret' of Carlyle's features. Millais seems to have deliberately left the image incomplete. The overworked surface of Carlyle's looming, isolated head contrasts with the twisted, agitated marks from which his hand is constructed.

must be 'sincere', made by 'a faithful human creature of that face and figure which he saw with his own eyes, and which I can never see with mine'.[2]

Such portraits, then, count as historical documents: visual primary sources. But this idea produces a more ambiguous one, the suggestion that the viewer could in imagination stand in the place of the original artist as he had once looked at the sitter, and so travel back in time to the moment when the sitter lived. The linking of these two ideas defines the Victorian conception of the authentic portrait.

In 1853 Carlyle had written out a proposal for a National Portrait Gallery, claiming that it could be a 'Pantheon, or home of all the National Divinities, for these our historical Heroes are'.[3]

Carlyle's plan arose from a speech given by Prince Albert suggesting a portrait gallery to commemorate scientists and technologists whose innovations had brought about the modern age.[4] Soon afterwards the historian and politician Lord Stanhope put a proposal to Parliament, enlisting the support of Disraeli. In 1856 the NPG was officially established.

The new gallery was to be devoted to portraits of 'eminent persons in British history'. The idea that images of such national worthies could be collected together as expressions of the common ideals of the country was not new. But Stanhope's plan was more ambitious than previous such galleries. By funding the NPG through Parliament Stanhope hoped to link the history of the nation to its political institutions. The individuals whose portraits were included would be a kind of historical analogy to Parliament itself, prominent members of the public brought together to represent the nation.

The concept of authenticity was bound up with these aspirations, but in an ambiguous way. Prince Albert's original proposal was an attempt to humanise modernity: to see the new machine age in terms of people. This project was ambivalent. It implied that the urban mass society emerging with industrialism was potentially dehumanising, that social relationships were increasingly experienced in a mechanistic, alienated form. A portrait gallery of great technologists would paradoxically celebrate and counteract this process. Like Carlyle's 'vague historical names', the makers of modern production would become recognisable as people; a modernity with a human face.

At a more popular level portraiture was already being used to bridge the gap between the complexity of modern society and the experience of individual identity. Engraved portraits of famous persons date back to the early sixteenth century; in the nineteenth century they proliferated. Collections of such images were often sold under the label 'National Portrait Galleries', usually with a summary of the achievements of the person depicted.[5]

The emergence of the illustrated newspaper offered a space for mixing portrait and biography. The *Illustrated London News*, which started publication in 1842, regularly included engraved portraits of figures who had emerged as important players on the national stage. Some illustrated newspapers and journals published weekly 'galleries' of their own. Such images would normally be of politicians, churchmen, or members of the intelligensia (Figure 74). Poorer members of the population also came to be incorporated into this increasing circulation of portraits, though such images often derived from a long tradition of prints depicting social types. This was beginning to form part of sociological and journalistic commentary on contemporary issues and events.

Portraiture, then, was drawn into the emerging forms of public communica-

OUR PORTRAIT GALLERY.

THE RIGHT HON. SIR GEORGE HAMILTON SEYMOUR, G.C.B.

THE services rendered to this country by the distinguished diplomatist, whose portrait we now give, will ever be associated with many of the most stirring and important events of English history during the present century, dating from 1817.

Sir George Hamilton Seymour is the son of the late Lord George Seymour, who was the seventh son of the first Marquis of Hertford. He was educated at Oxford, and in 1817, at the age of twenty, he entered the public service as *attaché* to the embassy at Hague, and was in the Foreign Office as *précis* writer from 1819 to 1821. In the following year, Sir George was appointed Secretary in the Foreign Office, and in 1822 attended the Duke of Wellington on a special mission to Verona. From this period his diplomatic career may be said to have commenced; for during the next eight years, we find him successively acting as Secretary of Embassy at Frankfort, Stuttgard, Berlin and Constantinople.

His more onerous duties commenced in 1830, when he represented his Sovereign at the Court of Tuscany, and acquitted himself with honour to his country, although at that period he was only about thirty-three years of age, a proof that his talents as a diplomatist and linguist had been early developed.

In July, 1831, Sir George was united in marriage to the Honourable Gertrude Brand, third daughter of Henry Ottway, twenty-second Lord Dacre. A numerous family is the result of this marriage.

He next represented this country in Belgium, in 1836, and in 1846 he was holding a similar position at Portugal. In 1851, he was despatched to St. Petersburgh; and the consummate skill by which, without deviating from a straightforward course, Sir George Seymour led the Czar from confession to confession, thus unmasking the secret design of Russia respecting Turkey, has often been commended.

In the secret and confidential despatches forwarded by Sir George H. Seymour to this country, at the time, the whole policy of the Czar of Russia was fully laid bare to the English Government; and the warnings and advice accompanying the despatches were remarkable for their force and justness. Indeed, when the private conversations of Sir George Seymour with the Emperor Nicholas were published in 1854, the world was taken by surprise.

He left St. Petersburgh at the express desire of the Russian Government several weeks before the declaration of war; and on his arrival in England, received ample thanks for the dignified, yet courteous, bearing which had marked his services throughout this difficult and critical period.

In the autumn of 1855, Sir George was appointed Ambassador to Vienna, in succession to the Earl of Westmoreland. Here he remained about three years, to the perfect satisfaction of his own Government and that of Vienna, when he resigned, in order to seek rest and retirement for awhile from his long official labours.

We must not omit to add, that Sir George H. Seymour received the Grand Cross of the Order of the Bath in 1847, having been made a Knight Bachelor and Grand Cross of the Order of Hanover in the previous year. In 1855 he was sworn in a member of the Privy Council.

SUCCESS IN LIFE.

SUCCESS is generally regarded, in the opinion of the public, as the best test of a man: and there is some foundation for the opinion. But impressions greatly vary as to what constitutes true success.

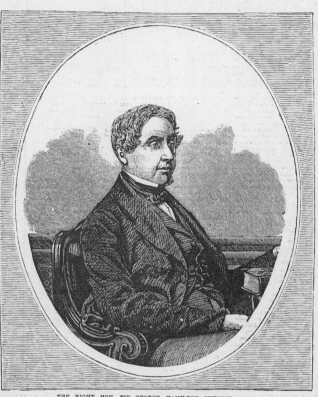

THE RIGHT HON. SIR GEORGE HAMILTON SEYMOUR, G.C.B

to estimate success and worldly position according to the money-standard.

The idea instilled into the minds of most boys, from early life, is that of "getting on." The parents test themselves by their own success in this respect; and they impart the same notion to their children. "Mak siller, Jock," said a Scotch laird to his son, "mak siller—honestly if you can, but mak it." The same counsel, if not in the same words, is that which is imparted, at least by example, if not in express language, to most boys. They have set before them the glory of making their fortunes. That is their "mission," and many perform it diligently, heeding little else but money-making throughout life. Public opinion justifies them in their course,—public opinion approving, above all things, the man who has "made his fortune." But public opinion is not always correct; and sometimes, as in this case, it is obnoxious to the sarcastic query of the French wit who once asked, "And pray, how many fools does it take to make a public?"

Yet worldly success, considered in the money aspect, is by no means a thing to be undervalued. It is a very proper object of desire, and ought to be pursued —honestly. A man's success in the accumulation of wealth, indicates that he is possessed of at least some virtues; it is true they are of the lower sort—still they are estimable. It is not necessary that a man shall be largely gifted with intelligence, or that he shall have a benevolent disposition, to enable him to accumulate money. Let him scrape long and diligently, and he will grow rich in time. Diligence and perseverance are virtues enough for the mere money-maker. But it is possible that the gold, when made, may lie very heavy indeed upon all the other virtues, and crush both mind and heart under their load.

Worldly success *may*, however, be pursued and achieved with the help of intelligence; and it may be used, as it always ought to be used, as the means of self-improvement and of enlarged benevolence. It is as noble an aim to be a great merchant or manufacturer, as to be a great statesman or philosopher,—provided that the end is attained by noble means. A merchant or manufacturer can help on humanity as well as other men—can benefit others while he is enriching himself, and set before the world a valuable example of intelligent industry and enterprise. He can exhibit honesty in high places—for in these days we need examples of honesty very much; indeed, a wit has observed, that in the arithmetic of the counter, two and two do *not* make four. And to test the remark, you have only to gauge a modern pint bottle.

But many successful merchants have declared, that in the end "Honesty is always the best policy." The honest man may not get rich so fast as the dishonest one, but, depend upon it, the success will be of a truer kind, earned without fraud, injustice or crime.

With the greater number it means success in business, and making money. Of one we hear it said— "There goes a successful man; he has made thirty thousand pounds within the last twelve months." Of another—"There you see a man who commenced life as a navvie; but, by dint of industry, perseverence, and energy, he has amassed a large fortune, bought a landed estate, and lives the life of a country gentleman, though he can hardly yet write his own name: that's what I call success." Or, of another—"That is Mr. So-and-so, the great astronomer, who was originally the son of a small farmer, and by diligent study and application he has now reached the first rank among scientific men; yet they say he is very poor, and can barely make the ends meet." We suspect that most people would rather exchange places with the navvie than with the astronomer, so ready are we

OUR PORTRAIT GALLERY.

THOMAS CARLYLE.

THE name of this profound thinker and philosopher is so well known throughout Europe and America as to make it truly and indeed a household name. Thomas Carlyle was born at Middlebie, near the village of Ecclefechan, in Annandale, on the 4th of December, 1795. His father was a farmer—an earnest, religious, Scotch Presbyterian—of the old type, and a man of great moral worth and vigorous intellect. Carlyle was educated at the Annan Grammar School. From Annan, in due time, Carlyle went to Edinburgh University, where he says, "By instinct and happy accident I took less to rioting than to reading, which latter I was free to do. Nay, from the chaos of that library, I succeeded in fishing up more books perhaps, than had been known to the keepers thereof. The foundation of a literary life was here laid; I learned, on my own strength, to read fluently in almost all cultivated languages, on almost all subjects and sciences."

Carlyle was destined for the Church, but now his views changed. He was appointed teacher of mathematics in a school in Kirkaldy, in Fifeshire, and subsequently became tutor to the late Charles Buller, which post he held for a year or two, and during that period formed a very close and affectionate friendship with his pupil, which continued until the melancholy death of the latter in 1826; but all this time Carlyle was steadily gravitating towards literature as his permanent profession. Thither his destiny pointed. His first work was a translation of "Legendre's Geometry," with an original essay on proportion. Next, in 1825, came the "Life of Schiller," first published in the "London Magazine." After that, in 1827, the translation of Goethe's "Wilhelm Meister," followed by a series of translations of German romances. From 1827 to 1844, various articles from Carlyle's pen appeared in the reviews of the day, which have been since reprinted in volumes, under the title of "Miscellaneous Works," and have become recognised as classics in English literature. In 1833-34 the celebrated "Sartor Resartus" first saw the light in "Fraser's Magazine." The manuscript of this immortal production was tossed about from publisher to publisher, but could find no acceptance from any; and while it was in progress of publication in the pages of "Fraser," it was denounced by a critic of the Sun newspaper, quoting from Dennis, as "a heap of clotted nonsense."

In the summer of 1837, Carlyle delivered six lectures on "German Literature," at Willis's Rooms; in 1838, twelve on the "History of Literature," &c.; and in 1839, another course on the "Revolutions of Modern Europe." None of these lectures were ever published, but the series given in 1840 on "Hero-Worship" was, and has long been, a favourite book. Meanwhile, the fame of Carlyle was culminating, for in 1837, "The French Revolution, a History," appeared, a work which deserves to be styled the "Epic poem" of the century. Sterling called it a "genuine breathing epic," and Dr. Arnold spoke of it in rapturous terms of praise. But why do we quote authorities? What man of any education in England is there that has not read it and re-read it with ever-increasing admiration? It is a realisation of the author's own idea of what history and historians ought to be, as set forth in his published "Life of Frederick the Great." In 1839 appeared his first political work. This is called "Chartism." "Past and Present" followed in 1843. In 1845, whilst the question—"Shall Cromwell have a Statue?"—was still in agitation, Carlyle erected "a monument more euhundred deaths, to which the guillotine and Fouquier Tinville's judgment-bar was but the merciful end! Look there, O man born of woman! The bloom of that fair face is wasted, the hair is gray with care; the brightness of those eyes is quenched, their lids hang drooping, the face is stony pale, as of one living in death. Mean weeds, which her own hand has mended, attire the Queen of the World. The death-hurdle where thou sittest pale, motionless, which only curses environ, as to stop; a people, drunk with vengeance, will drink it again in full draught, looking at thee there. Far as the eye reaches, a multitudinous sea of maniac heads, the air deaf with their triumph-yell! The living-dead must shudder with yet one other pang; her startled blood yet again suffuses with the hue of agony that pale face, which she hides with her hands. There is there no heart to say God pity thee! O, think

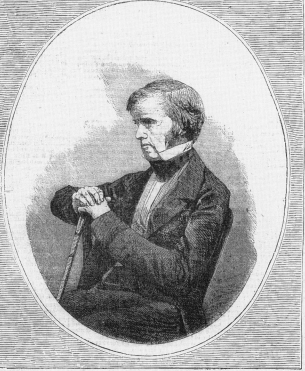

THOMAS CARLYLE.

not of these; think of Him whom thou worshippest, the crucified—who also treading the winepress alone, fronted sorrow still deeper; and triumphed over it and made it holy, and built of it a 'sanctuary of sorrow' for thee and all the wretched! Thy path of thorns is nigh ended, one long last look at the Tuileries, where thy step was once so light — where thy children shall not dwell. The head is on the block; the axe rushes — dumb lies the world; that wild - yelling world, and all its madness is behind them."

It remains for us now only to add that Mr. Carlyle married, about thirty years ago, Miss Welsh, the only daughter of a surgeon, and the lineal descendant of John Knox. This lady, who is also an accomplished writer, brought her husband some property, including a farm called Craigenputtock, where Carlyle resided some time after his marriage. In 1834, Mr. and Mrs. Carlyle removed to Cheyne Row, Chelsea, and there they live now; and from that singular locality most of the works which we have noticed have been sent forth to astonish and move the world. It is a quaint old house, and its immediate neighbourhood has not much changed during than brass," by the publication of his noble work, entitled "Oliver Cromwell's Letters and Speeches." In 1851 came out "The Life of Sterling," rendered necessary by a one-sided memoir from the pen of Archdeacon Hare.

In 1858, the first portion of Mr. Carlyle's long-expected volume, "The History of Frederick II, called Frederick the Great." This work has but recently been completed.

In order to show Mr. Carlyle's best style of writing, we extract the following picture of the death of Marie Antoinette:—

"Is there a man's heart that thinks without pity of those long months and years of slow-wasting ignominy; of thy birth, self-cradled in imperial Schonbrunn, the winds of heaven not to visit thy face too roughly, thy foot to light on softness, thy eye on splendour; and then of thy death, or hunfor the last half-century, and will probably change little for the century to come.

We must add, that Mr. Carlyle has a clear and penetrating insight into human nature, and that he works with perseverance and passionate earnestness.

THE LESSONS OF FAILURE.—It is far from being true, in the progress of knowledge, that after every failure we must recommence from the beginning. Every failure is a step to success; every detection of what is false directs us towards what is true; every trial exhausts some tempting form of error. Not only so, but scarcely any attempt is entirely a failure; scarcely any theory, the result of steady thought, is altogether false; no tempting form of error is without some latent charm derived from truth.

a daguerreotype photograph. The portrait appeared before Carlyle had developed the bearded image of Old Testament prophet in a suit, a persona that informs both Millais's and Watts's portraits.

tion produced by urban commercial society. Images were surrounded by textual comment, debate and information: a continually circulating and unresolved transaction between appearance and significance comparable to Millais's efforts to visualise Carlyle's identity.

These new forms of public engagement with the social and political realm constituted the beginnings of the modern concept of 'the media'. The NPG was in part an attempt to consolidate this unstable realm of public discourse, defining the new gallery as a site of officially sanctioned celebrity and significance.

The new importance given to portraiture was a significant departure from earlier theorisations of the genre. In the eighteenth century, portraiture was considered a relatively lowly form of painting. As John Barrell has shown in *The Political Theory of Painting from Reynolds to Hazlitt*, eighteenth-century art was informed by civic humanist ideas, in which arguments about the representation of the human body were of central importance. For civic humanists the human body signified the connection between individuals and the wider community of humanity in general.[6] It could also stand for the 'the public': the body of the community as a whole, made up of all that individual citizens hold in common.

The origins of Victorian thinking about portraiture can be found in the contribution of the essayist William Hazlitt to this debate. In a number of articles published at the beginning of the nineteenth century Hazlitt addressed the problem of the relationship between these civic humanist theories and the movement towards mass society. Barrell argues that Hazlitt's views represent the decline of civic humanism, citing his emphasis on individual character in preference to the civic humanist concern with the ideal (or 'general') body, epitomised by the nude figure.[7] This shift of emphasis involves an increasing interest in portraiture. For Barrell, Hazlitt's stress on personal identity marks the beginnings of the ethos of competitive individualism characteristic of industrial mass society.

However, it can be argued that Hazlitt was rethinking the way art could represent general human values in these new conditions. He wrote for the developing periodical press. His many essays expressed a fascination with the way in which the rapidly developing modern city led to a complex, dynamic culture, no longer controllable by any restricted formulation of public values based on precedent and tradition.

Chief among his targets was the Royal Academy of Art, particularly its first president, Sir Joshua Reynolds. Reynolds's *Discourses on Art* was the definitive exposition of civic humanist theory. Hazlitt's attack centred on Reynolds's comments on portraiture. In his fourth Discourse Reynolds describes why 'historical' narrative painting is the highest form of art. Portraiture cannot aspire to the ideal because it depends on likeness to a particular individual. As Reynolds explains: 'An History-painter paints man in general; a Portrait-Painter, a particular man, and consequently a defective model.'[8] If individuality is a 'defect', portraiture can only elevate sitters by omitting some of the peculiarities of their appearance. 'If a portrait painter is desirous to raise and improve his subject, he has no other means than by approaching it to a general idea.'[9]

For Reynolds, then, the problem of portraiture lies in the *difference* between individual appearance and a 'general idea' . There is no problem of the kind described by Froude. He does not think it the job of portraiture to seek to uncover the complexity of personal identity. Rather, it is all a matter of appearances: the quirks of individuals set against a general idea. In so far as Reynolds conceived of

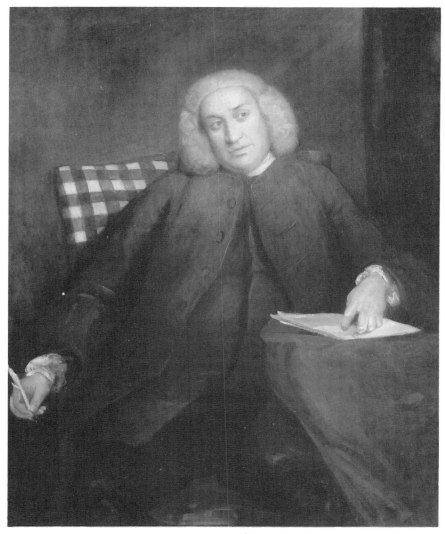

75 J. Reynolds, *Samuel Johnson, c.* 1756. Oil on canvas, 127.6 x 101.6 cm. This portrait oscillates between articulations of the social role and the physical presence of the sitter. 'Character' is constructed through the iconography of literary activity (pen, paper, desk) that is partially displaced by the odd, intrusive pose of Johnson's body in the pictorial space.

'character', it was by analogy with theatrical performance, a persona constructed by the artist and inhabited by the sitter.

Hazlitt claims that these opinions are wholly contrary to Reynolds's actual practice as a portraitist. Reynolds's paintings reveal more than the assimilation of ideal to real appearances, or the playful adoption of personas. In portraits of his friends, such as Samuel Johnson (Figure 75), Reynolds has recorded the sitter's unique gestures, poses and expressions, almost recreating their presence.[10]

From this Hazlitt begins to develop the idea of the authentic portrait, claiming that Reynolds's portraits of Johnson are of value to us not as works of art, but as a

means to grant a glimpse of the living man. Reynolds was privileged to have known Johnson personally. Today we can only *imagine* his presence through the portrait.

Hazlitt's emphasis on the complexity of individual character has led him to a view which involves a radical departure from debates centring on likeness. Art should not alter appearance for the sake of an ideal. Instead, it must seek meaning *through* appearance. The more completely art recreates the full complexity of an individual, the more it approaches the revival for the viewer of that person's life. The detailed appearance of the image stands for the unseen identity represented.

We would rather have seen Johnson, or Goldsmith, or Burke, than their portraits. This shows that the effect of the pictures would not have been worse if they had been the more finished and more detailed: for there is nothing so true, either to the details or the general effect, as nature.[11]

Hazlitt identifies 'nature' with personal individuality. Nature is a source of infinite variety, but is a unifying agency because of our common encounters with it. Art which relies on nature can be both individual and general. In portraiture this interplay between specificity and generality is equally internal and external. We encounter both unique personalities and common humanity.

Describing the portraits, Hazlitt writes almost longingly of the personal intimacy Reynolds knew with Johnson, Goldsmith, Burke and other famous wits. This implicit wish to recapture the lost cultural vitality of that moment is a crucial aspect of Hazlitt's thinking. In an age in which culture is experienced as fragmented and unstable, the portrait provides a link with an imaginary community of lost cultural intimacy.

This is the origin of the thinking behind the NPG. In an increasingly complex and impersonal society portraiture identifies the human source of thought and action, offering the prospect of a direct and intimate relationship between one individual and another. It links us to the value of humanity itself while affirming the irreducible complexity of individuality.

These ideas are developed further in the writings of Carlyle. His early essays argue that industrial development has produced a misplaced faith in machinery. The search for technical solutions extends from manufacturing into politics and psychology. Political debate centres on such abstractions as constitutional rights and the laws of economics. For Carlyle, the disruptive forces unleashed by rapid economic development will not be resolved by talk of 'rights' or 'progress'. Instead a way has to be found to revitalise thinking which centres on people.

This view was expounded in Carlyle's lectures on *Heroes and Hero Worship* (1840). Marcia Pointon has rightly stressed the importance of this book for the development of interest in the project of the NPG.[12] She connects *Hero Worship* with a number of other publications which interpreted history through the actions of outstanding individuals. But Carlyle's influence was more complex than this suggests.

Carlyle's belief in hero worship was a secular form of the concept of sainthood. Heroes provide edification and example in the same way that the lives of saints had done when culture was unified by Christian belief. They struggle to bring values into reality. Their lives are acts of faith.

Carlyle's most powerful evocation of this occurs in his book *Past and Present* (1843), which contrasts modern mechanistic thinking with the medieval faith in people. Abbot Samson of the medieval monastery of St Edmundsbury devotes his

life to the memory of the heroic martyr Saint Edmund. One day he decides to descend into the crypt where the holy relics of the saint are kept in a richly decorated sarcophagus. Accompanied by select members of the monastic community, he opens the sarcophagus to gaze on the body of the saint. Inspired by a profound reverence, he lifts up and caresses the body, holding the head in his arms and whispering to it as if cradling a child.[13]

For Carlyle, this apparently primitive behaviour is the epitome of true devotion. The abbot's life is lived in the belief that the dead body of the saint is sacred and that his immortal spirit guides the monastery. Pilgrims visit the community to revitalise their faith by experiencing this link between their own mortal bodies and the life hereafter. This is a literal version of the idea of authentic portraiture. Instead of a portrait the abbot has the physical body to stand for the saint's life. Nor is it just the memory of Edmund that influences him, but his real saintly interventions.

This passage, derived from a fragmentary contemporary biography of the abbot, occurs in the middle of Carlyle's lengthy disquisitions on the problems of modern society. He suddenly switches from theorising to storytelling. This move mirrors the simplicity and directness of the abbot's own attempt to experience intimacy with the saint. Equally suddenly, Carlyle drops the story of the abbot. His medieval source has broken off in the middle of its narrative. *Past and Present* returns to modern society and continues with its exhortations and commentaries.

The 'past' section of *Past and Present* is thus a relatively short interlude. Though the modern world is witness to the disintegration of integrated communities like Abbot Samson's, his story shows how the malaise of modernity can be alleviated. The narrative transports the reader back in time. Carlyle's style in this section of the book, often in the present tense, is intended to emphasise that he is abandoning claims to be a 'scientific' historian. He is not offering a learned commentary on medieval monastic life, but is trying to restore for the reader a lost form of experience: to make the past present.

Past and Present thus extends the conception of the portrait outlined by Hazlitt. The insertion of the story of Abbot Samson into the commentaries on modern society offers a vision of life lived by human rather than mechanical principles. These principles are clearly bound up with the value of portraiture; in a sense the whole sequence is a portrait of the abbot.

Carlyle's account of the monastery is not intended to convince the reader of the reality of saintly interventions in human affairs, but rather of the *meaning* of such belief. The act of portrayal is a mark of submission and devotion, a wish to 'imitate' another person. The portrait itself stands as a sign of this devotion. Encounters with portraits engender the experience of faith.

In Carlyle's view the function of a portrait gallery would be similar to the story of Abbot Samson. In the gallery, the visitor would experience communion with 'national divinities'. Just as the abbot's life had been animated by his devotion to the Saint, so the modern citizen of an alienated and mechanical society would be revitalised by contact with images of those who whose lives had contributed to the development of a national culture.'[14] Such images would provide the same contact with lived experience that Carlyle and Hazlitt both try to communicate in their writing. Carlyle visualises a portrait gallery as a place in which a kind of innocence is restored and modernity put to one side.

The NPG was to be such a space, engendering direct human contact through 227

each image. By collecting historical portraits the gallery would connect the modern viewer to the humanity which animates cultural and historical development: nation would be recognised as community.

In the Commons Palmerston explained how the imaginative leap between past and present offered by the authentic portrait had the effect of changing history from dry chronicle into imagined experience:

It is most interesting, after persons have been reading about the exploits of some eminent person, to be able afterwards to realise the man by seeing his portrait. As somebody has said, in reading that Cæsar conquered Pompey, all you know is that Cæsar was one man and Pompey was another. But it is highly interesting and instructive, after reading about Cromwell, or any other historical character, to go back to the day in which he lived, and to have before you the most faithful representation in painting or sculpture that can be obtained of his person ... The gallery will connect itself with the history of this country.[15]

The theory of authenticity was deeply problematic in practice. The selection committee could not proceed by simply collecting together portraits of the most important figures in British history. Its job was to judge the authenticity of portraits. If authenticity had not been a criterion for inclusion in the gallery the committee could simply have commissioned new copies of known portraits of historical characters. As long as the physiognomies of the subjects were transcribed accurately, then the gallery would still serve its original purpose, to show to the public the faces of those who had helped define the history of the country. A list of persons considered worthy of inclusion could have been drawn up and an artist commissioned to produce the copies. In fact there had been a long tradition of such commissions, as Stanhope himself recognised.[16] The new Palace of Westminster was the latest building to receive the treatment. An artist called Richard Burchett had been given the job of providing accurate portraits of figures from the Tudor court, to be based on authoritative originals.[17]

The obvious advantage of this system is that the subjects can all be chosen. The problem with the demand for authenticity was that no such choice was ever possible; it was necessary to rely on the availability of authentic portraits. This became apparent as the committee which had been set up to collect together the pictures assembled the beginnings of the gallery's collection. They were lucky that the first painting to be donated was the so-called 'Chandos' portrait of Shakespeare (Figure 76), the only portrait to have any claim to have been painted in Shakespeare's lifetime. Shakespeare was undisputed as the nation's number one cultural hero and thus deserved to be number one in the gallery's collection. Indeed, the Chandos portrait epitomises the concept of authenticity as Carlyle had envisaged it. The painting confronts the viewer as a relic of the time when Shakespeare lived and breathed. Like the body of St Edmund, it provides direct material contact with that moment in history. Standing before it, the viewer can re-experience the vision of the artist looking at the face and figure of the living Shakespeare. The painting *is* the experience of that meeting.

However, there are problems. What if the artist did not see Shakespeare? There is no proof of the authenticity of the portrait. It might be that it is a false relic, like many of the dubious saints' bones and pieces of the True Cross held by the Church in Abbot Samson's day. Even if it is authentic, what does it tell us? Can we learn anything about Shakespeare by looking at it?

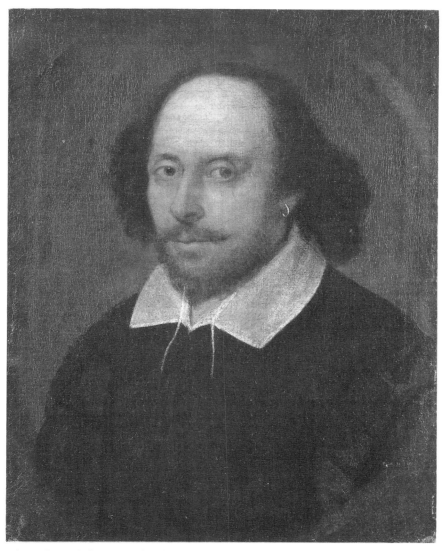

76 *William Shakespeare* ('Chandos' portrait), date and artist unknown. Oil on canvas,
55.2 x 43.8 cm. This picture epitomises the paradoxes of 'authenticity'. As a visual
document it offers an apparently unmediated access to the imagined presence of
Shakespeare himself. As a poor work of art, however, it fails to encode the qualities
of Shakespeare into its own pictorial surface. The presence of 'Shakespeare' seems
devoid of content. Even presence itself is rendered problematic, as the painting's claim
to link the viewer to the historical Shakespeare is undocumented.

These points were made by critics of the gallery while it was still being
discussed in the Commons.[18] An even more telling problem, however, was the fact
that the authenticity rule paradoxically produced the effect that the early collection
became a jumble of historical figures who were not united by any consistent logic.
Having obtained the portrait of the nation's greatest writer, the committee might
very well have wished to follow it with the greatest statesman, scientist,

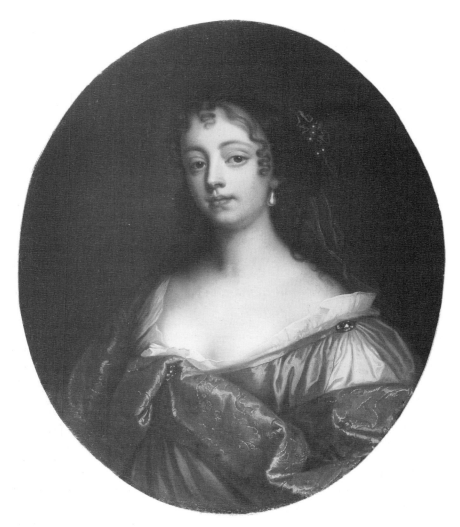

77 J. G. Eccardt, *Elizabeth Hamilton, Countess of Grammont*, date unknown, after Lely portrait of *c.* 1633. Oil on canvas, 76.2 x 62.2 cm. For many Victorian writers, Lely's style was itself morally suspect, imbued with the aspiration to seduce. The pose and expression of this portrait imply a relationship to the viewer alien to the rhetoric of heroism implicit in the work of Watts and Millais.

philosopher or artist. Instead, the gallery's second acquisition was a portrait of the minor Georgian painter Thomas Stothard.

The reason for this was simple. Authentic portraits were not easily come by. After all, the Chandos portrait is unique in the world. The chance that other authentic images of equally distinguished persons would become available was remote. If a portrait was donated or offered for sale, the committee had to decide then and there whether or not to take up the offer. As a result some early acquisitions seemed eccentric. Critics latched on to two such images in particular, the portraits of the writer Arthur Murphy and the Restoration beauty Elizabeth Hamilton, Countess of Grammont (Figure 77).[19] They wondered why such obscure

persons were numbered among the great of the nation. The *Art Journal*, the leading art periodical of the day, argued that the inclusion of these minor figures indicated a confusion at the heart of the project. 'We do not deny', pronounced the *Journal*, 'that in a Gallery of British Worthies a time may come for Arthur Murphy, – but his time is not yet. Nay, it is even a long way off.'[20]

For the *Art Journal*, the authenticity rule made a nonsense of the gallery. The truly great rubbed shoulders with the mediocre. The only solution was to return to the traditional concept of 'a gallery of British Worthies' by commissioning copies of existing portraits of genuinely great figures.

The *Art Journal*'s view was logical and consistent. If a painting by a major artist was acquired for the nation, then it should go into the National Gallery, which was devoted to the idea of great art. If a portrait gallery were also required, then it should only contain pictures of people who were genuinely important. The *Journal* rejects the relationship between authorship and authenticity suggested by Hazlitt and Carlyle. It does not think it important for the viewer to experience the psychological confrontation of artist and sitter. For the *Journal* a portrait is either good art or a useful record of the physiognomy of someone famous. There is no relation between these two roles. In fact it strongly suspected that the portrait of Hamilton owed its presence in the gallery, not to the celebrity of the sitter, which was suspect, but to the belief that it had been painted by Sir Peter Lely, the most distinguished artist of the era. Such a painting should be in the National Gallery.[21]

Parodying the arguments of those who advocated authenticity, the *Journal* described what would happen when the new gallery opened its doors to working-class visitors. Such people were 'scarcely the fit persons to bring into the presence of La Belle Hamilton, Duchess [*sic*] of Grammont'.[22] The passage is ironic. The *Journal* imagines these visitors to be literally in the presence of the Countess, brought before her by the magic of the authentic portrait. The fact that the Countess would be uncomfortable in their company suggests that simple snobbery might also have been a reason for her inclusion. In reality, it is she who has nothing to offer them.

If the authenticity rule led to the inclusion of mediocrity, it had the ironic effect that a single authentic portrait would not necessarily stand for its subject. By 1865 the gallery had obtained three portraits of Queen Elizabeth. Each had an equal claim to be an authentic work from the queen's reign, but each was unique. When the gallery was offered the chance to purchase a painting of a figure such as Elizabeth, it was difficult to turn it down.

Conversely, the commissioners felt under pressure to include portraits of some important historical figures, even though unambiguously authentic images were unavailable. The authenticity rule was badly bent in some cases; a terracotta bust of Oliver Cromwell was acquired in 1861, even though it was impossible to prove whether it was a preparatory model for a known marble or a copy dating from after Cromwell's death. Other acquisitions were also suspect. Many 'studio' copies by unknown hands were accepted.

As Carlyle affirmed, authenticity is a concept which requires the viewer's *faith*: the belief that the gaze of the artist did indeed meet that of the subject. The very impossibility of knowing this for certain, and the indirect nature of many such transactions, undermined the aspiration to achieve what Carlyle had envisaged.

Thus Carlyle's conception of a direct confrontation with the sitter was complicated by the fact that in some cases there seemed to be not one, but several such

confrontations, each one different. Attempts to apply the idea of authenticity involved something more complex and ambiguous than simple access to the past. The lost community conjured up by Hazlitt and Carlyle seemed in practice to be more like a confusion. In other words, a mirror of cultural fragmentation rather than a means to overcome it.

Likewise, the multiplication of portraits of some sitters meant that the problem of *defining* the nature of individual identity in history came to seem much more complex than it would have done had the gallery collected copies as the *Art Journal* advised. The advocates of authenticity had hoped that the NPG would allow the viewer literally to look the past in the eyes. But every attempt to see through the barrier between past and present was filtered through specific styles, conventions and symbolism. It was well known to Victorians that Queen Elizabeth was unwilling to be painted in a way which revealed her age. So an 'authentic' portrait of Elizabeth dating from her reign would most likely be a deceptive concoction, concealing truth rather than revealing it. The authentic portrait might seem to offer that spark of communication which allows the viewer to 'go back to the day in

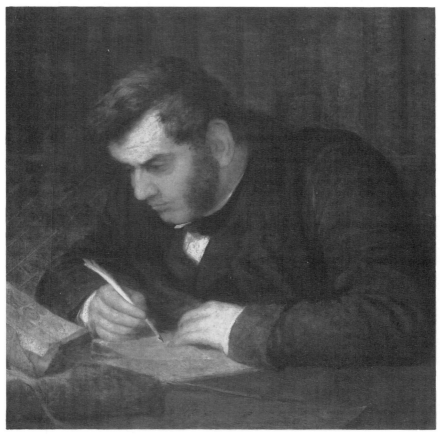

78 G. F. Watts, *Anthony Panizzi, c.* 1847. Oil on canvas, 75.6 x 75.2 cm. Watts's early portrait follows Reynolds by defining 'character' in terms of typical gestures and poses related to the recognisable iconography of the sitter's profession. Panizzi was librarian of the British Museum.

which [the subject] lived', but that day is defined by its own assumptions and requirements. Our separation from the past and its experiences remains.

The NPG's attempt to reconcile individuality with national identity created as many problems as it had tried to solve. Instead of clarity it offered more confusion. The haven was a maze.

These debates around the problems of authorship and authenticity raised questions about the way in which portraits engage with viewers. How is a portrait's authenticity as a historical document related to the visual conventions deployed by the artist? If an authentic portrait requires the viewer's faith, how can the painting convince that it deserves such faith?

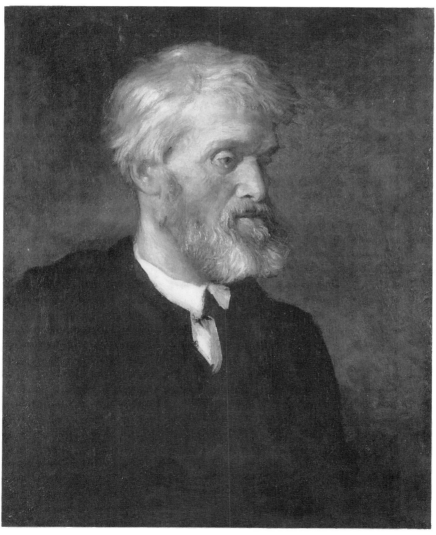

79 G. F. Watts, *Thomas Carlyle*, 1868–77. Oil on canvas, 66 x 53.3 cm. Carlyle objected that this portrait expressed only 'violence, awkwardness, atrocity and stupidity'. Such a sense of barely controllable energy and instability would not be inconsistent with Watts's concerns, or alien to his conception of masculine heroism.

These problems lead us back to Millais's encounter with Carlyle. Millais's portrait is one of a number of his paintings of celebrities and statesmen which are now in the NPG. These portraits are directly influenced by Carlyle's theory of authenticity. But Millais was not the only artist whose work was bound up with the ideas of the founders of the NPG. Back in 1851, G. F. Watts was thinking about creating a gallery of portraits depicting his most distinguished contemporaries.[23] The idea was not unusual. As we have seen, engraved collections of such images were already being marketed. E. M. Ward, an artist friend of Stanhope's, was also at work on a series depicting authors in their studies. Stanhope himself was to be one of the subjects. But Watts was to take Carlyle's account of the authentic portrait to heart. His own writings are full of Carlylisms about heroism and the value of creative labour. Unlike the NPG, Watts could choose all his subjects from the start. Nor would there be any doubt about the authenticity of his paintings. If the NPG could not contain the multiplicity of the past, at least Watts could create a unified vision of the present.

Watts's main problem was how to include within the image the evidence of its authenticity. An early portrait of Anthony Panizzi, librarian of the British Museum (Figure 78), adopts an approach derived from Reynolds. Panizzi is shown bent over his desk writing, as though glimpsed in a characteristic pose. But Watts soon abandoned this method in favour of a more static style. The portraits he eventually included in his 'hall of fame' tend to show only head and shoulders, with the emphasis on the head. There is little animation in the expressions and the background is generally undefined. Watts explained that a portrait should be a 'summary of the life of a person, not the record of an accidental position'. It should communicate the 'storms and vicissitudes' experienced by the sitter but 'should appear capable of action but performing none'.[24] This is a blueprint for the kind of image attempted by Millais.

Watts set to work to depict the great men of his age. He also sought to include great women, but was rarely happy with these works, perhaps because depicting the physical traces of 'vicissitudes' inevitably conflicted with contemporary ideals of femininity.[25] His aspirations were, however, realised in his paintings of Carlyle (Figure 79), Cardinal Manning, and others. As Watts's words indicate, each portrait was to contain within it an entire biography. The activity of life was to be combined with the iconic passivity of a secure identity.

Watts layers his paint thickly and roughly, creating an agitated surface of brushstrokes, smudges and scrapings. Colin Trodd has pointed out the importance that this apparently blotched and congested texture had for Watts. For Trodd, it exemplifies the 'primordial encounter with matter' that Watts identified as the condition of experience. Watts's theoretical writings combine Carlyle's ideas with aspects of the theory of evolution, resulting in a form of psychological Darwinism which stressed the unfolding struggle of consciousness to emerge from matter. Painting could visualise the relationship between the sheer physicality of matter and the activity of the mind, forcing vitality and significance from the mass of pigment.[26] In his portraits the troubled paint surface marks the vicissitudes of which he wrote. Often he uses layers of paint like skin and flesh, their broken patterns the equivalent of the physical effects of toil, weariness, struggle. The redness which lies literally under the painted skin around Manning's eyes, the knotty wrinkling of Carlyle's flesh: each works to identify the effort to visualise complexity through the body. Thus the struggle to paint a complex surface, half revealing hidden depths, becomes identified with that 'inner secret of the features' described

by Froude. Like Millais, Watts aspires to uncover that secret, while emphasising the difficulty of the task.

This struggle to visualise mind through matter is most evident in a self-portrait painted just before his death. As he attempts to represent his own consciousness working through his body Watts builds up the surface of the paint around the skull so that the dome of his own head appears to be physically emerging from the canvas, as though the image is forcing itself to break the

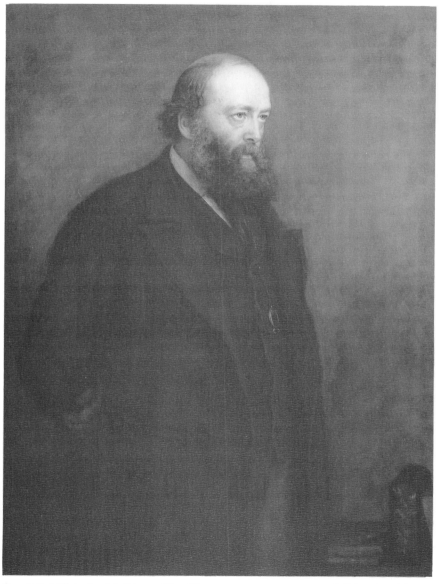

80 J. E. Millais, *Lord Salisbury*, 1883. Oil on canvas, 127.3 x 93.3 cm. Salisbury's mighty head emerges from an almost overwhelmingly heavy but uncertain surface of pigment. Note the 'double' marking of the edge of his lapel. The portrait tugs between emphases on stability and restlessness.

boundaries of representation. The painted head becomes an emblem of the way the mind pushes itself into being through matter.

This emphasis on the forehead is to be found in other late Victorian portraits, including those of Millais. Contemporary biology laid great stress on the size of the skull as evidence of the progressive force of evolution creating human intelligence.[27] When Millais was working on his portrait of Carlyle he was developing his own version of the methods used by Watts. Millais's late portraits of contemporary worthies such as Tennyson, Gladstone and Disraeli are constructed so that the head appears to emerge, glowing, from a dull flurry of undefined pigment. This background, a wriggling of paint across the canvas, is similar to Watts's primordially activated matter.

These features are apparent in his portrait of Lord Salisbury (Figure 80). This portrait mimics the process whereby an image is created from the raw materials of paint and canvas. The portrait becomes progressively more complex as the flat monochrome sketch of Salisbury's clothing at the bottom is increasingly replaced by a denser and more heavily worked surface. The picture creates the impression that it is building itself up from its own ground. Salisbury's head is the climax of this process of complication: the forehead thrusting itself forward into light. The brown and muddy matter of the paint surface complicates itself so much that it becomes thought.

Watts and Millais, then, direct the viewer to the struggle which makes an authentic portrait. The paint itself acts out the unresolved meeting of the body of pigment with the body of the subject, itself a sign of the engagement of one personality with another.

These paintings epitomise the idea of the authentic portrait. The signs of common humanity, age, care, the body, are the very means by which the artist signals the encounter with the sitter. The viewer is encouraged to identify with mortality and physicality. The reality of bodily decay merges with the transcendent triumph of complex identity. This is the nearest portraiture can approach to Abbot Samson's devotion to both the mortal remains of St Edmund and to his undying spiritual presence.

Watts's paintings are now part of the NPG. It was recognised at the time that his hall of fame more nearly approached the aims of the NPG than the gallery's own jumbled collection.[28] But authenticity brought another paradox. Because the NPG was dedicated to the commemoration of history, not modernity, Watts's portraits of living persons could not be admitted. Watts needed to have known his sitters personally to produce valid authentic portraits, but they had to be dead before the portraits could enter the collection. By the time Watts's work entered the gallery, it represented another lost cultural community, like that of Reynolds's literary friends.

There was one more paradox, though it was not immediately apparent. Watts's wish to include the viewer in the encounter which the portrait records led to an emphasis on unresolved struggle. In doing so he paved the way for modernist portraiture. His interest in the signs of struggle and pain are mirrored in the twentieth century in the portraits of Bacon, Auerbach and Kossoff; his agitated, worried surfaces and fascination with the conflict between the decay of the body and the intensity of the gaze persists in the sculptures of Giacometti.

Portraiture became a problem for modernist artists because modernism is incompatible with what Carlyle himself called the 'fundamental condition' of

portraiture, that it depict appearance. However, the Victorian conception of the authentic portrait already contains the seeds of the modernist fragmentation of identity. Millais's and Watts's agitated surfaces, rippling across apparently static figures, identify the fact that the attempt to grasp that elusive secret of the features was finally impossible. As Millais wrestled with his portrait of Carlyle, he knew that his single image had to hold together the multiple and contradictory elements of Carlyle's personality. The more he approached the invisible secret, the more 'it seemed to fade away'.

Notes

1 J. Froude, *Froude's Life of Carlyle*, ed. J. Clubbe (London, 1979), p. 641.
2 *Hansard*, 4 March 1856, p. 1770.
3 R. Ormonde and J. Cooper, *Thomas Carlyle 1795–1881* (London, National Portrait Gallery, 1981), p. 24.
4 *Hansard*, 4 March 1856, p. 1779.
5 Such publications included: W. Jerden, *National Portrait Gallery of Illustrious and Eminent Personages of the Nineteenth Century, with Memoirs*, 5 vols (London, 1830); W. C. Taylor, *National Portrait Gallery of Illustrious and Eminent Persons, chiefly of the Nineteenth Century*, 1846; *The Illustrated National Portrait Gallery of Rminent Personages chiefly from Photographs by Mayall ... with Memoirs by E. Halford*, 1858–63.
6 J. Barrell, *The Political Theory of Painting from Reynolds to Hazlitt: the Body of the Public* (New Haven and London, 1986), pp. 10–31, 97–9.
7 *Ibid.*, pp. 326–38.
8 J. Reynolds, *Discourses on Art*, ed. R. Walk (New Haven and London, 1959), p. 70. For a detailed discussion of eighteenth-century ideas about 'character' in portraiture see D. Shawe-Taylor, *The Georgians, Eighteenth Century Portraiture and Society* (London, 1990), pp. 21–32.
9 Reynolds, *Discourses on Art*, p. 72.
10 W. Hazlitt, 'Character of Sir Joshua Reynolds', *The Complete Works of William Hazlitt*, ed. P. P. Howe (London and Toronto, 1930), XVIII, p. 55.
11 Hazlitt, 'Character of Sir Joshua Reynolds', p. 53.
12 M. Pointon, *Hanging the Head: Portraiture and Social Formation in Eighteenth-Century England* (New Haven and London, 1993), pp. 227, 232.
13 T. Carlyle, *Collected Works*, Library Edition (London, n.d.), XIII: *Past and Present*, pp. 150–4.
14 Carlyle, *Collected Works*, VI: *Critical and Miscellaneous Essays*, pp. 243–4. The earliest expression of this idea is probably found in *Characteristics*, in which Carlyle looks for a means to restore unselfconscious experience amid the confusion of an age overdosing on the idea of scientific and technological progress. 'Knowledge is a symptom of derangement', he claims; Carlyle, *Collected Works*, VIII, p. 331.
15 *Hansard*, 3 August 1859, p. 887.
16 *Hansard*, 4 March 1856, pp. 1779–80.
17 *Parliamentary Papers: Fine Arts*, 12th Report, 1861 XXXIII, Appendix, pp. 415–16.
18 *Hansard*, 5 August 1857, p. 1118; 10 August 1857, p. 1316.
19 Arthur Murphy (1727–1805), playwright; Elizabeth Hamilton (1641–1708), Restoration beauty. See *Hansard*, 13 July 1858, p. 1422; Pointon, *Hanging the Head*, p. 235. Ironically, the portrait of Hamilton is now thought to be a copy dating from the eighteenth century.
20 *Art Journal*, 1858, p. 243.
21 *Art Journal*, 1858, pp. 55, 243.
22 *Art Journal*, 1859, p. 56.
23 M. S. Watts, *George Frederick Watts: The Annals of an Artist's Life* (London, 1912), I, p. 113.
24 *Ibid.*, III, p. 35.
25 *Ibid.*, II, p. 250.
26 C. Trodd, 'Vision, violence, value: G. F. Watts, G. K. Chesterton and the limits of land-

scape', conference paper, Association of Art Historians Annual Conference, 9 April 1994. See also G. Bayes, *The Landscapes of G. F. Watts* (London, 1907), p. XIV. Bayes discusses the idea that Watts's surfaces always emphasise the potential for further reworkings. For a complex account of Watts's work in relation to the problems posed by the identification of portraiture, see L. Johnson, 'Pre-Raphaelitism, personification, portraiture', in M. Pointon (ed.), *The Pre-Raphaelites Reviewed* (Manchester, 1989), pp. 148–52.

27 For the importance of physiognomic theory in Victorian culture see M. C. Cowling, *The Artist as Anthropologist: The Representation of Type and Character in Victorian Art* (Cambridge, 1989).

28 Watts, *George Frederick Watts*, II, p. 45.

12

The portrait's dispersal: concepts of representation and subjectivity in contemporary portraiture

ERNST VAN ALPHEN

The pictorial genre of the portrait doubly cherishes the cornerstone of bourgeois western culture. The uniqueness of the individual and his or her accomplishments is central in that culture. And in the portrait, originality comes in twice. The portrait is highly esteemed as a genre because, according to the standard view, in a successful portrait the viewer is not only confronted with the 'original', 'unique' subjectivity of the portrayer, but also of that of a portrayed. Linda Nochlin has expressed this abundance of originality tersely: in the portrait we watch 'the meeting of two subjectivities'.[1]

Such a characterisation of the genre immediately foregrounds those aspects of the portrait that heavily depend on specific notions of the human subject and of representation. As for the represented object, this view implies that subjectivity can be equated with notions like the self or individuality. Somebody's subjectivity is defined in its uniqueness rather than in its social connections; it is someone's interior essence rather than a moment of short duration in a differential process. Somebody's continuity or discontinuity with others is denied in order to present the subject as personality. One may ask if this view does justice even to the traditional portrait.

As for the representation itself, the kind of notion we get from this view is equally specific. It implies that the portrait *refers* to a human being which is (was) present outside the portrait. A recent book on portraiture makes this notion of the portrait explicit on its first page: 'Fundamental to portraits as a distinct genre in the vast repertoire of artistic representation is the necessity of expressing this intended relationship between the portrait image and the human original.'[2]

The artistic portrait differs, however, from the photographic portrait as used in legal and medical institutions, by doing a bit more than just referring to somebody. It is more than documentation.[3] The portrayer proves her/his artistic originality by *consolidating* the self of the portrayed. Although the portrait refers to an original self already present, this self needs its portrayal in order to secure its own being. The portrayer has enriched the interiority of the portrayed's self by bestowing exterior form on it. For, without outer form the uniqueness of the subject's essence could be doubted. The portrayer proves her/his own uniqueness by providing this proof.

The traditional portrait in this equally traditional view seems to embody a dual project. Two interests are intertwined in this genre. The first interest is quite obvious: the portrait's investment in the authority of the portrayed. The most innocent reading of portraits would be that the sitters were portrayed because they had authority in the first place, in whatever field of society. But since our insight into the past distribution of authority is mediated among other things through portraits of historical figures on which we bestow authority because they have been worthy of portrayal, this intuitive acceptance of the 'real' authority of the sitter is actually the reverse of that other activity, namely placing authority in them through the function of the portrait. From the perspective of the viewer this innocent reading is a case of analepsis, of chronological reversal. It is because we see a portrait of somebody that we presume that the portrayed person was important and the portrayed becomes the embodiment of authority in whatever way. Thus, authority is not so much the object of portrayal, but its effect. It is the portrait which bestows authority on an individual self. The portrait, especially when it is framed by its place in the National Portrait Gallery or a comparable institution, expects us viewers to stand in awe, not so much of the portrait, but of the portrayed.

The portrait, however, does more than this. Not only does it give authority to the self portrayed, but also to the mimetic conception of artistic representation that produces that increase of authority. Since no pictorial genre depends as much on mimetic referentiality as the traditional portrait, it becomes the emblem of that conception. The German philosopher Hans-Georg Gadamer is a clear spokesman for this exemplary status of the portrait:

The portrait is only an intensified form of the general nature of a picture. Every picture is an increase of being and is essentially determined as representation, as coming-to-presentation. In the special case of the portrait this representation acquires a personal significance, in that here an individual is presented in a representative way. For this means that the man represented represents himself in his portrait and is represented by his portrait. The portrait is not only a picture and certainly not only a copy, it belongs to the present or to the present memory of the man represented. This is its real nature. To this extent the portrait is a special case of the general ontological value assigned to the picture as such. What comes into being in it is not already contained in what his acquaintances see in the sitter.[4]

In the portrait, Gadamer claims, an individual is not represented idealised, nor in an incidental moment, but in 'the essential quality of his true appearance'.

This description of the portrait as exemplum of the (artistic) picture reveals the contradictory nature of mimetic representation. It shows how the traditional notion of the portrait depends on the rhetorical strategy of mimesis. According to Gadamer, in the portrait, more than in any other kind of picture, an 'increase of being' comes about. This increase turns out to be the essential quality of the true appearance of the sitter. The portrait refers to this sitter who exists outside the work. Since the sitter exists outside the work, we may assume that also her/his essence exists outside the work.[5]

This implies that the portrait brings with it two referents. The first is the portrayed as body, as material form. The second is the essence of the sitter, her/his unique authenticity.[6] Within the traditional notion of the portrait, it is a truism to say that the strength of a portrait is being judged in relation to this supposed essence, not in relation to the looks of a person. This explains the possibility of negative judgements on photographic portraits. Although a camera captures the

appearance of a person maximally, the photographer has as many problems in capturing a sitter's 'essence' as a painter does. Camera-work is not the traditional portrayer's ideal but its failure, because the essential quality of the sitter can only be caught by the artist, not by the camera.

But in Gadamer's text we don't read about an essential quality which has been *captured*. The essential quality of the sitter is the increase of being that seems to be *produced* by the portrayer in the portrait. 'What comes into being in it is not already contained in what his acquaintances see in the sitter.' The portrayer makes visible the inner essence of the sitter and this visualising act is creative and productive. It is more than a passive rendering of what was presumed to be already there, although interior and hence invisible. The portrayer gives this supposed interiority an outer form so that we viewers can see it. This outer form is then the signifier (expression) of the signified (the sitter's inner essence).

What to do with the surplus of the increase of being? It is clear that Gadamer does not use the term 'increase of being' for the portrait's 'likeness' with the sitter's material form. He indicates the second referent of the portrait: the sitter's essential quality. Gadamer *makes us believe*[7] that what comes into being in the portrait is the same as the referent of the painting. He presumes *a unity* between increase in being and the essential quality of the sitter, or semiotically speaking, between signifier and signified. By presuming that unity, he denies that the increase of being is a surplus. By doing that, Gadamer exemplifies the semiotic economy of mimetic representation. This economy involves a straightforward relationship of identity between signifier and signified.

This identity between signifier and signified is not inevitable. Andrew Benjamin historicises the kind of semiotic conception which also underlies Gadamer's view in the following terms:

The signifier can be viewed as representing the signified. Their unity is then the sign. The possibility of unity is based on the assumed essential homogeneity of the signified. The sign in its unity must represent the singularity of the signified. It is thus that authenticity is interpolated into the relationship between the elements of the sign. Even though the signifier and the signified can never be the same, there is, none the less, a boundary which transgressed would render the relationship inauthentic.[8]

Most surprisingly Benjamin attributes authenticity neither to the signifier nor to the signified, but to the special relationship between the two. In the case of the portrait this semiotic economy implies that the qualifications 'authenticity', 'uniqueness' or 'originality' do not belong to the portrayed subject or to the portrait or portrayer, but to the mode of representation which makes us believe that signifier and signified form a unity. In connection with the issue of authority, this entails a socially embedded conception: the bourgeois self depends on a specific mode of representation for its authenticity.

Now my earlier remark becomes clearer, because more specific, that the portrait embodies a dual project: it gives authority to the portrayed as well as to mimetic representation. The illusion of the uniqueness of the portrayed subject presupposes, however, belief in the unity of signifier and signified. As soon as this unity is challenged, the homogeneity and the authenticity of the portrayed subject fall apart.

In the following pages I will argue that in twentieth-century art the portrait has become such a problematic genre, marginal as well as central in a subversive way,

because from a semiotic point of view the crisis of modernity can be seen as the recognition of the irreconcilable split between signified and signifier. At the moment that artists stop seeing the sign as a unity, the portrait loses its exemplary status for mimetic representation. But artists who have made it their project to challenge the originality and homogeneity of human subjectivity or the authority of mimetic representation, often choose the portrait as the genre to make their point. The portrait returns, but with a difference, now exemplifying a critique of the bourgeois self instead of its authority; showing a loss of self instead of its consolidation; shaping the subject as simulacrum instead of as origin.

Subjected subjects

In an article on the ends of portraiture Buchloh sees the portraits Picasso made in 1910 of his dealers, Kahnweiler (Figure 67, p. 191), Vollard and Uhde, as pronouncements of the death of the genre:

These antiportraits fuse the sitter's subjectivity in a continuous network of phenomenological interdependence between pictural surface and virtual space, between bodily volume and painterly texture, as all physiognomic features merge instantly with their persistent negation in a pictorial erasure of efforts at mimetic resemblance.[9]

In these Cubist paintings Picasso has not only explored a new representational mode, but at the same time articulated a new conception of subjectivity. What kind of subjects emerge from these portraits, and how?

Picasso no longer makes use of a plastic system of signs which refer iconically to referents, fictional or not. His representational mode is no longer mimetic. He uses a small number of forms which signify in relation to each other, differentially. This new mode of representation is based on an economy in which no signifier forms a fixed unity with a signified. Yves-Alain Bois has described this Cubist mode of signification in detail in his article 'Kahnweiler's lesson'. He writes: 'A form can sometimes be seen as "nose" and sometimes as "mouth", a group of forms can sometimes be seen as "head" and sometimes as "guitar".'[10] The signs Picasso uses in these portraits are entirely 'virtual, or nonsubstantial' and can no longer be assumed to relate mimetically to the object of representation: parts of the sitters, faces for instance. The portrayed subjects are shaped mainly as a result of a differential process *between* the signifiers used.

But does this signifying model based on structural difference also give rise to a new conception of subjectivity? Because of my earlier claim about the intertwinement of these two kinds of conceptions, one should expect so. There are remnants of the mimetic model in so far as the portrayed dealers 'look' different. They can be distinguished from each other. But as we have seen, a 'good' portrait claims more than physical recognisability and it would be ludicrous to claim that Kahnweiler is depicted here in his full presence or essence. Here, the process of constructing the illusion of subjectivity with forms which are *arbitrary and exchangeable* has become predominant. To differentiate subjects from each other, to depict them as individuals, is not the same as bestowing authenticity on them.[11]

Andy Warhol's portraits have played a major role in posing questions concerning the social and public dimension of subjectivity. In his work the subject has acquired explicit mythical and incredible proportions. This ironic mythification

81 Cindy Sherman, *Untitled Film Still*, 1978. Black and white photograph, edition of ten, 20.3 x 25.4 cm. What we see is a photograph of a subject which is constructed in the image of representation.

leads to a disappearance of all subjectivity on both sides of the portrait: that of the portrayer and the portrayed. Warhol's individuality, his painterly performance, is systematically absent. His photographic, mechanically produced portraits leave no room for the illusion of the unique self of the portrayer. But the portrayed sitters are also bereft of their interiority. They are exhibited as public substitutes for subjectivity. We, viewers, see not a unique self, but a subject in the image of the star, totally modelled on this public fantasy of 'stardom'.

The avant-garde opposition to the portrait by pop-artists like Warhol stems from an uncanny insight into the formative dimension of the mass-media. In the 1980s feminism gave a new and more fundamental dimension to the conviction that identity is not authentic but socially constructed. It is not the domain of the mass-media which is foregrounded in its effect of making, or rather emptying out, the subject, but rather representation in the most general way. The *Untitled Film Stills* (Figure 81) by Cindy Sherman address this issue most disturbingly. These famous black and white photographs show female characters (always Sherman herself) in situations which remind us of Hollywood films of the 1950s. The *Untitled Film Stills* give the illusion that they are based on original shots from existing films and that Sherman has re-enacted such an original still. Each effort to point out the original film that the photographs are based on is, however, frustrated. There is no 'original' of a Sherman *Untitled Film Still*. As Krauss writes:

Not in the 'actual film' nor in a publicity shot or 'ad', nor in any other published 'picture'. The condition of Sherman's work in the *Film Stills* – and part of their point, we would say – is the simulacral nature of what they contain, the condition of being a copy *without an original.*[12]

It is not by accident that Sherman 'made her point' within the genre of the (self-)portrait, because it is exactly the relation between subjectivity and representation which is scrutinised in her work. The standard relation between subject and representation is now reversed. We don't see a transparent representation of a 'full' subjectivity, instead we see a photograph of a subject which is constructed in the image of representation. The traditional portrait, or rather the standard view of the traditional portrait, is turned inside out.[13]

In all her *Untitled Film Stills* we are impelled to recognise a visual style and a type of femininity. 'The images suggest that there is a particular kind of femininity in the *woman*, whereas in fact the femininity is in the image itself, it *is* the image.'[14] This conclusion could give the impression that there is little difference between the notion of the subject in pop-art portraiture and in Sherman's *Untitled Film Stills*. For, both oeuvres shortcircuit the idea that the portrait provides a representation of a subject which is authentic and original.

There is, however, a major difference between the pop-art portraits of the 1960s and the feminist photographs of Sherman of the late 1970s. This difference gives a new edge to the deconstruction of the portrait by twentieth-century artists. In the words of Rosalind Krauss:

Indeed, almost two decades of work on the place of woman within representation has put this shift into effect, so that a whole domain of discourse no longer conceives of stereotype as a kind of mass-media mistake, a set of cheap costumes women might put on or cast aside. Rather stereotype – itself baptised now as 'masquerade' and here understood as a psychoanalytic term – is thought of as the phenomenon to which all women are submitted both inside and outside representation, so that as far as femininity goes, there is nothing *but* costume.[15]

This implies that representations in the restricted sense – films, advertisements, novels, paintings – are part of a far more absolute set of mechanisms; of representation in the broader sense, called the symbolic order in Lacanian psychoanalysis.[16] Subjectivities are shaped, are constructed by this symbolic order.

The portrait receives a new significance in the light of this feminist, psycho-analytically informed conception of subjectivity. In Sherman's case the portrait is

not used as a critique of the mass-media, but as the framework which explores and exposes modes of femininity. This had to be done within the genre of the portrait exactly because according to the standard view of the traditional portrait that was the place were we could watch femininity as an essential quality, as beauty that is. If the portrait has been one of the main frameworks in which the notion of 'real' femininity had been advocated, it is of course the most relevant space for a deconstruction of that notion.

Subjecting powers of representation

Although I have assumed an intertwinement in the portrait between the conception of subjectivity and that of representation, I have so far focused on twentieth-century portraiture whose main point it is to propose new notions of the subject. Not all twentieth-century artists who have challenged portraiture began by reflecting on subjectivity. Some of them gave rise to new conceptions of subjectivity as a result of their challenging reflections on the effects and powers of representation, especially of the representation of human subjects. Because of the intertwinement of the two conceptions, the difference is often hard to discern. Challenging the notion of subjectivity has immediate consequences for the notion of representation; and the other way round. But emphases shift. Therefore, I will now focus on artists who have changed portraiture by their reflections on representation.

In his *Camera Lucida* the French critic and semiotician Roland Barthes has written about the nature of the relation between portrait and portrayed. In his view the image has a strong hold over the subject through the ability to represent the body of the subject as whole, an ability that the subject itself lacks. For the subject has only transient bodily experiences and partial views of its own body. To transform these fragmented experiences and views into a whole, the subject needs an image of itself.

Barthes, however, does not see the dependence on the unity-bestowing relation with the image as desirable, but as mortifying. 'I feel that the photograph creates my body or mortifies it, according to its caprice.' Barthes's remark about the effect of photographic portraiture can be read as a characterisation of discourse and representation in the most general sense.[17] The subject loses itself when it is objectified in representation. This loss of self is brought about because the objectification of the subject that bestows the experience of wholeness on it is a discursive transformation that translates the subject into the terms of the *doxa*, the platitudes of public opinion. The subject falls prey to a representation that constructs it in terms of stereotypes. So, according to Barthes, in the portrait the subject is not confronted with itself in its essential quality, but by becoming an image it is alienated from itself, because assimilated into the *doxa*.

Barthes's view on the portrait is highly ambivalent. One depends on portraiture for the illusion of wholeness, but at the same time one has to pay for that by a loss of self. One's image is always cast in terms of the already-represented. Barthes needs the portrait and resists it, which makes the portrait into a space of conflict. Barthes's view of the alienating effect of representation enables me to discuss the disturbing quality of the portraits of Francis Bacon. Barthes's account of the relationship between representation and subjectivity as a discursive conflict enables Bacon's portraits to be seen as efforts to unsettle the kinds of representations of the

self that mortify any self-experience. In his interviews with Sylvester, Bacon's emphasis on the need for distortion in order to represent the 'real' appearance of somebody can be understood as a fight against stereotypical representations of the subject.

FB: What I want to do is to distort the thing far beyond the appearance, but in the distortion to bring it back to a recording of the appearance.
DS: Are you saying that painting is almost a way of bringing somebody back, that the process of painting is almost like the process of recalling?
FB: I am saying it. And I think that the methods by which this is done are so artificial that the model before you, in my case, inhibits the artificiality by which this thing can be brought about.[18]

Bacon talks about his portrayals as conflicts between the artificiality of representation and the resistance of the model to that artificiality. That which Bacon depicts is exactly the fight between subject and representation. He folds the subject back onto itself, endorsing the resulting fragmentation as the inevitable consequence of this denial of the unity-bestowing power of representation.

There are many motifs in Bacon's portraits which give rise consistently to this view of the mortifying effects of representation on the portrayed subject.[19] Let me digress for a moment on one motif which strikingly and literally substantiates the power of the portrait to threaten subjectivity.[20] The painting *Three Studies of Isabel*

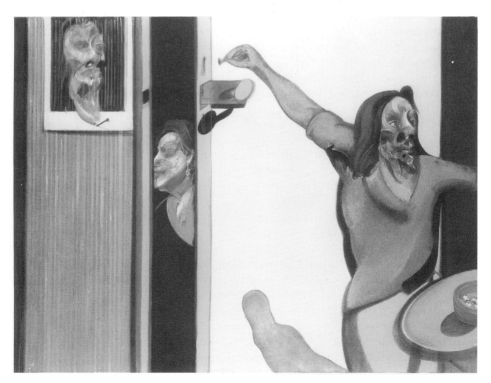

82 Francis Bacon, *Three Studies of Isabel Rawsthorne, 1967*. Oil on canvas, 119 x 152.5 cm. The nail suggests that any attempt to represent mimetically may be regarded literally as an attempt to nail down the subject.

Rawsthorne, 1967 (Figure 82) is not only a portrait, it is also a work about the portrait. Isabel Rawsthorne is portrayed on different ontological levels. We see her in the primal space of the painting, but also as the subject of a portrait nailed to the wall. In this painting the distinction, or tension, between inside (subjectivity) and outside (representation) is first of all thematised literally. We see the figure opening or closing a door.[21] But she does this with her back turned to the act she is executing. This suggests that there is danger or revulsion involved in this act, a reading supported by *Painting, 1978* in which we see a naked figure locking or unlocking a door. The extremely artificial pose in this second painting expresses even more unambiguously the anxiety involved in this simple act. But the ambiguity between inside and outside, and the ambivalence of the distinction as such, is repeated in the relationship between reality and representation, here thematised as the distinction between literal, primary space and figural, represented space. We see the female figure not only inside and outside the door; we see her as a shadow on the white door and in a painting nailed on the wall (thus represented indexically as well as iconically). This image on the wall encapsulates the tensions produced by the painting that it is part of. As in many Bacon portraits, it is as if the represented figure is coming out of the image; or perhaps it is the other way around and a figure is being sucked into an image. The figure is both inside and outside the image.

Bacon's representational logic also manifests itself in *Three Studies of Isabel Rawsthorne, 1967* in the form of another motif recurrent in his oeuvre. The portrait within the portrait is pinned down to the wall by a nail. This nail evokes immediately other Bacon paintings: his *Crucifixions.*[22] In the context of Bacon's allegorical polemic with the western tradition of mimetic representation, the motif of the crucifixion signifies more than just bodily suffering and sacrifice. Within Bacon's consistent reflection on the effects of representation the crucifixion betokens the inevitable consequence of representation, the tearing apart of the subject, the destructive effect of reproductive mimesis. And this is even more obvious in those works where the crucifixion is not represented by the cross or by slaughter, but subtly and microscopically by nails. As indexes of the immense suffering and the total mortification of the body, the nails suggest that any attempt to represent mimetically may be regarded literally as an attempt to *nail the subject down*. Bacon accuses mimetic representation, by foregrounding its mortifying effects on the subject.[23]

Portraits referring differently

The portraits of Sherman and Warhol undermine the idea that the portrait is able to refer to somebody outside the portrait. Portraits are caught up in the realm of representation. They refer to mass-media-produced stereotypes or simulacra which function as screens that block a transparent view of reality. Does this mean that reference is a passé notion in contemporary portraiture?

I don't think so. Instead, referentiality has become an object of intense scrutiny. The work of the French Jewish artist Christian Boltanski explores the concept of reference in a fundamental way and he does that mainly within the genre of the portrait. He is very outspoken in his desire to 'capture reality'. Many of his works consist of re-photographed 'found' snapshots. He incorporates these photographs in larger installations. In his *The 62 Members of the Micky Mouse Club* (1972), for

instance, he presents re-photographed pictures of children which he had collected when he was eleven years old. The original photos were pictured in the children's magazine *Micky Mouse Club*. The children had sent in a picture which represented them best. Looking at these pictures seventeen years after he collected them, Boltanski is confronted with the incapacity of these images to refer. 'Today they must all be about my age, but I can't learn what has become of them. The picture that remains of them does not correspond anymore with reality, and all these children's faces have disappeared.'[24] These portraits don't signify 'presence', but exactly the opposite: absence. If there were 'interiority' or 'essence' in a portrait, these photographs should still enable Boltanski to get in touch with the represented children. But they don't. They only evoke absence.

In some of his later works he intensifies this effect by enlarging the photos so much that most details disappear. The eyes, noses and mouths become dark holes, the faces white sheets. These blow-ups remind us of pictures of survivors of the holocaust just after they were released. This allusion to the holocaust, which I will call Boltanski's 'holocaust-effect', is not caused by choosing images of Jewish children. He has always avoided using actual photographs from the deathcamps and in only two of his works used images of specifically Jewish children.[25]

The 'holocaust-effect' undercuts two elements of the standard view of the portrait. By representing these people as (almost) dead, Boltanski foregrounds the idea that these photographs have no referent. And by representing these human beings without any individual features, he undermines the idea of 'presence' in the portrait of an individual. All the portraits are exchangeable: the portrayed have become anonymous, they all evoke absence. Absence of a referent outside the image, as well as absence of 'presence' in the image. About his *Monuments* (1986) (Figure 83), for which he used a photograph of himself and of seventeen classmates, he says the following:

Of all these children, among whom I found myself, one of whom was probably the girl I loved, I don't remember any of their names, I don't remember anything more than the faces on the photograph. It could be said that they disappeared from my memory, that this period of time was dead. Because now these children must be adults, about whom I know nothing. This is why I felt the need to pay homage to these 'dead', who in this image, all look more or less the same, like cadavers.[26]

The photographs don't help him to bring back the memories of his classmates. He calls his classmates 'cadavers', because the portraits of them are dead. The portraits are dead because they don't provide presence or reference. He only remembers what the picture offers in its plain materiality as a signifier: faces.

The dead portraits are in tension with another element of his installations. The installations are always framed as monuments, as memorials or as shrines. The portraits are often lightened by naked bulbs as if to represent candles, to emphasise their status as memorial or shrine. These framings make the intention of the installation explicit. These works want to memorialise or to keep in touch with the subjects portrayed. The photographs produce, however, an effect which is in conflict with this intention. They are not able to make the portrayed subject present. They evoke absence. That is why the memorials are not so much memorials of a dead person, but of a dead pictorial genre. The portrait is commemorated in its failure to fulfil its traditional promises.

248 But Boltanski has made other kinds of work which are closer to fulfilling the

standard claims of portraiture. In 1973 and 1974 he made several installations, generically called *Inventories*, which consisted of the belongings of an arbitrary person. In his *Inventory of Objects that Belonged to a Woman of New York*, he presented the furniture of a woman who had just died. The function of these

83 Christian Boltanski, *Monuments*, detail of installation view, 1986. Boltanski has said about this work that he 'felt the need to pay homage to these "dead" who in the image all look more or less the same, like cadavers'.

belongings was to witness the existence of the woman who had passed away. Semiotically speaking these *Inventories* are fundamentally different from the installations with photographs. While the photographs refer iconically (or better, fail to do that), the inventories refer indexically. The pieces of furniture represent the woman, not by means of similarity or likeness, but by contiguity. The woman and her belongings have apparently been adjacent.[27]

The point here is the shift from icon to index.[28] The difference between the iconical and the indexical works is a matter of pretension. The photographic portraits claim, by convention, to refer to somebody and to make that person present. They fail, as I have argued, in both respects. The indexical works don't claim presence: they show somebody's belongings, not the person her/himself. And strangely enough, they are successful as acts of referring to the person to whom the objects belonged. This success is due to the fact that one of the traditional components of the portrait has been exchanged for another semiotic principle. Similarity has gone, contiguity is proposed as the new mode of portraiture. When we stay with the standard definition of the portrait, Boltanski's indexical works fit much better in the genre of the portrait than his photographic portraits.

Although referentiality is more successfully pursued in the indexical installations, the problem of presence in these works is again foregrounded as a failure. In *The Clothes of François C.* (Figure 84), for instance, we see black-and-white, tinframed photographs of children's clothing. The photographs of these clothes immediately raise the question of the identity and the whereabouts of their owner. This leads again to the 'holocaust-effect'. The clothes refer to the storage places in the death and concentration camps where all the belongings of the internees were sorted (thus depriving them of individual ownership) and stored. After the war some of these storage places were found, and became symbols, or better indexical traces, of the millions who were put to death in the camps.[29]

Marlene Dumas, a Dutch artist of South African origin, also addresses the problem of reference in her oeuvre, which mainly consists of groups or individual

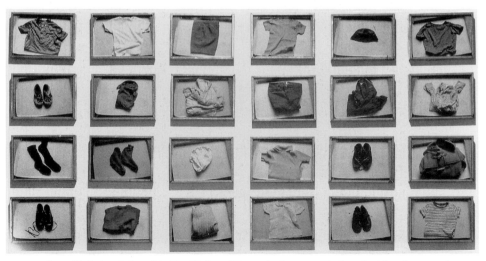

84 Christian Boltanski, *The Clothes of Francois C.*, 1972. Black and white photographs, tin frames, glass. Each photograph 22.5 x 30 5 cm. The photographs of these clothes immediately raise the question of the identity and the whereabouts of the owner.

portraits. This artist is even more explicitly concerned with the problems of refer-
ence. She has said about her work: 'I want to be a referential artist. To refer is only
possible to something which has already been named. (But names are not always
given by you.)'[30] Like artists such as Warhol and Sherman, Dumas is aware of the
screen of images and representation, which makes reference impossible, but she
does not accept the situation. Instead of foregrounding the screen and the im-
possibility of plain reference, she fights, while referring, against the conventional
'names' which were not given by her. How does she do this?

The portraits and group portraits of 1985–7 show faces which often look like
masks. The faces are usually very light, they look like sheets or screens which are
emptied out; black pupils surrounded by white, attract the attention in these
bleached faces. The eyes are very ambiguous in an uncanny way. It is not clear if in
their round darkness they should be read as remnants of subjectivity; as the eyes
peeping through holes in the artificial mask; or that they are nothing other than
stereotypical signs in a mask, indicating eyes. The mask, as well as the caricature,
has had an important function in dismantling the traditional portrait in twentieth-
century art. Buchloh describes this role of the mask and the caricature as follows:

both caricature and mask conceive of a person's physiognomy as fixed rather than a
fluid field; in singling out particular traits, they reduce the infinity of differential facial
expressions to a metonymic set. Thus, the fixity of mask and caricature deny outright
the promise of fullness and the traditional aspirations toward an organic mediation of
the essential characteristics of the differentiated bourgeois subject.[31]

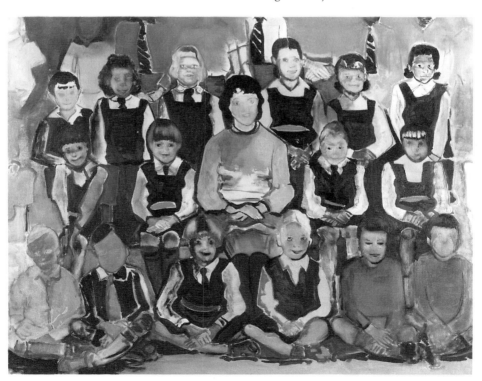

85 Marlene Dumas, *The Teacher (sub b)*, 1987. Oil on canvas, 160 x 200 cm.
The question arises whether it is the situation of the group as such or the portrayal
of a group which causes this putting to death of subjectivity.

The mask represents essential features of subjectivity as fixed, mechanical or grotesque. Although this is relevant for an understanding of Dumas's work, her mask-like portraits evoke at the same time a very different quality. The faces in her work evoke emptiness and death. Subjectivity is not present, but rather absent. Like Boltanski's installations, these portraits give rise to a 'holocaust-effect'. In her group portraits it seems that the group as such is responsible for this. In *The Teacher (sub b)* (Figure 85) (1987) she portrays a class of schoolchildren in uniform. Uniform is usual in South Africa, but this portrayal emphasises how apartheid culture fixed identities on the basis of the most superficial exteriority. As a consequence, the children's faces have the same empty, uniform expression as their clothes. In *The Teacher* we see that the uniform expression of the students is that of their teacher. This sameness is presented as death or absence. The question arises, then, whether it is the situation of the group as such, or the *portrayal of a group*, which causes this putting to death of subjectivity, this holocaust-effect? One cannot help remembering here that apartheid was quite literally the representation or 'portrayal' of groups. But Dumas's work goes beyond such a political statement alone. She explores the intricate relationship between the political situation of apartheid and the representational consequences of mimetic portrayal, looking for essences.

For Dumas's later portraits suggest by their difference that these earlier works are part of an overall project to explore and challenge systematically the

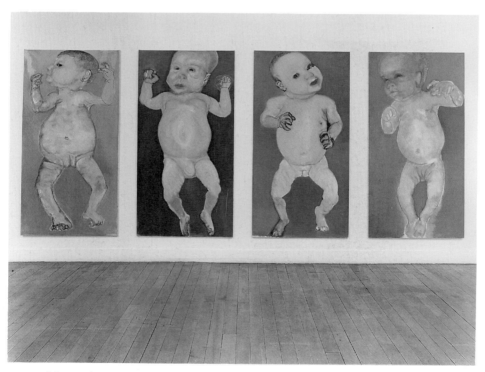

86 Marlene Dumas, *The First People (I–IV)*, 1991. Oil on canvas, each 180 x 90 cm. Depicted horizontally we would see these babies in all their vulnerability and powerlessness. But erected like this, these little creatures suddenly become monsters with grabbing claws.

conventional characteristics of the traditional portrait as a politically invested genre. In the later works she continues to pursue the genre's conventions, but takes a different approach. She begins to experiment with format. While portraits are usually vertical (reflecting the human subject in its most respected posture: standing), an extreme horizontal format is also introduced. In such images the figures are stretched out in all their horizontality. It is as if they are pulled down, made powerless, by the format of the portrait.[32] There is a relation between being depicted horizontally and powerlessness, as opposed to the connection between the vertical format of the portrait and the authority of the portrayed person. This becomes provocatively clear when Dumas paints a male nude in this horizontal position in *The Particularity of Nakedness* (1987). Dumas tells about a museum director's response to this painting.[33] He considered it a failure, because it had too many horizontals (*sic*). A successful painting needs verticals, he seemed to imply, without realising that Dumas had purposefully represented masculinity in this painting in such an unerect way.

Dumas's explorations of the relation between format and authority are shaped by contrasts. While representing masculinity horizontally, she depicts babies vertically in four vertical paintings: *The First People (I–IV)* (1991) (Figure 86). When depicted horizontally, we would see babies in these poses in all their vulnerability and powerlessness (see *Warhol's Child*). But erected these little creatures suddenly

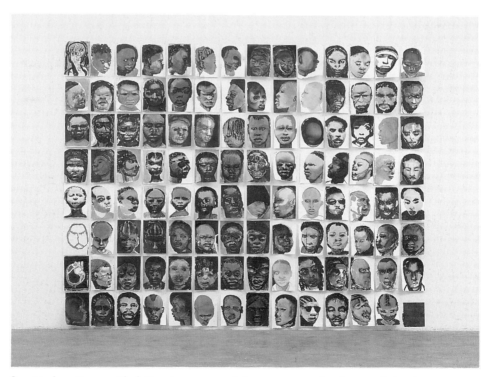

87 Marlene Dumas, *Black Drawings*, 1991–2. Ink on paper, 112 drawings, each drawing 25 x 17.5 cm. Dumas constructs a conception of subjectivity based on variety and diversity but not on unique individuality.

become monsters with grabbing claws. By enlarging this authority-effect of the vertical format, Dumas deconstructs this quality of the traditional portrait. She undoes the increase of being, namely the bestowing of authority on the portrayed, by giving it grotesque proportions and by attributing it to inappropriate exemplars.

In her work *Black Drawings* (1991–2) (Figure 87) and the portraits she made for the mental institution 'Het Hooghuys', in Etten-Leur (1991), Dumas explored portrayal in yet an other way. This time she made no individual portrait or group portrait, but a group of portraits. *Black Drawings* consists of 112 portraits of black people; the work made for 'Het Hooghuys' consists of 35 paintings, with one panel having a poem by the Dutch poet Jan Arends. Most of the paintings are portraits of the people who are living in the mental institution, some are of animals.

These two groups of portraits are radically different from the earlier group portraits. They don't produce a holocaust-effect. Nor do they work as a collection of original subjectivities. Instead of promoting black subjects or mentally ill subjects to the status of bourgeois subjectivity, she constructs a conception of subjectivity based on variety and diversity but not on unique individuality. The portrayed models are not bestowed with subjectivity in terms of original presence, but in relation to each other. They are, because they are all different. That is why they all deserve their own panel within their collective portrayal.

The kinds of images I have discussed all suggest that the portrait has not at all become a dead genre in twentieth-century art, as some critics have claimed recently. Conceptions of subjectivity and identity have been challenged, mimetic conceptions of representation have been undermined in all kinds of ways. This has led to the implausibility of the intertwinement of bourgeois subjectivity with mimetic representation, but not to the death of the genre as such. Although genres are of course contaminated by their histories, it is not necessary to define a genre by its history. Artists like Warhol, Sherman and Dumas show how a genre can be liberated from its history so that it can become an arena for new significations. The project of 'portraying somebody in her/his individual originality or quality of essence' has come to an end. But portraiture as genre has become the form of new conceptions of subjectivity and new notions of representation.

Notes

1 L. Nochlin, 'Some women realists', *Arts Magazine* (May 1974), p. 29.
2 R. Brilliant, 'Portraits: a recurrent genre in world art', in Jean M. Borattit and R. Brilliant, *Likeness and Beyond. Portraits from Africa and the World* (New York, Center for African Art, 1990), pp. 11–27, p. 7.
3 For the use of the photographic portrait in medical and legal institutions, see J. Tagg, *The Burden of Representation: Essays on Photography and Histories* (Amherst, University of Massachusetts Press, 1988); and A. Sekula, 'The body and the archive', in Richard Bolton (ed.), *The Contest of Meaning. Critical Histories of Photography* (Cambridge, Mass., MIT Press, 1989), pp. 343–89. Sekula argues that the photographic portrait extends and degrades a traditional function of artistic portraiture, that is, of providing the ceremonial presentation of the bourgeois self. 'Photography came to establish and delimit the terrain of the *other*, to define both the *generalized look* – the typology – and the *contingent instance* of deviance and social pathology'(p. 345).
4 H. G. Gadamer, *Truth and Method* (New York, Continuum, 1975), p. 131.
5 Brilliant sees the portrait as a transcendent entity: 'Portraits concentrate memory images into a single, transcendent entity; they consolidate many possible, even legiti- mate, representations into one, a constant image that captures the consistency of the

person, portrayed over time but in one time, the present, and potentially forever' (Brilliant, 'Portraits', p. 13). I contend that his transcendent entity, the result of the concentration of several images into one, is based on the same representational logic as Gadamer's 'instance of being'.

6 A. Benjamin, 'Betraying faces: Lucien Freud's self-portraits', *Art, Mimesis and the Avant-Garde* (London and New York, Routledge, 1991), pp. 61–74. He discusses the semantic economy of mimetic representation from a philosophical perspective. I follow here the main points of his argument.

7 See K. L. Walton, *Mimesis as Make-Believe. On the Foundation of the Representational Arts* (Cambridge, Mass., Harvard University Press, 1993).

8 Benjamin, 'Betraying faces', p. 62.

9 B. H. D. Buchloh, 'Residual resemblance: three notes on the ends of portraiture', in Melissa E. Feldman (ed.), *Face-Off. The Portrait in Recent Art* (Philadelphia, Institute of Contemporary Art, 1994), pp. 53–69, p. 54.

10 Y.-A. Bois, *Painting as Model* (Cambridge, Mass., MIT Press, 1990), p. 90.

11 Buchloh argues that postwar New York photographers like Diane Arbus, Richard Avedon and Irving Penn try to reassert the bourgeois concept of subjectivity. Photography is often the medium used for regressive reactions to new conceptions of the subject. Buchloh sees their works as desperate efforts to hold on to unique individuality. Since the mythical dimension of this notion is increasingly exposed, they try to convince by representing extreme cases. They focus on forms of eccentricity and on sitters who are the 'victims of their own attempt to shore up traditional bourgeois conceptions of originality and individuality' (Buchloh, 'Residual resemblance', p. 59). When the notion of individual subjectivity is more and more contested, it is safeguarded as a spectacular sight. It is hard to deny 'uniqueness' in the forms of the grotesque or in the life of freaks.

12 R. Krauss, *Cindy Sherman, 1975–1993* (New York, Rizzoli, 1993), p. 17.

13 For a brilliant Lacanian analysis of Sherman's *Untitled Film Stills*, see the last two chapters of Kaja Silverman's *The Threshold of the Visible World* (New York and London, Routledge, 1995).

14 J. Williamson, 'Images of women', *Screen*, 24 (November 1983), p. 102.

15 Krauss, *Cindy Sherman*, p. 44.

16 See J. Lacan, *The Four Fundamental Concepts of Psycho-Analysis*, ed. J.-A. Miller and trans. A. Sheridan (Harmondsworth, Penguin, 1979); and for a good introduction and critical discussion of Lacan, especially in its consequences and possibilities for such visual studies as art history and film studies, see K. Silverman, *Male Subjectivity at the Margin* (New York, Routledge, 1992).

17 For a relevant discussion of Barthes's view on the mortifying effect of discourse, see Ann Jefferson, 'Bodymatters: self and other in Bakhtin, Sartre and Barthes', in Ken Hirschkop and David Shepherd (eds), *Bakhtin and Cultural Theory* (Manchester and New York, Manchester University Press, 1989).

18 D. Sylvester, *The Brutality of Fact: Interviews with Francis Bacon* (London, Thames and Hudson, 1982), p. 40.

19 See Ernst van Alphen, *Francis Bacon and the Loss of Self* (London, Reaktion Books, 1992).

20 In chapter 3 of van Alphen, *Francis Bacon and the Loss of Self*, I develop a view on the portrait and of Bacon's deconstructions of that view, by focusing on Bacon's famous 'pope paintings'. I discuss the pictorial genre of the portrait there in comparison with the literary genre of the detective.

21 This situation of a figure opening or closing a door is a recurrent motif in Bacon's oeuvre. See, for instance, the central panel of *In Memory of George Dyer, 1971, Painting, 1978*, the outer panels of *Triptych, 1981* and *Study of the Human Body, 1983*.

22 See his *Fragment of Crucifixion, 1950, Three Studies for Crucifixion, 1962* and *Crucifixion, 1965*.

23 As often, Bacon also picks up a motif from the history of art to make his own point with it. In Vermeer's *Woman with a Balance* in the National Gallery of Art in Washington, DC, a tiny nail in the wall on the left of the represented painting of the *Last Judgement* also suggests a critical note on the illusionary quality of realistic painting. See the opening pages of M. Bal, *Reading 'Rembrandt': Beyond the Word–Image Opposition* (New York, Cambridge University Press, 1991).

24 Boltanski, quoted in L. Gumpert, *Christian Boltanski* (Paris, Flammarion, 1994).

25 In *Chases High School* (1987) and *Reserves: The Purim Holiday* (1989).

26 Interview with Christian Boltanski by Démosthènes Davvetas, quoted in Gumpert, *Christian Boltanski*.

27 Or rather, these belongings pretend to, and thus represent the idea of, having been contiguous to the woman, because later Boltanski admitted that he had 'cheated' the audience by exhibiting furniture which he had borrowed from personal acquaintances. But this only proves the semiotic status of his work. The sign, according to Umberto Eco's definition of it, is 'everything which can be used in order to lie'. Umberto Eco, *A Theory of Semiotics* (Bloomington, Indiana University Press, 1976), p. 10.

28 For a seminal discussion of the important role of the index in contemporary art, see R. Krauss, 'Notes on the index: part 1 and Notes on the index: part 2', *The Originality of the Avant-Garde and Other Modernist Myths* (Cambridge, Mass., MIT Press, 1985), pp. 210–20.

29 In other indexical portraits, the holocaust-effect is even more directly pursued. Part of the installation *Storage Area of the Children's Museum* (1989), for instance, consisted of racks of clothing. The piles of clothes which were stored on the shelves referred to the incomprehensible numbers who died in the concentration camps.

30 M. Dumas, *Miss Interpreted* (Eindhoven, Van Abbemuseum, 1992), p. 10.

31 Buchloh, 'Residual resemblance', p. 54.

32 This is especially the case in *Warhol's Child* (1991), but also in those paintings which seem to comment on the tradition of the female nude: *Snow White and the Broken Art* (1988), *The Guilt of the Privileged* (1988), *Snow White in the Wrong Story* (1988), *Waiting (for Meaning)* (1988) and *Losing (her Meaning)* (1988).

33 Dumas, *Miss Interpreted*, p. 43.

PART VII

What is a portrait?

I3

Pre-figured features: a view from the Papua New Guinea highlands

MARILYN STRATHERN

In this afterword, four examples suggest non-representational uses of bodily characteristics to communicate identity.[1] I shall draw analogies between two different kinds of cultural practice in the Papua New Guinea highlands, the use of the *imago* (a wax impression of the face of deceased male ancestors) in the ancient Roman Republic, and contemporary DNA fragment patterns in which genetic material taken from an individual is made to appear as a characteristic sequence of dark bands.[2]

Individual features

Euro-Americans looking at a portrait may well assume that they are looking at someone who has a name. The name may not be known, but the likeness of the features 'belongs' to the individual just as his or her name does. And although persons can be recognised by their gait or voice, conventionally it is to faces that names are given. It might be disconcerting therefore to think about the Asmat of Irian Jaya, who previously went on hunting expeditions to capture other people's names to give to their children. Men accomplished this by bringing home the head to which the name formerly belonged.[3] Or the Marind-Anim who, not necessarily knowing the name, would bestow as a 'head name' on their children the last utterance of the decapitated victim.[4]

Ethnographers of the Asmat and Marind-Anim suggest that the head-hunters were seeking access to the 'life-force' of the other people. This was thought of as a potency transferable between persons: what the head contained (this potency) rather than its features was important. When heads were kept, they were either stripped down to the skull or else remodelled – sometimes with the original skin, but stuffed beyond recognition.[5] They might be decorated with shell valuables and feathers to idealise them as sources of a life-force which now flowed through the living.

It would be stretching the imagination, then, to think of these heads as portraits in the sense of a physiognomic likeness which referred to the living or once-living person depicted. They obliterated rather than conserved the bodily uniqueness of their original owners. Above all, there seemed no interest in the

facial features as indicating the individuality of the person. The head might be an individual's head, but it was not deployed so as to suggest it represented the original owner *as an individual*.

In a conventional Euro-American portrait, by contrast, the individual person is recognisable in the depicted individualised body, with its unique characteristics, especially of the face. These characteristics I take to be 'features'. In a portrait, a principal medium is thus precisely the individual's body-features.[6] In Papua New Guinea, people certainly distinguish living people by their features. But when they come to 'represent' the individuality of persons, they do not use such features to do so. The New Guinea heads had their origin in individual persons, yet if features once made that person recognisable in life, they ceased to do so when its animation was taken by another.

Individuation lay rather in the capacities people evinced in their effect upon the world. Such individuality was evinced by the decapitator and/or by the recipient of the head. It was in the very *act* of severing the head that the Marind-Anim man displayed unique access to the power embodied in his ability to bestow a head-name on each of his children.[7] For Asmat men, repeated success in head-hunting was a requisite for personal honour; only someone who had taken several heads could sponsor feasts in his own name.[8] The boy recipients of the life-force bestowed by a head-name became the incarnation of that particular deceased person; the deceased relatives might treat him as their kinsman.[9] In short, the boy took on the decapitated person's identity. If anyone's individuality was represented in bestowing a head's life-force, it was thus that of its new owner.

But is 'representation' the right word?[10] Representation implies a medium, as facial features might be deployed as a medium through which Euro-American portraits refer to the individuality of persons. Yet in the Asmat case the individuality of the new owner was evinced by enactment. It was the demonstration of a capacity – to sever the head or absorb its life-force – that was individuating. Individuality was thus an *effect*, either of taking action or being the recipient of someone else's acts. The heads themselves remained as *evidence*; severed by the power of the decapitator and emptied by the recipient who had drained their life-force away. They did not mediate any relationship with the dead man in that they did not stand for him. It was the new man who appeared to the victim's kin instead of the old: a living person not exactly standing for the dead one, but standing in for him.

The *imago* displayed in aristocratic Roman families perhaps provides a better analogy for this than the twentieth-century concept of a portrait. As described by Dupont,[11] families of Republican Rome attested their nobility through their right to images of deceased male ancestors. *Imago* means both the wax impression made of the deceased's face and the wax masks which were repeatedly[12] made from these impressions. Dupont argues that there was nothing representational about the *imago*: it designated *both* the impression in the wax and the features which made the impression. It was 'the trace, not the figuration, of the deceased'.[13] This trace was counted as a material reality or evidence: the wax mask was bodily presence.

A distinction was made between the *imago* as the material presence of the deceased and figurative representations such as those in funerary orations, or the 'names' written on public signs hung from the boxes in which the *imago* was contained.[14] The *imago* contained an impression of the deceased; it could be seen as the living form of the deceased even as the Asmat boy was the living form of the decapitated victim. Words, by contrast, were a medium through which the

deceased's exploits became a spectacle. Honorifics were thus attached to the deceased through the medium of words, spoken or written by others, as representations of that person's achievements. Both the funeral oration and the titles had public significance, whereas the wax image was ordinarily kept out of sight.

In the Asmat or Marind-Anim use of heads, I suggested that the individuality being celebrated belonged not to the victim but to the decapitator/recipient. The deceased's lifetime achievements were taken away to become a life-force bestowed upon another. If we pay attention to those who handled the Roman *imago*, it would seem that they also received an individuality of a kind. Such individuality may well have inhered in the capacity of the living family of the deceased to make public the throng of ancestors as a source of glory – if not exactly life-force – for their descendants. This was achieved by bringing out the (*imago* of the) ancestors at the funeral oration for a newly deceased member of the family.

The oration aimed to produce a spectacle, evoking the illustrious past of the family in the context of praising the newly deceased. It was delivered from a rostrum on which the corpse was placed in the presence of the family's *imago*. The efficacy of the verbal praise as a source of glory was thus apparently dependent upon the ability to invoke the material presence of the deceased and his ancestors. The *imago* sat in the audience, in the form of masks worn by actors dressed according to the highest title of the ancestor in question. This was the moment when, removed from their boxes, the images were in public attendance, but they apparently processed anonymously. What was offered for the admiration of the crowd were unnamed features and the material insignia of power with which they were accompanied. Can this be read as a collective, public claim to individuality on the part of living family members?

Such individuality would not inhere in the wax faces of particular, named persons. The features conserved in wax were evidence above all of the *fact of the impression*, the form of a living presence uniquely claimed by those mounting the event. Bringing out the ancestors was thus an enactment of the very power they had passed on.

Composite features

We may judge the Roman *imago*, like the decapitated New Guinea heads, to be less than portraits. But they do prompt questions about where we should look for signs of individuality and about the nature of representation. Consider another figure, not the head itself, but the feather plaque Hagen men attached to the head, made to be seen frontally, above a dancer's face, and a further 'head'[15] of feathers atop the plaque (Figure 88). How might we (or might we not) think of this composition as a portrait?

But first I want to mention the difficulty I had in choosing this illustration, since my quandary illustrates some of the themes of this text. I was unwilling to take the liberty of including numerous pictures of individual dancers in a volume on portraits without asking their permission, particularly since a collection of images of New Guinea dancers in their feathers, wigs and face paint is liable to invoke Air Nuigini advertising, BBC documentaries, or *Time* magazine. A group photograph of dancers would be culturally more appropriate in that it would convey the collectivity of the event and the public nature of such occasions. Yet it would

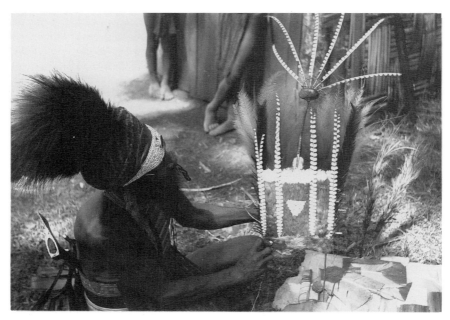

88 A man from Mt Hagen, Papua New Guinea, examines a feather plaque which will be worn as part of a friend's dance headdress. It has been assembled from birds of paradise and parrot feathers, freshly brought out of their wrappings. Crown plumes from the King of Saxony bird of paradise divide up the panels and form a further spray on top, like a head upon a head. Each headdress is at once a combination of conventional elements and unique, and the man is judging the overall effect of this assemblage.

also suggest that when you look at portraits of non-westerners you no longer see the individual. A single illustration could exemplify[16] multiple points and thus do the work of several photographs, while treating the individual in a respectfully unique way. But it would make one person represent everyone: the informant who doubles as everyman, anonymous and unasked.

In the end I included a single photograph. I never knew the name of the man depicted but in order to accord him a named identity, I have called him Ketepa after the bird-plumes. He was seemingly pleased by my photographic interest in what he was doing, although he belonged to a clan group with whom I had little acquaintance and to whom I was no doubt another tourist. On this occasion, in 1967, he was not formally dancing, but the bamboo tally on his chest tells of success on previous occasions. He was helping a dancer by adding plumes from the King of Saxony bird of paradise (*køi ketepa*) to his head decoration (*køi wal*). The colours were vivid: long eggshell-blue Saxony plumes set against the russet of *raggiana* plumes at the back; parrot feathers composing deep blue panels at each side and a contrasting bright red centre; a pool of startling blue in the very middle.

This decoration was being made in preparation for one of the public dances in which clans display their strength to an audience. The Saxony plumes which make up the 'second head', the spray, are said to be like fresh water which, when it flows, is a sign of life. Ketepa was looking at how the spray is attached, on a flexible cassowary quill. As the dancer moves, so the light catches the feathers which then shimmer like flowing water. The feather plaque is designed to be fastened to the

top of a gleaming black ceremonial wig, usually somewhat larger than the one Ketepa is wearing. It is an extension of a body already enlarged by decoration; the living head is pointedly *not* severed. Hagen men decorate in order to undertake a strenuous display of energy and endurance in full public view. They typically arrange themselves in a single line, to be admired primarily from the front. The living bodies support the signs of life that the men claim for themselves.

Display occasions are generally political: the dances ceremonialise gifts between allies or enemies in warfare, groups engaged in competitive bouts of gift and counter-gift. Gifts, comprising specially mounted pearlshells, livestock and money are handed over as an aggressive challenge to the recipient to make as good a return later. Carrying weapons, it is the current donors who decorate and dance. In the gift transaction, men are detaching wealth from themselves and in that act pointing to their capacity to attract wealth in the first place. They have received the valuables such as pearlshells in the same way as they gave them. Valuables, which may themselves be decorated for giving away, thus come and go between persons. A gift is always destined for and derived from a specific other. It travels along the routes of the relationships which link people.

Women, who pass between clans in marriage, are living valuables. In forging potential exchange roads between their brothers and husbands, they encapsulate the possiblity of relationship itself. Women sometimes decorate, but dances are overwhelmingly men's occasions. Hagen men and women say that it is the man's 'name' which goes on top in the fame which dances produce.

Gift exchange resembles the acts which I have discussed earlier in that one gives evidence of one's power by showing that it has been taken from others. The effect is speeded-up because this is accomplished through a constant flow of valuables between living persons, not through killing someone or keeping him in a box. Hagen people are explicit that one gives in order to receive, and that the accompanying wealth and hopes for prosperity and fertility constitute glory for oneself and one's clan alike. Every gift recapitulates other gifts, evidence of the ability to animate relationships.

A man does not dance by himself and decorations are never seen in isolation. The plaque seen in the photograph was virtually identical in pattern to those being worn by other dancers of the same patrilineal clan.[17] Indeed, this type of ornament is the most standardised of all decorations, worn only with certain assemblages. Clansmen also deliberately synchronise other effects such as the way they paint their faces. Does a group, then, constitute a sort of clan portrait? Is the feather plaque its emblem?

Certainly the Hagen clan is more than the members who gather to dance: the clan is its history, its territory, its lineage, its settlements, its wealth in cash crops or trucks. An institution such as a college, a company or a clan also consists in the values of loyalty and solidarity that bind its members together.[18] In evidence of such solidarity Hagen men dance shoulder to shoulder. The Hagen dancer is situated within the clan, yet decorations are neither emblems nor signs of office. Although they indicate certain dance-roles, they are not otherwise uniforms, costumes or even outfits.[19] The collective impression is achieved through, not at the expense of, 'inner individuality'.

This is partly because individuality and group identity are not seen as mutually exclusive. Collective action aggrandises each man's performance, but it is no different in kind from his own aggrandisement as a single person. The photograph

shows just one piece of one man's decorations, and also the *effect* of aggrandisement – plumes attached to plumes. Like each dancer in the line, each item of adornment has been the object of care and attention. Does this denote individuality then? Yes, but not because the items are visibly singular, like facial features. Neither is individuality proclaimed through the dancer's particular, bodily features. Indeed, a dance is only said to be a success if it becomes *impossible* to recognise the dancers. Their decorations must act as a disguise and are reckoned to have failed if the personal identity of the dancer is perceived too easily.

Individuality is proclaimed instead through the decorations themselves. It is an effect of each item being part of an assemblage of items. The dancer's attire has been put together for the occasion from many sources. The crucial analogy is between the clan as an assemblage of men and each man as an assemblage of men: his relations with others. If the Asmat head or the Roman *imago* imparts life-force or glory to other persons, the Hagen dancer is seen to attach to himself the life-force or glory of others. His ornaments – feathers, shells, leaves, cassowary quills, face-paint – can be thought of as so many bits of other persons appended to his person. Their presence is summoned or evinced thereby. The feather plaque is a condensed version of the entire process. No one can wear Saxony plumes without acknowledging (through compensation payments) those from whom he obtained them, in the same way as wearing the plaque at all demands sacrifice to his own ancestors.

Pre-figured in the decorations are the dancer's *relationships with other persons*. Before such an occasion a prospective dancer will have visited, borrowed from, and compensated with gifts numerous in-laws, maternal kin and friends in order to get the decorations he needs. Ketepa's (photographed) act of assembling recapitulates this initial act of gathering ornaments, just as the feather plaque recapitulates the kinds of attachments found in the decorations as a whole. Ketepa is doing this for the person who will dance, with whom he certainly had a relationship which pre-dates this help, but who is not in the picture. His work for the dancer is evident in the skill with which he has mounted the life-giving Saxony spray, and it is quite likely that the feathers belonged to him in the first place. Ketepa also has the dancer's audience in mind (again, not in the picture, though you can see the legs of two boy onlookers).

A man's decorations do not merely 'represent' these other persons; they are there through the activation of his relationship with them. Decorations detached from (the possession of) one person are attached to another. What is true of decoration is also true of identity. A man's capacity is shown twice over: in detaching wealth from others and in turning it into prosperity for himself. So the decorations are a composite of items, just as the man displaying wealth he is to give away is a composite of the relationships along which wealth flows. What distinguishes one assemblage from another, one man from another, is that invisible composition. Each constellation is unique. Similarly, it is in the relationships that a man sustains that his individuality lies. The accomplishments that bring a person a 'name' come from holding persons together, attending to clan brothers, military allies and enemies, his mother's and wife's brothers, and so on. And he always acts within this heterogeneous network.

In sum, what is pre-figured in the assemblages of decorations is the dancer's relationships with other persons. There is no 'whole', final product for which the dancer or his helper aims as he puts the assemblage together. Each individual item

recapitulates the entire effect. Each small act of attachment or aggrandisement adds to the overall process. We may make a further analogy, then, between a man and his decoration.

The man is *pre*-figured in so far as the relationships mobilised by the dancer are already there. Simply by virtue of being born, a person is enmeshed in relationships with mother's and father's kin. Both are celebrated in wealth exchanges: paternal kin in lifelong clan support, maternal kin as donors of fertility and recipients of wealth. Such connections are a principal subject of funeral orations, to draw a link with the Roman situation discussed earlier. Looking at a decorated dancer, the viewer may not know which particular person lent him this or that, but does know that the dancer can only stand thus by virtue of the relationships he has with these others, relationships which he has effectively activated. He is living *evidence* of this support.

The decorations are pre-figured in the knowledge that a man cannot put together an assemblage by himself. Liabilities follow: in addition to material compensation, the dancer must maintain good feelings towards his donors or the decorations may not succeed in their effect. What he manages to borrow is evidence of internal well-being. Inner strength and outer success go together. The ancestors ultimately provide this; without their blessing a man's decorations will appear dull and drab and the dance will fail. They only have to send a shower of rain to make everyone anxious. Notice the umbrella leaning against the wall behind Ketepa.

In what sense, then, is the feather plaque a portrait? It is not a portrait if we mean using a person's body features as medium. The media here are feathers that draw attention away from personal features, just as paint disguises the face. Feathers from the bodies of birds constitute a kind of bird body (*køi wal*)[20] for the man. With its bright coloured centre, this body-enclosure is like the house interior where men keep their valuables, or the maternal confinement of the unborn child, or the inner side of a man's outer skin.

It is not a portrait if we mean that inner individuality must show in the features, for individuality here lies in the act of assembling rather than the fact of appearance. Men dance with visually almost identical assemblages, but each has drawn upon his own unique constellation of relationships in order to do so. And it is not a portrait if we insist on representation, because although this is an artefact that invokes a conception of identity, it is as evidence or trace rather than symbol. We witness an outcome: the result or effect of mobilising relations. These assembled feathers – now in the hands of one person, soon to be in those of another – will not be attached to a *likeness* of the second man but to the person himself. The plaque will in turn have an effect: to make the man an exemplar of his own efficacy and publicise his 'name'. It thus pre-figures the presence of the dancer whom you cannot otherwise see in the photograph. He who puts on the plaque will make visible the efficacy of his support. In looking at the *køi wal*, Ketepa is looking at one of the effects of his own relationship with the dancer. In this sense he is looking at the dancer, and at the same time at himself.

Genetic profiles

I have argued on the supposition that, for twentieth-century Euro-Americans, portraits are conventionally seen to attend to people's features in order to represent

their individuality. These features have to be rendered in such a way as to denote uniqueness. The medium of paint or stone or whatever uses the person's form as a further medium: portraits are in that sense representational. The different treatments of the head which have been presented here raise questions about what is used to denote individuality, and 'where' individuality might be located. I have drawn attention to ways in which individuality is evinced through enactment, and claimed that the principal effect of these acts is not representation but efficacy: the ability to bring something about. There can be no substitute – one either does or does not evince it. We saw that in Republican Rome evidence had to be part of the real thing. Similarly with the decoration of the Mt Hagen dancer, evidence cannot appear as 'counterfeit', cannot appear, as portraits do, as 'a representation'. But this does not preclude seeking evidence that the efficacy has, as it were, had its effect.

Efficacy is evidenced by the head-hunter/the Roman ancestor's descendants/ the dancer who presents his decorations to his audience. The owner of the decorated person which is the Hagen dancer is also that composite of persons with whom he has relations. They are pre-figured in his very ability to appear at all. His kin have given him a body, his associates (like Ketepa) have contributed to its composition, and his exchange partners (allied or hostile) have elicited the display.

Indeed, the decorations re-make the body that is already there, formed by contributions from paternal and maternal kin. Recurrent themes of the decoration refer to the body: white bones, red blood, glistening flesh and dark skin. An assemblage should include both bright and dark elements. Brightness connotes outward connections and the ability to take into oneself the fertility of other persons and

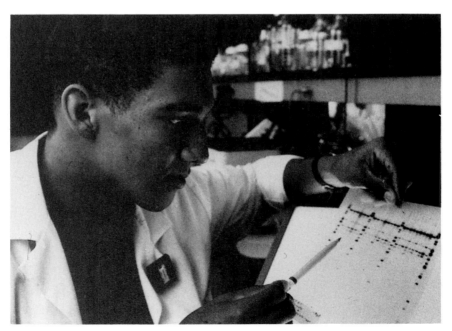

89 A scientist from Washington University, St Louis, USA, examines DNA fragment patterns. A person's DNA is made up of elements that combine for each individual in a unique way. Here the DNA has been cut at specific sites with enzymes and then separated by size; the smaller fragments travel further, so creating a visible banding effect.

other clans. Darkness connotes internal solidarity, outward hostility and ancestral protection. That much of Ketepa's face is shown in shadow is apposite, since the ancestral ghosts sit in the shadow round the back of the dancer's neck. The alternations of light and dark coloration in the arrangement of the feathers on the plaque are deliberate. A white Saxony spray may be flanked by black sicklebill feathers. In the photograph, the dark feathers are stuck into the ground near the packaging which kept them clean and are to be inserted into wands worn on either side of the plaque.

Unique and composite, pre-figured and relational, dark and light, the Hagen self-presentation might be compared with the human DNA fragment patterns with which some Euro-Americans have recently become familiar. Figure 89 shows a scientist examining such patterns.[21] The DNA has been cut at specific sites, suspended in a gel and then separated by means of an electric current. The smaller fragments travel further, creating characteristic bands, a 'bar-code' which can identify individuals and reveal genetic relationships.

We do not know to which cluster of characteristics the genetic sequences examined in Figure 89 relate, any more than we know the name and history of everything we may (now) acknowledge as a portrait. But it is genetic material from someone, not anyone. Genetic material is like the name most Euro-Americans are given at birth – a combination of elements recombined in other persons. It pre-figures that person's features and is composite and relational in that it is created through the combination of maternal and paternal contributions. Like a sort of life-force transmitted from one person to another, DNA sequences are the ancestral traces of connections between the generations, material evidence of the fact that features exist only as the outcome, the effect, of relationships.

The scientist (whose name I do not know) is looking at a representation produced through the medium of a specific technology. It is a picture of efficacy, a fragment of the 'code' for the appearance of certain features or characteristics. It is thus evidence of the genetic mechanism whose effect is always individualising and will show in that person. Indeed, it is that individualising quality which turns representation into evidence. In genetic finger-printing, similar light-and-dark depictions may be used as forensic evidence of individual identity. The depiction in turn is significantly featured: the patterns of bands appear simultaneously as physical characteristics of the DNA and as physical characteristics of the mechanical or biochemical processes which make them appear. Reflection on whether and why one might or might not consider such a depiction a portrait could make us think again about the other material in this chapter.

Notes

1 P. Gow, 'Visual compulsion: design and image in western Amazonian cultures', *Estudios*, 2 (1988), pp. 19–32.
2 My account draws on the prominence of analogy in Melanesian constructions. See F. Barth, *Ritual and Knowledge among the Baktaman of New Guinea* (New Haven, Yale University Press, 1975); M. Strathern, *The Gender of the Gift* (Berkeley and Los Angeles, California University Press, 1988); R. Wagner, 'Analogic kinship: a Daribi example', *American Ethnologist*, 4 (1977), pp. 623–42.
3 B. M. Knauft, *South Coast New Guinea Cultures: History, Comparison, Dialectic* (Cambridge, Cambridge University Press, 1993), p. 192.

4 *Ibid.*, p.156.

5 See G. Bateson, *Naven: A Survey of the Problems Suggested by a Composite Picture of the Culture of a New Guinea Tribe Drawn from Three Points of View* (Stanford University Press, [1936] 1958) on the 'portrait skull' from the middle Sepik area of Papua New Guinea.

6 On liberties with the term 'body', see M. Leenhardt, *Do Kamo: Person and Myth in the Melanesian World*, trans. B. M. Gulati (Chicago, University of Chicago Press, [1947] 1979); D. Battaglia, 'Projecting personhood in Melanesia: the dialectics of artefact symbolism on Sabarl Island', *Man*, 18 (1983), pp. 283–304.

7 Knauft, *South Coast New Guinea Cultures*, pp. 156–7.

8 *Ibid.*, p. 189.

9 *Ibid.*, pp. 191–2.

10 Symbolic analysis is the subject of much anthropological debate. See R. Neich, 'Semiological analysis of self-decoration in Mt Hagen, New Guinea', in I. Ross (ed.), *The Logic of Culture* (New York, Bergin Publications, 1982), a semiotic critique of A. and M. Strathern, *Self- decoration in Mount Hagen* (London, Duckworth, 1971).

11 F. Dupont, 'The Emperor-God's other body', in M. Feher (ed.), *Fragments for a History of the Human Body*, part III (New York, Zone Books, 1989).

12 *Ibid.*, p. 407.

13 *Ibid.*, p. 413.

14 *Ibid.* , pp. 409–11.

15 A conceit of mine. Apart from this, all statements about the Hagen material come from indigenous exegesis and from analysis of it. It is necessary to add that final phrase since anthropologists take people's interpretations as part of their data.

16 Instances or exemplars work not only as parts of a whole (metonymy) or through relations of substitution (metaphor) but as instantiations that retain the properties of trope across different scales and thus 'appear' as 'large' or as 'small' as any other instances.

17 See Strathern, *Self-decoration in Mount Hagen*, colour plate 6.

18 Cf. C. Townsend-Gault, 'Symbolic facades: official portraits in British institutions since 1920', *Art History*, 11 (1988), pp. 511–26.

19 T. Polhemus and L. Proctor, *Fashion and Anti-fashion: An Anthropology of Clothing and Adornment* (London, Thames and Hudson, 1978).

20 On birds and men, see S. Feld, *Sound and Sentiment: Birds, Weeping, Poetics and Song in Kaluli Expression* (Philadelphia, University of Pennsylvania Press, 1982); A. Gell, *Metamorphosis of the Cassowaries: Umeda Society, Language and Ritual* (London, Athlone Press, 1975); P. Sillitoe, 'From head-dresses to head-messages: the art of self-decoration in the highlands of Papua New Guinea', *Man*, 23 (1988), pp. 298–318.

21 From Paul Berg and Maxine Singer, *Dealing with Genes: The Language of Heredity* (Oxford, Blackwell, 1992).

Eclectic bibliography

In addition to the specific references cited in the footnotes to their articles, the contributors to this volume were each asked to provide a selection of texts in English which they had found helpful in thinking about portraiture. The resulting bibliography reflects their interests and includes not only items which explicitly concern portraiture, but also texts which address broader questions of the subject and representation through discourses such as psychoanalysis, the body, sexuality and gender, physiognomy and expression.

van Alphen, E., 'Facing defacement. *Models* and Marlene Dumas's intervention in Western art', in Marlene Dumas, *Models* (Frankfurt am Main, Portikus, 1995), pp. 67–75.

Artaud, A., 'The human face', in J. Hirschman, ed., *Artaud Anthology* (San Francisco, City Lights Books, 1965), pp. 29–34.

Bal, M., *Reading 'Rembrandt'. Beyond the Word–Image Opposition* (New York and Cambridge, Cambridge University Press, 1991).

Banta, M. and Hinsley, C., *From Site to Sight. Anthropology, Photography and the Power of Imagery* (Cambridge, Mass., Peabody University Press, 1986).

Barkin, L., *Transuming Passion, Ganymede and the Erotics of Humanism* (Stanford, California, Stanford University Press, 1991).

Barrell, J., ed., *Painting and the Politics of Culture. New Essays on British Art, 1700–1850* (Oxford, Oxford University Press, 1992).

Barthes, R., *Camera Lucida: Reflections on Photography*, trans. R. Howard (London, Flamingo, 1984), pp. 63–72.

Baumeister, R. F., *Identity, Cultural Change and the Struggle for Self* (New York and Oxford, Oxford University Press, 1986).

Benjamin, A., 'Betraying faces: Lucien Freud's self-portraits', in *Art, Mimesis and the Avant-Garde* (London and New York, Routledge, 1991), pp. 61–74.

Bois, Y.-A., 'Kahnweiler's lesson', *Representations* 18 (1987), pp. 33–68, reprinted in *Painting as Model* (Cambridge, Mass., MIT Press, 1990).

de Bolla, P., *The Discourse of the Sublime: Readings in History, Aesthetics and the Subject* (Oxford, Basil Blackwell, 1989).

Borch-Jacobsen, M., *Lacan. The Absolute Master* (Stanford, California, Stanford University Press, 1991).

Bray, A., 'Homosexuality and the signs of male friendship in Elizabethan England', *History Workshop* 29 (1990), pp. 1–19.

Breckenridge, J., *Likeness: A Conceptual History of Ancient Portraiture* (Evanston,

Evanston University Press, 1969).

Bremmer, J. and Roodenburg, H., eds, *A Cultural History of Gesture* (Oxford, Polity Press, 1991).

Brilliant, R., *Gesture and Rank in Roman Art* (New Haven, Memoirs of the Connecticut Academy of Arts and Sciences, vol. 14, 1963).

Brilliant, R., 'On portraits', *Zeitschrift für Asthetik und Allgemeine Kunst Wissenschaft*, 16:1 (1971), pp. 11–26.

Brilliant, R., *Portraiture* (London, Reaktion, 1991).

Brilliant, R., ed., *The Art Journal* 46:3 (1987). Issue devoted to portraiture.

Bryson, N., 'House of wax', in R. Krauss, *Cindy Sherman, 1975–1993* (New York, Rizzoli, 1993).

Buchloh, B. H. D., 'Residual resemblance: three notes on the ends of portraiture', in M. Felman (ed.), *Face-Off. The Portrait in Recent Art* (exhibition catalogue, Philadephia, Institute of Contemporary Art, 1994), pp. 53–69.

Burgess, R., *Portraits of Doctors and Scientists in the Wellcome Institute of the History of Medicine* (London, Publications of the Wellcome Institute of the History of Medicine, Museum Catalogue no. 3, 1973).

Burke, P., 'The presentation of self in the Renaissance portrait', in *The Historical Anthropology of Early Modern Italy* (Cambridge, Cambridge University Press, 1987), pp. 150–67.

Campbell, L., *Renaissance Portraits. European Portrait-Painting in the 14th,15th and 16th Centuries* (London and New Haven, Yale University Press, 1990).

Clair, J., *Identity and Alterity. Figures of the Body 1895–1995* (Venice, Marsilio, 1995).

Conisbee, P., *Painting in Eighteenth-Century France* (Ithaca, New York, Cornell University Press, and Oxford, Phaidon Press, 1981), chapter 4.

Cowling, M., *The Artist as Anthropologist* (Cambridge, Cambridge University Press, 1989).

Cropper, E., 'The beauty of woman: problems in the rhetoric of Renaissance portraiture', in M. Ferguson, M. Quilligan and N. Vickers, eds, *Rewriting the Renaissance. The Discourses of Sexual Difference in Early Modern Europe* (Chicago, University of Chicago Press, 1986).

Danow, O. K., 'Physiognomy: the codeless "science"', *Semiotica* 50 (1984), pp. 157–71.

Death, Passion and Politics. Van Dyck's Portraits of Venetia Stanley and George Digby (London, Dulwich College Picture Gallery, 1995).

Derrida, J., *Memoirs of the Blind. The Self-Portrait and Other Ruins* (Chicago and London, Chicago University Press, 1993).

Entry on portraiture in the *Encyclopedia of World Art* XI (New York, Toronto, London, 1966).

Feher, M., ed., *Fragments for an History of the Human Body*, 3 parts (New York, Zone Books, 1989).

Felman, M., 'The portrait: from somebody to no body', in M. Felman, ed., *Face-Off. The Portrait in Recent Art* (Philadelphia, Institute of Contemporary Art, 1994), pp. 9–50.

Forster, K. W., 'Metaphors of rule. Political ideology and history in the portraits of Cosmio I de Medici', *Mittelungen des Kunsthistorischen Institutes in Florenz* 15: 65–104 (1971).

Fortune, B. B., 'Charles Willson Peale's portrait gallery: persuasion and plain style', *Word and Image* 6 (1990), pp. 308–24.

Garb, T., 'The forbidden gaze', *Art in America* (May 1991), pp. 146–51.

Genet, J., 'Alberto Giacometti's studio', trans. C. Penwarden, in *Alberto Giacometti. The Artist's Studio* (Liverpool, Tate Gallery, 1991).

Gent, L. and Llewellyn, N., eds, *Renaissance Bodies. The Human Figure in English Culture c. 1540–1640* (London, Reaktion, 1990).

Goffman, E., *The Presentation of Self in Everyday Life* [1958] (London, Penguin, 1969).

Gombrich, E. H., 'The mask and the face: the perception of physiognomic likeness in

life and in art', in E. H. Gombrich, J. Hochberg and M. Black, *Art, Perception and Reality* (Baltimore and London, The Johns Hopkins University Press, 1972).

Gould, S. J., *The Mismeasure of Man* (London, Penguin, 1981).

Hackmann, W. D., *Apples to Atoms. Portraits of Scientists from Newton to Rutherford* (London, National Portrait Gallery, 1986).

Heller, T. C., Sosna, M. and Wellbery, D., eds, *Reconstructing Individualism. Autonomy, Individuality and the Self in Western Thought* (Stanford, 1986).

Johns, C. M. S., 'Portrait mythology: Canova's portraits of the Bonapartes', *Eighteenth-Century Studies* 28:1 (1994), pp. 115–29.

Johnson, L., 'Pre-Raphaelitism, personification, portraiture', in M. Pointon, ed., *The Pre-Raphaelites Reviewed* (Manchester, Manchester University Press, 1987).

Jenkins, M., *The State Portrait. Its Origin and Evolution* (New York, College Art Association of America, 1947).

Koerner, J. L., 'Rembrandt and the epiphany of the face', *Res* 12 (1986), pp. 5–32.

Koerner, J. L., *The Moment of Self Portraiture in German Renaissance Art* (Chicago and London, University of Chicago Press, 1993).

Kristeva, J., trans. L. S. Roudiez, *Strangers to Ourselves* (London, Harvester Wheatsheaf, 1991).

Leids Kunsthistorisch Jaarboek 8 (1989). Issue devoted to 16th–18th century Netherlandish portraiture, with a number of articles in English.

Leiris, M., *Francis Bacon: Full Face and Profile* (Oxford, Phaidon, 1983).

Lingwood, J., ed. *Staging the Self. Self-Portrait Photography 1840s–1980s* (London, National Portrait Gallery, 1986–7).

de Man, P., 'Autobiography as de-facement', in *The Rhetoric of Romanticism* (New York and London, Columbia University Press, 1984).

Mannings, D., 'At the portrait painter's. How the painters of the eighteenth century conducted their studios and sittings' *History Today* 27 (1977), pp. 279–87.

Marin, L., *Portrait of the King* (Basingstoke, Macmillan/University of Minnesota Press, 1988).

Martin, F. D., 'On portraiture. Some distinctions', *Journal of Aesthetics and Art Criticism* 20 (1961), pp. 61–72.

Martindale, A., *Heroes, Ancestors, Relatives and the Birth of the Portrait* (The Fourth Gerson Lecture) (The Hague and Maarsen, Gary Schwartz/SDU, 1988).

Nederlands Kunsthistorisch Jaarboek 46 (1995): *Image and Self-image in Netherlandish Art, 1550–1750*.

Owen Hughes, D., 'Representing the family. Portraits and purposes in early modern Italy', *Journal of Interdisciplinary History* 17 (1986), pp. 7–38.

Pace, C., 'Delineated lives: themes and variations in seventeenth century poems about portraits' *Word and Image* 2:1 (1986), pp. 1–17.

Partridge, L. and Starn, R., *A Renaissance Likeness: Art and Culture in Raphael's Julius II* (Los Angeles, University of California Press, 1980).

Peacock, J., 'The politics of portraiture', *Culture and Politics in Early Stuart England*, ed. K. Sharpe and P. Lake, (London, Macmillan, 1994), pp. 199–228.

Perry, G. and Rossington, M., *Femininity and Masculinity in Eighteenth-Century Art and Culture* (Manchester, Manchester University Press, 1994).

Pointon, M., 'A latter day Siegfried: Ian Botham at the National Portrait Gallery in 1986', *New Formations* 21 (1993), pp. 131–45.

Pointon, M., *Hanging the Head: Portraiture and Social Formation in Eighteenth-Century England* (New Haven and London, Yale University Press, 1993).

Pollock, G., 'Artists, mythologies and media. Genius, madness and art history', *Screen* 21:3 (1980), pp. 57–96.

Rajchman, J., ed., *Identity in Question* (London, Routledge, 1995).

Roth, N., 'Electrical expressions: the photographs of Duchenne de Boulogne', *Multiple Views: Logan Grant Essays on Photography 1983–1989* (University of New Mexico Press, 1991).

Ruggiero, G., *The Boundaries of Eros* (Oxford, Oxford University Press, 1985).

Schneider, N., *The Art of the Portrait. Masterpieces of European Portrait-Painting 1420–1670* (Cologne, Benedikt Taschen, 1994).

Sekula, A., 'The body and the archive', *October* 39 (1986), pp. 3–64.

Shawe-Taylor, D., *The Georgians – Eighteenth-Century Portraits and Society* (London, Barrie and Jenkins, 1990).

Simons, P., 'Women in frames: the gaze, the eye and the profile in Renaissance Portraiture' *History Workshop: A Journal of Socialist and Feminist Historians* 25 (1988), pp. 4–30, reprinted in N. Broude and M. D. Garrard, eds, *The Expanding Discourse: Feminism and Art History* (New York, Icon Editions, c. 1992), pp. 39–58.

Simons, P., 'Portraiture, portrayal, and idealization: ambiguous individualism in representations of Renaissance women', A. Brown, ed., *Language and Images of Renaissance Italy* (Oxford, Clarendon Press, 1995), pp. 263–311.

Solkin, D., 'Great pictures or great men? Reynolds' male portraiture and the power of art', *Oxford Art Journal* 9 (1986), pp. 42–9.

Solkin, D., *Painting for Money: The Visual Arts and the Public Sphere in Eighteenth-Century England* (New Haven and London, Yale University Press, 1993).

Spence, J., *Putting Myself into the Picture. A Political, Personal and Photographic Autobiography* (London, Camden, 1987).

Stanworth, K., 'Picturing a personal history: the case of Edward Onslow', *Art History* 16 (1993), pp. 408–23.

Starn, R., 'Reinventing heroes in Renaissance Italy', in R. I. Rotberg and T. K. Rabb, eds, *Art and History. Images and their Meaning* [1986] (Cambridge, Cambridge University Press, 1988).

Stevenson, S., *A Face for any Occasion* (Edinburgh, Scottish National Portrait Gallery, 1976).

Stewart, A., *Faces of Power: Alexander's Image and Hellenistic Politics* (Berkeley, University of California Press, 1993).

Taylor, C., *Sources of the Self. The Making of Modern Identity* (Cambridge and New York, Cambridge University Press, 1989).

Townsend-Gault, C., 'Symbolic facades: official portraits in British institutions since 1920', *Art History* 11 (1988), pp. 511–26.

Traub, V., *Desire and Anxiety. Circulations of Sexuality in Shakespearean Drama* (New York, Routledge, 1992).

Vickers, N., 'This heraldry in Lucrece's face', in S. Rubin Suleiman, ed., *The Female Body in Western Culture. Contemporary Perspectives* (London and Cambridge, Mass., Harvard University Press, 1986), pp. 209–22.

Walker, S., and Burnett, A., *The Image of Augustus* (London, British Museum Publications, 1981).

Walker, R., *Regency Portraits* (London, National Portrait Gallery, 1985).

Warner, M., *Portrait Painting* (Oxford, Phaidon, 1976).

Weinsheimer, J., 'Mrs. Siddons: the tragic muse, and the problem of "as"', *Journal of Aesthetics and Art Criticism* 36 (1987), pp. 317–29.

Wendorf, R., *The Elements of Life: Biography and Portrait Painting in Stuart and Georgian England* (Oxford, Clarendon Press, 1990).

West, S., 'Patronage and power. The role of the portrait in eighteenth century England', J. Black and J. Gregory, eds., *Culture, Politics and Society in Britain, 1660–1800* (Manchester, Manchester University Press, 1991).

Wilden, A., 'Lacan and the discourse of the Other', in A. Wilden trans., notes and commentary, *Jacques Lacan. Speech and Language in Psychoanalysis* (Baltimore and London, The Johns Hopkins University Press, 1981).

Williams, V., *Who's Looking at the Family?* (London, The Barbican Art Gallery, 1994).

Woodall, J., 'Painted immortality. Portraits of Jerusalem Pilgrims by Antonis Mor and Jan van Scorel', *Jahrbuch der Berliner Museen* 31 (1989), pp. 149–63.

Index

Works of art and literature are listed under the names of their authors.
Page numbers in italics refer to illustrations and captions on the pages cited.